YESTERDAY
and
TOMORROW

California Women Artists

edited by Sylvia Moore

MIDMARCH ARTS PRESS
New York 1989

MIDMARCH ARTS BOOKS

No Bluebonnets, No Yellow Roses: Essays on Texas Women in the Arts
Whole Arts Directory
Pilgrims & Pioneers: New England Women in the Arts
Women Artists of the World
Voices of Women: 3 Critics on 3 Poets on 3 Heroines
American Women Artists: Works on Paper
Guide to Women's Art Organizations and Directory for the Arts

Library of Congress Catalog Card Number: 88-063871
ISBN: 0-9602476-9-6

Copies of this book may be obtained from:
Midmarch Arts Books
Box 3304
Grand Central Station

New York, NY 10163

Contents

Introduction

Shivering, I left New York on a blustery February morning, yet when I walked out of the airport at San Francisco a few hours later the weather was 78 degrees and sunny. Friends drove me over the fabled Golden Gate Bridge and gave me my first glimpse of the Pacific. That day I began to comprehend why California has attracted and kept so many immigrants and why artists are so beguiled by its ambiance.

The art world in California seems Byzantine—divided, subdivided, sub-subdivided and at length fractioned. As artist/critic Kenneth S. Friedman has said, there are four basic divisions: the Bay Area, Los Angeles, La Jolla and "the rest." The Bay Area encompasses a good deal of Northern California, while Los Angeles includes a big slice of the South. La Jolla centers on the unique and prestigious University of California at San Diego, which has attracted to its faculty major figures from the international art scene. And the rest is, well, the rest—splintered into local groups, often dominated by cliques that are difficult to break into, surmount or by-pass. For California artists who do not teach in their field or have not established a reputation and the concomitant sales, it is tough to make a living in art. And in California, as elsewhere, for women and minorities it is toughest of all.

Some say the center of action is shifting southward from San Francisco to Los Angeles, where an economic boom has been followed by a cultural flowering. Wealthy patrons are supporting arts projects generously, and new dynamic galleries have made L.A. and environs the hottest market for contemporary art outside New York. The success of the Getty and Norton Simon museums, the L.A. County Museum and the Santa Monica Museum of Art has been recently enhanced by the Museum of Contemporary Art in downtown L.A. On the other hand, San Francisco, which will soon have a new $70 million home for its Museum of Modern Art, retains its respect and prestige.

Only a comparatively few women, among them the ones we designate "Leading Ladies," have made a splash in the Pacific art world's rough waters. But California women artists have been formidable cultural innovators, agitators for women's, artists' and minorities' rights, and avant-garde practitioners of the

new technologies. On the very doorstep of Hollywood they have pioneered in film, video and performance techniques; they have advanced mural painting from idealized government-sponsored WPA art to a frankly political community art form. Just as plucky women photographers and landscape artists of the 19th century braved the raw frontier towns and the wilderness, courageous feminists of our time risked their careers to bring to birth a truer expression of women's lives and to fight for women artists' visibility.

Following our collections of essays on New England and Texas women artists, this third book in Midmarch's regional series encompasses much of the range of the art experience for California women artists. We include subjects that are often omitted from or slighted in traditional surveys, subjects such as folk and naive art and the crafts of ceramics and quilting. We are fortunate to have found contributors to devote essays to minority women artists—Asian, black and Hispanic—a topic we could not cover adequately in previous books, to our great regret, due to the difficulty of finding knowledgeable writers. We have taken a look at 19th-century artists, educators and photographers and artists from the early years of the 20th century, and we touch upon some topics of concern to women artists today—spirituality, autobiographical imagery and politics in action.

Throughout the chapters devoted to the latter half of the 20th century, you will note the tremendous impact that "Womanhouse" and the burgeoning feminist art movement of the 60s and 70s has had on California women artists. We close with a warm and insightful reminiscence by Miriam Schapiro and some poignant memoirs by others who were "present at the creation" during those days of self-awareness and self-expression.

While we make no claims of comprehensive coverage in this series, we are convinced that our work has value to all those with an interest in the development and continuance of the arts and culture of regional America and for those with a special interest in women's studies and art history. Scholars will be glad to know that a cumulative index is planned. We hope the essays, researched and written with keen interest and diligence by our fine group of contributors, will serve as an introduction to women artists of particular geographic areas and will open doors on their specific situations and concerns. In this way, increased knowledge of our similarities and differences as women and as artists will serve as inspiration and encouragement.

—**Sylvia Moore**

The Women of the WPA Art Projects: California Murals, 1933-1943

The stock market crash of 1929 signaled the greatest economic catastrophe the United States had ever experienced. The days of the flapper, the hip-flask and economic prosperity were over. The Great Depression that followed took the average person by surprise. Every man, woman and child's life was tremendously altered. For the vast majority of people, the humiliation of charity and the loss of financial independence were devastating.

According to Barbara Rose, "ironically, the Depression turned out to be the greatest thing to happen to American artists. They were, for the most part, better off during the Depression than before or after."[1] This phenomenon was especially true for women artists. Never before in the history of American art had women artists been treated as professionals: art was considered merely a hobby for most of the women of the 19th and early 20th centuries. Through the relief projects of the New Deal, implemented by Franklin D. Roosevelt's administration, women artists were treated with the same respect afforded their male counterparts. The short period when these projects were intact, 1933-1943, was a time of great artistic and personal growth for both female and male artists.

Though their numbers were small, the women artists of the Depression era made a significant contribution. Surprisingly, there has been little scholarly attention paid to these women or to the art of the New Deal in California. Women's participation in art during the Depression decade can most clearly be seen in the mural projects. With groups of artists working together to create a single mural, male and female artists worked as equals. This chapter will attempt to fill a void by concentrating on the women muralists working under the auspices of the New Deal in California.

Our stereotypical image of women during the Depression can best be visualized in **Dorothea Lange** photographs of the period. Lange typically depicts a woman of the Dust Bowl states, destitute, holding her hungry and dirty children close to her bosom, seeming to implore the viewer to help feed them. We also have a mental image of the homemaker eking out household expenses

1

from her husband's much diminished earnings. This was not the case with the women muralists of California. Perhaps for the first time, women were being paid a salary to produce art, and enjoying equitable treatment. Women were not merely help-mates to male artists, they were project supervisors, administrators, designers and creators of murals. Theirs was not a service role in relation to men; they were serving their country by working beside men to create murals of hope for a country suffering from social despair.

Francis O'Connor, one of the most prolific scholars of New Deal art, describes the feeling of the Depression in the following way:

Depression, psychologically, is a loss of self-esteem, a loss of a sense of one's self-worth, one's dignity. It is usually induced by some disaster which acquires a sense of profound guilt, whether or not justified in fact. During the 'Depression' era, millions of Americans lost their jobs, their savings, their homes, and their futures in the maelstrom of the market crash, bank failure, and dust bowl. . . . Attributes of self-reliance, hard work and reward no longer applied. The ways in which people define themselves, through what they do in their lives, was stolen from them. . . . It was the genius of the New Deal that it recognized the necessity of restoring and strengthening not only the economic system (which it could not essentially change) but also the dignity of those dispossessed by its failure. To that end it was radical in seizing opportunities and inventing solutions to restore the economy and renew a sense of individual relevance.[2]

At the time of the inauguration of President Roosevelt in March, 1933, there were almost 10,000 artists across the country registered as unemployed. "There was the desire to relieve the material wants of the unemployed men and women, but a desire modified by the decision to utilize their specific ability and training, rather than to hand out a mere dole; to give them employment with dignity and to create in them the realization that they had a constructive and valuable contribution to make to society as a whole, which that society appreciated."[3]

On May 9, 1933, George Biddle, a well-known artist and Roosevelt's friend since school days, wrote the president a letter proposing a solution to the plight of artists, "The Mexican artists have produced the greatest national school of mural painting since the Italian Renaissance. Diego Rivera tells me that it was only possible because Obregon allowed Mexican artists to work at plumbers' wages in order to express on the walls of the government buildings the social ideals of the Mexican revolution. The younger artists of America are conscious as they have never been of the social revolution that our country and civilization are going through; and they would be eager to express these ideals in a permanent art form if they were given the government's co-operation. They would be contributing to and expressing in living monuments the social ideals that you are

struggling to achieve. And I am convinced that our mural art with a little impetus can soon result, for the first time in our history, in a vital national expression."[4] This letter started the chain of events that led to the creation of the New Deal's cultural support programs: first, the Public Works of Art Project (PWAP, 1933-34); second, the Treasury Department's Section of Painting and Sculpture (Section, 1934-43), dedicated to commissioning, through public competitions, art for public buildings; and third, the Works Progress Administration (WPA), started in 1935, with separate projects for writers, musicians and theater. The Federal Art Project (WPA/FAP, 1935-43) employed artists from all media and provided a weekly wage in return for specified services provided by artists for tax-supported institutions. The latter two projects employed many young and in-experienced artists, especially muralists, many of whom had never touched a wall with paint before.

On December 8, 1933, a meeting was held in the home of Edward Bruce, a prominent lawyer, businessman and professional artist, to create the first U. S. government arts program as a two-month experiment. It was so successful that it was extended for six months. Forbes Watson, a respected art critic and curator, was chosen to head the PWAP, which by the time of its dissolution spent over one million dollars for 4,000 artists to produce almost 15,000 works.

Bruce's dream was to "support professional artists and thereby create quality art; second, to educate the public to appreciate the art thus generated; and third, to please the patron (i.e., the United States government) without threatening patriotism or violating conventional art traditions (i.e., produce nothing too avant-garde or left-leaning)."[5] Bruce knew that for the program to be successful he would have to win the support of the established art circles as well as the general public. He did this by hiring 16 regional chairmen, mainly directors of established museums. It was their job to promote an egalitarian art style and subject matter that the average citizen could understand and accept.

Most of the murals in California were created under the Federal Arts Project and the PWAP. The FAP employed 5,212 artists at its peak. It created both portable art and architectural art in non-federal buildings, such as schools, post offices and state courthouses. Over 2500 murals were produced in the United States, with the major concentration in New York, Chicago and California. Approximately 300 were produced in California, 65 by women artists.

Holger Cahill, director of the FAP, was neither artist nor art critic; he was a museum curator, organizer of art exhibitions, aspiring writer and art lover. FAP monies were based on employment quotas and salaries of the relief roles of the community and only secondarily on the number of artists needing aid. From

Cahill's viewpoint, the integration of the fine and the practical arts was essential to create a fully developed art movement, drawing together major art forces in America. Because of Cahill's desire to help young and promising artists, the WPA/FAP was not structured like Bruce's patron-artist system but like a medieval guild system, making it possible for novices to learn under a master artist. The sense of competition was done away with in the FAP, unlike the other projects. FAP artists saw themselves as workers performing a social service.

Joseph Danysh, Western Regional Director of the WPA/FAP, felt that "we were among the forefront of the people of that era who were pulling out of [the] tragedy of the Depression, something beautiful and something lasting."[6] Creating art for the people now seemed necessary and dignified. That one could live from one's art gave it a new status in the eyes of the artists as well as in the eyes of fellow Americans, most of whom came into contact with art for the first time as a result of the WPA programs. The principle theme of the murals was an optimistic one, human progress through the ages.

Women of the Depression decade are sometimes referred to as "Daughters of the Depression," giving the impression that all of them can be categorized in the same way. However, the situations of these women varied greatly. "Although women artists flourished in the thirties, it was a time of peculiar ambivalence for American women in general."[7] American women artists did not share in that ambivalence, but the average "white-collar" woman worker suffered from the harsh realities of discrimination, especially married women. Many people were hostile to married women workers and accused them of undermining the stability of the home and taking jobs from men and unmarried women.

Winifred D. Wandersee, documenting the status of women workers during the Depression, states, ". . . for those women who were in a position to make decisions regarding their career, the hostile environment of the thirties was undoubtedly discouraging. Although all women workers were suspect, outright discrimination through the actions and policies of employers was always directed at the married worker."[8] Private employers and state and federal governmental agencies were all guilty of overt discrimination.

In contrast, there were many married women artists associated with the art projects. In California, for example, **Jane Berlandina** was married to Henry Howard, architect of Coit Tower in San Francisco; **Jean Goodwin** was married to fellow muralist Arthur Ames; **Maxine Albro** to artist Parker Hall; **Edith Hamlin** to artist Maynard Dixson; **Marguerite Zorach** to sculptor William Zorach; **Dorothy Wagner Puccinelli** to sculptor Raymond Puccinelli. There is

no evidence that any of these women suffered discrimination due to their marriages.

Concentration of women in just a few "white-collar" professions was a reflection of the employment pattern that prevailed across all major professional fields. As new economic opportunities became available, certain kinds of jobs were still implicitly labeled for one sex or the other. American terms such as "women's work" and "a man's job" have always been value-laden expressions. The other side to this segregation was that there was always a demand for a female work force. Since a high proportion of female workers were concentrated in a few occupations, the demand for workers in these occupations created a demand for female labor. Thus men and women seldom competed for the same positions during the Depression.

Again, we see a very different situation in the arts. Since there was no real competition for jobs, there was not the same kind of segregation. Women were not relegated to being the support system of male workers. Women were often the chief artist on a project, as with **Helen Lundeberg** on the Centinella Park wall mural in Inglewood, California. She complained that she was so busy telling her assistants what to do, she rarely touched the wall herself.[9] There were many female assistants to Master artists, but this was because of their lack of experience and not due to their gender. Women were also designers of projects, such as **Grace Clements** at Venice High School in Venice, California. These women artists were the creative forces behind many of the California murals. They climbed scaffolds, mixed plaster for frescoed walls, made major stylistic decisions, collected paychecks and wore pants alongside their male peers.

The Depression established that women were in the labor market to stay, no matter the economic conditions. It is ironic that after the Depression the careers of many women artists faltered. Some women, such as **Claire Falkenstein, Lee Krasner** and **Helen Lundeberg,** went on to achieve international reputations, but for the majority this did not apply. Not that women artists stopped producing art after the Depression, but the majority never achieved national recognition.

Much current scholarship concerns itself with the thirties only as related to the background of artists who achieved prominence in the abstract movements of the fifties and sixties. The only scholarly attention given specifically to women artists of the Depression decade was the exhibition catalogue for Vassar College's 1976 exhibition, "Seven American Women—The Depression Decade," co-curated by **Karal Ann Marling** and **Helen A. Harrison**, both scholars of the period. Although no California artists were dealt with, the exhibition made a great contribution to the better understanding of women in the Depression.

Eleanor Tufts also added to our knowledge of the subject with her 1975 College Art Association colloquium entitled, "Women Artists from the Age of Chivalry to the New Deal."

The favorable situation of women artists of the thirties did not just happen. There was a definite succession of women who came before that helped pave the way for these women, who seized the opportunities afforded them. In the 1866 Congressional debate over whether to extend the right to vote to the women of Washington DC, Senator Peter Frelinghuysen, speaking against the motion, asserted that ". . . women are, by nature, higher and holier than men, and too holy to engage in the nasty business of public affairs. From their pedestals of honor in the home, women's mission was 'to assuage the passions of men.' Man sullied his moral sensibilities in the quest for material goals. Woman cleansed and renewed his tarnished virtue."[10] This was typical of the attitudes women were faced with and forced to react against.

In 1876, **Candace Thurber Wheeler** headed the South Kensington School of Art Needlework, which sought to improve the lot of "gentlewomen" and establish markets for their work. Wheeler was instrumental in creating the New York Society of Decorative Art, whose goal was "to establish a place for the exhibition and sale of decorative work, and to encourage the production of such work among women."[11] At the 1893 Chicago World's Fair, New York women furnished the library of the Women's Building. Wheeler was authorized by the state to compile a permanent record of women's accomplishments in the decorative arts. This resulted in the volume, *Household Art*, written by seven women who were themselves noted commercial designers.

The general impulse toward the acceptance of women as artists also led to the emergence of summer art colonies around the turn of the century. The chance to study painting freely under respected teachers was a crucial turning point for women. The informal atmosphere of the summer colonies stimulated a novel approach to organizing exhibitions which broke down rigid sexual distinctions.

Although the 1893 Women's Building was segregated, it cannot be underestimated. From its example, several national organizations for female artists were founded—The National Association for Women Artists founded in 1889, the Pen and Brush Club in 1893 and the Catherine Lorillard Wolfe Art Club in 1896. All reflected increased activity on the part of women, but also created an atmosphere of female separatism. "Women constituted an established artistic minority to be reckoned with as the Depression approached. The campaign for the right to participate had been won. The struggle for objective

judgment of women's art, a judgment predicated on an asexual definition of the term, 'artist,' was about to begin in earnest."[12]

There were many women involved in the arts, though not artists themselves, who made a tremendous contribution during the Depression and to the position of women in general. In New York, **Juliana Force** of the Whitney Museum became Regional Director of the PWAP in 1933. **Audrey McMahon**, director of the College Art Association, editor of *Parnassus* and managing editor of the *Art Bulletin*, was among the first vocal advocates of public assistance for artists. With the help of her colleague Francis Pollock, she obtained emergency aid for destitute New York artists before formal government programs were conceived. Her counsel was vital to Harry Hopkins, the National Relief Administrator, in the early planning stages of the FAP. In 1935 she was named Regional Assistant to the director of the Federal Art Project. **Frances Perkins** became President Roosevelt's Secretary of Labor, and was the first woman to attain Cabinet rank. She has come to symbolize an unprecedented, and still perhaps unparalleled, recognition of a woman's ability to serve effectively at the highest, most sensitive levels of government. **Ellen Sullivan Woodward** became the director of women's work under the Federal Emergency Relief Administration. Her programs continued under the Civil Works Administration, and in 1935 she became an assistant administrator of the WPA. **Florence Kerr** acted as Director of the WPA's Women's and Professional Division.

In 1928, **Mary Fanton Roberts**, editor of *Arts and Decoration* magazine, demanded two kinds of rights for women artists. ". . . the right to participate, and the right to be judged on an equal footing with men." The economic disaster of the Great Depression, by placing art under the jurisdiction of government for nearly a decade, answered both demands. "The art projects sanctioned and consolidated the gains of a century of women's struggles for access to training, and for professional recognition, by coming to the rescue of artists to whose skills and cultural contributions sexual labels were no longer germane."[13]

The art of the New Deal was derived from three basic cultural sources: the Depression era, the contemporary American scene and the Mexican mural movement. In California artists produced art compatible both iconographically and stylistically with the political purpose of the relief projects, which were con-servative in that they were structurally harmonious with traditional capitalistic values.

According to **Marilyn Wyman** in her thesis on New Deal art in Southern California, ". . . the arts of California have been neglected because they were considered provincial and regional by East Coast scholars. As in other areas of

art criticism, California is seen as the distant cousin of the Eastern tradition and is therefore given cursory treatment at best."[14]

The 1976 exhibition catalogue of "New Deal Art: California," held at the de Saisset Art Gallery and Museum (University of Santa Clara), sought to remedy the situation. The text, dealing specifically with New Deal art in California, was written by Steven M. Gelber who created a systematic guide, categorized by artists. He also supplied pertinent information regarding the status of the murals as of 1976. Although some of the murals have been destroyed since 1976 and others have been found and restored, Gelber's contribution is invaluable.

The California Art Project produced one of the most active mural developments in this country. Compared to their male counterparts, the women muralists were very few in number—only 40, compared to almost 140 males. The numbers are not as important as what these 40 women accomplished

A mural is inherently a public work of art. Done on a wall, it is invariably large when compared to easel art. Mediums varied in New Deal murals, from fresco to mosaic and gold-leaf. Whatever the medium, muralists had to consider the appropriateness of the work to the site and serve the needs of the architecture and the audience. "Under the government projects, they were given the opportunity to address a new audience by decorating institutions for which murals had never before been commissioned."[15]

Edward Bruce set a precedent when he announced that painters in the PWAP would be required to paint the American scene. "This was in accordance with the goal of the PWAP to create a permanent record of the aspirations and achievements of the American people."[16] Bruce was not imposing his personal tastes, but supporting a pre-existing artistic movement: a conscious drive to create a uniquely American art. This was related to the rise of nationalism during the 1920s and 1930s, intensified by America's policy of isolationism and the crisis brought on by the Depression. For one decade, art became a social experience, carrying with it a message associated specifically with the emotional and historical experiences of the community, told in a language understood by the majority.

In pre-Depression America, mural painting meant decoration as American painters imitated their European counterparts. Nineteenth century American artists went abroad to study the decorative style, inspired by the French school of muralists, headed by Pierre Puvis de Chavannes. To most artists of the thirties, the problems brought about by the Depression made the decorative style seem trite, ineffectual and complacent. Many adopted Marxist, socialist or other leftist

ideological attitudes. They felt the arts should actively promote the improvement of society or at least give the common person hope for a better world.

There developed in this country two distinctively American styles during the Depression: the Regionalists, led by Grant Wood, John Steuart Curry and Thomas Hart Benton and the Social Realists, led by Ben Shahn, Jack Levine and Philip Evergood. The Regionalists were less adventuresome in style and less obvious in political comment than the Social Realists. California was more Regionalist than the East Coast. The radical artists in California (mainly in San Francisco) were a minority compared with New York. Most California artists produced art that the public and administrators expected, easily understood art— and that meant representational. Regionalists saw the common man as the embodiment of America's fundamental strengths. The farmers, for example, were considered the true descendants of the early settlers who had forged their existence out of the American wilderness. **Henrietta Shore**'s murals in the Santa Cruz Post Office are a good example of this depiction of the heroic farmer. Shore's *Santa Cruz Industry* was painted in 1936 under the auspices of TRAP. *Cabbage Culture*, a lunette over the Postmaster's door, depicts two men and a boy hard at work in a field of ripe cabbages. *Artichoke Culture*, located at the opposite end of the small lobby, shows two field workers gathering artichokes, a subject applicable to life in Santa Cruz even today. One only has to drive a few miles out of town to see the fields of artichokes growing under the warm California sun.

New Deal artists in California were painting conservative propaganda, communicating the message that the system as it existed had the solution to any problems. Nowhere is this more apparent than in the artists' treatment of farmers and workers. Farm workers in California murals were not the poverty-stricken dust bowlers photographed by Dorothea Lange. The strong, tanned, well-fed and happy farm workers in Maxine Albro' *California Agriculture*, painted in 1934 for Coit Tower in San Francisco, had no cause for complaints. One of the flower pickers is obviously going directly from work to a dance in her lace-trimmed dress and pearl necklace. It is hard to imagine these workers living in shacks and tents, or leaving the golden sunshine on the fields to join a picket line.

The artists' refusal to paint the Depression was an implicit political statement. To them the Depression was an aberration, not a natural part of a good socio-economic system. Unlike political radicals who viewed the Depression as the inevitable result of a system which held the seeds of its own destruction, the majority of artists affirmed their faith in America by painting a world that did not exist.

The Mexican muralist movement was a very important influence on California muralists, many of whom studied directly with Diego Rivera. While American artists turned their backs on Europe, the Mexican muralist movement provided a strong base from which to work. The goals of the Mexicans were akin to the American Scene painters: to develop a nationalist and popularist art, using representational images. Weary of the 19th-century tradition in the United States, derived from artists such as Puvis de Chavannes, Edwin Austin Abbey and J. Alden Weir, with empty allegories and academic figures, bored with the illustrative taste as seen in Currier & Ives prints, American artists were seeking a new style to embody new ideas and to represent the contemporary spirit. Geoffrey Norman, commenting on how Mexican artists rekindled an interest in mural painting in this country, said, "They opened our eyes to the possibilities of mural painting by demonstrating a simple return to the methods of the old Renaissance masters, that of painting in strong but simple terms a simple message of universal interest."[17]

Diego Rivera, Jose Clemente Orozco and David Alfaro Siqueiros were the three most influential Mexican muralists. In Mexico they had been part of the movement, approved by President Obregon, in which art became a public statement of political principles and a symbol of the state. They painted murals illustrating the oppression and eventual rise of the peasant, the suppression and hopeful triumph of the Indian, and the independence of Mexico from powerful outside forces.

Rivera had a major stylistic influence on federally sponsored art in California. Many women artists in California worked directly with Rivera, such as Henrietta Shore, Maxine Albro, Jean Goodwin Ames, **Emmy Lou Packard** and **Marion Simpson**. Rivera's use of montage space, his puffy modeling, linear brush work, use of saturated earth colors, black underpainting, and minute attention to detail were tremendously influential. His murals were filled with revolutionary images in accordance with his own Marxist ideology, but they were usually optimistic and had a pleasant decorative quality.

On May 1, 1931, Rivera gave a speech to students at a guest luncheon held at the Fairmont Hotel in San Francisco. "It is of little good," he said, "for young students to sit before easels and paint things which mean little to them and less to others in the hope that the great spark will come to them to make something really great. It is far better for young men and old men, women and children to work with metals and stone and wood and make things expressive of this modern life and for the beautification of their homes and their city."[18]

Rivera lived 15 years in Europe, soaking up modernistic influences. His style was Mexican, with just an edge of the European styles. By 1934 Rivera had forged a mural tradition in the Americas. According to Gelber,". . . his walls had become the standard against which those who aspired to be muralists were judged (or judged themselves). Rivera was the role model both stylistically and ideologically."[19]

Rivera was also influential in reviving the art of fresco. Fresco is the technique of mural painting in which the artist paints directly on fresh, wet plaster and when it dries, the paint and plaster become one. He claimed to have rediscovered the true fresco technique from Giotto of the Italian Renaissance. He used vine black underpainting and over this laid colors in a fine mesh or embroidery of individual brushstrokes with which he built up the plastic form. This technique became a standard of fresco in the United States.

Diego Rivera's ideological and stylistic influence can most clearly be seen in the murals of Coit Tower in San Francisco, which look like they could have been painted by one hand, a hand guided by Rivera. In his opinion, "San Francisco is a strategic point which links the Eastern culture with the Western, and there should develop here an art that is typically that of the people here and individually Californian."[20]

The Coit Tower murals are typical of New Deal murals in Northern California. The Tower is located on Telegraph Hill in Pioneer Park and was dedicated to the city of San Francisco on October 8, 1933 in memory of one of the city's most beloved citizens—**Lillie Hitchcock Coit**. An open competition was held to decide on a fitting monument. The architect Henry Howard, working in the firm of Arthur Brown, Jr., was chosen for the simplicity of his design. The tower is made of grey concrete and stands 180 feet high above a 32-foot high rectangular base. The observation deck offers a 360-degree view of the city through its arched windows.

Inside the base of the tower there are 3,691 square feet of murals "depicting California life as it appeared to the 26 artists and their 19 assistants (themselves artists) who painted the interior walls in 1934, one year after the Tower was opened to the public."[21] Four of the artists were women. At the time of their completion, the murals represented three-quarters of all the frescoes on walls in California.

Lillie Hitchcock came to San Francisco from Maryland in 1851 at the age of seven with her father, an Army surgeon, and her mother, a Southern plantation-belle. Soon after she arrived, she was playing in a deserted house with friends when it caught fire. Lillie escaped, but two of her playmates did not. In the

1850s, San Francisco firemen were heroes to a city that suffered from many fires. There were groups of volunteer firemen, made up of local businessmen, dressed in red shirts, shining black peaked caps and black trousers stuffed into high black boots. These heroic men had to drag their hand-drawn fire engines up the hills of the city to put out fires. The story goes that one afternoon on her way home from school, Lillie Hitchcock, now a teenager, came upon a shortstaffed Knickerbocker Engine Company No. 5 of the Volunteer Fire Department pulling its engines up Telegraph Hill to reach a fire. Lillie, remembering her experience as a young girl, threw down her schoolbooks and hailed some male bystanders to help as she herself began hauling on the rope shouting, "Come on, you men, pull!"[22] No. 5 raced up the hill and was the first engine to douse the fire. After this, Lillie became the mascot of No. 5, wearing an honorary uniform, smoking cigars, and playing poker with the men. She proudly wore the gold diamond-studded fireman's badge reading "No. 5" awarded her in 1863. For the rest of her life, she signed her initials, *LHC5*. At her cremation at age 86, Lillie wore the famous badge.

She lived with her husband, Howard Coit, a wealthy member of the San Francisco Stock and Exchange Board, in San Francisco until his death in 1863, then lived in France for a time. She came home to San Francisco toward the end of her life and died there in 1929. Never having had children, Lillie Hitchcock Coit left two-thirds of her fortune to the Universities of California and Maryland. As evidence of her affection for San Francisco, she bequeathed the remaining third to the City and County of San Francisco, "to be expended in an appropriate manner for the purpose of adding to the beauty of the city which I have always loved."[23]

"Aspects of California life" was the theme of the murals, and work began in December, 1933. However, in February of 1934 a problem arose, sparked by the controversy over the destruction of Rivera's Rockefeller Center mural because it included a portrait of Lenin. In turn, seemingly Communistic elements were found in some of the Coit Tower murals, including the murals by Victor Arnautoff, John Langley Howard, Bernard Zakheim and Clifford Wight. The women muralists were only involved in the controversy to the extent that they refused to paint out the questionable elements. Maxine Albro went as far as to read a resolution presented at a protest meeting at the Tower regarding the destruction of Rivera's mural in New York. It stated that this was ". . . no isolated example of the prejudices of any private individual or group, but rather an acute symptom of a growing reaction in the American culture which has threatened for years to strangle all creative effort and which is becoming increasingly menac-

ing."[24] The controversy over the Coit murals finally died down and all the questionable elements were allowed to remain except one of Wight's. After having been shut down in the early summer, Coit Tower opened to the public on October 20, 1934.

Aside from the murals that stirred controversy, the majority show everyday life, such as farmers, cowboys, lawyers, stockbrokers and mill workers. Upstairs, collegians at sport are depicted along with campers, outdoor sportsmen and an overview of family life at work and play. The murals of **Suzanne Scheuer**, Maxine Albro, **Edith Hamlin** and Jane Berlandina fit this category.

Suzanne Scheuer's *Newsgathering* fresco is located in the lobby, adjacent to Bernard Zakheim's controversial library panel. It measures 10 feet by 10 feet and clearly reflects the influence of Diego Rivera. In fact, at the top of the gun-slit window which the mural surrounds, a man sitting at a large table and smoking a fat cigar looks strikingly like Rivera. The scene depicts men and women working together in harmony at a busy newspaper. A white-haired man (art patron William Gerstle) sits at the table approving a news item for publication, while above him a woman is gathering news by telephone. Scheuer continues the scene above the window with the actual printing of the newspaper, and our eye is then led down to the young boy, probably Peter Stackpole (son of the artist Ralph Stackpole), who hawks the fictitious *San Francisco Gazette*. Along the window ledge, Scheuer has painted a replica of the *San Francisco Chronicle*, with the headline "Artists Finish Coit Tower Murals, April 1934; Albro, Arnautoff, Boynton, Stackpole, Langdon, Howard, Daum (Scheuer's assistant)." The border design around the window shows the color process used to produce comic strips, here "Moon Mullins." Scheuer's figural style, with the broad facial features, solid, stocky bodies and infinite attention to the smallest details, hark back to Rivera. However, she brightened her corner with more blues and reds than the usual earth tones of the fresco palette.

Suzanne Scheuer went on to paint murals in two Texas Post Offices, at Caldwell and Eastland. She also has a mural in the Berkeley Post Office, entitled *Incidents in California History*, painted for TRAP in 1937. She designed six houses built in Santa Cruz, in addition to hand-building fireplaces, tiled patios and stone walls. She worked as a lithographer, carver, sculptor and architect during the 1940s and 1950s, as well as continuing to paint easel pictures and murals. She also became a teacher at the College of the Pacific in Stockton.

In 1977, at the age of 80, Scheuer, along with fellow artist Bernard Zakheim, returned to Coit Tower. They attended the reopening ceremonies of the tower after it had been closed to the public for 20 years. Peter Kuehl, writing for

the *San Francisco Chronicle*, recalled seeing the frescoes, "Most of the frescoes reflect the tough, depression times, showing men and women at hard labor. The eyes stare straight ahead and there is little joy in the faces."[25] It is interesting that years after the end of the Depression, Kuehl could not see the joy of hard work on the faces of those portrayed in the murals. The newspaper workers in Scheuer's mural look quite content in their endeavors, happy to have purpose in their world.

Just after assisting Diego Rivera with his San Francisco murals, Maxine Albro received her commission from the PWAP to paint a fresco for the newly completed Coit Tower entitled *California Agriculture*, measuring 10 feet by 42 feet. Her cheerful scene of farmworkers harvesting oranges and gathering flowers, with their stubby figures and simplified, massive forms, again clearly show the influence of Rivera. Her fresco is a shining example of the style of the New Deal, showing an improved life for farmers. The National Recovery Agency (NRA) blue eagle, symbol of the New Deal, is stamped on the orange crates.

Workers in the flower industry, wearing what were at that time called "beach pajamas," are happily going about their work. Holding the calla lilies is **Helen Clement Mills**, assistant to the Coit Tower muralist Gordon Langdon. At the top of the scene, the seasonal changes are depicted. A bright summer sun shines over a dairy; snow tops a wintery Mt. Shasta; springtime almond orchards are in bloom; while at the far right we see autumnal rains. Albro inserted portraits of her fellow artists, Ralph Stackpole (in a checkered shirt) and her husband, Parker Hall, standing by the trays of apricots. Albro entices the viewer to ignore the door in the center of the wall, which was originally painted bright blue, by leading the eye to look down a row of trees.

Maxine Albro was born in Iowa and attended the California School of Fine Arts. She studied in Paris during the 1920s, and then went to Mexico to study with Rivera. While her mural at Coit Tower was in no way controversial, some of her later work was. In 1935 four portly Roman sybils executed at the Ebell Women's Club in Los Angeles offended some of its members and were destroyed. The women rescinded their approval of the frescoes, which were originally intended to last "as long as the concrete of the wall lasted."[26] Albro's mosaic of animals over the entrance to Anderson Hall at the University of California Extension in San Francisco was also destroyed. She did many fresco decorations for private homes in Northern California, including the home of Col. Harold Mack in Monterey.

Edith Hamlin's Coit Tower fresco is located upstairs, on each side of the elevator door. It measures 9 feet by 12 feet and is titled *Hunting in California*. We see two hunters taking aim at a group of mallard ducks overhead. Three deer inhabit a forest, which **Masha Zakheim Jewett** describes so poetically, "whose large leafed branches unify this elegant scene by their shapes and the foliage tones of greens, browns, and pale yellows—a sylvan contrast to the earnest hunters on the marsh."[27] Again the broad planes of the facial features and the body reflect back to Rivera and the Mexican influence. The hunter, holding two ducks after the kill, stands strong and proud in the accomplishment of his endeavor. There even seems to be a gallant pride in the dog which sits below. Both man and animal seem to have a definite purpose in their world.

Edith Hamlin, a native Californian, also studied at the California School of Fine Arts. She painted on paper, canvas and gesso, as well as in fresco. Her work exists in many private homes, the Post Offices of Tracy and Martinez, California, and at Mission High School in San Francisco. She also painted two panels in the Department of the Interior Building in Washington, DC.

The most unusual of the Coit Tower murals is that by Jane Berlandina. She came to San Francisco from France, where she studied with Post-Impressionist Raoul Dufy. She learned costume design in France and continued this work for the San Francisco Opera Company, where she also created sets for "Der Rosenkavalier." Berlandina exhibited at the Metropolitan Museum of Art in New York as well as many local museums.

Located in the little room on the second floor of Coit Tower, *Home Life*, measuring 9 feet by 34 feet, is separate from all the other murals in the tower. Berlandina chose to decorate the room in a silhouette approach in egg tempera (egg-yolk-based paint applied to dry plastered walls), with a limited palette in shades of chartreuse, russet, and brown, with white outlines. Her technique was very much like the calligraphic technique of Dufy. The four walls make up a house, where she portrayed scenes from everyday home life. Each wall has a different theme. In the kitchen a mother and two girls make an apple pie, while in the living room a bridge game is being played. There are three people at the table, one being Henry Howard, designer of Coit Tower and husband of the artist. The woman standing by the table watching the game is Jane Berlandina herself. On another wall, a man reads a newspaper while the boy at his feet is absorbed in a book. Above them all is a picture of the hotel in Olema, California. On the last wall we see a group at a piano, with a woman playing for two dancing couples. Painted curtains line the doorway, thematically connecting the other room decorations. Jewett describes the murals beautifully when she says,

"The spontaneity of the designs and their 'hollow' quality give this final, iso-
lated room a charming light spirit after the solid frescoes and oils with their more
serious subjects on the other walls at Coit Tower."[28]

These four women are fine examples of the professional attitude of women
artists of the Depression decade. They were not women painting as a hobby.
Their murals helped portray the ideals of the New Deal as applied to everyday
life and in this way helped the average citizen understand these ideals.

The history of the Coit Tower murals has continued long past the 1930s.
The Tower was closed in 1960 due to vandalism. The Department of Parks and
Recreation, under whose jurisdiction the Tower remains to this day, ordered
locked glass doors installed to keep the public out of the first floor corridor and
locked the door of the stairway leading to the second floor. Dorothy Puccinelli
Cravath, another New Deal muralist, began the careful restoration of the vandal-
ized portions, and in 1975 another local New Deal artist, Emmy Lou Packard,
restored portions of the art that had been damaged by water seepage, plaster
cracking, scratches and flecked paint. She also removed a 40 year accumulation
of cigarette smoke film from the lobby panels. Today the lobby is open to the
public, and the murals are roped off for protection. The stairway and second
floor are only open on Saturdays and the public can view them only under strict
supervision.

The art of Coit Tower served as a prototype for the decade of New Deal art
that followed with the WPA/FAP. The project provided an iconography of the
American Scene with its themes of agriculture, education, urban and rural life,
social protest and New Deal idealism.

There was a tendency in the Bay Region toward a palette of ochre tones, the
effects of which were made richer by the cloudy, grey weather of Northern Cali-
fornia. In this subdued light the close color values preserved a maximum of tonal
qualities. Along with fresco, the art of mosaic was a popular medium in North-
ern California, dependent upon the traditional Venetian glass tesserae that were
left over in great abundance from the Panama-Pacific International Exposition of
1914. According to New Deal mosaic artist, **Helen Bruton,** "It seems perfectly
natural that a revival of interest in mosaic should come along with the revived
interest in the other old mediums, and with a greater concern for the architectural
fitness of decoration, it had endless possibilities. But in this exciting period of
opportunity for artists, there will be places that are right for mosaic, and others
that are right for fresco, and others that are much better left undecorated, and we
shall need to use both good judgment and restraint lest we overplay our parts."[29]

One of Helen Bruton's finest mosaics can still be seen on the outer wall of what once was the Old Art Gallery at the University of California, Berkeley. Working as a team with artist **Florence Swift**, assisted by a crew of six male technicians, these two women portrayed the arts in *Music, Painting and Architecture*. The two main panels, ten and a half feet by 15 feet and 14 by 15 feet, were completed in 1937 for the WPA/FAP. Although contemporary in expression, these works are comparable in manner to the classical mosaics of Ravenna and Venice. The use of both matte surface and glazed tiles serves to vary the texture in different objects and outline. The size of the tesserae are more like Greco-Roman floor mosaics than the smaller and more elegant glass tesserae of Byzantine Italy. The palette is neutral earth colors like those used by Rivera, and the broad, heavily outlined eyes of the figures also show his influence. Bruton and Swift sneak in a personal contemporary element, the short cropped hairstyle of the women of the 1930s.

Helen Bruton, along with her sister Esther, used these same techniques for mosaics in the loggia of the "Mother's House" at Fleishhacker Zoo, now the San Francisco Zoo. The two glazed tile mosaics, each six feet wide by 13 feet high, were completed in 1934 for the PWAP. They are entitled *St. Francis with Animals* and *Children and Their Animal Friends*. In the second mural, a young girl holds a rabbit and a boy holds the reins of a horse. Beautiful trees bloom with white flowers behind them. Again, Bruton uses the warm earth tones and figural style of Rivera. The gentle, harmonious scenes exemplify the hopeful nature of the New Deal.

Also located in the Mother House (now the Zoo Shop) is one of the most beautiful murals painted by women in the Bay area. **Helen K. Forbes** and Dorothy Wagner Puccinelli (Cravath) teamed up to bring to life the story of Noah and the Ark. The fresco encompasses all four interior walls of the small building, originally built in 1925 by Herbert and Mortimer Fleishhacker in memory of their mother, Delia.

Puccinelli and Forbes completed the frescoes in 1938 for the WPA/FAP. The frescoes tell the story of the building of the ark (north wall), the loading of the animals (west wall), the landing of the ark (south wall), and the ark's passengers disembarking (east wall). The two women often sketched the animals at the zoo and used these portraits as a basis for their design. The murals were painted with egg tempera and covered with a thin coat of varnish, which darkened with age. Puccinelli returned in the 1960s to restore the murals.

Covering nearly 1200 feet, the frescoes are unique both in style and purpose. The story of Noah is told in clear, pastel hues, not the warm, dark earth

tones of Rivera. The people and animals are finely stylized, almost cartoons. As in the Mexican story-telling technique, Noah and his animals travel in a particular course around the room, with a definite beginning and ending to the story.

These murals were created by women for women and their children. The Mother's House was a place where mothers brought their babies and small children to feed and care for them. It contained restrooms, a nursery, and medical rooms where doctors and nurses were available for advice. Distilled water and milk were supplied for making formula, and refreshments were available for the mothers. No males over the age of six were permitted to enter. "It is interesting that only women artists were commissioned to execute the mosaics (Bruton sisters) and murals of the Mother's House, since very few WPA projects in San Francisco were done by women."[30]

There is a peacefulness and gentleness in the frescoes that connect to the Bruton mosaics on the loggia. Even now, when the small Italianesque building is used as a gift shop, there is a feeling of warmth, security and serenity. In the 1920s and 1930s, the rooms were furnished with wicker settees and potted ferns. It is sad that the original purpose and furnishings were not preserved along with the murals.

According to the merchandise manager of the Zoo Shop, attempts are now being made to protect and restore the murals. The rain storms of 1981-82 damaged one of the interior walls,.and scaffolding has been erected on the west side to protect against further water damage. Total restoration of the murals has been estimated at approximately $17,000.

The manager also mentioned that boys who were not permitted to enter the Mother's House, now returning as grown men, are delighted to enter the gift shop and see what they were missing. The murals of the WPA continue to be a part of people's lives and will endure as long as people enjoy them and appreciate their worth.

Marion Simpson, who trained with Diego Rivera, created two strong, handsome marble mosaics which flank the east entrance of the lobby in the Alameda County Courthouse in Oakland. The two panels entitled *Settling of California*, and *Exploration of California* were done in 1938 for the WPA/FAP. Simpson was the designer and the Italian sculptor Gaetano Duccini executed them. The courthouse itself was erected by the WPA, and the foyer panels were reserved for mural decoration. Simpson was the first artist in California to use the elegant technique of *opus sectile*, dating back to classical times, in which each piece of the murals was cut from different colored marbles and then fitted

together like the pieces of a jigsaw puzzle. In all, she used 24 different types of marble in 52 different colors.

Simpson's mosaics had to be placed adjacent to slabs of neutral orange and yellow-orange marble, thus the interior of the lobby presented a real problem for the artist. Oil painting texture would be wholly out of place, and murals in tempera or fresco would have been too dry and dull a surface for the high polish of the surrounding walls. The use of mosaics with small facets of mat-surfaced marble or tile or even the high gloss of vitreous enamels would appear alien next to the vast expanses. The idea of using *opus sectile*, with color planes large enough to be cut from marble slabs fitted together and polished was the best solution. Duccini so masterfully fit the pieces of marble together that the junctures of the sections are almost invisible.

These stories of the common people's history in California are housed in the symbol of justice and hope—the courthouse. The figures of Indians and white men and women taking part in the settling and exploration of California are depicted in a solid, stately style derived from Rivera.

Edith Hamlin painted an egg tempera mural in 1937 for the library of Mission High School in San Francisco, *The History of the Mission of San Francisco*, under the auspices of the WPA/FAP. Hamlin chose the theme because the Mission Dolores was in the neighborhood, and many of the children at the school were of Mexican and Indian heritage. The children loved to watch her work on the two 30 foot wide panels, and sometimes served as models. The paintings show the building of the mission and its activities, including pottery, weaving and blacksmithing. The murals were unveiled amidst much celebration, attended by the mayor, members of the board of education and the press. *Art News* in 1937 described Hamlin's work "as a prime example of the new 'art for the people' that was emerging from the Federal Art Project."[31]

Finally, there is Henrietta Shore, who stood alone both in style and attitude. Though influenced by the Mexican muralists, she was always an easel painter at heart. Born in Canada in 1880, Shore came to the United States while still in her twenties and became an American citizen in 1921. She studied in Toronto and at the New York School of Art and the Art Students League, with Kenneth Hayes Miller, William Merritt Chase and Robert Henri. She also traveled to Europe, studying in London and Holland. She moved to Los Angeles in 1913, becoming a founding member of the Los Angeles Society of Modern Artists, and won a silver medal in the San Diego Pan-American Exposition. Shore was often compared to Georgia O'Keeffe, but never gained the same notoriety. In 1924 she was one of 25 artists chosen to represent American art in Paris, and in 1925 she

became a founding member of the avant-garde New York Society of Women Artists, of which Marguerite Zorach, (another WPA muralist in California) was president. Shore traveled to Mexico in the late 1920s and met Rivera, Orozco and Jean Charlot, all of whom influenced her work. In 1927 she met Edward Weston. They remained close friends and major influences on each other's work for the rest of their lives. Shore settled in Carmel, where Weston lived and died in San Jose in 1963.

Until 1986, there had only been one book on Shore's life and work, published in 1933 by Edward Weyhe, owner of a rare book shop and art gallery in New York. Merle Armitage, impresario in the arts and close friend of Shore and Weston, edited the volume of which only 250 were printed. More than 50 years later, the Monterey Peninsula Museum of Art published a catalogue on Henrietta Shore as part of their 1986 retrospective exhibition of her work. Because no Shore journals have ever been found, there is little first-hand information on her other than her letters to Weston, published in his Daybooks.

As noted in Weyhe's book, Shore referred to Goethe in describing her philosophy of life, "There is no past we need to return to—there is only the eternally new which is formed out of enlarged elements of the past, and our genuine longing must always be productive for a new and better creation."[32] Critic Arthur Millier asserted in 1927 that "Miss Shore . . . is unquestionably one of the most important living painters of this century, as strong as any on the west coast for a synthesis of intellectual, technical and aesthetic qualities in her latest work."[33] Edward Weston added in 1933, "One day collectors will eagerly bid for her drawings; they will be widely sought but the examples few. Henrietta Shore has created with enduring and comprehensive importance."[34] Shore never achieved the fame that some had predicted for her, and it has been said that this left her embittered.

Shore painted six murals in Northern California, five for TRAP and one at the Monterey Old Customs House for the PWAP. The four lunette murals in the Santa Cruz Post Office were all easily accessible scenes for the common worker. The oil paintings, framed by white carved lunettes, are titled, *Cabbage Culture*, *Fishing*, *Artichoke Culture* and *Limestone Quarries*. Shore was paid a total of $233.74 for her work. Her style, expansive yet simple, has been described as an ". . . organic precisionism in its clarity and emphasis on fundamental shape, line and mass. Her laborers are dignified, monumental forms enveloped by the rhythms of flora and sea to the craggy solidity of the terrain."[35] Her style can be compared to both Diego Rivera, in the massive body shapes, and to Georgia O'Keeffe in the organic treatment of those shapes. In any particular scene, a leg

can look like a rock or a leaf can resemble a finger. These murals were restored in 1984 by Philip Mix of Museum Services in San Jose, who then expected his next commission to be Shore's mural located in the Monterey Post Office, but nothing has taken place.

The Monterey Post Office mural, *Monterey Bay* has had an interesting history. It was on public view since its origin in 1937 until shortly after the artist's death in 1963. At that time the post office was remodeled and the mural was boarded over. It remained hidden and largely forgotten until 1984, when the Postmaster, a history buff, became curious. He had the paneling removed and there it was, although damaged by nail holes and hammering. The mural is now located in the Postmaster's office over the window. The colors are more subtle than the Santa Cruz murals, but they still have the same acid, clear quality. We see fishermen standing alongside a beached (Baleen) whale, while people congregate on the pier. Women stroll in long dresses and carry parasols, reminding us of a more genteel period of history.

Shore's last wall painting was originally done for the Old Customs House in Monterey. Built in 1814, it is the oldest building in the city. It is a scene of farm workers titled *Artichoke Pickers*. The painting has since been removed, and is currently in the care of the California Department of Parks and Recreation in Sacramento.

Shore painted the ideals of the New Deal—the nobility of hard work, such as farming and fishing. According to a past administrator of the local branch of the WPA in Monterey, Shore was never happy being on relief. She found it humiliating having to sign the document stating that she was destitute. Because she lived in a friend's house, rent free, her normal allotment of $75.00 was cut, leaving her with not enough money for a phone. This is one of the few instances where I have found indications of an artist feeling unsatisfied on the project.

Just as California has been thought of as provincial in relation to the rest of the country, Southern California has suffered in relation to Northern California. The appointment of Walter Heil, supervisor of the Northern California Project and director of the De Young Museum in San Francisco, was considered an example of bias. Southern California artists protested that their accomplishments under the PWAP merited individual representation before the government panel. Their petition was denied by Edward Bruce on the grounds that the national advisory committee was a transitional body, to be disbanded when and if other art projects were approved. Southern California did eventually gain individual status when Stanton Macdonald-Wright became director of the Southern California Federal Art Project.

The most popular style throughout the 1920s in Los Angeles had been land-scape painting, called "The Eucalyptus School" by Merle Armitage. Artists found their inspiration in the local environment, celebrating the sunshine, mountains, valleys and deserts. European modernism was adamantly rejected in Southern California, except in private galleries in Los Angeles. In the 1930s the Laguna Art Association, the California Watercolor Society and the Art Club re-fused to exhibit any such works. The Laguna Art Club's seascape tradition and the Eucalyptus group of decorative, muted landscapes demonstrated the strength of conservative art forces in the south. Southern California was ready and willing for New Deal art—Social Regionalism fit very comfortably with the conservative nature of art circles already in existence by the time of the Depression.

There was a small group of modernists in Los Angeles called the Post-Sur-realists, including Lorser Feitelson, Lucien Labaudt, Knud Merrild, Ejnar Hansen, Helen Lundeberg and Grace Clements. Many of these artists continued working in modernist styles during the 1930s by juxtaposing the acceptable New Deal style of Regionalism with their private explorations in more progressive styles. Grace Clement's organization of space in the Long Beach Daugherty Field murals reflect similar spatial organization in her Post-Surrealist canvases.

The mosaics of Grace Clements for the Long Beach Municipal Airport on Daugherty Field, created in 1942 for the FAP, constitute some of the rare mod-ern mural work for California projects. Most of the work has now been covered with carpet or paint, but Clements' mosaics had originally covered the floors and walls of what is now the Administration Building. The only remaining mosaic is the more traditional "Zodiac" floor mosaic, located in the restaurant foyer, where geometric designs surround the circular pattern encompassing the signs of the zodiac. *Aviation & Navigation*, now painted over, depicted the energy of air travel through the use of airplane motors and machinery organized along the wall in cubist style, looking like a large collage.

The medium used for the murals most distinguished the federal art of Southern California from that of the north. Stanton Macdonald-Wright had a passion for novelty and saw that the sunny climate lent itself to outdoor murals. There were many more indoor, painted murals in Northern California due to the climate. In Southern California, due to the interest of Wright and the technical brilliance of ceramicist Albert H. King, the mosaic form reached a high level of sophistication. Macdonald-Wright and King felt that the clear skies and bright sunshine demanded highly colored and highly glazed tiles. They rejected the random grout line and unglazed tesserae used by Helen Bruton in San Francisco,

for example, in favor of glazed tiles laid in intricate formal patterns. These are usually referred to as "texturalized mosaics." Macdonald-Wright also invented an art form known as "petrachrome," or, more accurately, he invented a term for a modern variation of the ancient technique, *opus sectile*. Petrachrome included the process of mixing colored chips of marble or other material into concrete, which could then be poured into interlocking forms to create individual sections of the mural. Each color would then be poured separately to create a mural of durable resistance to the bright, bleaching Southern California sunshine. The finished mural, pried from its backing and buffed to a high polish, could then be incor-porated directly into the side of a building. It was hoped that the petrachrome would retain its lustrous finish as well as its strength, but unfortunately the sharp colors did not always last. As the concrete base aged, a film developed over the surface, clouding the original colors.

A perfect example of a petrachrome mural can still be seen in Inglewood. Created by Helen Lundeberg in 1942 for the Southern California FAP, it is lo-cated in Centinella Park. The wall mosaic is probably one of the longest works executed for the New Deal. With her husband and teacher Lorser Feitelson, Lundeberg led the Post-Surrealist movement. Beginning in 1933, they attempted to reconcile subjective, introspective material with the logical and rational con-scious mind. Lundeberg wrote the theoretical manifesto to accompany their first Post-Surreal exhibition in California. She continued this style on her own time during the Depression, while spending her weekdays working on the Project. Lundeberg decorated the eight-foot high by 245-foot long curved outdoor wall in Centinella Park with a panoramic mural, *History of Transportation*. The story begins with the Indians, travels through time to the white settlers and their cov-ered wagons, ending in the 1940s with trains and airplanes. The colors have faded, but this does not detract from the fluid and clearly stated message of pride in California history and the progress made in a relatively short amount of time.

Lundeberg has been described by her fellow FAP artists as an efficient leader and organizer in her quiet way, supervising groups of skilled workmen. In her opinion, "The FAP made it possible for me to work full time as a professional artist at a time when the 'art market' was extremely depressed. It also...gave my general self confidence a boost...obliged me to undertake things I might not otherwise have dreamed of doing. It was a good experience, but I don't think that what I did for the Project had much, if any, influence on my later work. I had continued to paint 'for myself' on my own time, and as soon as the art project ended I began a series of very small and personal paintings—a reaction to the impersonal and public aspects of mural painting."[36]

Southern California murals were on the whole apolitical. Artists avoided themes of social confrontation and extremes of patriotism. They portrayed the inevitable Lincoln and Washington and other historical subjects, but did not deal extensively with themes of national glory, nor provide propaganda for American policies. They generally explored themes in which the people, not the government, was the main focus. This added greatly to their public appeal because the average citizen could easily identify with them.

This apolitical nature is very apparent in murals dealing with education. Helen Lundeberg's *Quests of Mankind*, a petrachrome mosaic at Canoga Park High School, deals chiefly with the education of children, with patriotic themes running through it only secondarily. Our forefathers are seen signing the Constitution, and busts of Washington and Lincoln rest on textbooks, but the emphasis remains on education.

Among the most careful petrachrome murals are Lundeberg's *Valley Forge 1776* and *George Washington* for the auditorium foyer of George Washington High School. Here she exploited the modular pouring process of the medium, creating interlocked areas of flat color, such as in the billowing smoke of a campfire or the long, sinuous curve of a dead tree trunk. These elements frame Washington, shown holding the limp body of a musket-bearing young soldier. The broad, abstract forms and simplification of detail are typical of murals done in petrachrome.

At Lindbergh Jr. High School in North Long Beach, Grace Clements and **Jean Goodwin** Ames painted *The History of Aviation* in fresco for the FAP in 1940. The struggle to achieve flight from ancient times to the success of Charles Lindbergh and on to space flight are told in story form, as in Lundeberg's *History of Transportation*, with a definite beginning and end. Men and women are portrayed in historically accurate dress. These are educated, affluent people. A student could easily get the point that education and success are interrelated

Helen Lundeberg teamed up again with Grace Clements to create a fresco for Venice High School in 1941. Here they narrate the history of California in unrelated vignettes that seem to float across the walls of the library. On the east wall is the *History of Early California*, the age of exploration, with scenes of Magellan, Drake, Cortes, Balboa and Cabrillo. On the sides are local Hupa Indians and Father Junipero Serra and the development of the missions. Each scene floats on an undifferentiated background, only minimally tied together. On the west wall is *The History of Southern California*, starting with the mission period through the development of the city of Venice. Each fresco measures approximately 18 feet high by 33 feet long; both are in remarkably good condition.

The colors are strong and crisp and the story is beautifully portrayed. Clements even incorporated her own name into the painting, naming one of the ships "Grace." The subject of this fresco is appropriate for its location,. a history lesson for the students using the library.

Clements and Lundeberg were the main designers of the murals at Venice High School, as well as being the master artists and supervising four assistants. This is yet another demonstration that women were leaders in the California projects and deserve the same respect afforded their male contemporaries.

Suzanne Miller worked exclusively in education themes in Long Beach and South Gate. She studied mural painting at Pratt Institute in Brooklyn, then worked at Fontainebleau and Paris assisting one of the foremost French mural artists, John Despujols. She can be compared to the Northern California muralist Jane Berlandina, since both received formal training in France and both had unique styles. Miller's nine murals for the Long Beach Public Library have a highly glossed and highly finished style. Painted in 1937 for the FAP, they appear to be painted in oil on board. The subjects were chosen from English and American literature, and the central Biblical theme was included on the grounds that the King James Version of the Bible is one of the great English classics. Recognizable to library patrons are the stories of *Hiawatha*, *Rip Van Winkle*, and *Alice in Wonderland*. "Considered from the point of view of painting," Miss Miller says, "the treatment of this subject matter is at the same time academic and modern. The drawing has little apparent distortion and is, on the whole, academically realistic. Many forms have been simplified into pictorial symbols rather than distorted. But in the arrangement of dark and light, in color scheme, and in brush technique there is more the feeling of the modern school. By this combination of the modern and the academic the artist has tried to arrive at a style which as wall decoration will be pleasing to a majority of the people."[37]

More in line with California fresco style are Miller's work at the Jane Addams Elementary School in North Long Beach and at the South Gate Library and Museum in Los Angeles. *A Visit to the Jungle* at Jane Addams is painted in the muted earth tones of fresco. It is located in the library, positioned over the bookcases. In this quiet, serene scene are three young children by the river's edge, surrounded by a multitude of calm, happy animals. These animals have gathered from all around the world in this fantasy landscape in order to teach the children to respect and cherish their animal friends.

Miller's frescoes in South Gate depict *The History of Printing Through the Ages*. Painted in tempera for the FAP, it is another "teaching" mural. The building where the murals are housed began as a library and is now a museum. There

are three separate panels that explain the history of the printed word. In the first panel there is a banner stating its purpose, "Egyptian use of papyrus reed and Hieroglyphics." The adjoining panel depicts the Chinese papermaking technique while the third mural portrays modern man in the Machine Age, printing on all available types of machines. They are painted in the same muted colors as at Addams' school.

Another Modernist artist who painted in the regionalist style for the New Deal was **Belle Baranceanu**. She was most active in the San Diego area during the Depression, but also exhibited nationally throughout her career. Regarding painting for the Projects she commented in 1950, "I have always loved mural painting. An oil when you finish you either keep or sell, but a mural you share with everyone and still have."[38] Like Henrietta Shore, Baranceanu worked in an organically abstract style. Baranceanu met Diego Rivera in the 1930s, and the solidity of her figures do seem to have been somewhat influenced by his style. Rivera's influence is however, not as apparent in Southern as in Northern California.

Baranceanu's first federally funded mural was for the PWAP, entitled *San Diego*, and painted for the California Pacific International Exposition held in San Diego in 1935. In this oil on canvas, she depicted the industry of San Diego— naval ships, farmers, oil wells—as well as a mission. Measuring eight feet by five feet, it remained in the San Diego Fine Arts Gallery until 1975, when all federally sponsored art works were recalled to Washington, DC. Her second commission was for the Palace of Education (now the Balboa Park Club) on the Exposition grounds. In a letter to a friend regarding the murals, Baranceanu wrote, "It represents the youth of today and his heritage. When the competition started it was suggested that we use 'the development of man' as the subject and in some way introduce the child. There are so many phases to the development of man (one could paint a mural on any one alone) that much had to be left out. I started with the cave man decorating the wall of his cave. From that I jumped to the Egyptian culture represented by the Sphinx and pyramids, the Greek by the temple, and so on down through the middle ages to today."[39] Baranceanu, like other women artists of the New Deal, paid close attention to detail, both compositionally and historically. This work at the Balboa Park Club is one of the few murals by Baranceanu that is still extant.

There is another mural still in place by Belle Baranceanu at the La Jolla Post Office. Painted for TRAP in 1936, *California Landscape* is yet another example of public art in a public place with an easily accessible subject. The artist knew that the citizens of La Jolla wanted to see their community in the finished mural,

so she climbed to Soledad Mountain and made many sketches. The composition of this oil on canvas is more abstract than the majority of murals painted in California. When she sent her sketches to Washington, DC, the government officials wanted a deeper perspective. Baranceanu felt she had a good design, so she agreed to their requests, then followed her original design anyway.

Baranceanu's last WPA mural, painted during 1939 and 1940, was dedicated in 1941. Painted under the auspices of the FAP, it was entitled *The Seven Arts* (Literature, Drama, Dance, Music, Painting, Sculpture and Architecture). It was painted on the proscenium arch of the La Jolla High School auditorium and was tragically demolished in 1975. The medium was the dry fresco technique in which casein pigment is applied directly to the dry surface. To further aid in the public appeal of the mural, she incorporated famous local personalities such as sculptor Donald Hord, conductor Leopold Stokowski, violinist Yehudi Menuhin, dancer Harold Kreutzberg, actress Katharine Cornell and even her own self-portrait.

The Southern California Art Project Mosaic Unit was started in June of 1936. As of 1939, the project had completed 27 wall panels in glazed and unglazed tile, from 22 square feet to 803 square feet in area. Fourteen exhibition panels varying in size from two to 35 square feet and large numbers of sample panels, three process demonstration panels and 115 different tile textures were completed as well. The mosaic department trained about 40 artists in the making, designing, cutting and mounting of tesserae and sometimes in actual installation. Artists such as Macdonald-Wright, Albert King, Grace Clements and Jean Goodwin Ames were involved in this extremely indigenous style. In the production of mosaic where one or more artists make a design and 20 to 30 coworkers cut and erect the mosaic, creative vanity has no place. In both Northern and Southern California there was an amazing amount of free experiment in the use of available material. Southern California mosaicists were fortunate that Gladding McBean, a major producer of vitreous floor tiles, donated tiles to the Art Project. The bright, clear colors and the wide range of available colors enlarged the artist's vocabulary in the mosaic division.

Jean Goodwin and Arthur Ames created the two mosaic panels for Newport Harbor Union High School in 1937 under the auspices of the FAP. Each created their own mosaic, but they appear to have been done by one hand and one mind. Jean Goodwin Ames recalled ". . . that a WPA mosaic assignment was the springboard to a long successful career."[40] After the Depression she became known nationally as an enamelist and tapestry designer. Jean Goodwin, raised on an orange ranch in Santa Ana, studied at the Art Institute of Chicago and married

Arthur Ames in 1940. They collaborated on murals and public decorations in Southern California for many years.

At Newport Harbor Union High School, Goodwin and Ames each designed a mosaic panel for the patio. Goodwin chose *Fisher Girls* and Ames chose *Fisher Men* as themes because of the location of the school near the water. Again, the theme is appropriate for its location. The murals, each measuring eight feet square, are easily readable and relatable to those in contact with them every day. Goodwin and Ames captured the flowing, linear rhythm of water in the sinuous patterns of the tiles. Using unglazed vitreous tile, they pioneered in the use of floor tile for wall mosaics. The durable tile had the advantage of bright color and uniform size, allowing the artists to construct their murals in a studio with assistants and then transport the finished segments on board to the site.

The financial support from this and other commissions made it possible for Jean Goodwin Ames to obtain a Master's degree at USC and become a college professor. Later she became chairperson of the Graduate School of Art at Claremont, and eventually achieved the status of Professor Emeritus at that institution. She is a prime example of a well-educated woman achieving success in the arts while truly standing hand-in-hand with a male artist, her husband.

The largest mosaic mural made in California was the Long Beach Auditorium mosaic, now located at the entrance to the Long Beach Mall. It is the largest unbroken expanse of glazed tile mosaic in a single composition to be found anywhere in New Deal art. Entitled *Recreational Activities of Long Beach*, it measures 38 feet high by 22 feet wide and is composed of approximately 462,000 pieces of tile. A total of 40 artists worked on the mosaic, one of whom was **Louisa Etcheverry**. The mural was designed by Stanton Macdonald-Wright and Albert Henry King and was full-scaled by Stanley Spohn, John Hubley, Robert Boag and Louisa Etcheverry. Etcheverry also designed the border of the horseshoe-shaped mosaic, entitled *California Flowers*, for this 1938 FAP mural. Running 109 feet by six inches wide, it consists of California wild flowers with an interwoven line formed by the names of the artists and assistants who executed the mosaic. The tiles were glazed by project artists under Etcheverry's supervision. The completed mosaic's real contribution was in the use of the "textural" process. Before this time, mosaic effects were obtained through the use of arbitrary shapes or casually cut pieces, objects being identified through the use of color and outlines. But in the Long Beach mosaic, sky, water, flesh and fabrics are depicted as different, not only in line and color, but also in texture. When the mural was in its original place, high above the auditorium's

entrance, it could be seen for miles. According to Long Beach residents, when the mosaic was illuminated ". . . the colors glittered like inset jewels in the archway."[41]

The advent of World War II marked the end of the Federal Art Projects. Edward Bruce was unable to convert the program to wartime objectives. By 1943, Cahill and Bruce's goals were unrelated to the shifting priorities of the Roosevelt administration. The New Deal art programs became a casualty of war, extraneous to the daily concerns of the American people. After the projects ended, many works of art done during this time were neglected, painted over or lost. During the ensuing period of Abstract art, New Deal realism was no longer in vogue. Only in recent years have critics, art historians and artists begun to see the work of the New Deal as a positive development in the recognition and integration of the arts in California and elsewhere.

Private citizens are also recognizing the great wealth of Californian and American history that rests in these murals. One of the most gratifying parts of my research for this project has been speaking to these people who work with these murals everyday. From postal employees to librarians to school custodians, the response to the murals has been very positive. There seems to be a protective attitude in those caring for the murals today. One such person is Yvonne Clark, the maintenance supervisor at Lindbergh Jr. High School. Once every year she buys a new broom and personally dusts the murals of Grace Clements and Jean Goodwin Ames. She will not allow anyone else to touch them. When the library was recently repainted, she made sure the murals were well protected.

Suzanne Miller's murals in the South Gate Museum are being threatened by progress at present. The building itself is going to be leveled soon for the construction of a parking lot. The museum curator, along with the Associate City Planner and the City Planning Illustrator, are all very concerned. They are trying to raise funds to move the murals and save them from destruction.

Plans are already under way to restore the frescoes of Helen K. Forbes and Dorothy Puccinelli at the San Francisco Zoo. The Merchandise Manager of the Zoo Gift Shop has been trying to locate the daughter of Dorothy Puccinelli for some time with little luck. She brought her husband to the zoo a few years ago to show him her mother's murals and told someone that she had in her possession her mother's original drawings. Since that time, she seems to have disappeared.

The initiative taken by the Postmaster in Monterey to find Henrietta Shore's lost mural clearly shows that the murals of the Depression decade have not been forgotten. Belle Baranceanu's murals for Roosevelt Jr. High School in San Diego were saved by the director of the San Diego Historical Society, when they

were rolled off the wall and allowed to fall to the ground. They are now safely stored at the Historical Society, and there are plans to install them somewhere permanently. Regarding Baranceanu, when I phoned La Jolla High School to determine the status of her mural there, I could hear the sincere sadness from the woman on the other end telling me the mural had been inadvertently destroyed years ago.

The city of Inglewood is trying to determine the best way to preserve Helen Lundeberg's petrachrome wall mosaic in Centinella Park, especially since a runaway car recently smashed into it. The city is considering planting flowers along the wall's base, enclosing it with a chain-link fence and installing night lighting in an effort to stop runaway cars. It would cost an estimated $25,000 to move the wall to a safer place, and even if the city of Inglewood could afford to do this, Lundeberg has advised against it, fearing the wall could not survive a move.

In Long Beach, it was only due to public outcry that the auditorium mosaic was not destroyed and was permanently installed just outside the mall for all to enjoy.

One common thread connects the murals created during the Depression to the present time—a sense of pride. As we have seen, there are many people today who genuinely care about the future of these murals in California. It is unfortunate that this was not always true in years past.

The murals of the New Deal no longer fulfilled a need in America after World War II. Perhaps with all the death and destruction of the war, Americans were tired of looking at the human figure and all the hope that the New Deal implied. Abstract art was gaining a firm base in this country which left the murals looking provincial. Critics and historians have not done much to rectify this situation until recently. According to Barbara Rose (who seems to have changed her mind about this period at some point) "The physical neglect the art of the New Deal era has suffered over the years reflects the general critical disdain for the period. The paintings of the social realists, were little more than illustrational reformulations of academic painting. The regionalists have been forgotten, and for good reason, since they painted in a dead provincial manner that pandered to the worst elements of popular taste and did nothing to add to the development of American art."[42]

In order to fully appreciate the murals, they must be judged in their own era, the time of the Depression and the New Deal. Holger Cahill characterized the 1930s as a time in which America, through its artists, searched for and portrayed its roots. Questions of quality were then and remain today determined by the passions of the viewer. In the long run, it may not have been the technical skill

or creative instinct of the artist that was important, but the opportunity to unite a nation of people emotionally in a common cause to challenge the common enemy, the Depression.

Perhaps George Biddle was correct in his conviction that mural art can only flourish when artists and society are united in a common faith. Never before in American history had the artist found a place where his or her talents could be more congenially employed to serve the needs of the country's public. The artist and society were complementary in providing a meaningful cultural environment for the entire nation. The New Deal provided both the walls and the social faith to inspire muralists to develop an American style and a much needed national pride.

The reader must decide whether the women artists of the Depression decade had any major impact on the art of the New Deal in California. If one disregards their small numbers in relation to the male artists on the projects and simply examines the finished products of their labors, it is clear that these women produced art of the highest quality and did in fact make a significant contribution to public sector art. The WPA art projects also enhanced the careers of these women. While few achieved international or national recognition, the WPA projects allowed women artists to work as professionals with no fear of discrimination, if only for a short time. The accomplishments of women artists during the Depression decade shows that, given the opportunity, men and women can work together, side by side, without the discriminatory gender roles that hamper the success of both.

—Nancy Acord

Notes

1. Barbara Rose, "Life on the Project," *Partisan Review* (1985), p.74.

2. Seven Gelber, *Guide to New Deal Art in California* (Santa Clara, California: The de Saisset Art Gallery and Museum; University of Santa Clara, 1976), Introduction.

3. Mrs. Franklin D. [Eleanor] Roosevelt, "New Government Interest in the Arts," *American Magazine of Art* (March 1934).

4. George Biddle, *An American Artist's Story* (Boston: Little & Brown, 1939), p.268.

5. Masha Zakheim Jewett, *Coit Tower, San Francisco—Its History and Art* (San Francisco: Volcano Press, 1983), p.29.

6. Gelber, *Guide . . .* , Introduction.

7. Charlotte Streifer Rubinstein, *American Women Artists* (New York: Avon Books, 1982), p.217.

8. Winifred D. Wandersee, *Women's Work and Family Values 1920-1940* (Cambridge, Mass.: Harvard University Press, 1981), p.98.

9. Jan Butterfield, (Interviewer), Archives of American Art Interview with Helen Lundeberg (July 19 and August 29, 1980), Roll 3198.

10. Karal A. Marling and Helen Harrison, *Seven American Women: The Depression Decade* (Poughkeepsie, NY: Vassar College Art Gallery Exhibition Catalog, 1976), p.8.

11. Ibid, p.10.

12. Ibid, p.12.

13. Ibid, p.14.

14. Marilyn Wyman, "A New Deal for Art in Southern California: Murals and Sculpture Under Government Patronage," Ph.D. Dissertation, University of Southern California, 1982, p.4.

5. Helen Harrison, "Social Consciousness in New Deal Murals," Master's Thesis, Case Western Reserve University, 1975, p.60.

16. Melissa Walker, "American Scene Art and Government Murals in Northern California," from *Exposition to Exposition: Progressive and Conservative Northern California Painting, 1915-1939*, Joseph Armstrong Baird, Jr., ed. Essays by participants in Art 288, UC, Davis, p.50

17. Geoffrey Norman, "The Development of American Mural Painting," from *Art for the Millions*, Francis V. O'Connor, ed. (Boston: New York Graphic Society, 1973), p.51.

18. "Painter Finds San Francisco Setting for Artists," *San Francisco Chronicle* (May 1, 1930).

19. Gelber, *Guide . . .* , p.171.

20. *Diego Rivera* Exhibition Catalog (San Francisco Museum of Art, 1940), p.18.

21. Jewett, *Coit Tower . . .* , p.12.

22. Ibid, p.19.

23. Ibid, p.20.

24. Helen A. Harrison, *San Francisco News*, (February 14,1934).

25. *San Francisco Chronicle*, (May 15, 1977).

26. Jewett, *Coit Tower . . .* , p.121.

27. Ibid, p.115.

28. Ibid, p.120.

29. Mary Morsell, "California Mosaicists," *Magazine of Art* (October 1937), p.625.

30. Lorna Wadsworth, "The Mother's House at the Zoo," *At the Zoo Bulletin* (San Francisco Zoo, April/May 1981).

31. Rubinstein, *American Women Artists,* p.263.

32. Merle Armitage, *Henrietta Shore* (New York: Weyhe, 1933), p.2.

33. *Los Angeles Times*, (June 12,1921), pp. 3,24.

34. Armitage, *Henrietta Shore*, p.12.

35. Jo Farb Hernandez, *Henrietta Shore—A Retrospective Exhibition—1900-1963*, organized by The Monterey Peninsula Museum of Art (1986), p.38.

36. Rubinstein, *American Women Artists*, p.253.

37. Long Beach Public Library, Vertical File—Art—Music—Philosophy, WPA Artists: Suzanne Miller.

38. Gerry McAllister, ed. with essays by Bram Dijkstra and Anne Weaver, *Belle Baranceanu—A Retrospective* (University of California, San Diego, Mandeville Gallery, 1985), p.6.

39. Ibid, p.28.

40. Rubinstein, *American Women Artists*, p.264.

41. Marilyn Wyman, "A New Deal . . . ," p.223.

42. Catherine Barnett, "Writing on the Walls," *Art & Antiques* (March 1988).

The above chapter was written in preparation of a Master's thesis, California State University, Northridge, Art History.

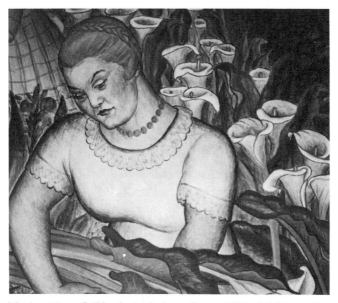

Maxine Albro, *California Agriculture*, fresco, 1934. Coit Tower, San Francisco, PWAP.

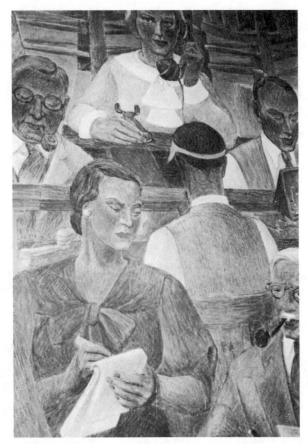

Suzanne Scheur, *News Gathering*, fresco, 1934. Coit
Tower, PWAP.

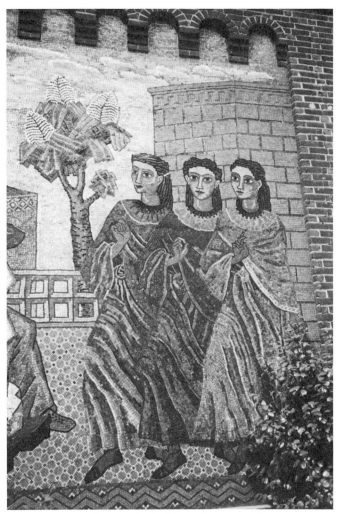

Helen Bruton and Florence Swift, *Music, Painting and Architecture*, mosaic, 1936. University of California, Berkeley (Old Art Gallery), FAP.

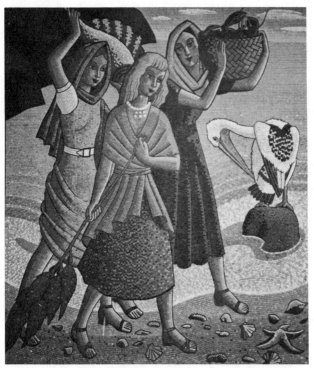

Jean Goodwin Ames, *Fisher Girls*, mosaic, 1937. Newport
Harbor Union High School, FAP.

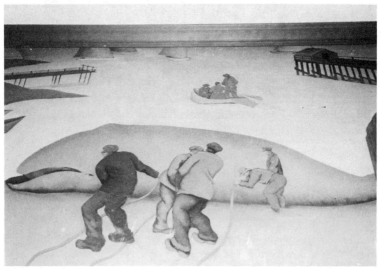

Henrietta Shore, *Monterey Bay*, o/c, 1937. Monterey Post Office, TRAP.

Strength, Vision and Diversity:
Women's Community Murals

The 1960s were troubled times, but for women, minorities, students, the poor and working classes it was a decade of mass political awakening, the first time many people felt the possibility of gaining some measure of control over their lives. When art went public in a new way with the beginning of the community mural movement, women were (and are) a major part of it. Any single aspect of the era, however, can only be understood in relation to the surrounding framework; all parts were interconnected.

The basic context was set by civil rights struggles against racial oppression and for recognition of the worth of minority cultures. The anti-Vietnam War movement politicized people throughout the country and showed that domestic issues were international in scope. May 1968 in France underscored that fact, as did women's liberation movements in several countries.

In response to this growing unrest, in order to "insure domestic tranquility" while pursuing an aggressive and expensive foreign policy, including the Vietnam war, military excursions in Central America and covert operations worldwide, President Lyndon Johnson launched his War on Poverty in 1964, and followed it the next year with his programs for the Great Society. Money was pumped into ghettoes and barrios, locations where murals would take root by the end of the decade. These programs established both a precedent for such expenditures and an administrative framework for programs like the Comprehensive Employment and Training Act (CETA), which was to provide salaries for muralists, among others, during the deep economic recession following the Vietnam war.

The women's liberation movement articulated in word and deed both the historical oppression of women and women's potential. Again and again women muralists in California commented that the women's movement "made it possible for me to paint murals"[1] by providing examples of women doing traditionally male jobs, organizing large-scale public projects and "doing heavy lifting."[2] Most of all, the women's movement developed a public atmosphere

of women "trying new things for our reasons, not someone else's." Women's art began to find (and create) its due recognition. Women's galleries opened in Los Angeles, as they did elsewhere, run by and for women. Women muralists were aware of these and of the women's movement in general, but for reasons of isolation, racism and the bourgeois bias of much feminism, they were not often actively a part of it. Most of all, the women's movement demonstrated the strength to win prolonged political struggles against class, racial and male-dominated hierarchies. Indeed, women's community murals are virtually emblematic of these battles, always in process, often in image.

Why paint murals in particular? For politicized arts students, minorities, women and working class people, community murals offered a chance to express their ideas, analyses, hopes and aspirations in their own terms. Denied access to mass media, they turned to the walls of their own communities. The mural format is crucial, says **Judith Baca**, because it provides an approach to a different audience than through the "fine arts." A successful mural also serves to heal such dislocations in society as the separation of art from segments of the population because of class differences, partly through a process open to the public, and partly through the large-scale metaphors the murals articulate. Murals encourage narrative approaches to material, and telling stories makes them (the stories and the images) readily accessible to all portions of the population, from children to elders, thus enabling the form to show people without power over their lives that space can be acquired and controlled. Community murals appeal to "marginalized" people in particular because they traditionally have least control over their lives.

Generally speaking, California contributes significantly to this process by offering a year-round painting season, and abundance of relatively clean walls (free from the grime of much of the industrial East) and a large Latino population traditionally receptive to monumental public artworks. In making immediate geographical and social references, California murals cannot be separated from either the location or the population surrounding their work.

More specifically, the state divides into two parts, North and South. There are roughly 400 miles between the Bay Area and Los Angeles—a day's drive, often made, but long enough to preclude much immediate interaction. In the South, Los Angeles is huge, hundreds of square miles, relatively conservative compared with San Francisco, with an enormous Chicano-Mexican population. San Francisco is tiny, only 49 square miles, and politically liberal. Its Latino population is mostly Central American in origin. Its varied residents are in daily

communication with each other just by virtue of living in the same small city; because of this any given mural is much more visible than in the South.

Within these contexts each women community muralist works,[3] and it is with reference to these contexts, implicitly and explicitly, that this essay proposes to sketch some main currents in women's community murals in California, noting the most significant exponents and characteristics. Because of its far greater output of Women's community murals, we will begin in the North.

North California 1967-76

There is a precedent for controversial political murals in San Francisco beginning in the early 1930s with the arrival of Diego Rivera, who painted four frescoes in the city during the next several years. Among his assistants were **Lucienne Bloch** and **Emmy Lou Packard**. Bloch, with Stephen Dimitroff, in 1965 went on to paint a history of San Francisco, among other works. Packard worked mainly in print formats during her distinguished career. Always politically active, both women became advisors to community mural projects in the 1970s. San Francisco is also the site of the famous Coit Tower monument, built in 1945, whose interior is decorated with mural panels executed by several artists, including **Maxine Albro** and **Edith Hamlin**. Hamlin has continued consulting with muralists. Together, these women provide a model of women muralists actively engaged in their city's public art life. The lesson was not lost on the community muralists of the 1970s.

In 1968, **Ruth Asawa Lanier** and **Sally Woodbridge** formed the Alvarado School Community Arts Program,[4] which, over the next several years, provided arts workshops in public schools and executed dozens of murals in them. One of the keys to the success of this program was the hiring of professional artists such as **Nancy Thompson** to lead the workshops. This established a precedent for muralists working in grade schools which has continued to this day, although funding normally comes now from the California Arts Council (CAC), which sponsors artists in residence. Although in San Francisco there have been men who worked with school children, this level of mural work has been preponderantly staffed by women artists, perhaps because the general perception that women are more aware of the importance of raising children is accurate, but also because there have been fewer opportunities of other kinds for them and because there is a tradition of women working in public schools.

The Political Heart

Concurrently with the beginning of school programs in San Francisco a group of murals were painted across the Bay in Oakland, coordinated by art teacher **Helen Dozier** at Merritt College in 1969. These walls were militantly political, titled *Leaders and Martyrs, La Causa/Peace & Love & Perfection*, and directed either by women or jointly with men. They pictured militant leaders such as Malcolm X and strong, angry faces interspersed with slogans and were executed in a stark, super-graphic style. The women who worked on them, **Shirley Triest** (with David Salgado), **Joan X** (and students) and **Wilma Bonnett** were expressing the politically militant attitudes of the time and particularly the influence of the Black Panther Party, the most militant "black power" group of the period, which was headquartered in Oakland.

Little subsequent women's muralism occurred in the East Bay until the end of the 1980s, but these Oakland murals represented the political heart of the first half of the next decade and also hinted at the shift toward less militance and more spirituality that came after the Bicentennial.

The most influential mural group in the early seventies was the Mujeres Muralistas (Women Muralists). The mere fact that a group of Latinas were painting large-scale public murals caught the imagination of women muralists throughout the state, and although their images were not overtly militant, everyone understood their dual significance: ·*women* painting murals, and an ethnic minority asserting its own culture. In 1973, **Patricia Rodriguez** and **Graciela Carrillo**, denied participation by male muralists in their projects, decided to paint their own mural across from Rodriguez' apartment in Balmy Alley. They called themselves Mujeres Muralistas. The following year, they were joined by **Consuelo Mendez**, from Venezuela, who had worked on the Jamestown Center murals, and **Irene Perez, Esther Hernandez, Xochitl Nevel, Tuti Rodriguez** and **Miriam Olivos**. These eight women painted *Latinoamerica*, a bold panorama of Latin American cultures in traditional locations combined with current manifestations in the Latino Mission District of San Francisco. A Bolivian devil dancer is seen, and Andean pipe players. A family dominates the center, flanked by sun and moon, corn stalks grow along the base, and there is a scene that could have been painted directly from life on Mission Street, running next to the mural wall. Later that summer Mendez and Carrillo agreed to paint *Para el mercado* [For the market], depicting traditional food gathering and market societies of Latin American at a taco stand two blocks from a proposed McDonald's. Carrillo asked **Susan Kelk Cervantes** to help with color as a means of unifying the two-part design. From then until the group formally

disbanded in 1976, in one configuration or another the Mujeres Muralistas painted nearly a dozen murals. An indication of their range is given in this partial list: *Fantasy World for Children* (in the Minipark at 24th and Bryant Streets), *Black History*, a free-standing rhombus for the San Francisco Art Commission show at City Hall Plaza, two works in the Bernal Dwellings housing project. Hernandez points out that "the Mujeres was a way of describing what we were doing, not necessarily a formal group." Partly through the pressure of publicity and partly through political differences they never had time to work out thoroughly, rarely did more than two of them paint together after the initial, extraordinary burst of expression.

The most significant mural work in the Haight-Ashbury neighborhood was executed by the Haight-Ashbury Muralists, led by **Miranda Bergman** and **Jane Norling**. Other members of the group were **Jo Tucker**, Thomas Kunz, Miles Stryker, **Vicki Hamlin** and Arch Williams. They began in 1972, prompted into action by a trip Bergman took to New Mexico where she saw the murals of Los Artes Guadalupanos de Aztlan. "The first time I saw ideas being painted on a wall—culture, hope, strength, history—I knew I wanted to do it," she said. Upon her return "home" to California in 1972, she and Norling proceeded to paint murals in the neighborhood. Both women were already politically conscious and active, and saw community murals as a way of combining their activism with their artistic abilities. They were the heart of the most politically engaged of northern mural groups, and were self-described in 1977 as "anti-imperialist cultural workers,"[5] an attitude which determined their subject matter and their process. For example, this consciousness generated the collective's struggle to find new, non-hierarchical ways to organize and paint.[6] In this regard, their most successful effort was their last, painted in the summer of 1976. The effort to combine styles in a period of declining political activism was too great, and the group, still friends, disbanded.

In 1975 Norling painted a solo mural for a women's law firm in Berkeley, titled *Sistersongs of Liberation*. In a spectacular use of interior architecture, the mural confronts the viewer opening the exit door of the office with a group of women from many cultures about to rush into the office. Later, this mural was removed to the Neighborhood Legal Assistance office in San Francisco, and a detail from it was made into a famous poster celebrating International Women's Day.

Their major work was the 300-foot-long *Our History Is No Mystery*, dedicated on May 19, 1976 (the birthday of Malcolm X and Ho Chi Minh). It depicts a history of San Francisco emphasizing poor people and people of color, from

the Ohlone Indians to a vision of both sexes and people of all colors working together to build a harmonious, prosperous society. One way or another, this vision is the main theme running through all the group's murals.

There were, to be sure, other women painting murals in San Francisco at this time. **Judy Shannon** painted *A Tribute to Black Theater* in 1975, and the following year **Camille Breeze** painted a mural at the Red Shield Playground, both in black neighborhoods. In the Haight-Ashbury, **Selma Brown** and **Ruby Newman** painted *Come Together Each in Your Own Perceiving of Yourself* as part of a three-mural neighborhood Bicentennial grant of $10,000. Their mural at the Page Street branch of the public library is perhaps the purest example of "the Haight's" penchant for combining a romanticized ideal of the Native American and nature, with a desire for personal growth, clarity and community. Another example of the area's counter-cultural, alternative lifestyle period, e.g., **Johanna Zegri**'s 1967-69 *Evolution Rainbow*, depicts biological evolution from amoebae to more complex life forms as a rainbow progresses from darker to lighter colors. Men also painted some murals in the area depicting a romanticized pastoral ideal.

Regardless of funding source, the heart of these women's murals was political, either overtly or through expression of ethnic pride. There was often a clear presence of spirituality as well. In fact, in the Haight, where hippies were painting the interiors of their apartment with psychedelic fantasies, "going public" by painting outdoors was not such a big step. The Haight-Ashbury Muralists made the practice consciously political.

Militant political expression dominated a show presented by the San Francisco Museum of Modern Art. "People's Murals: Some Events in American History" included many of the major muralists in the city, including the Haight-Ashbury Muralists and the Mujeres Muralistas, and several men. Each artist or group painted on masonite or plywood panels which were exhibited in the main gallery of the museum, then distributed to selected locations throughout the city. **Nancy Hom** and James Dong devised a V-form on which to paint *The Struggle for Low Income Housing*, a mural about the fight to save the International Hotel (home to about a hundred elderly Filipino merchant seamen) and low-cost housing in general. **Shoshana Dubiner** painted with dozens of school children on an international theme. Roberto and **Veronica Mendoza** painted one of the few Native American murals, *The Struggle for Native American Sovereignty*.

The significance of the Bicentennial show was perhaps symbolic. After it, San Francisco murals were supported almost solely by CETA and then the Mayor's Office of Community Development (OCD), which locally administered

federal HUD funds. The pressures attendant on these sources, combined with a shift in lifestyles and a quieting of mass political attitudes in the country, meant community murals began following a different, less politically engaged track than previously, with occasional significant exceptions.

Bay Area, 1977-88

After the early murals, San Francisco artists fought for and won the right to be included in CETA programs, beginning in 1975. Murals in the last half of the decade were basically funded from this source and thus faced its attendant bureaucratic pressures for conformity.[7]

When CETA funds stopped at the end of the decade, a representative group of muralists under the leadership of **Kathie Cinnater**, head of the San Francisco Mural Resource Center, met with the head of OCD to discuss how murals could help develop communities and received a significant grant of support, which has been regularly renewed through the 1980s. Because of the city's small size, its average of support for about five murals each year looms extraordinarily large on the public art landscape.

The shift of murals to less politically militant images after the Bicentennial was not dictated solely by a shift in funding sources. There were also factors such as changes in lifestyle as women grew older, had more at stake in "regular" jobs and began families within a shrinking economy. There has been a distinct drop in mass political activity to influence the content of women's (and men's) murals over the past dozen years. But throughout the second half of the seventies, CETA was the main, and almost the only, funding source for community murals in the Bay Area.

Fran Valesco was the most prolific CETA muralist, having painted 16 murals under its auspices. Her style, unusual for muralism, she calls "abstract surrealism." With it, she paints "what the people wanted to see," but highly stylized in her own manner. What introduced her to mural painting was working with the Mujeres Muralistas in 1975, where she immediately "felt a kinship through working with other women, enjoying their sensitivity to other people and lack of power orientation." For Valesco, this base combines with the stimulation of living on the Pacific Rim in "a place that has been the end of the continent," where "people come for their dreams, where you live in the illusion that here you can make your fantasies come true." Her work displays a wide variety of subjects, from her *Puerto Rican Social Club* mural on Mission Street, through murals at the YWCA depicting women's roles, successes and histories, to the

humorous homage to Hollywood film, *Playland at the Beach*, painted on the side of a movie theater. In Oakland, CETA and the CAC supported separate mural projects by Esther Hernandez and also by Xochitl Nevel-Guerrero, two of the Mujeres Muralistas who continue to paint murals. Hernandez was also a participant in the 1986 San Francisco Art Institute mural show, where she executed an evocative mural/installation using a textile design to condemn United States crimes against Central American people.

We find in this period especially, the development of the spiritual element in women's community murals, each with its own perspective, yet contributing to a group of murals sharing an emphasis on the spiritual. This is seen most clearly in the murals of Selma Brown, **Claire Thurston**, and Susan Cervantes. Brown and Ruby Newman painted the Page Street Library mural in the Haight for the Bicentennial, and Brown has continued painting since then. She maintains a concern with the environment and the natural world, "some element of nature and the people functioning in that," as in her *Masters of Metal* showing the process of extracting metals from the earth and smelting them. Environmental elements are present even in her large *Ben Franklin School* mural of 1986. Another woman sponsored largely through CETA is Claire Josephson Thurston, who arrived in 1975 from the East. For her, the architectural environment was the stimulus in the West. In contrast to the East, "here were big, open spaces, warehouse buildings without East Coast grit," like "blank canvasses everywhere you look." Thurston's content is consistent with her murals' locations in childcare facilities and schools, but they share a common thread, a psychological incorporation of women's ideals into "big outside works," each with some element of spirituality, of "unity and the spiritual dimension of life, not religiosity, but a deeper level of things." Perhaps the mural where the spiritual elements are most vividly expressed is the 1982 joint effort of Brown, Thurston, and **Johanna Poethig**, *Elements of Infinity*, painted on a daycare center directly across from a senior citizens' apartment building. Even with this semi-abstract mural, the concern for the community was paramount. "It's what the seniors who were going to have to look at it everyday wanted," says Poethig.

CETA has supported women primarily working in schools and other institutions, and notably the work of Susan Cervantes, who in 1977 founded Precita Eyes Muralists along with others she had worked with, both women and men. It is a mark of her organizational ability that Precita Eyes has grown over the years to become the oldest and most productive mural group in the city.

For Cervantes, the process of collective work embodies her view of the family as the central unit of a better future, expressed through the collective

process of Precita Eyes and in her search for expression of universal images. The chance to work in her neighborhood with her family and neighbors is unique and is celebrated in the huge diptych she executed with **Judy Jamerson** and others on the Leonard R. Flynn Elementary School across Precita Park from her home. Called *Family Life and the Spirit of Mankind*, the two panels exemplify her commitment to her community and to "universals as the bridges between the different cultures. I look for a way of unifying these elements. What are the values needed to maintain our quality of life? To uplift the spirit?" *The Spirit of Mankind* is based on a spiral design and features a multicolored blossoming of a Tree of Life. "In its branches the life cycle is represented by images of birth, childhood, old age and death." Its companion, *Family Life*, also a spiral composition, "is a representation of the spirit and many faces of mankind . . . all people from the neighborhood."

"Doing murals is the best thing a woman can do," Cervantes says, "because it is large scale, and outside. You can bring your family to it. Work in the neighborhood *and* be with your family." Her subsequent work with Precita Eyes includes a number of murals, such as the perfectly appropriate undersea scene at the Garfield Park Swimming Pool, and a group of portable murals now mounted at the Las Americas School. These revolve around themes of myth and vision for a healthful future for our children.

Two women in particular who have worked with Precita Eyes have also painted significant other solo or group projects. **Margo Bors** painted a historical mural in her local Potrero Hill Library and a calming landscape in a hospital operating room in Berkeley, perhaps the least accessible and most deeply appreciated mural in the area. Judy Jamerson's best known murals are painted at Mission High School and portray both the daily experiences of the students in a silhouette mural well adapted to its architectural space (a long, low wall), and a more idealistic Lamp of Knowledge image next to it, which was regularly defaced with the phrase "Life's not like this, Judy" over the course of several months, even after the graffiti was cleaned off.

In 1981 and 1982 four murals were painted for the San Francisco Women's building in the Mission District. The exterior *Women's Contribution* was directed by **Patricia Rodriguez** with **Francis Stevens**, **Miranda Bergman**, **Nicole Emanuel**, and **Celeste Snealand**. It depicts exemplary women of four races in the large wall spaces between the building's second story windows. Rodriguez was one of the original Mujeres Muralistas and continued her engaged, community-oriented mural work in the District with murals at the Mission Mental Health Center, and Casa Nicaragua (with Nicole Emanuel). The

Women's Building was her last mural, however, as she then turned to increasingly more individual art forms in the later 1980s.

Murals emphasizing ethnic pride in this period became not so much assertions of ethnicity as expressions of the dignity of minority cultures. **Brooke Fancher**, after working with a number of local muralists, in 1987 painted *Tuzuri Watu* in the black Hunter's Point/Bayview neighborhood. The title is Swahili for "We are a beautiful people," and Fancher, a white woman, incorporated into the design quotations from five black women authors, noting that the respect for women's literature was a springboard into the community and made it possible to work with people instead of imposing her ideas on them. "Poor people are used to being imposed on, and it was important not to repeat that attitude." The relative openness of thinking in the Bay Area, so aptly demonstrated in this project, is what brought Fancher here and encouraged her to represent a cultural cross-section of the area in her murals. She tries to "provide alternative images of people invisible in the mainstream," and "reads 'The Question Man' in the daily paper because that is the main place you see Third World people expressing themselves."

Fancher says that "artists are there to dream for the people. To do that, I've got to learn how to present an alternative reality to capitalism, to competitiveness, the star system, dog eats dog, and all those abhorrent things that make the world go around right now. I want to express a global feminism, women's values in terms of the future of the planet and taking care of what we have." Among murals attempting a similar vision are two dedicated in 1988 by **Juana Alicia**, *Cultura Sin Fronteras* [Culture without borders] on the Novato Hispanic Cultural Center north of San Francisco, and a multiethnic *Bridge of Peace* at World College West, in nearby Petaluma.[8]

Such murals also have a community focus, and are thus allied with those murals that narrow the larger concerns of seventies political murals to specifically neighborhood-oriented community expressions. These walls include Cervantes' and Fancher's works and also the joint effort *Balance of Power* painted by Cervantes and Alicia with Michael Mosher and local residents (mostly youth). It depicts local gangs, history, problems and aspirations on a long wall of a narrow dead-end street on the Mission Playground Swimming Pool, on the front of which they later painted *New World Tree*. Another such mural, painted in 1987, was jointly designed by Fancher and Nicole Emanuel, and executed by Emanuel and Scott Branham, Dan Fontes, Luke McGlynn, Peter Collins and **Storme Webber**. *Reflections of Potrero Hill*, although a relatively innocuous depiction of Potrero Hill neighborhood history as if

captured in old-fashioned postcards, nevertheless sparked a vociferous campaign against it from a small group of local arch-conservatives. This mural thus exemplifies in its process the sort of politics earlier murals sought to depict in their images. Emanuel, too, tried to show appreciation of things not depicted regularly enough in mainstream U.S. culture, such as black history, women of different nationalities and creativity in general. Having worked in Balmy Alley with PLACA, and with the ILWU Mural-Sculpture and her own projects, Emanuel continues to pursue large-scale murals as a means of expressing this sense of community.

Among several muralists who have painted murals of different types in the 1980s, Johanna Poethig's work stands out for both the strength of her themes and her "realist expressionist" style, which is more highly stylized and includes more abstract elements than many other murals, and breaks up the linear expectations of the composition. Supported entirely by OCD and CAC, Poethig's goal is "to bring less well-known communities such as Southeast Asian and gay, to share with the broader community so that the broader community can learn. Both those who identify with the images and those who might not need to build mutual respect." Her best-known mural is *Lakas Sambayanan* [People's power], near the Bayshore Freeway, depicting the fall of dictator Ferdinand Marcos and the rise to power of Corazon Aquino in the Philippines(painted with Vicente Clemente and Presco Tabios). Poethig has also painted at the Women's Building on *Elements of Infinity*, and a group of complex interior murals at a mental care facility. In 1987 she completed the *Harvey Milk Memorial Mural* in honor of the assassinated gay San Francisco supervisor. Poethig's commitment to the ideal of community is clear because she paints on behalf of such diverse groups. "There's a fine line between what murals must do politically in terms of what the community wants and what they can do aesthetically so that they are not just more of the same old tired styles," she says. Her artistic stylization may well become influential, since several artists are beginning to explore new artistic expressions in their murals.

Since the mid-seventies some women have also worked on more directly political issue-oriented murals, and among them are some of the most powerful projects of the past decade. Norling and Bergman were rejoined by Arch Williams and Vicki Hamlin, and together with **Maria Ramos** repainted the magnificent *Our History Is No Mystery* into its new embodiment, *Educate to Liberate*. Tucker has painted other murals since the Haight-Ashbury days, including CASARC, the child sexual abuse center at San Francisco General Hospital. Miranda Bergman painted in Juvenile Hall under both CETA and CAC

sponsorship, and upon returning from a trip to Cuba painted a delightful *Bird of Peace* in the 24th Street Minipark. In 1981 she painted a mural in Minneapolis with **Marilyn Lindstrom** on the Haymarket Press building. Bergman was also a founding member of a multiracial group called Oakland Wallspeak, dedicated originally to painting community murals against apartheid in mostly black Oakland. The group also includes **Kim Anno,** who painted a mural for the culinary workers union in San Francisco in 1988, and **Edythe Boone,** who painted in Harlem before coming West, in addition to several men. Wallspeak's challenge is to build an ongoing community-based mural tradition in Oakland's poor communities, and women have taken the lead in its development and administration.

Jane Norling painted portable murals on connected 8 x 4 foot masonite panels for the 1979 Chicano Moratorium, others for a show at the Galeria de la Raza in San Francisco (with Bergman and others) and a senior citizens' center in Watsonville, and helped in painting *New Visions for Disabled People*, directed by **Susan Greene** with a group of developmentally disadvantaged adults. Greene also painted a multicultural group of portraits of revolutionary leaders for the Socialist Bookstore in the Mission District. All of these projects indicate a continuing focus on political issues in various forms, but the project in San Francisco, which perhaps best embodies the political strain from earlier murals, was executed in 1985 in Balmy Alley.

Originated by muralist Ray Patlan, the Balmy Alley project brought together nearly three dozen mural activists to paint 27 new murals in a block-long alleyway in the Latino Mission District. Women worked on 19 of the murals. For example, **Miranda Bergman** worked with O'Brien Thiele on *Culture Contains the Seed of Resistance Which Blossoms into the Flower of Liberation*, showing a group of mothers of "disappeared" men and children in Latin American dictatorships and the richness of indigenous culture in the form of a rainbow streaming out of a guitar. Jane Norling painted *Give Them Guns But Also,Teach Them How to Read*. Nicole Emanuel painted *Indigenous Beauty*, and Brooke Fancher, Susan Cervantes, Patricia Rodriguez and Xochitl Nevel-Guerrero also painted pieces there.

Significantly, Balmy was funded independently, with a small grant from the local Zellerbach Foundation and generous donations by a local paint company (Politec) and the artists themselves. The murals depicted dual themes of opposition to U.S. intervention in Central America and celebration of indigenous cultures. Among the most poignant is Juana Alicia's *Te Oimos Guatemala* [We hear you Guatemala], showing a woman crying out over the body of a murder victim.

Juana Alicia is probably the most prolific and influential muralist in the Bay Area, and her various works represent many of the strains we have noted. Since arriving in the early 1980s she has painted over a dozen major pieces,sometimes alone, sometimes with others. Believing that "the arts world is basically a white male's world, and murals are not an exception," she constantly strives for clarity of expression in her work on significant topics, emphasizing anger, resistance, children, birth, growth and a desire to protect nature. The fact that she paints so prolifically indicates the strength of her vision and her commitment. She is angry at the crimes visited on Latin American countries by the United States, and about how difficult it is sometimes for a woman to go out and work on a public mural. Women "are not easily welcomed on the street. The street can be an alien domain." Yet her passion for her art, for "murals as an excellent opportunity for the artist to have a dialogue with the community about the pressing issues of our time" propels her to work. Continuing her concern for mothers and children, a 1987 work, *Alto al fuego* [Cease fire] shows a young body facing massed rifles against a backdrop of lush Latin American countryside. Between the boy and the rifles are hands (ours?) blocking the weapons. The murals' location in the Latino Mission District locates which war and which people are affected most by the wars there, and who has a responsibility to try to stop them. Alicia makes the point when she says, "Living as a Chicana in an exile community has a strong influence on what is happening with our brothers and sisters in the Third World and the impact of war."

Her 1985 mural *Las Lechugueras* [The Women lettuce workers] shows a pregnant lettuce worker being sprayed with pesticides while on the job—and being watched by employers' stooges. Her concern over the ecological devastation is clear. But in a joint work of 1987 (in collaboration with Susan and Raul Martinez), *New World Tree*, she painted a collective, ideal vision of hope in an architecturally powerful mural showing a healthful, positive future. Alicia's subject range is wide because she sees problems and hope in many areas. "The point is, they're all problems for *all* of us, not just mine because I'm a woman." So she works in all three strains of the mural movement from issue-oriented political, to cultural expression, to spiritual, and in institutions such as schools, hospitals, colleges and cultural centers.

In Northern California outside of the Bay Area women have painted a number of murals, from the Chicano-UFW-oriented walls in Watsonville near San Jose by **Victoria Petrovich** and Luis Espinosa, Juana Alicia's at the local high school, and others in San Jose schools by **Wilma Contreras**, **Lupe Carranza**, and **Carmen Leon**, to **Lorraine Garcia**'s work with the RCAF in Sacramento.

A multipanel project outside of a Fresno migrant labor camp was completed by the Mujeres Muralistas del Valle led by **Irene Perez**, who had worked in San Francisco with the Mujeres Muralistas as early as 1974. These projects share a concern for the history of Latino people in California. However, no ongoing women's mural programs grew from these murals.

Yv Wathen painted a collage of women's images for the entrance to the U.C. Davis Women's Center in 1975, and from 1976 to 1979 **Doris A. Barker** supervised a group of CETA murals in rural, mountainous Nevada County. Thirty painting projects were complete, often depicting local history, all painted by local artists with assistance from youth in the area.

Further north, in Susanville, Lassen County, **Jacquie Danilov** painted a mural about Native Americans and local history, and Native American **Jean Lamarr** painted murals depicting all the different peoples of the communities in the area, including the often-excluded local Indians. Lamarr also did a powerful portable mural for the 1986 mural show at the San Francisco Art Institute, making her one of the few active Native American muralists in the country.

Southern California 1969-77

Similarities between Northern and Southern California women's murals include the politicized origins of the work, the commitment to expressing pride in traditional ethnic cultures and local communities, and the leading role of women in founding and administering community arts organizations.[9] The same general conditions prevailed in Southern California as up North—mass political activity and an active women's liberation movement. But women's mural output has been considerably smaller in the South than in the Bay Area. On the surface it would seem that Los Angeles has a powerful mural tradition via Siqueiros' *America Tropical* and Orozco's *Prometheus* at Pomona College, but *America Tropical* was painted over soon after it was created in the 1930s. Barely visible beneath the whitewash, it was perhaps more of a symbol than an inspiration, and *Prometheus* was located at an elite private college, miles away from where muralists lived. There were some New Deal murals, but none with the impact of, say, Coit Tower, and no women muralists continued to be active in the public arts community. Women in the sixties had to build their tradition from scratch. While men painted murals by the hundreds in L.A., women, facing greater obstacles, painted only a few.

Those that were done were powerful and influential out of proportion to their small numbers. Citywide Murals Program sponsored 150 murals in these

years, but however many women were called, very few ended up as muralists. **Eva Cockcroft** explains why: "Many women tried mural work, but not all of them became muralists. Community mural work, although highly rewarding, requires a certain kind of openness and great dedication. It also demands physical labor, community organizing, going to meetings, and an ability to deal with the great variety of people who come up to talk or make comments."[10]

Women's murals in this period were painted by Chicanas, often on the theme of respect for women. A teenage girls' gang, the Classic Dolls, painted an ancient Coatlique with the gang members standing around it, thus bringing together a consciousness of themselves as women with an ancient Latino tradition. **Norma Montoya** began painting in Estrada Courts housing project at this time, working on several designs among the eighty-odd walls painted there. In a bandshell, Judith Baca painted *Mi Abuelita* [My grandmother] designed so that the grandmother's arms reach out along the interior sides of the concavity. Baca's work with the White Fence Gang in East Los Angeles, *Medusa Head*, and her work with women prisoners at the California Institute for Women at Frontera indicate her ability to work with different sorts of groups under widely varying circumstances. In 1974 she became the head of Citywide Murals Program and thereby set a precedent for the state, of a woman running a major community arts program, and for herself learned how to organize big projects and complex organizations. Citywide produced 150 murals under Baca's direction, but the dangers of being funded from a single, municipal source became readily apparent when she left and funding was cut back, thereby reducing the number of new community murals in Los Angeles, which were very much tied to it.

Southern California 1977-84

Outside of Los Angeles women in the South have painted few murals. In rural areas or smaller towns the lack of support (and resources) makes such endeavors prohibitively difficult. But in San Diego's Chicano Park, women painted two early murals, in 1974 (**Charlotte Terry**) and in 1975 (*To Women*, painted by RCAF women from Sacramento, Lorraine Garcia, **Celica Rodriguez**, and **Irma Lerma** in 1975).[11] **Antonia Perez** and **Yolanda Lopez** worked on the exterior murals of the Centro Cultural de la Raza in Balboa Park around this time, but, as Lopez says, "women are not as visible in San Diego as in other parts of the state, partly because of acculturation, lack of money and resources, and male antipathy." It was not until the 1977 "Muralthon" that Chicano Park became

open to new artists who had not been a part of the early struggles to establish the park (founded in 1973 in a highly militant fight).

In 1977 a group of high school girls, the Mujeres Muralistas de San Diego, inspired by their namesake in San Francisco and helped by Yolanda Lopez, painted *Preserve Our Heritage* and also painted a mural in a local high school. The following year, building on the example of these girls, **Socorro Gamboa** designed *Suenos Serpentinos* for Chicano Park with the Centro Cultural, **Dolores Serano Velez** began a *Horoscope of the Chicano Park Takeover*, and **Susan Yamagata** executed the first of two murals she painted with Michael Schnorr on Latino themes. **Josefina Quesada** has also painted murals in local high schools.

In Los Angeles, Citywide Mural Program funding was reduced through the City's decision in 1977, and further by Proposition 13, passed under the guise of a taxpayer's revolt in 1978. Funding for Citywide Murals stopped by 1983, but, as with muralists in the Bay Area, the reduced funding was only one of a number of elements contributing to a decrease in mural activity. **Glenna Boltuch** took over Citywide in 1977 when Baca left, and faced from the outset more difficulties trying to protect funding than providing encouragement to produce community-based murals. As with the CETA sponsored murals in San Francisco at the same time, there were increasing pressures to tone down imagery, partly because of less overt political activism generally, and also due to reduced funding and increasing bureaucratization (which meant more pressure not to offend and thus less opportunity to express strong ideas).

In this period Judith Baca founded the Social and Public Art Resource Center (SPARC) in Venice and continued work on *The Great Wall of Los Angeles*, begun in 1976. Glenna Boltuch, **Yrene Cervantez** and **Margaret Garcia** contributed importantly through their work with youth and in institutions such as schools and community centers. The City of Angels saw a brief flurry of mural activity for its bicentennial in 1981 and again for the Olympics in 1984, and a significant output form **Ann Thierman** and **Jane Golden** in the Westside area. Finally, in the late 1980s, Baca, Garcia and Carrasco began moving beyond the borders of California, yet retaining their base in Los Angeles.

The Great Wall of Los Angeles has become one of the major mural projects in the world since its first section was painted under Judith Baca's direction in the summer of 1976. The conception was to paint a history of California emphasizing the contributions of working people, people of color and women—the groups normally given short attention in conventional histories. The location was the vertical concrete west wall of the Tujunga Wash, a flood control canal that cuts through the San Fernando Valley. The first section, 1000 feet long, covers

from prehistoric times to the 1920s in Los Angeles. Two years later, the entire summer was devoted to painting a section on the twenties; in 1980 the thirties, in 1981 the forties, in 1983 the fifties. By 1988, it was over half a mile long, making it probably the longest mural in the world, "a tattoo on the scar of the Wash," says Baca. The sixties and seventies are planned for execution in the summers of 1990 and 1991.

Originally, Baca tried to direct the entire project herself, but soon found the conception demanded a much more complex organization. The key to it was twofold. On the one hand, the actual painting and preparation was done by groups of teenagers from several parts of the city, and Baca found that they needed much more than a simple summer job. Some were functionally illiterate, and so needed to be taught such basic skills as use of a ruler, not to mention the significance of their history and of its exclusion from most of their educations. Also, the wash was an oven, often reaching temperatures of 120 degrees. The second aspect was the artwork. Baca realized that a carefully composed team could accomplish more than any single person, so she set up lectures and theme-planning sessions with historians during the winter and spring preceding the summer painting. Enlisting help from others, she was thus able to give direction to the project, work out the final designs, and include much greater numbers of youth than she could alone. The sophistication of the design and painting increased greatly when this process began with the panel on the thirties. *The Great Wall* has involved hundreds of L.A. youth, some of whom have returned in later years to be team leaders and codesigners.

The scale and organizational complexity of Baca's work, however, is exceptional. Most women's mural projects have been more "traditional," in the sense of consisting of one or two muralists working alone or with a small group of assistants, mostly local youth, on a one-shot mural. To some extent, the shift in the work of **Judith Hernandez** typifies the thematic and organizational emphasis of the majority of these murals painted since the mid-seventies. In 1976 she painted a mural in Ramona Gardens Housing Project whose legend reads (in English and Spanish) "Since the days of ancient history of Mexico our women have always fought for the good of their family, their country, and their people—This mural is dedicated to them, the daughters the mothers and the grandmothers of Aztlan." The murals' images show a large woman in the background, before whom are arrayed flowers, an ancient idol, a Virgin of Guadalupe, seamstresses and striking UFW members. This mural embodies several of the most influential elements in Latino struggles in the United States, including the par-

ticipation of women. It is a strong piece, communicating the strength both of the struggles it commemorates and of the muralist.

In 1981 Los Angeles celebrated its bicentennial, and Hernandez and others painted murals for the occasion. A glance at them suggests the shift in murals since the early seventies. Hernandez' mural is titled *Remembrances of Yesterday—Dreams of Tomorrow*, and shows the Queen of the Angels, after whom Los Angeles is named, above a scene showing a mission, farmlands, palm trees, City Hall, and two campesinos. The only sign of the future is a male Olympian bearing a torch. The political shift from the earlier Ramona Gardens mural is striking. It has the aura of officially sanctioned artwork. In contrast to this pasteurized imagery is the mural painted for the Community Redevelopment Agency by **Barbara Carrasco**. Her 16 x 80 foot mural of the *History of Los Angeles* shows it intertwined as scenes in the flowing hair of a woman. It sparked a prolonged censorship effort by the Agency, which objected to such scenes as the internment of Japanese-American citizens during World War II and a detail from *America Tropical*, the last black slave in Los Angeles in the 1880s. Officials who found portions of the city's history offensive objected, and Carrasco felt even more isolated by the refusal of several muralists to get publicly involved lest their association with the project jeopardize their own future commissions, even though some of the muralists had actually helped paint the piece. It was never mounted as originally intended.

Carrasco began mural work by helping established muralists Carlos Almaraz and John Valadez. Her commitment to progressive politics, combined with her respect for Latino figures such as David Alfaro Siqueiros (as a model of the artist who committed his skills to political causes) and Dolores Huerta, a Chicana organizer of the UFW, led her to paint mural-sized banners for UFW marches and demonstrations. The need for clear graphic features in these projects led to the development of her flat, stylized style which continues in her own mural work. Carrasco, like Baca and others, is concerned with the exclusion of people of color from official histories and these concerns find their way into her mural work.

At that time, the late 1970s, murals were painted in the Crenshaw area by **Suzanne Jackson** and by **Vernette Holloway**, both fine artists who later sought to earn their living through their artwork in galleries. They are two rare examples of black women painting in L.A., although Glenna Boltuch, a white woman, painted portraits of black entertainers with local youth at the Watts Tower Art Center in 1979, and several women have worked with racially mixed groups and painted multiracial images.

It was also during these years that women interested in painting murals turned to CAC and CETA grants to support mural work with local youth and/or at schools. On the East side, Boltuch, Yrene Cervantez and Margaret Garcia are representative. Glenna Boltuch's contribution to Los Angeles murals has been significant both because of her directorship of the Citywide Murals Program from 1977 to 1981 and because of her own mural work. Under her guidance, over 100 murals were painted throughout the city. Her own murals have been done with children, each with a design relating to a cultural characteristic of the particular group, such as their ancestry. But in Los Angeles, as elsewhere, such admirable and apparently inoffensive desires can be fraught with difficulties. For example, in 1984 she directed *The Buddha Sakayamuni and Asian Art* in Chinatown with fifth and sixth graders. Although Boltuch's palette is heavily influenced by the California sunlight and Latino art and the children wanted bright colors, the school authorities did not want the mural "to look Mexican." The colors were toned down and the children disappointed, and the opportunity to integrate art styles and cultures was missed.

Boltuch was selected as one of two women (out of ten muralists) to paint a mural in honor of the 1984 Olympics. She executed a delightful line of children jumping, running, hopping along a long wall leading to a freeway exit ramp, the children's actions creating a flowing rhythm for the fast-moving drivers' eyes to glimpse. Baca's Olympic mural, titled *Hitting The Wall*, provides an obvious pun on women painting wall murals and on reaching that point of exhaustion in long-distance exercise where the body runs out of the necessary blood sugar to keep it going. Baca's image portrays a woman breaking the finish tape, winning the race in spite of the wall.

Yrene Cervantez began her mural work in a CETA program in Long Beach, but has produced a steady output since then in Los Angeles proper, working with youth of the specific area where the mural is located. For her, "youth is a focus" and by working with them "you can have a real influence on a community, but you must be willing to be influenced, too." Yet Cervantez has confronted censorial bureaucracies time and again. Official bodies, sanctioned by the City, demand that artists be inoffensive, and since nearly anything issue-oriented is going to offend somebody, it is almost impossible to use politically progressive symbols. Her challenge is to break down the divisions such social separations encourage by integrating spiritual, political, cultural and personal in her work, "each in its respective strength, not watered down." What happens in practice is that Cervantez (whose predicament is shared by others) wants to work with local residents or youth to develop appropriate culturally based imagery for a project.

But with increasing time constraints by funding organizations, which seem to be looking for "cost efficient" murals, more and more is demanded of the artist, and that means less and less involvement by the community, less opportunity to introduce new ideas or teach youth painting techniques.

Margaret Garcia's first mural, *The Whales*, was painted with Randy Geraldi in Santa Monica in 1978, and in it one can see the rudiments of her bold, painterly style, "where paint looks like paint," she says. Thereafter she painted a series of murals at schools and with youth, including the Echo Park swimming pool with Yrene Cervantez. Working in Los Angeles helps, because, like other women artists, she finds people there "more open" than, for example, in Chicago, where she lived for a time. "Here they are more tolerant of each other," and that contributes to her own sense of self and power as expressed in her work. But "the system" perceives things differently, she notes. She was disturbed that in the Echo Park Pool project the "kids were upset when they didn't get to do their own art because of the need for a conservative City Council to approve the design." In 1984 she painted *Silent World*, about the hearing impaired, and had hoped, because of the importance of any community to define itself, to train a deaf artist. Perhaps that hope will be realized in the future, but in the meantime she has followed her belief that "the most important thing is to make a statement on something close to your heart."

Not far from Garcia's *Whales*, further west and almost at the beach, is *John Muir Woods* painted by Jane Golden in 1979. Golden's vision of murals is unusual, and, while she is insistent upon the importance of working with the community of people that lives with the mural, the area lacks the ethnic- and class-oriented daily struggles so imperative in the east side of town, and that makes a difference in the images painted. Working in the relatively affluent Santa Monica-Venice neighborhoods, her work seeks to "fight urbanity with wilderness," and Golden sees "art as a window you are looking out of at something you don't have. Murals can be a mystery, a beauty, an illusion into the city." Los Angeles is so new, she feels, that it seems rootless, and has a lack of reality compared with the East, where she comes from. These walls engage with their communities because their process involves nearby residents, and by implication are political in their implicit criticism of the status quo—if things were so good, we wouldn't be charmed by pictures of somewhere else.

Her first mural, *Ocean Park Pier* painted in 1976, memorializes the recently destroyed Ocean Park amusement pier. "It was wonderful to do something with meaning and impact" for the people who live near the mural, she says. That mural and another, *Hester Street*, are romanticized versions of a bygone time,

appreciated and supported by the nearby residents. In 1981-83, at the Ocean Boulevard underpass in Ocean Park, her last California mural provided a special experience. The support of the community (in the form of hundreds of signatures on petitions), the active involvement of several people in the design process, and the actual painting with youth working for a foundation she had established to help young people on parole—all these did not forestall a campaign of deface-ment perpetrated by three men who wanted a friend of theirs to paint the wall facing Golden's on the other side of the street. After the City of Santa Monica failed to offer serious support for her, she acceded to their demands and the friend of the three men did paint one side of the underpass, leaving Golden richer for the experience. She has since moved to Philadelphia, where she is in charge of an anti-graffiti network which has painted more than 600 murals since 1984. She feels the Santa Monica experience helped prepare her for the Philadelphia job by teaching her how to work with the community and how to withstand those who would destroy it for their own purposes.

Ann Thierman also worked on the west side, but her murals stress social engagement, albeit of a particularly nurturing sort. Thierman is trained as a clas-sical musician and painter, with much emphasis on figurative work, and has an activist Unitarian-Quaker background. The combination motivates all her murals in that they all try to create peaceful images showing people caring for each other. She started to paint murals in New York, inspired by both the massing of figures in Rivera and Siqueiros and by the light effects in Caravaggio. She came to California in 1976, and her first work in the state was *Nurturance*, painted in Venice in 1977. In 1979-80 she completed five murals on such themes as *Windows on Alcoholism*, *Meals for Millions*, and histories of Unitarianism and of Santa Monica for Lincoln Park seniors. Thierman actively looked for groups to work with, feeling that "it's kind of like being an accompanist for the com-munity" to paint murals.

Her largest work has been the 1982, 300-foot-long *History of the Pico Neighborhood* done with neighborhood kids, although she developed the design herself. This mural is typical of her approach. It celebrates the cultural diversity of Los Angeles, was done in the excellent Southern California climate, is the product of a complex organization, and has a sharp political point to those who study it. A common experience in Los Angeles is that freeways cut across neighborhoods, especially poor neighborhoods, separating people. This mural shows neighborhood residents reaching across the freeway—again touching, reaching out—to reconnect their lives; something she hopes the mural accom-plishes as well as shows.

As the eighties draw to a close, Boltuch, Cervantez and Garcia continue actively working with youth of various ages in institutions, and Baca continues with *The Great Wall*. Besides these efforts, however, mural activity in the Southland is low. Still, Carrasco, Garcia and Baca have all begun to move beyond California, in fact, beyond the United States to foreign or multi-national projects. Carrasco painted two murals in the Soviet Union, in Yervain, Armenia, with muralists from the East Coast and from the U.S.S.R. In 1986 she painted in Managua with Yrene Cervantez, Kathy Gallegos, Carlos Callejo and Francisco Letelier. In 1988, Garcia completed a project with Los Angeles Youth in a Soviet-American youth project for an Outward Bound program about the problem of cultural isolation. Upon completion, the mural was sent to the U.S.S.R. Judith Baca continues work on the Worldwall, a portable, seven-panel mural that will be shipped inside the aluminum support structures on which the mural is to be mounted in other countries, where muralists from those countries will contribute additional panels to Baca's vision of a world at peace.

Conclusion

In general, all of the types of women's community murals in California are becoming more sophisticated artistically and conceptually as artists look beyond previous confines literally in their trips outside the state and figuratively as they explore new ways of thinking about their project. At its heart, the mural movement is still politically engaged with the community of people surrounding the images, and the metaphor suggested by many women is fundamental: in process and content these murals are about making a family, an inclusive experience. In their originality, sensitivity and strength they are, as Judith Baca notes, a variety of feminist performance art, embodying "always a dream of better possibilities, creating a vision of hope, but also facing what is."

—Timothy W. Drescher

Notes

1. All quotations are from interviews conducted with California women muralists in the summer of 1988 unless otherwise noted.

2. Indeed, Judith Baca felt it necessary to write *Woman's Manual: How to Assemble Scaffolding* in the early days of the Citywide Mural Program. Cited in Shifra M. Goldman and Tomas Ybarra-Frausto, *Arte Chicano* (Berkeley: Chicano Studies Library Publications Unit, 1985), p. 43.

3. It should be noted that women often work in teams with male muralists, and that the extensive work of male muralists is highly important to the work of women. The mural community as a whole is closely knit, and especially in the Bay Area muralists regularly work on each others'

projects, sometimes formally, sometimes casually as a gesture of support or friendship. The subject of women-men joint projects is worthy of consideration, as is the influence of interaction among the artists, but beyond the scope of this essay.

4. Information on this program is taken from Joan Abrahamson and Sally B. Woodbridge, *The Alvarado School Community Art Program* (San Francisco: The Alvarado School Workshop, Inc., 1973).

5. Eva Cockcroft, "Women in the Community Mural Movement," *Heresies* 1 (January 1977), p. 19.

6. Ibid. Cockcroft notes that this is a hallmark of women's muralism in general.

7. CETA had some very positive aspects, such as providing artists with regular paychecks and the concomitant opportunity to work in communities. It also prohibited its funds from being used for materials, which meant muralists had to develop community support to provide buckets, scaffolding, paints, etc. for projects. This was difficult, but ultimately positive because it meant the projects looked to the communities for significant support. CETA also required attendance at meetings, paperwork, attention to administrative (not to say bureaucratic) details, and, according to some artists, if not harassment, at least strong pressures to conform and not develop politically strong designs. The specter of outright censorship raised its head when it was declared that every design executed with public money or on a public building had to be approved by the Visual Arts Subcommittee of the San Francisco Arts Commission, a group notably unsympathetic to community-based work. To some extent, this also meant having to develop designs before projects began, instead of developing designs as part of the project. One woman muralist reports that a man on the committee once told her to "make that Asian woman's head smaller" with, as she took it, a clearly political reason. The combination of such pressures discouraged several muralists, who simply did not put up with being chided for "not being at the wall from nine to five, like other workers," as if painting community murals were like collecting garbage or working in an office.

But OCD has developed a bureaucratic network of its own, and justifies its support of muralists by having them provide a thick packet of materials in order to be considered for project selection. It also determines the geographical areas in which projects will be selected each year. This means that muralists must on their own time and money do all the organizing, including a final sketch to scale of the design, gathering petitions from community members, letters of support, and so on, before they submit a project for consideration. Designs must be approved by the Visual Arts Subcommittee, too. Thus does control of the community murals pass from artists and communities to bureaucrat with no direct responsibilities to the community. Planning and preparation are done with an eye toward satisfying the bureaucracy, not necessarily the community. Nevertheless, women have painted outstanding OCD-supported murals.

8. See also the work of west-side Los Angeles muralist Jane Golden, who expressed a similar motivation but produced a completely different type of mural.

9. Since community mural painting, unlike studio work, involves enormous amounts of administration, women's roles as leaders of groups, administrators and organizers deserves notice, although it is beyond the scope of this essay. In fact, women have taken the primary roles in the most important community mural organizations in the state, from Judith Baca's at Citywide Murals Program and then at SPARC, to Glenna Boltuch at Citywide, **Veronica Enrique** at San Diego's Centro Cultural de la Raza, and, earlier, **Tomie Caramillo** on the Chicano Park Steering Committee, and several women making up the administrative heart of Sacramento's RCAF.

In the Bay Area, in addition to women leading Precita Eyes, the Haight-Ashbury Muralists and Oakland Wallspeak, Kathie Cinnater (and later **Luz de Leon**) organized and ran San Francisco's Mural Resource Center. Also, during its decade of publishing materials about the worldwide community mural movement, at least half of the editorial group of *Community Murals Magazine* were women. In short, California women muralists, as elsewhere, have accepted and discharged organizational and administrative leadership of the mural movement in addition to contributing their images to the walls and communities.

10. Cockcroft, "Women . . .," p. 15. She is speaking nationally here, not about California only.

11. For information about Chicano Park I am indebted to Eva Cockcroft, "The Story of Chicano Park," unpublished 1982 manuscript, in addition to interviews.

Acknowledgments
I wish to acknowledge the generous cooperation of California's women muralists, and the guidance, support and assistance of Linda Allen and Shifra M. Goldman in the development and writing of this essay.

Jane Norling, *Sistersongs of Liberation*, 1974. Berkeley.

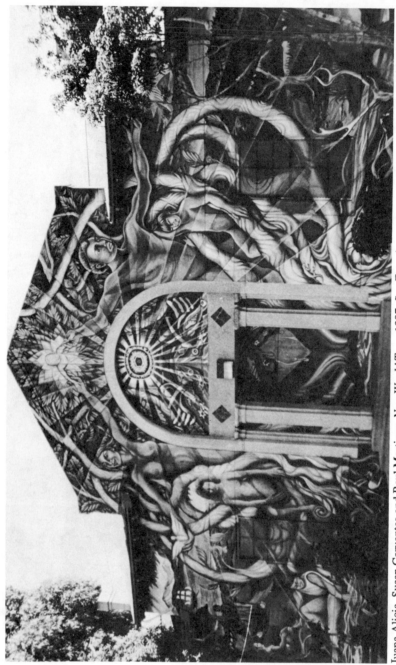

Juana Alicia, Susan Cervantes and Raul Martinez, *New World Tree*, 1987. San Francisco.

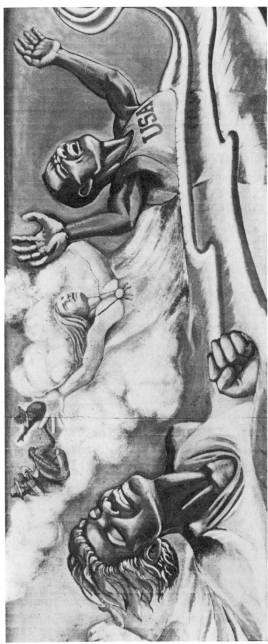

Judith Baca, *Great Wall of Los Angeles* (detail), "Olympic Champions 1948-1964; Breaking Barriers." Los Angeles.

Artists of the California Landscape, 1850-1950

As early as the 1850s, California women landscape painters exhibited regularly in San Francisco. Some won national and international acclaim. Early California women also played a major role in the growth and development of art communities through their participation in art schools, art associations, art colonies and public art exhibitions and through their activities in the promotion of art education. Yet these landscape artists rarely have been seen or acknowledged. It is time to recognize and examine their role from 1850 to 1950 as both educators and painters of the natural landscape.

Early American Landscape Painting

It was Thomas Cole of the 19th century Hudson River school of painters who said, "Go first to nature" (Gussow, 1971, p. 29). Artists took him literally. Albert Bierstadt did magnificent panoramic composites of the western land. Worthington Whittredge traveled 2,000 miles across the western plains "to pursue his studies" and sketched outdoors under a white umbrella. Thomas Moran, on his padded saddle, explored Yellowstone with Hayden's geological expedition of 1871 and painted his *Grand Canyon of the Yellowstone* so convincingly that Congress was moved to set aside Yellowstone as a national park. John James Audubon, in the early 1800s, foresaw the changes resulting from increased population and hastened to document the vivid landscape and wildlife. These artists acted as surveyors, documenters and publicists to communicate to an uninformed eastern audience the wonders of the West and the opportunities there for development and settlement.

Influence of the California Landscape on the Artists

To live in California is to have a preoccupation with the natural landscape. It is almost impossible to be oblivious to it—from the wind-whipped rocky coast washed by northern currents at the Pacific edge of the continent, inland through the fog-nourished coastal forests and hills, across the great agricultural valleys of central California, over the rugged Sierra range, to the arid deserts of the eastern

border. "The California landscape makes a strong impression on its inhabitants," wrote David Rains Wallace (*The Wilder Shore*, 1984, p. 1). "It is a strong landscape, a rugged assemblage of sedimentary and igneous rocks pushed up from the sea by tectonic movements of the earth's crust, and covered with some of the most striking flora and fauna on earth." Californians cannot forget their closeness to nature, especially since they are buffeted seasonally by drought, flood, earthquakes, freezing fog or baking sun.

This landscape has made a strong impression on its artists and resulted in light-filled paintings with sharp contrasts, vast spaces and brilliant colors. Artists respond to the variety and beauty of the landscape in many ways, whether realistically, surrealistically, abstractly or playfully. The ethnic mix of peoples, ideas, events, religious and social attitudes, as well as the landscape, have all influenced California's unique and individual landscape art form.

In southern California before 1920, only a few artists were painting the sunny coast, rolling hills, eucalyptus trees and southern Sierra. Some painters were influenced by a California version of Impressionism. The colors most representative of Los Angeles painters are white, blue and yellow, and the art in general is "clean, intellectually clear, high-colored, light-filled" (Hopkins, 1981, p. 10).

The natural setting of San Francisco with its cold coast, bay, green or golden hills and forested ridges of the Peninsula influenced painters toward richer, denser colors of silver, gray and green. Interestingly, the paintings of artists moving from South to North or vice versa changed with their new landscape, but in both areas, the paintings always expressed the ambience of light (Hopkins, pp. 10,12).

Because of this diverse geography, it is an oversimplification to categorize the artists within two areas—northern and southern California. The northern area included artists from the San Francisco to Monterey Bay areas; the southern from Los Angeles to Laguna Beach and San Diego. San Francisco and then Los Angeles developed as the major art centers of the state. At first, California's art life centered mostly in San Francisco, but that changed around the turn of the century as Los Angeles grew from 102,000 to 1,750,000 in population. Now the undefined limits of Los Angeles are home to nearly three million people, while some 600 thousand residents live within the San Francisco peninsula. Educators and artists, art schools, museums and art galleries clustered around these two centers and the patronage of landscape painters developed in both areas.

California Landscape Painting

Until the 19th century, the California landscape had never been painted. Foreign explorers of the Pacific Coast in the early 1800s brought artists to record their discoveries of prominent and interesting sites both along the coast and inland. Government surveys enlisted artists to record the geology and geography, vegetation and inhabitants of this westernmost region. But there were no female Audubons, women explorers, nor women artists on government survey teams. Social restrictions prevented women from traveling alone in the wilderness or with expeditions recording, as did Thomas Moran, the landscapes of the California Sierra and the Grand Canyons of the Yellowstone and the Colorado. Landscape in the 19th century was a male concern, and men did not encourage women's participation. Exploration, building the railroad and recording these events by writing, photographing and painting on site was, as late as 1860, men's work. Although women were hardy and strong, custom dictated that they travel west in wagons with their families. Most left little record in sketches or paintings of the land they saw. Their narrative was found, not in military reports or governmental communications, but in letters, diaries, cook books, crafts, songs and stitcheries and on tombstones. Perhaps the hardships of frontier life required all the attention, energy and endurance of these pioneer women. Many did not survive disease and frequent childbirth. On the average they failed to live to their 40th year (Kovinick, 1976, p. ix).

Yet there were women painters working. When gold lured covered wagons west, women were among the early settlers in California, and by the closing of the frontier in 1890 there were more than 1,100 women artists and art teachers active in the west (Kovinick, 1976, p. x). Although many of the paintings of these early artists remain more as historical documents than as works of art, they represent the beginnings of a California visual heritage.

Since the arrival over a hundred years ago of **Mary Park Seavey Benton**, an educator and one of the "first ladies of painting," the California frontier has matured into many cultural communities supported by a wealth of talent. Other early women concerned with the California landscape included **Mary Hallock Foote** (1847-1938), whose engravings and essays on western life were published in national periodicals; **Constance Gordon-Cummings** (1837-1924) who painted the Yosemite Valley and the Sequoia redwoods and **Eliza Barchus** (1857-1959), whose penchant for mountains resulted in a painting of Mt Shasta. Mary Benton, however, was one of the first women art educators of the state when she became a drawing teacher in the San Francisco schools.

The Educators and Landscape Painters of Northern California

Mary Park Seavey Benton (1815-1910). In 1855 Mary Benton came to California to join her husband, Reverend John Elliott Benton. She was one of the first known women artists and art teachers to arrive. Born in Boston, she enrolled at age eight in a drawing school. Throughout her life she painted and taught art. Mary Benton helped finance their home in Mission Valley by giving drawing lessons and for many years directed the teaching of drawing in the San Francisco public schools. Her students exhibited their work along with her portraits and landscapes at the annual California State Agricultural Society Fairs and the San Francisco Mechanics' Institute Fairs. In 1867 the family moved to Oakland, where Benton taught drawing at the City Female Seminary. Among her works are views of Yosemite (*Nevada Falls, Yosemite Valley*, c. 1850-1860) and the San Francisco area (*Mission Valley*, 1857).

Helen Tanner Brodt (1838-1908). Helen Tanner was born in New York. After her marriage to A.W. Brodt in 1861 she moved to California. She explored northern California mountains and was one of the first women to climb Mount Lassen. Lake Helen near the summit was named after her. Helen Brodt's residences included Berkeley and Red Bluff. She worked in oils and pastels, doing buildings (the Carmel and San Juan Bautista missions), ranch scenes, still lifes, portraits and animals, along with landscapes. Arthur Mathews, later an educator, was among her students when she was supervisor of art for the Oakland public schools between 1875 and 1885.

Calthea Campbell Vivian (1857-1943). Born in Missouri, Calthea Vivian came to California in the 1870s and studied at the Crocker Art School in Sacramento, and later with Arthur Mathews at the California School of Design. She continued study in Paris at the Colorossi Atelier and the Grand Chaumiere, and with Charles Lazar in England. A painter of figures as well as of landscapes—French country scenes, California missions, and the Oregon coast—she worked in bold color with forceful strokes. In between her painting trips Vivian served as both instructor and head of the drawing department at San Jose Normal School. Later, she taught watercolors at the California School of Arts and Crafts in Oakland during 1917,1919 and 1921-1923.

Alice Chittenden (1860-1944). Chittenden came West from her native Brockport, New York. She studied at the California School of Design in San Francisco (now the San Francisco Art Institute). She was a member of the San Francisco Art Association and the Society of Women Artists. Becoming a member of the faculty of the School of Design, she taught still-life drawing and painting from 1897 to 1941. She was one of the first two women to exhibit at the previously all-male Bohemian Club annual art exhibition in 1898. Her work won

awards from the San Francisco Exposition of Art and Industries in 1891 (for flower painting), from the Lewis and Clark Exposition in Portland in 1905, from the Société des Artists Français in 1908, and from the Alaska-Yukon Exposition in Seattle in 1919. Though Chittenden was recognized as a portraitist and worked on many commissioned portraits, she also painted florals and landscapes. In order to paint the wildflowers of the West in their natural location, she traveled the foothills, mountains, valleys and deserts for prime examples. Her paintings of native trees were donated to the San Francisco Arboretum.

Mary De Neale Morgan (1868-1948). A native of San Francisco, De Neale Morgan studied at the California School of Design, and later with William Keith and William Merritt Chase. Known as the "Dean of Women Painters," she worked in oil and watercolor—painting the cypresses, sand dunes and old adobe landscapes of the Monterey-Carmel area. Her work displayed a fresh, vigorous, Impressionistic style. She established two studios—one in Oakland and one in Carmel, but later moved permanently to the small coastal town and became involved with the community. For many years she directed the Carmel Summer School of Art. A member of the National Association of Women Painters and Sculptors and the California Watercolor Society, she continued to exhibit actively in California, New York, Washington D. C., Baltimore and Cincinnati.

Geneve Sargeant (1868-1957). Born in San Francisco, Sargeant had a well-rounded education in painting with studies at the Chicago Art Institute, the New York Art Students League, the California School of Design, and with Lhote and Friesz in Paris. Sargeant was active in San Francisco, New York and Paris painting landscapes and figures, as well as genre scenes, portraits and still life. She was an original member of the San Francisco Art Association and painted many landscapes of the San Francisco Bay Area and the San Fernando Valley. She taught at the San Francisco Art Institute (1931-1932) and was on their Board of Directors for some years.

Gertrude Partington Albright (1883-1959). Gertrude Partington migrated to California from Heasham, England, where she was first taught by her artist-father, John Partington. She was one of seven artistic children who all became active in some field of the arts. Her studies took her to Paris, Madrid and The Netherlands. Working as an illustrator for the *San Francisco Examiner* paid for her trips. Albright taught painting, still life and composition at the California School of Fine Arts from 1917 to 1940. Her creativeness combined with her energy and drive made her a good teacher. Working in etching and oils, she did landscapes, portraits and genre scenes. Weekend trips around San Francisco and summer sketching trips to Shasta and Sonoma Counties resulted in many

sketches and paintings of those landscapes. A charter member of the California Society of Etchers, she is well known for her etchings. Albright exhibited in Paris, at the Carnegie International in Pittsburgh, Corcoran Gallery in Washington, DC, the Pennsylvania Academy of the Fine Arts and the Boston Art Club. A member of the San Francisco Art Association and a continual exhibitor, she won a medal at the Panama-Pacific International Exposition in San Francisco in 1915. As a director of the San Francisco Society of Women Artists, she helped further the work of women artists and through her interest in promoting art in the Bay Area, served on many art juries. Her work is represented in the San Francisco De Young Museum, at Mills College and in many private collections.

Isabelle Percy West (1882-1976). The daughter of a San Francisco architect, Isabelle Percy grew up in Alameda as one of the liberated women of those early times. She studied at the Mark Hopkins Institute of Art in San Francisco (originally the California School of Design), with Dow and Snell in New York, and with Brangwyn and Robinson in London. After obtaining her MA in Comparative Arts from Columbia University she, along with Perham Nahl and Frederick Meyer in San Francisco, became founders of the California College of Arts and Crafts in Oakland. For many years she was Professor of Design there. She designed book plates and worked in oil, pastel, watercolor and color lithography, and in 1915 won a bronze medal for her lithography at the Panama-Pacific International Exposition. Percy built her own house in Sausalito and in 1916 married George West, a newspaperman. She was a member of the San Francisco Art Association, the California Sketch Club and the California Society of Etchers. Her work was exhibited in Paris, Germany, New York, Philadelphia and Chicago, in addition to the Panama-Pacific International Exposition in San Francisco.

Constance Macky (1883-1961). Born of Scottish ancestry in Melbourne, Australia, young Constance Jenkins was encouraged to draw and paint and began to study art seriously at 15. She studied at the National Gallery School of Painting in Melbourne, winning yearly scholarships, including some years of study at the Academy Julien in Paris. In 1912 she married Spencer Macky, and for two decades their large classes in painting and drawing at the San Francisco Art Institute helped to foster early California art. The couple collaborated on decorative panels in the Panama-Pacific International Exposition of 1915 and also exhibited paintings in the Palace of Fine Arts. Constance Macky exhibited with the San Francisco Art Association and the San Francisco Society of Women Artists. Always aware of new trends, methods and media, she was considered one of the most constructive art teachers of her era.

Ruth Armer (1896-1977). Armer was born in San Francisco and studied art at the California School of Fine Arts, at the Art Students League and the New York School of Fine and Applied Arts. Her teachers included Jay Hambridge (dynamic symmetry), Bellows, Miller and Sloan. Growing up in San Francisco, Ruth Armer became a painter of landscapes, musical themes and figures in oils and watercolors. She exhibited at Gumps, the San Francisco Art Association and San Francisco Women Artist Annuals, and at a gallery in New York,as well as in Cincinnati, Cleveland, Los Angeles, Portland and Honolulu. Her work is included in many private collections. She was in two competitive exhibitions at the Metropolitan Museum in New York, was twice invited to show at the Whitney Museum of American Art and was represented in the 1956 Biennial International Exhibition in Sao Paulo, Brazil. A frequent award winner, she claimed to be the "oldest living abstractionist in San Francisco." From 1933 to 1940 she taught drawing, painting, design and children's Saturday classes at the California School of Fine Arts, and for many years served on their Board of Directors. Abstract and low-keyed, her painting is quiet and lyrical in color, full of movement with jagged edged forms sliding into one another. In a Gumps exhibition catalog, she wrote, "What I want to create is a milieu wherein one can flow with bits and pieces of a luminous universe." By 1934 she had done several landscapes, many quite dark and a few with warm autumn foliage. In her last years she made small abstract paintings of "orbs and illusions of vast spaces that fragment into energized squiggles, leaf patterns, and paisleys." Harvey Jones of the Oakland Museum of Art felt that her work represented the "post-Surrealism" of the 30s and 40s, which led to the abstract paintings of the 50s.

Jane Berlandina Howard (1898-1962). Born in Nice, France, Jane Berlandina studied at the Ecole Nationale des Arts Décoratifs and with Raoul Dufy and Naudin. She exhibited in Paris, the Corcoran Gallery of Art in Washington DC, the Museum of Modern Art and the Whitney Museum of American Art in New York, the Art Institute of Chicago, and later at the California Palace of the Legion of Honor, the Galerie Beaux-Arts, and the Society of Women Artists in San Francisco. Working in egg tempera, watercolors and oils, she painted still lifes, portraits, genre and landscapes. Her accomplishments also included murals in Paris, at the Coit Tower in San Francisco in 1934 under the WPA Federal Works Project and at the Golden Gate International Exhibition in 1939. The Coit Tower mural, *Home Life*, was a semi-abstraction in the style of Dufy. At the California School of Fine Arts she lectured in art history.

Euphemia Charlton Fortune (1885-1969). E. Charlton Fortune, as she signed her name, painted and exhibited in San Francisco and the Monterey-

Carmel area when she was not abroad. She studied at the Edinburgh College of Art, Scotland; St. John's Wood School of Art, London; the Mark Hopkins Institute of Art with Arthur Mathews; and at the Art Students League in New York. Though she began by painting portraits, much of her later work consisted of landscape paintings of coastal areas in southern France and the Monterey peninsula. Fortune lived, worked and exhibited for long periods in Europe. Familiar with French painting, she worked in an almost pure form of American Impressionism. Her *Monterey Bay* is an accomplished example of this. From 1912 to 1921 she taught summer classes in Monterey . Her work won silver medals at the 1915 Panama-Pacific International Exposition at San Francisco, and the California-Pacific International Exposition at San Diego. Other exhibitions included the San Francisco Art Association and the Salon de la Société des Artistes Français in Paris. She was recognized internationally for her work, described by critics as "masculine in its strength and directness, feminine in the delicacy of its subtle tonal gradations" (*Impressionism*, 1982, p. 86). According to art historian Richard Boyle, Fortune's style was Post-Impressionist, with its bright palette and broken brushwork. The loose construction of her landscapes was perhaps a forerunner of work by Diebenkorn and other modern California painters. Certainly her paintings had an influence on the Oakland Society of Six, an early Modernist and Fauvist San Francisco Bay Area group.

Lillie May Nicholson (1884-1964). Nicholson grew up on the family ranch near Aromas and graduated from the California State Normal School, San Jose. At first she combined teaching and painting in Honolulu, then in Kyoto, Japan. Back in California, she taught full time in Santa Clara and Oakland and studied summers at the California School of Fine Arts. After studying, traveling and painting in Europe during 1921, she established a studio in Pacific Grove and painted the coastal landscape of the Monterey area. Though influenced by Monet and French Impressionism, she developed her own unique style of loose brushwork and bright, broken color. Her isolation and lack of recognition may have aided her in producing such quality work. In 1938, she closed her studio permanently to move to Oakland and train as an Aircraft Engine Mechanic at the Alameda Naval Air Station. In the early 1940s, after completing 368 hours of training, she began work inspecting and overhauling aircraft engines—until her retirement at 62 in 1946. Nicholson did not paint again. According to Petteys (1985), she was "frustrated with career limitations of her time, sensitive to the needs of the poor, and dejected because her painterly, expressionist landscapes and social realist painting statements were too bold for California in the 1920s and 1930s" (p. 525). At one time she attempted to destroy her work, but

fortunately was prevented from doing so. In 1979 Walter Nelson-Rees and James Coran became interested in her paintings, and while visiting the family ranch in Aromas, accidentally discovered a large collection of Lillie Mae Nicholson's paintings in an old washhouse. They had been stored for over 40 years in two old trunks. Very little is known of her teaching—she may have taught subjects other than art. She rarely exhibited, although there is a record on the back of paintings of a single work entered in shows at Pacific Grove (1923), the Arizona State Fair (1927) and the Santa Cruz Art League (1928).

Educators and Landscape Painters of Southern California

May and **Frances Gearhart** (1872-1951) (1869-1959). The sisters May and Frances Gearhart were pioneers in the field of color prints. Both used brilliant color—May in her etchings and Frances in her woodblock prints. At times they collaborated on woodcuts. Their color was perhaps influenced by a trip to Mexico, but also by some early motion pictures in which the film frames were hand tinted. The Gearharts held their own exhibition of color prints based on the sets for some of these early films. Frances used both wood and linoleum for her blocks, and completed the entire process herself from sketching and cutting to printing. She exhibits a bold assured, and somewhat decorative use of line and texture in her overall print designs. Except for a brief period of study in the East, she was essentially self-taught in woodcut. She also painted in watercolor,, but did not exhibit these. Her Pasadena home and studio was a meeting place for the Print Makers Society of California and an exhibit place for her work and for other artists of the color woodblock print. Frances gave up teaching English history in the Los Angeles high schools to make prints of the California coast, mountains, forests and inland valleys. Some of these prints are now in museums throughout the United States, including the Library of Congress, Smithsonian Institution, Art Institute of Chicago, Los Angeles Museum and Sacramento State Library.

May Gearhart managed to combine printmaking with her duties as a superintendent of art—first in the Oakland public schools (1900-1903), then in the Los Angeles school system (1903-1939). She studied art at the Art Institute of Chicago, with Arthur Dow in Massachusetts, at the California School of Fine Arts, the University of California at Berkeley and Columbia University. She exhibited frequently from 1911—quite often in joint exhibitions with her sister—in Washington DC, and in Los Angeles at the California Printmakers Society and the Los Angeles Museum.

Donna Norine Schuster (1883-1953). As the daughter of a Milwaukee cigar manufacturer, Donna Schuster had the resources to study with America's best painters of the Impressionist style. After training and graduating with honors from the Chicago Art Institute, she moved to Boston and studied with Edmund Tarbell and Frank Benson at the Boston Museum School. Later, she joined a painting tour of Belgium led by William Merritt Chase. As a result, her work was strongly influenced by the Boston School and Monet's Impressionism—as tempered by Chase. Moving to California, she studied again with Chase during his last summer class in Carmel. Schuster won a silver medal for watercolors at the San Francisco Panama-Pacific International Exposition in 1915, and another for watercolors at the Panama-California International Exposition in San Diego that same year. An active exhibitor, both locally in California and nationally, she won a gold medal in the Minnesota State Art Exhibition, and had both solo and joint exhibitions at the Los Angeles Museum, and in Wisconsin, Phoenix, Arizona, and at the Laguna Beach Art Association. Schuster settled in Los Angeles and taught at the Otis Art Institute. She also helped organize several artists' groups: The California Watercolor Society, and a group which later became Women Painters of the West. In summers, when she moved to her small home in Laguna Beach to paint, she helped establish the Laguna Beach Art Association. Working in both watercolors and oils, she used varying subject matter and styles—from a Monet lily pond to more flattened Art Nouveau scenes. Her interest in the color, light and atmosphere of Impressionism also embraced the simplified forms of Cezanne. Her free use of color and her openness to new ideas was untraditional. Later study with Stanton McDonald-Wright influenced her to use a hotter palette. She was interested in Cubism and in later years was aware of Abstract Expressionism. Her paintings recorded many areas of the Southern California landscape before it expanded into the congested metropolis of today.

Anna Althea Hills (1882-1930). Like many other young women aspiring to art, Anna Hills, who grew up in Olivet, Michigan, studied at the Chicago Art Institute. She continued her studies at Cooper Union in New York, and later with Arthur Dow. After teaching for two years, she pursued further studies at the Academy Julien in Paris, and stayed on to travel and paint in France, Holland and England. Back in the United States, she settled in Laguna Beach in 1912 and became active in the founding and developing of the Laguna Beach Art Association. An active member of that community, she worked to protect the beauty of the ambient environment. Her own work as painter and teacher of private students did not keep her from working to promote a better

understanding and appreciation of art in the community. She lectured for the
P.T.A. and other groups and organized circulating art exhibits for the schools of
her county. Her painting in Europe, realistic in manner and in the "brown soup"
color mode, was influenced by the traditional academic work of Dutch genre.
The California sunshine and open countryside, however, converted her to a
plein-air landscape painter of mountains, coast and desert spaces. Despite a
physical handicap, she traveled to remote areas of the west. Because she was
especially interested in trees and painted them in her light, airy impressionistic
style, she and similar painters were labeled the "Eucalyptus School."

Conclusion

Nineteenth-century artists went into the western wilderness to report on a land-
scape not known. Painters today report about a landscape we risk losing. Despite
increasing blight, women artists continue to paint the natural landscape with as
much sensitivity as their 19th-century counterparts. Their landscape paintings
are a reminder of a California we are apt to forget,of unpolluted skies, clear
cascading streams and standing forests. They express the artists' faith in the
continuity of the natural landscape as subject matter. Alan Gussow wrote,

Only the most hopelessly naive landscape painter could suggest that these paintings are
demanded today, except by a few. . . . [But] these paintings can and do serve an important
function. The natural is becoming an artifact, buried beneath massive demonstrations of
technological capability. These gentle paintings direct us earthward; they remind us of
season, of times of day, of processes outside of human factors. They urge upon us a
balance. They do not suggest a return to rustic simplicity wholly inappropriate to our
times. They are not retreats. These paintings ask only that we value, as the artists who
made them value, efforts to discover harmonies between our own inner state and our
surroundings (*Art Education*, 1970).

The Golden Gate International Exposition at the San Francisco Museum of
Art in 1939 summarized the work of California artists in two exhibits:
"California Art in Retrospect" and "California Art Today." Throughout these
eras (early and contemporary), women artists enriched California's visual
heritage through their work as painters, educators, jurors, newspaper art critics,
gallery owners, museum administrators, collectors and patrons. They were
important in the growth and development of California culture, furthered art
education and contributed greatly to public art exhibitions. Yet, these women
have remained for the most part an anonymous group and their work largely

unacknowledged. It is time to see women as part of the mainstream in California art.

<div align="right">—Heather Anderson</div>

Sources

Albright, T. *Art in the San Francisco Bay Area 1945-1980*. Berkeley, CA: University of California Press, 1985.

Archives of California Art, Oakland, CA, Oakland Museum Art Department.

Baird, J. A., ed. *Directions in Bay Area Painting: A Survey of Three Decades, 1940s to 1960s*. Davis, CA: University of California, Davis Library Associates, 1981.

Baird, J. A. *From Exposition to Exposition: Progressive and Conservative Northern California Painting, 1915-1939*. Sacramento, CA: Crocker Art Museum.

Baird, J. A. *Theodore Wores and the Beginnings of Internationalism in Northern California Painting: 1874-1915*. Davis, CA: University of California, Davis Library Associates, 1978.

Brommer, G. *Landscapes*. Worcester, MA: Davis Publications, 1977.

California, The State of Landscape 1872-1981 (exhibition catalog). Newport Beach, CA: Newport Harbor Art Museum, 1981.

Dawdy, D. *Artists of the American West: A Biographical Dictionary*, 2 vols. Athens, OH: Swallow Press, 1981.

Farrington Jones, N. & R. Early California and Western Art Research (slide reproductions). Ross, CA, 1986.

Gatto, J. *Cities*. Worcester, MA: Davis Publications, 1977.

Gussow, A. *A Sense of Place: The Artist and the American Land*. New York: Friends of the Earth, 1971.

Gussow, A. *Art Education*. (October 1970).

Hailey, G., ed. *California Art Research*. San Francisco: WPA Project 2874, 1937.

Hopkins, H. *Fifty West Coast Artists*. San Francisco: Chronicle Books, 1981.

Hughes, E. *Artists in California 1786-1940*. San Francisco: Hughes Publishing Company, 1986.

Impressionism, The California View (exhibition catalog). Oakland, CA: The Oakland Museum Art Department, 1981.

Kovinick, P. *The Woman Artist in the American West 1860-1960*. Fullerton, CA: Muckenthaler Cultural Center, 1976.

Leopold, A.S. *Wild California*. Berkeley, CA: University of California Press, 1985.

Moure, N. *Dictionary of Art and Artists in Southern California Before 1930*. Los Angeles, privately printed, 1975.

Nelson-Rees, W. *Lillie May Nicholson, 1884-1964: An Artist Rediscovered*. Oakland, CA: WIM, 1981.

Orr-Cahall, C., ed. *The Art of California. Selected Works from the Collection of the Oakland Museum*. The Oakland Museum Art Department, 1984.

Petteys, C. *Dictionary of Women Artists*. Boston: G.K. Hall, 1985.

Rubinstein, C. *American Women Artists: A Complete Chronicle of Women's Contribution to Our Artistic Heritage*. Boston: G. K. Hall, 1982.

Slices of Time: California Landscapes 1860-1880, 1960-1980 (exhibition catalog). Oakland, CA: The Oakland Museum Art Department, 1981.

Starr, K. *Americans and the California Dream 1850-1915* (1973)

Starr, K. *Inventing the Dream: California Through the Progressive Era* (1985).

Stoltenberg, D. *The Artist and the Built Environment*. Worcester, MA: Davis Publications, 1979.

Van Nostrand, J. *The First Hundred Years of Painting in California, 1775-1875*. San Francisco: John Howell Books, 1980.

Wallace, D.R. *The Wilder Shore*. San Francisco: Sierra Club Books, 1984.

Westphal, R. *Plein Air Painters of California, The Southland*. Irvine, CA: Westphal Publishing, 1982.

A Woman's Vision: California Painting into the 20th Century (exhibition catalog). San Francisco, CA: Maxwell Galleries Ltd., November 1983-January 1984.

Frances Gearhart, *Trail In*, color woodcut, c.1915.

Orpha Klinker, *Winter Touches the Desert*, aquatint, 1938. Courtesy of the Annex Galleries.

Jessie Botke, *Carmel Hills*, woodcut, 1930s. Courtesy of the Annex Galleries.

Gene Kloss, *Sierra Stream*, etching, 1929. Courtesy of the Annex Galleries.

Mary Park Seary Beuton,
*Vernal Hills, Yosemite
Valley*, 1850-60. Courtesy
of the Maxwell Gallery,
San Francisco.

Mary DeNeale Morgan, *View Across Bay from Parnassus Heights.*

California Women Artists, 1900-1920

In 1920 **Mabel Alvarez** was an up-and-coming young Los Angeles painter. An article about her in the *Los Angeles Evening Express*, "L.A. Girl Artists Win New Laurels by Display at Exposition Park Gallery," commented, "you never heard of a 'one-woman' exhibition." So the gender issue was alive and kicking even then.[1] Indeed, echoes reverberated up and down the California coast well before that time. The reviewer of **E. Charlton Fortune**'s 1918 solo show at San Francisco's Helgesen Gallery wrote:

This artist, who is most womanly in type, personality and demeanor, has nevertheless a most masculine stroke in her painting. Neither is it an affectation; her brush runs fluently and with deep feeling, but there is a vigor that one seldom finds in the feminine painter, unless acquired or forced.[2]

These anonymous articles do not indicate the gender of the writer. However, Phyllis Ackerman called San Francisco modernist **Anne Bremer**, after the artist's untimely death from leukemia in 1923, "the woman painter with a man's touch."[3] That may have been in reaction to the words of Bremer's devoted cousin and loyal supporter, collector Albert Bender, who wrote, "without being in any sense masculine, her pictures have power . . . that feminine power we feel in our mother, the earth, or in the moon sweeping the wide night."[4] At any rate, Ackerman qualified her statement:

It might be expected that it would be a western woman who would break away from the point of view and the habits of her sex. For in . . . California . . . the conventional assumptions drop away and women cease to be primarily women and become first of all persons, so that when they approach a job they can do it unselfconsciously in a workmanlike spirit.[5]

Oakland Tribune writer Laura Bride Powers bridled against the hanging of a separate women's show, as her 1916 article covering the opening of the Oakland Art Gallery, forerunner of the Oakland Museum, reveals.

Personally, I have small sympathy with an exclusive women's show. There is no sex in art. Nature reveals herself alike to men and women, the same opportunities for study are

available to women, and in this day of grace, the segregation of work seems something of an anachronism. . . .[6]

Few women artists ranked equally with their male counterparts over the first two decades of the century.[7] One who did was sculptor **Julia Bracken Wendt** (1871-1942), who, married to "plein-air" painter William Wendt, came to Los Angeles in 1904. Formerly a student at the Art Institute of Chicago and an assistant to Lorenzo Taft, Wendt earned a sound reputation over the years of her career, winning praise as the "foremost woman sculptor of the west . . . taking her place indisputably among the foremost sculptors of the day, whether men or women."[8]

Wendt, who principally sculpted portraits, fountains and bas-relief medallions in bronze, was not a modernist, but she proclaimed her feminist sensibility in her contribution to the Panama Pacific International Exposition (P.P.I.E.), held in San Francisco in 1915 and in San Diego in 1916. It was an event which gave many California artists their first glimpse of European modernism. Many women won silver and bronze medals, but in San Diego Wendt was again exceptional, carrying off a gold medal.

Wendt executed figures in the Woman's Building typifying "the attributes of woman."[9] According to critic Elizabeth Waggoner, the artist completed the work herself and supervised the installation of the works, raising them to their lofty stations when the workmen despaired at the difficulties. It is this force and executive ability, coupled with profound thoughtfulness and imagination, that give the vital quality to her genius.[10]

To embark on an occupation demanding inordinate physical strain was not then common among women artists. More often they were painters, their subjects usually related to the domestic environment. Flowers, interiors, portraits and genre subjects were typical; paintings of children abound. This was especially true in Southern California, where much of the landscape was still virgin territory, raw, rugged terrain undoubtedly considered off-limits for the female artist, whether travelling on foot, by horse or in a carriage. Most plein-air painters, landscapists whose work reflected the influence of French Impressionism, a departure from the tonalism that typified earlier California landscapes, were men. For some this came about through study in France, but more often by exposure through *The Ten*, the East Coast group which included Childe Hassam, Edward C. Tarbell and Evan Maurer.

One of the first to venture out into the great out-of-doors was **Marion Kavanaugh Wachtel** (1876-1954). Born in Milwaukee, she met her husband, plein-airist Elmer Wachtel, while studying with William Merritt Chase in New

York, the two joining Hudson River School-inspired William Keith later in San Francisco. She abandoned portrait and figure painting to work in landscape after arriving in Los Angeles in 1904. Wachtel favored watercolor, but her spontaneity, which captured a unique sense of light and transparency, also invaded her oils, for a luminosity that was absent from her husband's somber palette. With foreground trees close to the surface, her work responded to Impressionism, with gnarled, knotty trunks lending a mystical touch and thinner branches forming Art Nouveau patterns.

Ohio-born **Anna Althea Hills** (1882-1930), a founder of the Laguna Beach Art Association in 1918, had studied at Paris's Académie Julien as well as the Chicago Art Institute and New York's Cooper Union before coming to Los Angeles in 1912 and settling at Laguna Beach in the next year. Hills also began as a figure painter, but on discovering Laguna's light to be much like that of France, she turned to landscape and marine subjects. Her work acknowledged the dissolving atmosphere of Impressionism, frontally disposed trees patterned in the linear rhythms of Art Nouveau, and an interest in bark, leaves and hillside textures.

Other women affirmed a more independent spirit and personal vision, which eventually looked well beyond Impressionism and Art Nouveau. **Helena Dunlap** and **Henrietta Shore** were two who vigorously undertook a more advanced pursuit of modernism and a willingness to experiment that few male artists dared, even through the second decade of the century.[11]

Dunlap (1876-1955), born in Whittier near Los Angeles, began as a student at the Art Institute of Chicago and then attended the Pennsylvania Academy of Art in Philadelphia, which awarded her a travelling scholarship. A sojourn in Paris gave her the opportunity to study with Raphael Simon and André L'Hôte, and show in Paris Salons, before returning to southern California in 1910 and continuing to experiment with the Post-Impressionism to which she had been exposed.[12]

An artist whose eyes were wide open to contemporary movements, her exhibition history suggests that her commitment to modernism and unwavering lobbying on its behalf were not detrimental to her career. But that wasn't all that aroused the enthusiasm of the *Los Angeles Times* writer who reviewed her first show at the Steckel Gallery in 1911.

. . . remembering the edict of her master that if you can't find a model, you must paint anything in sight, she took a corner of her studio and painted what I think is the most exquisite picture in her entire collection—a thing of light and lovely color, of harmony complete and satisfying. . . . We are left to wonder why she has withheld her excellent

pictures from us so long. . . . We need pictures like hers in Los Angeles, because they are "so different."[13]

Later, commenting on her pure color laid down with broad brushstrokes, the reviewer confided that her work "may make you stare and wonder, [but] it won't offend you . . . in spite of the flamboyant primary colors. Perhaps the neo-impressionists [sic] are not quite so mad and bad as we had supposed."[14] Indeed, the writer found Dunlap's relation to Post-Impressionism a matter of issue, but supported her stance on the grounds that "a work of art is not a copy of nature, but an attempt at putting down what the artist felt about nature."[15]

Dunlap was awarded an exhibition at the Los Angeles Museum of History, Science and Art in April of the same year, and a second in November 1917, when she showed work completed in Taos, New Mexico, during the summer of 1915. Principally a figure painter, her subjects tended to be close to the surface and scaled to nearly the full height of the canvas, the figure participating in the Seurat-like geometric organization. This characterizes 1916 portraits of young girls, one seated in ballet costume in *Waiting her Turn*, another standing on a boardwalk along the beach in *Girl at Newport*, the configuration softened by the flaring, evanescent tutu on the former, and a breeze-swept skirt on the latter.

Dunlap, an eight-year member of the California Art Club and a founder of the Los Angeles Modern Art Society (1916-18), renamed the California Progressive Group in 1919, ceased contributing to the older, conservative organization by submitting a letter to the editor of *Art and Artists*. Protesting against the bias of a jury composed of the same men each year, each time presenting the same view of what is "good and bad art," she advocated a one-year limit for jurors along with other changes to bring about "a benefit to the entire club rather than a few men."[16]

Critic Antony Anderson summarized her letter, informing readers that "she believes that some men (she will not say all) hold such an attitude toward women that when they (the women) stand up for what they believe to be right and just, they are at once accused of being 'troublemakers.'"[17]

Dunlap was a tireless champion of modernism, according to letters from her travels published in the *Los Angeles Times*. Arriving in Paris for a second time in early 1920, she focused on the newest "experiments," finding them "more modern than anything Los Angeles has yet seen."[18]

Vividly descriptive letters revealing her sensitivity to the human condition were mailed from Marseilles, Venice and Port Said, as well as Bombay and Agra, where she arrived in 1921. Her paintings from India were exhibited the following year at Los Angeles' Stendahl Galleries. Later, after visiting the South

Pacific (1923-24), she returned to Paris, where she communicated her impressions of the Exposition des Arts Décoratifs.

The very first thing I did was to see the exposition where everything was a new idea! In fact, only new ideas were accepted! How wonderful to encourage and develop individual talent. If we only had something like that in Los Angeles, how we would grow! . . . If Los Angeles had only welcomed and accepted modern art fifteen years ago, we would be far ahead instead of backward. How is it that the "powers that be" do not realize this—for I have known it for a long time! [19]

Henrietta Shore (1880-1963), a friend of Dunlap's—they visited Mexico together in 1927—was perhaps the boldest and most advanced modernist among woman artists in California before 1920. When she first arrived in Los Angeles from her native Toronto in 1914, her oeuvre was dominated by rosy-cheeked children in portraits and scenes of groups at play. In 1916, however, an abrupt change to flattened forms and suppressed detail in the large-scaled figures issued from a disciplined brush unmistakably affirmed that a rebellion was underway.[20]

Shore was a modernist of special distinction. A sojourn with Ash Can artists Henri, Chase and others at the Art Students League in New York in 1900 exposed her to Impressionism before her study in Europe, principally at the Heatherly School in London, around 1905. The loose, energetic stroke that marks her earliest Los Angeles canvases suggests that Henri's influence overtook all others. Such work won silver medals at the P.P.I.E. in 1915 and again in its San Diego reprise in 1916, but almost immediately afterwards, it gave way to the limited tonalities and simplified planes of the *Violinist* (1916), a starkly light-and-dark composition in which severity is relieved by the linear Art Nouveau patterning of a sleeve. This marked a decisive leap toward the radically reduced, semi-abstract style which would emerge following the *Nude* (1920), itself remarkable for its time. A taboo subject in southern California at the turn of the century, and undoubtedly still questionable at the time of its execution, Shore's rendition was a frankly erotic interpretation that was hardly likely to have been publicly exhibited in southern California. Indeed, that issue may well have contributed to her move to New York that same year, assured of a more hospitable environment and compatible community.[21] Nevertheless, she returned to Los Angeles from 1923 until 1930, when she settled in Carmel.

The rounded anatomical shapes of the *Nude*, pale skin in extreme contrast with a dark Japanese-style hairdo, are echoed by a concentric cloud pattern suggesting a mandala. The seated figure is simply but sensuously rendered, its linear curves reiterated by those of the wrap dropped behind her, intensifying the sensuousness of the configuration. Overtones of mysticism are reflected by the

mandala-like shape which layers this work with cosmic implications. Indeed, this backdrop persists in paintings still to emerge.

Like many West Coast artists then and since, Shore was no doubt sensitive to the Japanese aesthetic; she may also have been aware of Eastern philosophy. With the work beginning in 1920, ideas of universal form, perhaps revealing an interest in Theosophy and intuitions of Jungian archetypes, are suggested by a recurring embryo-like form in images of shells, rocks, petals, clouds and even human anatomy. It offers testimony to inclinations that are corroborated by titles such as *Two Worlds, Life, Trail of Life,* and even more striking examples like *Creation, Source, Growth, Embryo,* and *Unity.*

With papers pertaining to Shore's life and career destroyed, presumably on her commitment to a San Jose mental institution in the late 1950s, a preoccupation with metaphysics remains undocumented, although its presence has been suggested. One writer, Henry Tyrrell, reviewing her exhibition at the Erich Galleries in New York in 1923, commented, "There is something profoundly moving, strangely suggestive of the mystic source of our being and of creation's dawn,"[22] That she may have probed the Freudian psychology that was newly in the air is implied in the words of Raymond Henniker-Heaton, one of Shore's portrait subjects and director of the Worcester Art Museum. Author of the catalogue essay accompanying the Erich show, cited as "fourth dimensional interpretations," he awkwardly attempted to define what he perceived as "subconscious emotionalism."[23]

In the first pictures there is evidence of psychic confusion; the color is feverish and involved. In later ones we observe a greater clarity in conception and a simplification of design and color. We feel a growing power of construction, and although there is more or less adherence to naturalistic form in three dimensions, it is really abstract—the entire character coming much more from within than without.[24]

The same enigmatic seedlike shape—at first swelling, then attenuated—appears in drawings of Düreresque nudes and idiosyncratic portraits of friends and colleagues, among them Orozco, Jean Charlot, and one *Erwin Gautchi, Swiss Dancer* (Shore studied dance in the mid-20s) before an outspreading aura similar to *Nude.* This portrait was executed 1923-27. Curiously, photographer Edward Weston, with whom she became close in dialogue in 1927, and whose work was markedly influenced by her images of rocks and shells, is portrayed by her without a surrounding aura.[25]

Shore's oeuvre was uneven and tended to abrupt changes in style—decoratively patterned scenes of Mexican peasants painted in 1927 hint of the social realism which would invade her murals in the next decade--but hers was a

singular stance for her time, one that marks her as a feminist as well as a visionary. Unfortunately, the relatively small body of work known to be still extant has had limited exposure, denying this artist the prominent place she deserves in American (and Canadian) art history which, some critics have considered, is comparable to that of Georgia O'Keeffe. Indeed, in assessing her work some have suggested that had she enjoyed promotion and support comparable to O'Keeffe's, Shore would have been regarded as the superior of the two.[26] Unlike O'Keeffe, however, Shore's career ended with the 30s, when obscurity and impoverishment clouded her life. She died at 83 in the hospital to which she was committed some five years earlier.

Shore, as well as Dunlap, participated in founding the Los Angeles Modern Art Society, a miniscule group of artists concerned with "artistic freedom." They proclaimed "one basic principle and one only forms the foundation of this society, that of circulating the latest developments of the East and comparing it with the freshest expressions of the West."[27] The Society mounted only two exhibitions, one in 1916, another in 1918, in which both women participated. Renamed the California Progressive Group in 1919, it held another show, but the departure of both women in 1920 left a gap in modernist ranks, one that would have gone unfilled but for the 1919 return to Los Angeles from Paris of Stanton Macdonald-Wright and the arrival from Russia of Boris Deutch.[28]

Other southern California women joined modernist ranks. Cleveland native **Meta Cressey** (1882-1964) was also a member of the Modern Art Society, although she and her husband, Herbert Chester "Bert" Cressey, were somewhat reclusive and, moreover, did not depend on sales of work for income. The couple first met in Spain, where both had followed Robert Henri in 1911 after studying with him in New York.

Arriving in Los Angeles in 1914, Meta Cressey found in Southern California's light good reason to reject the darker tonalities learned from Henri for a brilliant palette, transforming herself into a "California Impressionist." In her hands, a deftly energetic brush translated the verdant outdoors of pepper, banana, guava and avocado trees that covered the Cressey's two-and-a-half-acre garden in Hollywood Hills into luminous patches of color. With small figures of women interspersed in the environment, her canvases recall Bonnard's light-dissolving or reflecting forms.

Milwaukee-born **Donna Schuster** (1883-1953), considered the Southern California artist closest to French Impressionism prior to 1920, was not a member of the Modern Art Society; like Cressey she was a less advanced modernist than Shore and Dunlap.[29] Schuster moved to Los Angeles in 1913 following

study with Tarbell at the Boston Museum of Fine Arts School and with Chase and Frank W. Benson in New York. Both Schuster and Wachtel studied with Benson in Carmel when he taught there in the summer of 1914.

An ardent disciple of Monet, whom she discovered through Chase, Schuster did watercolor studies of the Panama Pacific Exposition under construction, a commission in the fall of 1914, that suggest accord with modernist trends. Her devotion to Impressionism, reflected by strokes dissolved in shimmering light, also marks her oils, flattened images of atomized paint. Schuster, who went on to study with Macdonald-Wright, later turned to Cubism, and before her death, Abstract Expressionism.

As for **Mabel Alvarez**, (1891-1985), born in Hawaii and raised in Los Angeles, she was a member of the California Art Club in 1918, and considered, but declined, an invitation from Shore to join the Modern Art Society.[30] Alvarez won praise as a home-grown artist. Alma May Cook declared as early as 1913,

Gray skies of Paris have never cast their leaden hue on her art, which is as spontaneous as California sunshine and if she has missed anything in not going to gay [Paree] she has more than made up for it in the freshness, the naivette [sic] of her work.[31]

This was on the occasion of Alvarez' completion of a mural decoration "half realist and half idealist and wholly out of the ordinary"[32] for the California bungalow at the P.P.I.E in San Diego in 1916, the same year that dancer Ted Shawn posed for her in her studio.[33] Discovered while still in high school by a noted art teacher, James McBurney, who reported later that "she has her own fund of originality and talent to execute what she conceives,"[34] Alvarez attained a distinguished reputation over her long lifetime, ultimately winning praise in a 1963 *Artforum* review.[35]

In the early decades of the century, and indeed until the 1960s, Los Angeles was little more than an outpost when compared to San Francisco, already established as a cultural center. In San Francisco, women artists were not only greater in number, but enjoyed a stronger voice in the artistic community and were organizing themselves even before the turn of the century. The Sketch Club, an exclusively female alliance, was founded in 1887. As the San Francisco Society of Artists, as it was later known, it merged in 1915 with the San Francisco Art Association, also founded by women, in 1916, bringing about the forerunner of today's San Francisco Museum of Modern Art at the site of the Palace of Fine Arts constructed by the P.P.I.E.

The Sketch Club survived the traumatic upheaval of the San Francisco earthquake and fire in 1906, under the vigorous leadership of painter **Anne Bremer**, elected in 1905, who also guided it over its transition to modernism.

That change was revealed in the 1906 "Women Artist's Exhibition," whose 65 works, predominantly Impressionist-influenced landscapes and portraits, effected a sharp contrast to the flower paintings that characterized the inaugural show 20 years before.

Yet if women emerged as modernists a generation earlier in San Francisco than in Los Angeles, none made the vanguard strides of a Shore or Dunlap, nor, despite their support of modernism, did they proclaim it with Dunlap's vehemence.

British-born **Gertrude Partington Albright** (1883-1959), the daughter of artist and musician J.H.E. Partington, who was as well a contributing editor to the *Manchester Guardian*, moved to San Francisco in 1890. Raised in a family which participated in the San Francisco cultural scene, the arts were part of everyday life in the Partington home. Albright's principal teacher was her father, who opened an art school in 1892 at which she became an assistant., She became an illustrator for the *San Francisco Examiner* when she was barely sixteen. In 1900, she spent six months with the *Philadelphia North American* before travelling to Paris for study, mastering the technique of dry-point under Paul Helleu and returning to California in 1903. She made a second Paris sojourn 1909-1912.

A painter who often worked on mahogany, Albright was best known as an etcher, especially in dry-point. This was the medium of a series of portraits of "beautiful women" commissioned by Rodman Wanamaker, of the Philadelphia department store family, in 1906. She made etchings of P.P.I.E. architecture in 1915, also winning a bronze medal for a portrait in the exhibition. Married to photographer H. Oliver Albright in 1917, she was appointed to the faculty of the California School of Fine Arts in the same year. Albright was lauded by Sheldon Cheney as one of "only three or four real masters of dry-point in the world ." He also predicted that she would be hailed as one of the world's greatest artists in that medium.[36]

Albright's embrace of modernism was not a venturous one by the end of the second decade, although her work was described as "cubistic," in 1918, when she completed landscapes recalling the Cézannesque style of Braque and Picasso and portraits which engaged the use of brilliant primary colors.

Unlike many other women artists in the Bay Area, Albright bypassed the influence of of Arthur Mathews (1860-1945), director of the Mark Hopkins Institute of Art. His towering presence dominated Bay Area style over the turn of the century and continued to mark work by former students well past that time.[37] Founder of the California Decorative Style which fused Art Nouveau and the

Arts and Crafts Movement, his most notable artistic impact was on the student who became his wife, **Lucia Kleinhans Mathews** (1870-1955). Lucia Mathews, who worked separately as well as in collaboration with her husband in the decorative arts, furniture making and painting, married Mathews in 1894. A native San Franciscan who had previously attended Mills College, she studied with Whistler at the Académie Carmen in Paris in 1899, during the couple's two-year sojourn in Europe. Sharing the Mathews studio and workshop beginning in the late 1890s, she joined her husband in articulating the decorative style as the overwhelming aesthetic of the Bay Area.

Following the 1906 earthquake, the couple used their influence for the rebuilding of San Francisco. This was achieved largely through the magazine *Philopolis*,dedicated to ideas for reconstructing the city. Lucia designed vignettes and decorative borders and undertook layout; in collaboration with Arthur, she designed special bindings.

Lucia Mathews' painting acknowledges the influence of her husband with flat, decorative garlands sharing the canvas with figures, but her work tends to be less dependent on Puvis de Chavannes, whose style was especially notable in her husband's work.[38] Executed with a firm brush, it reflects greater restraint and spareness and exudes an atmosphere quite her own. Nevertheless, Lucia Mathews did not effectively depart from the decorative style to venture further into modernism. Other former students, while never fully released from Mathews' influence, reflected more progress. One was Anne Bremer, (1872-1922) a native San Franciscan, and the first California women to have a solo show in a New York gallery.[39] Educated at private schools, she spent a year in Europe at the age of 12. As the cousin of Albert Bender, whose collection became the nucleus of the San Francisco Museum of Art, she found continuous, loyal support. Bender established many memorials in her name, including the Anne Bremer Memorial Library at what is now the California School of Fine Arts.

Bremer was exposed to Impressionism and Post-Impressionism at the Académie Moderne and then with André L'Hôte with whom she studied in Paris around 1901, completing her studies with Mathews and Emil Carlson. A second Paris sojourn, 1910-12, revealed to her the Cubism and Futurism which affected the work that followed. Bremer's Mathews training is reflected especially in her early work, in subjects such as dilapidated houses and old barns and landscapes of Saratoga, San Jose and Monterey. These images later became more abstract as she forsook Mathews' tonalism for clearer, brighter patches of pure hues. Regarded as a leading modernist, that work was admired for its brilliant color and

for the expressiveness of her drawing. A P.P.I.E bronze medallist, she won numerous awards, executed murals at Mt. Zion hospital in San Francisco and decorated the San Jose YWCA. She also taught in her studio, recalled as a salon "where one could meet the artists, the writers, the thinkers, the progressives, the personages of the hour, in friendly informal association,"[40] a statement found among the tributes published by Bender in 1927 together with a collection of her poems, *The Unspoken and Other Poems*, written from the time she was first struck by leukemia in 1920.

Bremer's painting was lauded as early as 1912. A painter of still life, figures, and portraits as well as landscape, she was praised for capturing "the peculiar light of varied California weather, sensitive to both dull and bright effects."[41] Critic Porter Garnett praised her as "the most 'advanced' artist in San Francisco . . . in a style and with a technique that are more modern than the style and technique of any other artists hereabouts. . . ." However, in this review written a year before her death he pronounced her a "conservative Post-Impressionist," adding, "she sees with an eye similar to the eye of Cézanne, but she is unwilling to wear the spectacles of Matisse."[42]

The light of the Monterey Peninsula attracted many artists, including Bremer, especially following the San Francisco earthquake, when many relocated in Carmel. Among former Mathews students attracted to the Peninsula was **E. Charlton Fortune** (1885-1969). Born in Sausalito, Fortune—"Effie" to her friends, for she loathed the name Euphemia—summered there for ten years beginning in 1912, settling permanently in 1927. Over the earlier period she taught landscape painting at the Carmel Summer Art School; it was she who persuaded William Merritt Chase to teach there in 1914.

Encouraged in art by her mother, who accompanied her for much of her extended study/travel, she recalled that her education "was just enough to express my efforts to paint [the] light and movement which have been the chief reasons why I became a landscape painter."[43] Her studies began in Scotland, her father's native country, first at St. Margaret's Convent School in Edinburgh (1897-1903), then at the Edinburgh College of Art. Later, after a year at St. John's Wood School of Art in London, she returned to the Bay Area to attend Mathews' classes before the earthquake prompted her to move, first to Stockton, then to Carmel. In 1907, however, she enrolled at New York's Art Students League under Frank Dumond, Louis Mora and Albert Sterne, while supporting herself as a portrait painter, and returned to Scotland in 1910 before a sojourn in Paris to attend Jules Lefebre's classes at the Académie Julien, viewing the first Futurist exhibition there. Fortune's extended years of study were completed under Chase

at the Art Students League in New York in 1911.[44] On returning to California, she divided her time between Monterey and San Francisco, moved to San Tropez in 1921 for six years then resettled in Monterey.

Called "the Mary Cassatt of American landscape painting," Fortune, a long-time exhibitor at Carmel's Del Monte Hotel Gallery (1907-40), was noted especially for her extraordinary capacity to capture light.[45] Sonia Bryen explained how she achieved this.

She was looking for a free style that would be adaptable to the portrayal of the sparkling sunlight of her native California. She did not find it until she developed her own technique of "broken color" in rich, hasty brush strokes several years later. Like the French Impressionists, Fortune employed rapid brushstrokes and a high-keyed palette. And, she was an artist who recognized the special quality of California light.[46]

Fortune, a confirmed modernist at this time, was an important influence on the next generation of Bay Area artists, among them, members of the Society of Six who emerged in the 1920s.[47] Later, however, with the founding of the Monterey Guild in 1928, she applied her aesthetic energies in another task. Although she did not disavow her earlier direction, as a devout Roman Catholic, her distaste for 1920s church decoration provoked her to dedicate herself to reviving ecclesiastical art.[48] From then on she devoted herself to designing church interiors, undertaking remodeling projects throughout the country. With regard to modernist artists of the third decade, she reflected some disapproval:

I do think the moderns have become a little high-handed and illogical. I can't find in any of their arguments (I mean those of San Francisco) any one clearly defined point of view. They quote a good deal about [sic] those of their own school when they desire to damn everyone else.[49]

Bremer and Fortune were leaders among Bay Area modernists. Other women, like **Mary De Neale Morgan** (1868-1948), a friend of Fortune's, lagged somewhat behind them in reflecting modernism. Addressed as "De Neale," Morgan also signed her work with an initial for her first name.

Morgan studied with Virgil Williams, Emil Carlsen and Amédée Joullin, all of them prominent teachers as well as artists, and worked for six years with Keith at Carmel, which she first visited in 1902, while maintaining an Oakland studio. Her engagement with Impressionism was less notable, but she contributed important documentation of San Francisco's earthquake damage in a series of sketches made at the scene. Following that disaster she resettled in Carmel where she founded the Carmel Club of Arts and Crafts, which inaugu-

rated the Carmel Summer School of Art in 1912. Morgan directed the school for seven years.

Helen Hyde (1868-1919), born in Lima, New York, and raised in San Francisco by her grandparents, came to be removed from the mainstream both aesthetically and geographically. Also a poet and illustrator of children's books, she was a member of the Sketch Club and a developing watercolorist while studying at the California School of Design with Emil Carlsen, but like Albright, Hyde emerged as a printmaker. Working in etching and woodblocks, however, her work responded to a very different tradition than did Albright's.

Hyde first traveled to Holland and Paris for further study. Rejected by the Salon in the latter center, she was prepared to abandon an art career, but on being shown Japanese art at the Musée Guimet by her French teacher, her interest was rekindled. Thus it was that Hyde, who had been affected by the Oriental culture in San Francisco—she had copied Japanese prints as a child, and was inspired by the city's Chinatown—decided to move to Tokyo, remaining there for 15 years. There she worked squatting on the floor of an old temple that served as her studio.

Hyde studied for two years with Kano Tomanobu, the last of the Kano school, and learned to use her brush in the Japanese manner, immersing herself in their tradition. Beginning with color etching, she attained skill at colored wood-block prints, or chromoxylographs. Finding enthusiastic acceptance she was rewarded with an invitation to execute a kakemono for the annual spring exhibition in Tokyo. Sheldon Cheney lauded her skills, describing the process she learned in Japan.

There she has outclassed the natives at their own art of woodcut designing and has introduced a new art in her colored etchings. Her method is to etch her subject [in] outline and print as with an ordinary plate. Then she paints the colors of her design on the surface of the copper and runs the print through the press a second time to take on its tints. In this way she obtains an unusual softness and flatness of tone.[50]

After returning to California, Hyde spent two years in Mexico City, then moved to Chicago until she settled in Pasadena.shortly before her death. She was posthumously applauded for her "unique achievement" in being able to

span the gap between the art of the East and the West and to convert the age-old ritualistic Japanese art of color printing from wood blocks to a medium for expressing vital modern subjects from the glowing life of the Orient today.[51]

Hyde demonstrated her independent spirit by departing from San Francisco for an exotic foreign environment, although she pursued a direction which veered sharply away from modernism.

Those women who remained in the Bay Area, however, tended to play an active role in their art community, winning a level of recognition despite the "segregated" status about which Laura Bride Powers complained. San Francisco, despite its sophistication and modernism, had a too-well-entrenched tradition for its artists to escape. Even Bremer and Fortune, the most advanced women working there, tended to take guarded steps in assimilating Post-Impressionism and the later styles to which they were exposed in Europe in gaining their release from the powerful presence of Arthur Mathews.

In Los Angeles conditions differed. Its aesthetic was not yet firmly rooted, despite prevailing plein-air painting, which was, for the most part, in the hands of male artists. Thus it might seem that a Shore had little to risk in departing so radically from the status quo; a Dunlap's dissent could even find a sounding board in the *Los Angeles Times*.

Little more than a cultural outpost even in the second decade of the twentieth century, Los Angeles offered its women artists less opportunity, as it also took less notice, by and large, of their presence and participation. Nevertheless, with their northern sisters they made a valuable contribution toward creating the foundation on which art could grow and flourish in its evolution toward the stature those centers would attain in the contemporary scene.

—**Merle Schipper**

Notes

1. Anonymous, *Los Angeles Evening Express*, 1920.

2. Undated clipping, *San Francisco Chronicle*, Fortune papers, Oakland Museum, Oakland, California.

3. Phyllis Ackerman, "A Woman's Painter with a Man's Touch," *Arts and Decoration* (Spring 1923), p. 110.

4. Albert Bender text in "Anne Bremer," *California Art Research Monograph*, ed. Gene Haley (San Francisco: Works Progress Administration, 1937), Vol. VII (1922), p. 114.

5. Ackerman, op.cit.

6. Powers, "Art and Artists about the Bay," *Oakland Tribune*, February 1916.

7. The present writing does not attempt to present an all-inclusive discussion of woman artists, active 1900-1920, but is necessarily selective, focusing primarily on painters whose work reflects an engagement with modernist styles beginning with Impressionism. Other sculptors were **Gertrude F. Boyle** (1878-1937) and **Sybil Unis Easterday** (1876-1961), of San Francisco, and **Ruth Norton Ball** (d.1962), active in San Diego. Women painters not covered here include **Alice B. Chittenden** (1868-

1937), **Maren Froelich** (1870-1921), **Grace Carpenter Hudson** (1867-1937), **Bertha Lum** (1879-1954), all of the San Francisco Bay Area, **Elizabeth Borglum** (1848-1922), Los Angeles and **Alice Klauber** (1871-1951), San Diego.

8. Waggoner, "The art of J.B. Wendt, *Los Angles Herald Sunday Magazine*, March 27, 1910, p. 1.

9. Ibid.

10. Ibid.

11. A notable exception was Rex Slinkard (1887-1918), a singular artist in Los Angeles, and a member of the Modern Art Society. Slinkard was known to carry postcards of Cézanne works exhibited at the Armory Show (1913) in New York.

12. Anonymous, "Pictures of Places," *Los Angeles Times*, October 22, 1911, Section 3, p. 21.

13. Ibid.

14. Anonymous, "California Snow Scenes," *Los Angeles Times*, April 11, 1915, Section 3, p. 15.

15. Ibid.

16. Antony Anderson, "A Fly in the Ointment," *Los Angeles Times*, August 31, 1919, Section 3, p. 2.

17. Ibid.

18. "Miss Dunlap in Paris," *Los Angeles Times*, February 1, 1920, Section 3, p. 3.

19. "Helena Dunlap and the New Paris Idea," Los Angeles Times, August 9, 1925, Section 3, p. 22.

20. For a fuller discussion of Shore's career, see catalog of exhibition, *Henrietta Shore*, Monterey Peninsula Museum of Art, December 12, 1986-January 20, 1987, essays by exhibition curator Richard Lorenz and Roger Aiken. Information on the artist was drawn principally from this catalog. See also Merle Armitage, *Henrietta Shore*, (New York: Weyhe, 1933).

21. See Roger Aiken, "California and New York: 1913-1927," catalog, *Henrietta Shore*, p. 20. Shore had studied dance.

22. Henry Tyrell, "High Tide in Exhibitions Piles Up Shining Things of Art," *New York World*, February 4, 1923.

23. See "Subconscious Emotionalism on Canvas," *Arts and Decoration*, (February 1923), p. 26. Except for the first paragraph, which labels the exhibition "fourth dimensional interpretations," and cites it as "one of the sensational art shows of the season," the anonymous article is a reprint of Henniker-Heaton's catalog essay.

24. Ibid.

25. See Roger Aiken, "Edward Weston and Mexico 1927-1930," catalog, *Henrietta Shore*, pp. 21-29.

26. See Aiken, preface to catalog, p. 11. Bietry-Salinger (Carlson), art reviewer for the *San Francisco Examiner* in the late 20s and early 30s and editor of *The Argus*, was a friend of Shore's from 1927 until the late 1950s. Interviewed by Aiken, she stated "In my opinion, if Henrietta had been in the hands of a sharp dealer, she would now be regarded as far superior to an artist by the

name of Georgia O'Keeffe." See also Tyrell, op. cit. He cites the works by Shore and O'Keeffe, exhibiting concurrently in New York, "an extraordinary manifestation of modern art, expression and feminine self-revelation through the medium of semi-abstract symbolistic painting," adding, "No radical idea, whether in religion, fashion, politics or art, ever amounted to anything until the women took it up. Then, and only then, the infusion of life blood began, never to cease until it had been nourished to maturity and fruition." Aiken, p. 19, takes issue with Tyrell's ambiguous language in the article as "patronizing" and "degrading."

27. Arthur G. Vernon, foreword to catalog of exhibition, Modern Art Society.

28. Also affecting this was the loss of Slinkard, who entered the armed forces in 1918, and in the same year died of pneumonia in New York. See p. 11, op.cit.

29. John Caldwell, "California Impressionism: A Critical Essay," in Harvey Jones, *Impressionism: The California View: Paintings 1890-1930* (Oakland: Oakland Museum, 1981), p. 14. See also, catalog of exhibition *Donna Norine Schuster*, (Downey, California: Downey Museum of Art, 1977). Essay by Leonard De Grassi.

30. See Mabel Alvarez papers, Archives of American Art, Washington, DC.

31. *Los Angeles Tribune*, August 30,1914.

32. *Los Angeles Express*, September 13, 1914.

33. Artist's journal, 1914, "Ted Shawn posed for me today." Alvarez papers.

34. Quoted by Florence Lilian Pierce, *Los Angles Times,* February 7, 1913. Pierce described her as "an exceedingly pretty young woman."

35. A[rthur] S[ecunda], review of group exhibition, Kramer Gallery, Los Angeles, in *Artforum*, 1:7 (September, 1963), p. 20, describes her *Flower Sellers* as "iridescent in its refined sumptuousness and subtle glow."

36. Cheney, "Notable Western Etchers," *Sunset Magazine*, Vol 21 (December 1908), pp. 737-44. See also "Notable Etchings by Gertrude Parrington," "Book Reviews," *Sunset Magazine*, Vol 21, (May 1908), pp. 85-87.

37. According to Anna Cora Winchell, "Artists and their Work," *San Francisco Chronicle*, August 4, 1918, p. E6.

38. See Harvey Jones, *Mathews: Masterpieces of the California Decorative Style* (Oakland: Oakland Museum, 1972).

39. The exhibition was held at the Arlington Galleries, New York. Mentioned, *New York Times*, May 12, 1918.

40. Described by Helen Dare, in Sharon Chickonzeff, "The Unspoken Ann Bremer," n.d., unpublished manuscript, Bancroft Memorial Library, University of California, Berkeley.

41. *California Art Research Monographs*, Vol. VIII, ed. Gene Haley (San Francisco: Works Progress Administration, 1937), p. 88.

42. Porter Garnett, "Miss Bremer Pronounced One of San Francisco's Most Talented Painters," *San Francisco Call*, September 15, 1922.

43. E. Charlton Fortune papers, Oakland Museum.

44. Ibid.

45. Isabel True, "E. Charlton Fortune," Monterey Museum of Art artist's file, February 12, 1980.

46. Sonia Bryen, "Impressionism in California: The Impact of 19th Century French Artists," in *From Exposition to Exposition: Progressive and Conservative Northern California Painting 1915-1939*, (Sacramento: Crocker Art Museum, 1981), p. 15.

47. See Gary Szymanski, "The Society of Six,", in *From Exposition to Exposition: San Francisco 1914-1939*, pp. 24-27. "While in Monterey, Gay met C.S. Price, Gile met E.C. Fortune through Gay and under her influence began using red as a dominant element," p. 27. See also, Nancy Boas, *The Society of Six* (San Francisco: Bedford, 1988), pp. 69-71.

48. Fortune's maternal grandfather, Julius Hertzberg, was Jewish.

49. Fortune papers. Undated, the letterhead showed a Monterey address.

50. Sheldon Cheney, "Notable Western Etchers," *Sunset Magazine* Vol. XXI (December 1908), p. 740.

51. Helen Hyde obituary, *San Francisco Bulletin*, August 21, 1919. The text quoted a memorial statement by the Friday Club of Chicago.

I am grateful to Penny Perlmutter, San Francisco, for her unstinting help and hospitality, and to Robert Simpson, Long Beach, for his aid in providing documentation necessary to the completion of this essay.

Henrietta Shore, *Nude*, o/c, 1920. Collection Michael Fedderson, Laguna Beach.

Helena Dunlap, *Arab Café*, o/c, 1920. Private collection.

Donna Schuster, *Miss Livingston at the Piano*, o/c, 1912. Private collection.

Gertrude Partington Albright, *Child in High Chair*, o/c, 1920. Private collection.

E. Charlton Fortune, *Monterey*, o/c, 1919.

Bay Area
Fragments of a Vision

San Francisco had a very romantic quality for me as a child. The changing moods of the landscape . . . the way the city's constructed on hills . . . the museum which had so many Chinese artifacts . . . the little boats on the Bay . . . foghorns, ferry boats, Chinese pagodas.

—Ynez Johnston, painter[1]

The striking visual beauty and the dramatic perspectives of San Francisco have long lured visitors and immigrants alike. From its gold mining days of rough wealth-seeking 49ers, "Baghdad by the Bay," as our local gossip columnist, Herb Caen, affectionately calls it, has always been a center for new ideas and visions. Yet San Francisco has always been home to wealthy families, and through their patronage the city has nurtured the development of several museums and private collections.

The Bay Area actually constitutes nine counties, each different in landscape and population. However, San Francisco has been and continues to be the center, "the City," where California trends are credited with starting, even though they may have begun somewhere else. The natural setting of San Francisco Bay does make it a pleasantly livable urban environment. Henry Hopkins, former Director of the San Francisco Museum of Modern Art, says, "Almost every day presents a surprise of nature made up of Japanese, Norwegian or Mediterranean skies, depending on the fog and the mini-chill in the air. The art of the area continues to come out of a hundred-year tradition that reflects this environmental beauty and the individual's response to it. Whether naturalistic, abstract or playfully personal, the art emerges as a response to nature . . . characterized by heavy impasto; rich dense color; strong steel; wood; and rough plaster."[2]

Those of us who live and work in the Bay Area have an intuitive sense of its dichotomies. Mostly, they lie in the area's blend of urban and rural. One may be in the heart of the city's North Beach and suddenly see the Marin headlands in the distance at the end of a crowded thoroughfare. Or driving across town you may glimpse the Bay with Alcatraz or Angel Island floating in the distance and

boats on the horizon. San Francisco always surprises with its natural beauty and its many faces. The cold fog of summer that is legend with tourists plays a vital role in giving the city its mystery and its special silver-gray light.

Most important, the Bay Area has always been a tolerant matron known for its dictum of "live and let live," welcoming and humoring all manner of eccentricity and individualistic thinking. It is this setting that has attracted and nurtured the hundreds of women artists who make the Bay Area their home.

The history (or herstory) of women artists in the Bay Area, as one might expect from its ambience, neither matches the artistic trends prevalent on the East Coast, nor falls into any set pattern that reflects a particular body of "women's work." In fact, most women artists, whether they think of themselves as feminist or not, continue to resist the label of "women's art" and fight for recognition of their work for its individual expression and vision.

In my interviews with women artists and art scholars, I was struck by the range and diversity of styles in Bay Area women's art. No one could take the last 40 years and identify artistic trends or artistic groupings. The only attempt at such a cumulative analysis was the Fresno Art Center and Museum's year-long series of exhibits, 1986-87, on California women artists.

This ambitious and inspiring series, organized with enormous hard work and insight by curator **Kathryn Funk**, was a remarkable feat. Yet many of the artists invited to submit work for the show were reluctant to be part of a "women artists only" exhibit. Funk had to convince them that the exhibit did not represent another attempt to "ghettoize" women artists' work, but that it was a special exhibit, like any other. The show, titled "A Survey of California Women Artists, 1945 to Present," was organized as follows:[3]

1. "In the Advent of Change: 1945-1969"

This first exhibition focused on the period following World War II and preceding the Women's Movement. The California artists who came to prominence during this time are some of America's most noted. Guest curator **Joyce Aiken** selected the work to be exhibited from an impressive group of 20 artists, including **Ruth Asawa, Joan Brown, Jay DeFeo, Claire Falkenstein, Helen Lundeberg** and **June Wayne** (see chapter "Leading Ladies" for additional information on Falkenstein, Lundeberg and Wayne).

2. "The Years of Passage: 1969-1975"

The political and social changes that occurred in the sixties and early seventies gave momentum to the efforts of women artists working to be recognized for art produced from a distinctly female perspective. Judy Chicago, guest professor at

California State University at Fresno in 1970, began the feminist art program there. The impact of the program would influence women emerging at this time in a profound manner. Guest curators **Dextra Frankel** and **Judith Dunham** selected works of artists from all areas of California. Among the women included who established their careers in this climate are **Judy Chicago, Lita Albuquerque, Judith Baca** and **Betye Saar** from Southern California and **Joan Moment, Judith Linhares** and **Louise Stanley** from the Bay Area.

3. "Present Perspective: 1975 through Present"
After the tumultuous years of the Women's Movement, the number of women artists emerging to pursue careers has increased tenfold. The impetus for the work being done by these younger artists comes from a variety of sources. Many are dealing with social and political issues. Some are addressing psychological aspects. Others are reinvestigating art historical issues in the context of the modern. The questions of male/female role playing is another subject found in some artists' work. Among the more than 20 artists included are **Squeak Carnwath, Constance Mallinson, Pat Klein, Alison Saar** and **Judith Simonian.**

This exhibition series showed the work of over 100 women artists in California and is a testament to the work that women artists have created here in the last 40 years. Several books have been written on the Bay Area art movements, including a collection of interviews under the direction of Mils College Art Professor, **Moira Roth.**

For this chapter I wanted to focus on profiles of women artists in the Bay Area who are representative of its traditions, its diversity and its individuality. I selected these artists because they have found their own voice and because their work creates a clear identity and vision that goes beyond any category of artistic influence, even ones they themselves may claim. Their strong sense of personal expression gives them their strength.

Included in the exhibition covering the earliest period were the paintings of **Maxine Albro** (b.1903) and **Emmy Lou Packard** (b.1914). Both of these artists were involved in the "New Deal Art" of the thirties, worked closely with Diego Rivera on murals, and developed their own styles. Albro's idealized pastoral handling of subject matter made her stand out from other "Social Realists" painting at that time. By the sixties, Packard's style had shifted toward Abstraction, and her work was recognized with commissions for several sculptures, including a carved concrete wall for the Kaiser Center in Oakland. (See chapter on "Women of the WPA Art Projects.")

Ruth Asawa (b.1926) has long been recognized outside the Bay Area for her sculpture. Born in Norwalk in Southern California, Asawa studied at the fa-

mous Black Mountain College from 1946 to 1949. She has always found her in-
spiration in natural forms and in their intricate relationships and patterns.

Where do your ideas come from? is a question I'm often asked. The best ones come
unexpectedly from a conversation or a common activity like watering the garden. These
can get lost or slip away if not acted on when they occur. We are often too busy with
"real" work. In 1962, our friends Ginny Hassel Ballinger and her late husband, the
photographer Paul Hassel, returned from the desert bringing my husband and me a plant. .
. . The complexity of the plant made it possible to draw. By constructing it in wire,
however, I could begin to understand the interwoven growth pattern. This led me into
electroplating, bronze casting and resin casting.[4]

Asawa has received several commissions, and her public art can be seen
around the Bay Area, including the Hyatt Regency Embarcadero's atrium. A
more traditional mermaid sculpture is at Ghirardelli Square. Despite weakening
health, Asawa continues to be active in the San Francisco art community and has
worked for years on art programs with schoolchildren.

Joan Brown (b.1938) is the best-known nationwide of Bay Area painters.
She established her reputation early in her career and has gained acclaim for her
work around the world. Brown's early work was influenced by the environment
of the San Francisco Art Institute and the teaching of David Park and Elmer
Bischoff. However, she quickly found her own personal iconography with the
use of motifs that set her apart from other Bay Area figurative painters.

Although her early work used the heavy impasto style of Bischoff, her later
style became increasingly exotic. *The Bride* (1970), for example, shows a flat-
tened perspective and a cat-faced bride with brightly colored fish floating in the
sky behind her. Brown explains the influences on her work: "In my early years
as an artist I was very influenced by Expressionism, Impressionism and the Old
Masters—mainly Rembrandt, Goya and Velazquez. . . . In the last few years,
I've been particularly interested in the work of Mark Rothko. Mysticism and
Eastern thought have been an influence on my life and my art."[5]

Recently Brown has been working in sculpture and has completed several
commissions in public parks of permanent outdoor pieces made of bronze, steel
and ceramic tile. The installations are lively monuments incorporating her inter-
ests in ancient cultures as well as being appropriate for the environment.

Brown continues to travel to ancient power sources around the world, at the
same time studying the civilizations, religions and cultures she finds (of particu-
lar interest are those of India and Egypt). Like Frida Kahlo, Brown continues to
surprise us with the unique personal mythology of her work and the inclusion of
sacred forms, figures and animals.

Squeak Carnwath (b.1947) is concerned with life's big issues—love, death, time and identity. Her art is very much of the eighties, the international style of Neo-Expressionism with flattened cartoon-like forms in complex combinations with layers of meaning that challenge the viewer. Carnwath completed her undergraduate and M.F.A. at the California College of Arts and Crafts studying with Viola Frey. A professor at UC, Davis, she has received National Endowment for the Arts Fellowships in 1980 and 1985.

In an interview with **Anne Gray Walrod** for *Connecting Conversations*, Carnwath says: "I really believe in handmade, man-made, person-made, and that we are losing track of that. Part of my job that I see here is to preserve that. I want to preserve primary ways of being and perceiving like making paintings, making sculptures and doing things with our hands. It reminds me of the fragility of being, like the *memento mori*. It does not smooth anything out. It is unforgiving in a way that's forgiving."[6]

Jay DeFeo (b.1929): "When I graduated from the University of California at Berkeley in 1951, I received a Sigmund Heller Traveling Fellowship and left for a year and a half of study in North Africa, Spain, France and Italy. During my art history courses I had become very interested in the art of the Renaissance and of pre-historic peoples. At the same time, I was increasingly affected by Abstract Expressionism, especially through my friendship with Sam Francis in Paris. When I returned to the United States, all these influences came to find their expression in sculptural works. When I returned to painting in the mid-fifties, I brought to it the sensibility of a sculptor."[7]

DeFeo has long been recognized as ". . . the most powerful artist to emerge from the early period of Funk Art" in the Bay Area. After she married in 1953, she moved to a large building on Fillmore Street in the city that became a center or "Grand Hotel" for artists in all genres. The house soon became a studio for many of the well-known artists of that period, such as Joan Brown and **Sonia Gechtoff**. In 1958, DeFeo completed *The Eyes*, a large signature drawing where two piercing eyes seem to shimmer behind a series of vertical lines.

DeFeo was one of the 16 artists selected by Dorothy Miller to be exhibited at the Museum of Modern Art in New York (1959). DeFeo is perhaps best known for *The Rose* (1958-1964), a creation which took the impasto style to its ultimate statement by building a personal monument and symbol that weighed over 2,300 pounds when completed. DeFeo's monochromatic style is best exemplified by her favorite painting series, *Crescent Bridge*, a transitional work in the abstract style. In a recent interview, DeFeo was asked to discuss this work and revealed her otherworldly connection to the world of the working artist: ". . .

I don't often refer to representational objects as specifically as I did in the case of these two paintings, but they are teeth are they not? There is a connection here, in that during the six years I worked on *The Rose* I suffered an overexposure to all that oil paint and my gums developed a serious condition that resulted in the loss of some of my teeth. . . . [But] as you look into *Crescent Bridge*, you can imagine endless space behind those objects . . . like my life . . . laying and layering . . . its additive and subtractive . . . a constructive and destructive process ... the bridge refers to the old life and the new life."[8]

DeFeo has taught for many years and is now an Associate Professor at Mills College.

Susan Marie Dopp (b.1951) is one of the younger Bay Area artists already being recognized for her personal artistic vision. Dopp, born in Texas, received her B.F.A. and M.F.A. from the San Francisco Art Institute. She was most recently awarded the prestigious Society for the Encouragement of Contemporary Art (SECA) from the San Francisco Museum of Art, where a collection of her work was exhibited in 1988.

Dopp's work is most clearly influenced by the dramatic personal narrative and symbolic style of Frida Kahlo. Her dream-like motifs are beautiful and arresting: "Unlike the Surrealists, who placed random images in unusual juxtapositions to describe the workings of the unconscious, I assemble forms and symbolic images of personal significance to express specific dreams and conscious as well as unconscious states of being."[9]

Recurring symbols such as pears, roses or snakes dramatize the underlying themes of sexuality and violence. Her past works have been small, icon-like images frequently encased in spiky, metal frames accentuating the images' three-dimensional quality and underlying the distance between the viewer and the object. Dopp's most recent work, *Las Rosas* (1986-88), is a collage of panels continuing and expanding the themes and motifs of previous work. in a form that allows greater narrative progression.

Viola Frey was born in 1933 in Lodi, the heart of the agricultural valley of California, and has an MFA from Tulane University. She has taught at her alma mater for the last 23 years, and during that time has been recognized as one of the leaders in the figurative art movement.

Frey's training included working with Diebenkorn and Rothko at the College of Arts and Crafts. Her use of color to define space and form, as she puts it, "[intensifies the objects'] participation in space and light." From her famous *Grandmother* series to her most recent figures of men in business suits, Frey's work evokes American folk images and imbues them with a mysterious and

ritualistic presence. Although she draws from life, myths, dreams and autobiography are also included.. Her ceramic sculpture melds two techniques—vividly colored three-dimensional paintings with a clay form (or sculpture) beneath. The work has been shown extensively, including a 1981 retrospective at the Crocker Museum, at the CSU Fullerton Gallery in 1982, the Whitney Museum, New York, 1984 and the Goldie Paley Gallery at Moore College of Art, Philadelphia.

Sylvia Lark was born in Buffalo, New York, 1947. Almost immediately after obtaining her M.F.A. from the University of Wisconsin she started teaching at California universities and is now a professor at UC, Berkeley. Overlapping layers of translucent colors and delicate surface modulations inform the abstract imagery of her paintings. In her earlier work she used shapes and symbols derived from shrines, rituals and calligraphy encountered in her travels in the Far East and Asia. She explains her interest in primitive societies: "the primitive societies are much more in touch with themselves and who they are in the world—their religion, their spirituality. They are closer to the earth and that really affects me." Lark's method of working is intuitive, as she described some years ago in an interview with Peter Selz: "I don't know what the painting is going to look like when I start. I might start with some kind of image, but mostly the painting just grows out of itself. There are lots and lots of layers. It's a very intuitive process for me. I just keep working and let the painting tell me what to do."[10]

Sylvia Lark's work has been shown extensively in California galleries and museums, as well as nationally and internationally.

San Francisco art critic Thomas Albright's book on Bay Area artists, like many art history books, focused primarily on the influence of male artists on the artistic trends of the last 40 years. However, in his bibliography he lists over 100 women artists and gives brief biographies of their accomplishments.

This chapter has mentioned just a few of the hundreds of women artists who are teaching and working in the Bay Area. However, one must see the works of these women artists to fully understand the diversity of talent here—artists such as **Eleanor Dickinson, Eurania Cummings, Jo Hanson, Lynn Hershman, Yolanda M Lopez, Mayumi Oda, Catherine Wagner,** and many others who have made enormous contributions to the artistic community. Many are members of the Women's Caucus for Art, which continues to be a central support group for some women artists in the area.

The size of the Bay Area necessitates that many women artists work away from centers of support and activity and away from the traditional institutions of the artistic community. Art criticism in the area is dominated by men, and art receives little coverage in the media, regardless of an artist's gender. These facts

contribute to women artists' continuing struggle to be exhibited and recognized for their achievements.

—Rita Cummings Belle

Notes

1. Charlotte Streifer Rubenstein, *American Women Artists* (New York: Avon, 1982), p. 295.

2. Henry Hopkins, *50 West Coast Artists* (San Francisco: Chronicle Books,1981), p. 10.

3. Fresno Art Exhibit notes.

4. Hopkins, p. 26.

5. Ibid, p. 34.

6. Moira Roth, *Connecting Conversations* (Oakland: Eucalyptus Press, Mills College, 1988), p. 28.

7. Hopkins, p. 37.

8. Roth, pp. 48-49.

9. Dalia Judovitz, catalog, *Susan Marie Dopp SECA Award* (San Francisco Museum of Modern Art, 1988).

10. Melinda Wortz, catalog, *Diversity and Presence* (Riverside: University Art Gallery, 1987), p. 30.

Acknowledgments
Special thanks to the following for their assistance in compiling the research for this chapter: Whitney Chadwick, Professor of Art, San Francisco State University; Kathryn Funk, former curator, Fresno Art Museum and Center; Sylvia Lark, artist and Professor of Art, University of California, Berkeley; Mary Ross Taylor, Administrator, "Through The Flower"; Gloria Wheeler, Docent, San Francisco Museum of Modern Art, artist and art consultant.

Twelve Artists

The Triton Museum, Santa Clara, launched its inaugural exhibition of their "Bay Area Masters Series" in the fall of 1988. George Rivera, Curator of Art at the museum, wanted to find artists who were doing high-impact work, artists who were not first-timers, but people who had "paid their dues." Five or six names immediately came to mind, all women artists whose careers Rivera had been following for years. As he continued to collect names, the list soon swelled to well over 100 women. Since his goal was to keep the show small so that each artist could display several works, he eventually narrowed the list down to 12.

The range of Rivera's choices appropriately reflects the great diversity among artists living and working in the Bay Area. Certain unique art historical and socio-psychological factors in Northern California have contributed to this diversity and helped to shape the mature visions of these 12 artists. The Bay area is heavily populated, largely affluent, cosmopolitan and spread out over several large counties. It boasts a gorgeous climate and has many cultural advantages with San Francisco as its hub. Despite all this, artists have never had the opportunities in terms of galleries, museums, serious patrons or press available to artists in, for example, Los Angeles, New York or Chicago. In fact, for many years the major museum, the San Francisco Museum of Modern Art, has had a policy of not showing local artists unless they have already gained national recognition.[1]

These factors have, to a large extent, shielded Bay Area artists from fads, mainstream trends, gimmicks and the art world hype so plentiful in major art centers. Such insulation can be detrimental to one's career, but not to one's art. In my opinion, this regional "problem" has contributed to a more personal, pluralistic approach to art which, in the long haul, is the fertile ground from which springs work of more importance, originality and endurance. The work in the Triton exhibition reflected this view, and included a few artists who have achieved national recognition.

Augmenting the diversity of the artists in the Bay Area is an array of lifestyles spanning the irreverent openness of the Beat Generation of the 50s, to the "group grope" movement of the 60s, to the endless West Coast preoccupation with self quest and intellectual and spiritual growth. As for art historical influences, in the recent past we had to look to the art schools in universities and colleges. During the late 40s and 50s the dominant aesthetic was Abstract Expressionism, having as its locus the San Francisco Art Institute. By the late 50s and early 60s many leading artists from the San Francisco Art Institute, the Uni-

versity of California at Berkeley and the College of Arts and Crafts at Oakland
had tired of Abstract Expressionism and launched the Bay Area Figure Painting
School.[2] This event had a powerful impact on California art and brought national
attention to the area. The other major movement of national scope which left a
lasting imprint on Bay Area art was Funk. It started in clay work at the
University of Davis around 1965.[3] Funk was characterized by eccentric
iconoclasm, a sense of humor and distorted figures. The movement opened up
the imaginations of many artists and let loose an "anything goes" attitude that is
still with us.

These aspects, along with an anti-traditional, anti-mainstream narrative im-
agery,[4] were evident in the Triton Museum exhibition in the works of **M. Louise
Stanley, Viola Frey, Judith Linhares, Erin Goodwin-Guerrero** and **Roberta
Loach**. M.Louise Stanley, as superb a draftswoman as she is a painter, works in
an American narrative genre mode. Her explosive gestural figures are done in a
painterly style with vivid colors, daring compositions and a titillating sense of
humor. Like Stanley, Roberta Loach works with genre themes, but with a
satirical bite. Both Stanley and Loach comment on socio-psychological aspects
of society. The cartoonish figurative style and garish colors used by Loach owe
much to Funk in terms of content and imagery. Both artists work in gouache, but
Stanley also does oil painting, while Loach works in acrylics.

Viola Frey's huge ceramic figures with their brightly colored glazes and
figural distortions also seem natural inheritors of Funk, but their size and
intensity of color give them great presence and power. There is also more than a
touch of whimsy in the facial and bodily expressions. Frey's painterly style bears
elements of the Abstract Expressionist, but has a unique linear character. The
narrative approach in Judith Linhares' paintings owes something to the San
Francisco Figure Painting school, but her work is full of private symbolism and
mythologies, often Mexican in origin. Working with equal facility in gouache
and oils, her paintings are done largely in somber but strong colors with exuber-
ant brushstrokes. The work of Erin Goodwin-Guerrero bears similarities to Lin-
hares in its haunting imagery, also turning on myth and ritual with its narrative
origins in contemporary Mexican culture. She photo-silkscreens animals onto
paper surfaces and adds loosely painted devils and other symbolic objects.
Working in bright, hot colors, Goodwin-Guerrero uses oils, oil sticks and other
media. Both Linhares and Goodwin-Guerrero's works reflect the influence of a
strong undercurrent of mythmaking pervasive in art of the area during the 70s.[5]

Inez Storer's paintings and monotypes also contain figurative forms re-
flective of this trend, although her narrative imagery is more dreamlike than real.

In general, her work shows the influence of the Bay Area Figure Painting school. The work of **Squeak Carnwath** also falls into the category of personal myths and symbols. She paints quasi-primitive figures that seem to live in a very private world. Words and numbers enigmatically become integral to her very large somber-colored oils.

Though from two separate generations, the work of **Pia Stern** and **Jay De Feo** pay a distinct homage to the Abstract Expressionist era. Both women work nonobjectively, but now and then one senses objects in Stern's brightly colored, painterly canvases. De Feo's current works employ abstract forms in an expressionist style. Her large canvases are striking in black and white with an occasional touch of bright color. Proving the diversity of Bay Area art is **Mary Snowden**'s large realistic watercolors of household objects and florals. What sets her work apart is its sheer beauty, achieved through her deft handling of watercolors.

Deborah Butterfield's works continue the pattern of variation. She is a sculptor working with imagery she loves: horses. She works in metal, wood and found materials constructing her life size or smaller scale animals in a personal, expressionistic manner. Finally, an important example of work is that of photographer **Judy Dater**. Expressing a strong concern for the human figure, Dater usually works in black and white.

The strengths of the Triton Museum exhibition were its diversity and the high quality of the work. The exhibition was a success; it demonstrated and documented what is happening in the art world of San Francisco Bay Area at the end of the 80s.

—**Roberta Loach**

Notes

1. John Marlowe, "Power Politics and Publicity: But Is It Art." *San Francisco Magazine* (May,1988).

2. Thomas Albright, *Art in the San Francisco Bay Area 1945-1980* (London: University of California Press Ltd., 1985), pp. 39-55, 57-80.

3. "David Gilhooly in Conversation with Roberta Loach," *Visual Dialog Magazine: Works in Clay*, Vol. 2:1 (1976), pp.13-17.

4. For a thorough discussion of narrative and figurative art in the San Francisco Bay Area, see Whitney Chadwick, "Narrative Imagism and the Figurative Tradition in Northern California Painting," *Art Journal*, Vol. 45:4 (Winter, 1985).

5. Albright, pp. 231-233.

(Although all the artists in this exhibition were women, there was no mention of it in the title or published brochure.)

Sylvia Lark, *Blushing Girl Painting.* **Collection Susan Moldaw and Mathew Brooks, San Francisco.**

Roberta Loach, *Important New Talent*, 1988.

Viola Frey, *Untitled (Man Blue Lips)*, 1987. Courtesy Rena Bransten Gallery, San Francisco.

Judith Linhares, pen and ink drawing

Joan Brown, *A New Age: The Harbinger*, enamel, c.1984. Courtesy Fuller Goldeen Gallery, San Francisco.

Autobiographical Imagery
in the Art of Los Angeles Women

*What would happen if one woman told the truth about her life? The world would
split open.*

<div align="right">

—Muriel Rukeyser

</div>

Ruth Weisberg stands on the sand dunes of her childhood, gazing at an image of
herself, age six, as she turns to leave the pretend world of her girlfriends. Cheri
Gaulke places her nude self upon an Early Renaissance cross, as she agonizes
over her place in the Christianity of her father and her father's father. Rachel
Rosenthal, apparently already intoxicated, greets her audience in evening gown
and jewels to recount how she was recently swindled; all the while she drinks
yet more champagne and eats an elaborate gourmet meal. Laurie Pincus, cut
from wood and painted crayon-bright, sleeps in the bed of her adolescence,
dreaming of adult roles, adult games. Joyce Treiman, with a mischievous grin
crossing her face, peers out from a curtain of Impressionist lilies; then she sits
next to Death, embraces the Nemean lion, rides with General Custer. Carol
Neiman appears in her wedding dress, images of her failed marriage floating
behind her, a license plate emblazoned with "X WIFE" hung around her neck.
Barbara Carrasco places herself in the familiar double braids of the great
Mexican painter Frida Kahlo. Yrena Cervantes paints Kahlo astride a mammoth
jaguar; Kahlo holds up a mirror and Cervantes' own face is reflected. Kathryn
Jacobi paints herself as a child, caught by unearthly light, masked by wisdom;
she calls the portrait *Dwarf in a Tall Man's Closet*. These women are Los
Angeles artists. Placing themselves in compelling and confronting situations
from their personal past, they use art to construct autobiography.

How they explore images of self is unprecedented. Self-portraiture has ex-
isted throughout time: the nun Claricia drew a whimsical image of herself
swinging on an illustrated letter in a medieval manuscript; Rembrandt painted
his face again and again in a kind of visual diary that traced the painful ravages
of time; Michelangelo included a flayed self-portrait in the Sistine "Last
Judgment" as an ironic protest of the Pope's autocratic patronage. But

systematic use of the visual arts to explore autobiography, to investigate what has been termed the "trauma of individuality," has not been a primary motive of image making until the 20th century. Both the history of artistic patronage and the previous systems of artistic training led earlier artists to create images for a public rather than private self.

Most artists of the Euro-American tradition, from cave painters to Impressionists, depicted the world as others would have it. Michelangelo worked for the largest corporate entity of his day, the Catholic Church. Jacques Louis David worked for and ultimately ran the French Academy of Fine Arts, which was founded by Louis XIV to ensure state control of image production. Neither the Catholic Church nor the French government was disposed to pay for the creation and exhibition of subversive images.

Further, the European guild system, and later the academies, limited who was "allowed" to create such consensus images. Like its counterparts throughout Europe and the Americas, the French Academy controlled not only education in but also exhibition of the fine arts. Because admission to the academy school and participation in its salons were limited to white Christian men, it controlled who produced art, as well as how it was produced. Blacks, Jews and women were largely excluded from the Euro-American fine arts tradition until this century.[1]

Pelfrey and Pelfrey, in their excellent *Art and Mass Media*, suggest that it is the Academy of Motion Picture Arts and Sciences which has in the twentieth century taken over the role of consensus image production.[2] Movies and television create the consensus images for mass consumption. Movie theaters nurture our shared dreams; TV fabricates our extended families.

Screenwriter Judith Fein said in a recent interview, "I was sitting in front of the computer thinking, 'The computer is a model of the human mind, and the camera is a model of the human eye. . . .' Then it hit me: TV is a model of human emotions."[3] But these are models of mainstream minds, eyes and emotions. Very rarely does either film or television present an authentically personal or idiosyncratic vision. That kind of image-making is left to the visual arts. And it is frequently left to women, since our culture is notorious for not allowing men to express their innermost emotions.

I am arguing that a dominant theme of late 20th-century artistic production is the creation of handmade images of individual vision and that the primary practitioners of this art form are women. One reason for this is the Women's Movement. With its consciousness-raising process and its conviction that "the personal is political," the Movement gave women not only encouragement to be

artists in much greater numbers than ever before, but also validation that their personal experiences were worthwhile material for art. Autobiographical content in the visual arts, as well as in performance art, was championed by the Women Artists Movement.[4]

In Los Angeles, the Woman's Building, founded in 1973 by artist **Judy Chicago,** designer **Sheila Levrant de Bretteville** and art historian **Arlene Raven,** has given women artists an important forum for exhibitions, performances, readings, and screenings. In doing so, it has developed an audience of support for women whose very personal art is often seen as too definitively "other" to be viable in commercial venues. With its publications, conferences, and classes, the Women's Building has also educated women in technical skills and the theoretical premises of image making. Many of the women I discuss credit the Women's Movement or the Woman's Building, or both, with making their art careers possible. It was while working to organize a Woman's Building conference on art criticism for women (held in conjunction with U.C.L.A. in January, 1988) that I became more conversant with contemporary theories relating to autobiography and images of self. Poststructuralist theory tells us that the self is a socially determined construct and that gender is not absolute, but also a function of culture. Feminist essentialists counter that the self is known only from within a body and that the nature (gender) of that body influences the knowing.[5]

The Los Angeles artists I shall now discuss explore the human condition as experienced in the unique self. Their work shuttles between poststructuralist and essentialist, often seeking a resolution of the two theoretical positions. For the sake of organization, I cluster the artists under "theme" subtitles that indicate one thrust of their autobiographical work. But most of the artists deal with multiple aspects of their artistically constructed selves; a few have created work that deals with all of the themes. Some artists present images of themselves to create autobiographical visual texts. Others construct their pictorial stories through images of their mothers, grandmothers or aunts. For some, the autobiographical impulse is satisfied through exploring experiences they share with other people, especially women. (This is true for text and image artist **Alexis Smith,** for example.) Others place themselves among images of historical women in order to examine their relationship to the past. For some, autobiography is only possible after the dismantling of negative stereotypes of women, what **Nancy Jones** calls "the boogies," used to justify women's secondary status in our culture. For many of these artists, feminist issues are

paramount. They use autobiographical imagery to give substance and validation to images of women in general and themselves in particular.

Whatever the strategy, such images work to reverse or erase the confines of the dominant culture's limiting (consensus) view of women. This is *not* the result of the narcissistic self-absorption characteristic of the "Me Generation." These artists have explicit social/political agendas. They give themselves—and all of us—new possibilities, new images of how women can be in the world.

The Self in History

The first generation of feminist art historians focused on excavating women artists lost in the mines of history and on reevaluating the images of women created by male masters.[6] Artists, too, have contributed to the search for forgotten women.[7] They have also appropriated and reworked historic images of women. In Los Angeles, several artists place themselves among historic personages, in the midst of historic compositions or in the throes of historic situations. They do so to establish their own place in history and to assert that they have the right to determine that place.

Ruth Weisberg—painter, printmaker, feminist activist, educator—has been placing herself in her art since the 1960s. "I started in an era when it was absolutely forbidden," she remembers. "It had to do with asserting that a woman's life was valuable, that a woman could be the subject of art on a woman's terms.[8] Weisberg began by incorporating herself into important monuments of the history of art. She placed herself in two compositions quoted from Spanish Baroque master Diego Velazquez. In *Disparity Among the Children* (1975), Weisberg kneels like a lady-in-waiting, attending the princess who is in the center of Velazquez's immense *Las Meninas*, while Weisberg's daughter Alicia, a small nude child, runs away from the staid, formal situation. In *Elegy*, a lithograph from the 1970s, Weisberg seats herself in the room Velazquez populated with his *Spinners*. The room itself spins in glistening lights. Weisberg thus muses contemplatively about the women Velazquez portrayed, about her place among them and among other women of history. More recently, Weisberg has done a series of paintings that explore the individual life cycle. There are images of ancestry, birth, growth, maturity, and, ultimately, death in her *Circle of Life* series (1985). In *Pentimento*, Weisberg depicts a broad stretch of the Italian landscape she came to love while a student there. In the lower right hand corner are Adam and Eve, quoted from Massaccio's famed 15th century *Expulsion* fresco. Weisberg turns away from the anguished pair, but, like them, she realizes

she cannot return to the paradise of her past. In *Dance of Life* she joins a group of friends as they dance in an echo of Edvard Munch's composition, but in Weisberg's version, the artist herself is both part of the dance and standing outside it, observing and painting it in her studio. "My aesthetic is very personal: I deal with the individual and the specific in order to get to the universal. Modernism goes straight to the universal and loses most of us en route—it becomes so neutered, so neutral, that its originality evaporates."

Weisberg's work with the history and imagery of her Judaic heritage is hardly "neutral." Her most ambitious drawing is *The Scroll* (1987). A monumental 94 feet long, *The Scroll* unites images of the life cycle with ceremonial patterns and biblical history. Marriage is celebrated, and *bat mitzvah*. Angels reach to touch the lips of tiny babies, children lean to embrace dying parents. Striped uniforms hang outside gas chambers. Souls tumble through space into new existence. Again and again, Weisberg includes herself, her family and her friends. In discussing *The Scroll*, art historian Thalia Gouma-Peterson refers to Joanne S. Frye's *Living Stories Telling Lives: Women and the Novel in Contemporary Experience* and asserts that "Weisberg's recent autobiographical narrative work has much in common with women's literary narrative."[9] Weisberg is aware that including herself in her work also has to do with internalizing the muse. "Male artists have the external female muse. We don't. So we have to become our own muse; we have to merge with our muse rather than separate from it."

Joyce Treiman, too, has been putting herself in her art since the 1960s. "I want to be there!" she exclaims. "If I'm going to use someone specific, it might as well be me. It has nothing to do with ego. It's more about leaving a trace of myself, evidence that I was there." In the 1970s, Treiman began her ongoing series of paintings about painters, painting herself in conversation with Thomas Eakins, **Mary Cassatt** and John Singer Sargent. "I wanted to show my respect, to document my friendships with these artists. It was a time when they were all being trashed. I wanted to say, 'Hey! What the hell do you think you're doing to these good artists?!!' Those paintings are autobiographical, not because they're about, say, a trip to the desert with my aunt, but because painting is so much a part of my life that my autobiography has to do with looking at paintings."

In the early 1970s, Treiman travelled to France with a group of friends and visited Claude Monet's home in Giverny. She painted herself and her companions experiencing Monet's water lilies from the inside out. Virtually disembodied, they float through the shimmering reflections of light and color, riotously drinking champagne while immersed in the Impressionist environment. Later,

Treiman depicted Monet watching her as she painted the ramshackle canals in Venice, California. But not all of Treiman's autobiographical renderings are luminous and optimistic. In the 1980s, Treiman did battle with cancer, and her work, for a moment, became more ominous. She painted herself mocked by a Joker, then dancing with him on a mysterious ocean liner. She appeared wreathed in cigarette smoke, embraced by a smiling skeleton, caught in the shadow of a skull. She confronted her own ghosts and her culture's. "Those came after my experience with mortality," she says. "Facing death had a big effect on me. I began to think that everyone alive is a Joker, that we're just playing out these roles, that life in a sense is a joke." At the same time, she painted vibrant depictions of Hercules' trials, with her impish face peering out from a corner of the composition, and a full-sized portrait of herself as Rembrandt's son Titus. Today she places herself in the romantic swirl of the Wild West—seated astride an elaborately festooned stallion, galloping to war with an Indian chief or quietly mocking charging cowboys. "Those are about game-playing and myth-making," she asserts. "I've always been fascinated by myths." But Treiman does not image myths or history as male artists do, not even the male artists to whom she often pays homage. She rewrites myths and history to include herself and, by extension, all women.

The Self and Ethnic Identity

For both **Barbara Carrasco** and **Yrena Cervantes**, exploration of pictorial autobiography is intertwined with reclaiming their Chicana heritage. And for both artists, **Frida Kahlo**'s compelling self portraits are important precedents.[10]

Barbara Carrasco has always done drawings of her own face. In 1978, after graduating from U.C.L.A., she travelled to Mexico where she met several of Frida Kahlo's students and read Kahlo's biography. Like Kahlo, Carrasco came to see braids as important cultural symbols. She remembered that her mother always braided her hair, and realized that braids are a traditional Mexican hair style. In 1986, she did a drawing of herself and Kahlo with their braids coming together. Carrasco describes the image as "real idealized." Each hair was perfectly in place. A year later, she did another of her and Kahlo, less idealized: "We don't look like we've just come from the beauty parlor!" Carrasco had come to realize her relationship with her Mexican past was less than "beauty parlor" perfect.

When asked to do a mural for Los Angeles' bicentennial, Carrasco created *L.A. History: A Mexican Perspective.* Members of the numerous ethnic groups

that make up the city's heritage were bound in a tapestry of woven hair. Carrasco herself pulls some strands of hair away to emerge into freedom. The city rejected this mural, but it was exhibited at M.I.T. Today Barbara Carrasco is working on what she terms a "therapeutic" exhibition about her experiences growing up Catholic. Titled *Thirteen Stages of the Double Cross*,the exhibition relates—with satire and humor—both the artist's and others' experiences. Carrasco, who spent nine years in Catholic school, remembers the nuns as being very critical and insensitive.

Many of the exhibition's images are based on photographs Carrasco culled from her mother's albums and stories her mother told. When her mother admitted to using birth control pills, the priest yelled from the confessional, "You're no longer welcome in the church!" Although Carrasco's mother could never return to mass, she continued to go to the church to pray. Such experiences are crucial to Carrasco's understanding of herself and her family.

To prepare for the exhibition is to come to terms with her religious heritage, her lineage and herself.

Yrena Cervantes began doing self-portraits while an undergraduate student at Santa Cruz. "That was a real transitional period for me," she remembers. "It was the first time I was away from my family. It was also a turbulent time in terms of finding my self-identity and my place in the Chicano movement. Making the self-portraits was a good way to reflect. I used them like some people use diaries." Santa Cruz offered no classes in either Chicano art or Precolumbian art when Cervantes was there. Eventually she found a book on contemporary Mexican painters. When she saw reproductions of paintings by Frida Kahlo and Maria Izquierda, she knew she had finally found work that was "culturally relevant" to her.

Cervantes left Santa Cruz in 1975. A few years later, she saw an article excerpted form Hayden Herrera's biography of Frida Kahlo. Waiting anxiously for the book to appear, she became increasingly interested in Kahlo's art. "She was the primary Latina artist I felt close to. She was very active in the Communist Party, but also expressed her feelings in her self-portraits. I admired her integration of political, social, and personal issues." In 1978, Cervantes painted Kahlo on a jaguar, her stomach bulging with numerous fetuses (because of her physical handicap, Kahlo never bore children). And she put her own face in the mirror that Kahlo holds up. "I could see the relevance of Frida's work to our times. She really validated the maxim that the personal is political."

Throughout the 1980s, Cervantes has done self-portraits dealing with personal relationships. "It's a very intense period for women. We're experiencing

extraordinary changes in terms of what we'd expected our lives to be." In her *Despedida a las Ilusiones* (*Farewell to Illusions*, 1985), half of her face is naturalistic, and the other half is a calavera, a skeletal image inspired by Mexican folk art. In *Tu Solo Tu* (*You Only You*)—a title taken from a popular Mexican ballad—Cervantes dances with a calavera figure. In *Besame* (*Kiss Me*), she reclines to embrace the skeleton. Each of these is an ironic comment on the temporality of romance—and of life in general—as well as a continued assertion of Cervantes' affinity to things Mexican. "I consider myself to be a political activist," says Cervantes. "But there have been so many contradictions in the set of rules we have been given to live our lives by, so many contradictions in the way we see ourselves, that personal statements are just as important as political ones."

Kim Yashuda's search for self is predicated by issues of ethnic and cultural identity. Of mixed Japanese and American descent, the infant Yashuda was adopted in Northern California by Japanese parents. Her recent installation piece at the University of California addressed the manner in which cultures, filtered through generations on foreign soil, become fractured vestiges.

Yashuda's preferred medium is photography. The installation centered around a blowup of the suburban house of her childhood. At one side was a hedge, alluding to issues of fencing in and fencing out, the absurd separation of little plots of private property. The hedge was pierced by a hole through which one could see a mural of the Japanese flag. The central solar disc of the flag had been compressed, condensed to the oval shape that often frames old-fashioned family portraits. On the other side of the hedge was a diving board topped by a rusted chair. Below was a pool of type reading, "Gravity was my enemy." Beyond the diving board were three iron skillets with holes cut in them. The skylights over the gallery space were covered with water, and the sound that flowed through the room was a recording of Yashuda swimming laps in an Olympic pool. Outside the space was a porch light and under it the word "Tepid." Yashuda explains, "The installation was very autobiographical, but I didn't want to dictate a hot or cold reading. I wanted the potential to emanate out to the viewer's experience. The diving board and the chair, for example, relate to how we confront any choice or risk. Many times I remain suspended in indecision. But also, I had curvature of the spine as a child. I went from teeth braces to a back brace. My doctor told me gravity was my enemy. But, he told me, I could be in the pool all day long. So water became my escape from that contraption. The pans refer to the generational transference of culture, to the reduction of identity. As the pan gets smaller, the hole gets larger."

"I'm third-generation Japanese-American. Much of my identity has been fabricated from photographs, especially those of my adopted father. I just read an article in *October* magazine that referred to the movie *Bladerunner* and to the replicants who would confiscate photographs to establish their identity. (The replicants were robots, so the identities were all illusory.) My work is about that—about the loss of identity in Post-Modern society."

Previously, Yashuda had composed several photographic diptychs, juxtaposing images taken from her father's negatives with photographs of what she calls her "pseudo-rituals." A photograph of the traditional Japanese tea ceremony is paired with an image of Yashuda's robed back as she turns away from the tea table. She says that the photographs deal with aphasia (the loss of the power to use or understand words), which is the result of moving Japanese into mainstream American culture.

"I had to find the right formula to be autobiographical and to be inclusive of more than myself," says Yashuda. "It bothered me to exclude others. Now I had formulated a way to balance the personal and the universal. That way readers can derive their own meaning."

The Self and Icons

For many Los Angeles women, construction of the self is only possible after destruction of the social and religious icons they feel are used to establish women's oppressed position. They select images that have particular significance for their lives, then dismantle or reverse those images to illuminate their positive potential.

Nancy Ann Jones reworks images that have inspired male definitions of women, as she reworks her own definition of self. Jones is a ritual artist who also does multimedia drawings with collage additions. She states: "I first had to redeem for myself that it's okay to be a woman with a body and bodily functions. That's what the piece with Eve in it is all about." Jones' *Challenging Myths #3* (1986), a drawing in prismacolor and metallic inks, presents a large Eve, after Albrecht Dürer's Eve in the Prado Museum, confronting a smaller horned figure taken from Goya's *Witches' Sabbath*. The title comes from Judy Chicago's assertion that we must challenge myths before sociology and economics will change. Jones explains, "Eve is one of the icons held up like a bogey to women, to justify our second class citizenship. Images of Eve are used to say, 'You should accept this, you were created after Adam, from his body, you are responsible for the Fall from Grace. I want to change that." She continues,

"There's a connection between the temptation of Eve and the belief that many women who get raped 'ask for it.' But I remember taking a self-defense class with Betty Brooks. She stood there and said, 'I don't care if you are sitting at a bus stop in Hollywood, butt naked, painted purple and loaded out of your mind. No one has the right to cross that line and touch you, much less rape you." For Jones, a rape victim herself, doing such a drawing is a way to work out the anger and sorrow of her personal past, as well as her response to events like the multiple rape in the New Bedford, Massachusetts bar.

Many of **Ruth Ann Anderson**'s early sculptures deal with reclaiming the woman's body and reversing negative stereotypes of the female form. Throughout the 1970s and into the early 1980s, she worked on body casts (usually her own body), built up of rings of mailing tape. She began with fully articulated bodies; then they began to disintegrate. A 1978 piece is related to motherhood. There are two women at a tea table. One gets up, turns, tries to reject the sedentary position of the other, who is bound to or merging with the chair, perhaps trapped inside it. The mailing tape falls away from the rising figure to reveal a luminous wax persona underneath. "It is about rejecting domestic values and learning to reincorporate myself," explains Anderson. In a 1981 piece, a mailing-tape woman sits on a couch, reading *Even Cowgirls Get the Blues* under a mailing-tape lamp. The book is the only "real" thing in Anderson's tableaux. The woman and her environment are all bound by the tape, which symbolizes cultural conventions.

Perhaps Anderson's 1974 work is most optimistic. She did a series of herself seated on a bench. The tape gradually falls away, and wax faces emerge. The wax has more definition and clarity, is more luminous than the tape; the internally defined self is more authentic than the culturally determined woman. "It's also about aging, death, and internal growth, which goes on at the same time as outward disintegration," adds the artist.

Today, Ruth Ann Anderson is working on a series of mammoth images of powerful women. They stand ten or twelve feet tall. One has the head and beak of a bird; another is wrapped in the potent cloak of a priestess. They are depictions of the spiritual essence of women. Anderson grew up in a very devout Christian household, but rejected the faith of her parents when her education and experience in social work made her challenge its values. Then she found the Goddess. Her current sculptures and her ongoing "Full Moon" rituals give form to the spiritual quest that dominates so much of her life.

Performance artist **Cheri Gaulke**, daughter of a fourth-generation clergyman, also does art that reacts to her religious upbringing. Gaulke uses her art to

expurgate the misogynist implications of the Judeo-Christian tradition and create positive images of women. Gaulke says: "My art is very personal and very auto-biographical in a vulnerable way, but it has universal application, too. I'm remaking, reconstructing myself in my own image, rather than God's image, the Church's image, my parents' image. It's like an exorcism of Christian guilt. The female body—and soul—has been taken away from us. (It's true for men, too.) Our sexuality has been robbed. The burden of that has been largely on women and on the earth; it's the cross we women have had to bear for the culture." In her *This is My Body* performance (1983), Gaulke projected slides of key monuments of European art, then placed herself over the depictions of Eve, Mary, the crucified Christ. How, she implied, could she relate to such images of divinity? In the *Virgin* performance (1987), she presented our culture's various myths of conception and reproduction. During the Renaissance, for example, European Christians believed Jesus was conceived through Mary's ear. What are the implications about female sexuality implicit in such a belief? "Despisal of the flesh is such a big issue, so deep in our culture, that it may be something I deal with all my life," Gaulke concludes.

The Psychological Self

Artists have always had access to the fantastic; cave painters imaged those who traversed supernatural realms; medieval artists translated their worst nightmares into representations of the tortured damned; demonographers illustrated the categories and attributes of devils. Hieronymus Bosch drew on dreams and visions to fabricate his Hell. Albrecht Dürer described his dreams in books and depicted them in watercolor. Francisco Goya etched a self-portrait of the artist asleep, maddened monsters swirling around his resting head. But it was not until Sigmund Freud unlocked the Pandora's box of psychiatry that an entire artistic movement dedicated itself to plumbing psychological depths. The movement is Surrealism, and many of its most important practitioners have been women.

Dreams and fantasies have always been the subject of **Carol Neiman**'s art. In Los Angeles in the 1980s, Neiman practices Surrealism, a genre established in Paris in the 1920s. Often, she is an actor in her dreams. She hovers in a pristine moonscape behind a man who wears a tuxedo coat and tie, but is nude from the waist down; they stand beside a still white horse, over a confusing cluster of street signs. She is lost in the elaborate maze of a fairy-tale palace, chased by a unicorn and a prince and a howler monkey.

In her paintings, Neiman employs oil medium in the same demanding glazing technique perfected by Northern Renaissance masters like Jan Van Eyck. But Neiman is also intrigued by the most contemporary of media. Her *X-Wife* series involves xeroxed collage and computer-generated form to depict the dizzying whirlwind experience of her divorce. *A Fine Romance My Dear This Is* portrays Neiman in her romantically elegant bridal gown, clutching an oriental rug, umbrella and lace-lined satin heart, fleeing the ominous space behind her. To her right, a hallway of redwoods opens to a view of the Taj Mahal, certainly the most impressive wedding gift a man has given a woman. A stallion gallops through the trees toward Neiman, past white-clad teens in a tentative embrace. To her left, an Italianate arcade supports the neon flash of the Sandman Hotel. A coyote lurks in its shadows. Neiman turns to look over her shoulder at the dark horse, and at the illusory reflection of the Taj Mahal. She pulls up her skirt, which is covered with the capricious graffiti of young children. In doing so, she partially obscures an "X-WIFE" license plate hung like an albatross around her neck.

Gretchen Lanes also creates fastidiously rendered oil paintings that relate to dreams and fantasies. Lanes often appears in her own work. Her self-portraits are confrontational and eerie. Her open eyes are riveting, her expression frozen. She sits in nightmarishly fractured spaces, with warped walls and tilted floors. A rocking horse totters nearby; fish float above churning water; skewed windows frame impossible landscapes.

Lanes supports herself as a beautician; her self-portraits often have shaved heads. In a double portrait called *Sam and Delilah* (1984), she sits at a dinner table with her balding lover. A bowl of spaghetti in front of him alludes to Samson's shorn locks; Lanes holds up two fingers like scissors. Behind her is a barber's pole, behind him a Salomonic column. Lanes' use of the Samson story is autobiographical: she speaks of boyfriends who have been threatened if she tried to cut their hair, of customers who have commented on the power she has over them as they sit in her salon chair. But *Sam and Delilah* also has archetypal significance. What is the power women have over men? Does it always threaten to rob them of their strength? How does the Samson story (like the story of Eve re-imaged by Nancy Jones) fuel women's oppressed position?

Robin Ficara is an assemblage artist. She finds images that have a particular autobiographical resonance for her, surrounds them with thickly textured paper, then constructs whimsical stick frames for them. She scatters evocative symbols over the paper ground—teeth, fangs, serpents, stitched twigs, wrapped fabrics. They act as objective correlatives for the frenzied tornado that is life in

Los Angeles. It is the central icons and the illuminating titles that give access to Ficara's autobiographical content. An image of a woman pressed close up against a man, who spews yellow kernels at her, is called *Too Close for Comfort*. An image of a woman's spread legs with a knife angling towards them is called *Wide Open*. An image of a marble woman, reclining over her icy sarcophagus, is *An Awkward Position*. There is only allusion in Ficara's work, never explication. We see a fragment torn from an impassioned diary, a fractured reference to a heightened, climactic moment. Ficara leaves us aching, yearning for narrative completion, as if we have wakened from a haunting dream only to forget it.

The Self and the Cosmos

In performance artist **Barbara Smith**'s early work, the personal was often hidden by metaphor, or only obliquely alluded to. "My first big piece was a ritual meal in 1969. It was about the merging of the universal consciousness with— literally—the body. Guests wore surgical gowns, all the food was served with surgical instruments, and all around I projected images of body parts over fields of stars and planets. It was about the merging of the self into a new reality. I had just left a marriage and felt I was going into a void. So the reality of my identification with the piece was total, but it was also quite cosmic." Later that year she did a piece called *Faces*, which was about a relationship that was driving her crazy, and about verbal bullying, badgering, how abusive it was. But again, the autobiographical was clothed in symbol. Ultimately, she realized she had to put herself into her work directly. In *The Fisherman is the Fish*, she did a two-day exploration of the Zen koan. Her own body was the focus of the performance: at one point, she was wired to the wall and had a "how-to-fish" film projected on her torso. She also used the performance to explore dramatically and explicitly both her relationship with her sportsman father, and related issues of gender roles: Who's the victim? Who's the hunter?

Barbara Smith is presently working on two community action performances. The *Religion of the Holy Squash* is both a parody of Christianity and a statement about earth-oriented feminism. *Ground Zero* has been conceived for SPARC (the Social and Public Art Resource Center, founded in 1976 by muralist **Judy Baca**, artist **Christina Schlesinger** and filmmaker **Donna Deitch**). People will start in one-mile radius lines out from SPARC, then converge on the old jail building. Smith is convinced that as they walk toward SPARC, the participants will encounter all of our nation's social problems—poverty, homelessness, racism, sexism, etc. They will bring the problems into the center, where Smith

will perform a healing ritual. As Smith says, "The work isn't so personal any more. It's gone through that, now it's a lot more about healing. My work has gone through stages; it's taken consciousness leaps. One was the result of when I got involved with Buddhist meditation (to try and deal with the sorrow over losing my children in the divorce). Then I was raped, and that took me way out of the personal, threw me into a much larger space. My identity became the earth. What happened to me is what is happening to the earth. . . ."

Rachel Rosenthal is another artist who began with performances that were extremely personal and autobiographical, but has moved to global issues. After years of traumatic vacillation between painting and theater, between what she perceived as the inherent contradictions in the term "woman artist" and her parents' stigmatized view of acting as a profession, Rosenthal came to performance through the Woman's Movement. Rosenthal's first performance, *Replays*, was done in 1975. Composed shortly after her mother's death, it dealt with how her knees had become so painful after her mother's passing that she couldn't walk, as if her mother hadn't left her a leg to stand on. "I decided to do a piece on it, from the point of view of how did I get myself to that condition, on a psychological and autobiographical level," she explains. The swelling went down right after the performance.

Her work from 1975 to 1981 was primarily autobiographical, although she always used her life events as metaphors for larger issues. Then in 1981, she did a powerfully realistic piece entitled *Soldier of Fortune*, which dealt with how she had been embezzled out of all her money. After that, she was no longer solely interested in reconstructing her life through art. Since 1982, she has dealt with issues such as nuclear power, toxic wastes, feminism, animal rights and the relationship between spirituality and technology. Rosenthal has manifest social goals in her work: "I need to know that the earth is given a chance to survive and that she will continue long after we are gone. . . ."[11]

Betye Saar says that she has moved through images of her ancestral past to those of her racial past to those of her personal past. Saar is, like Robin Ficara, an assemblage artist. She collects revered antiques and refuse, precious saved icons and discards, then arranges them in combinations that are unexpected, unsettling, often beautiful. In 1975, Saar's great aunt Hattie Keys died. While dismantling her aunt's house, Saar found faded photographs, lace-trimmed gloves, embroidered handkerchiefs—things that symbolized her family's past. She began creating objects and images of her extended family, her grandmother, her mother, herself. She framed sepia portraits with aged lace and stitched memorabilia. She collected personal souvenirs and placed them in padded boxes.

Now Saar is focused on future images, which she sees as both autobiographical extensions and mystical predictions about the earth, the environment and the human spirit. She labels her recent art "visionary," saying that it often deals with dream time, with reverie, with those moments "in between." Like Rosenthal, she had moved beyond specifically autobiographical material to encompass the cosmos in her own artistic universe.

The Self as Child

Laurie Pincus uses dream imagery, but her dreams are those of a child. Indeed, she says that her art is a direct continuation of when, at age three or four, she used to divide her crayons up into male and female characters and invent stories about them. Today her characters are cut from plywood, then painted in bright acrylic patterns. They range from miniature to larger-than-life size, so that the viewer is disoriented, forced—like Lewis Carroll's Alice—to suspend her familiar hold on reality. Pincus portrays herself as an adolescent, asleep in her cluttered bedroom with a companion dog crouching at her feet. All around her, adults perform the trancelike roles of modern life. A glamorous woman searches endlessly for Mr. Right. A couple stands in a squarish rowboat on a moonlit lake. They embrace, but their arms coil like enervated serpents, and their glazed eyes wander off in opposite directions. Five women pose in vapid self-absorption around a Palm Springs swimming pool. Pincus' characters parade blindly before her, in passive acceptance of quiet discomfort. They defer awareness to an unattainable future. Each image is engaging in its brilliant visual appeal and discomforting in the distilled profundity of its satirical, often sinister depiction.

Pincus' art expresses her life in the city of illusions, a life where fantasy and reality collide constantly and jarringly. Involvement with the industry of illusions, Hollywood, has always been a factor of Pincus' life. Her father was in the movie industry; her commercial artist husband often designs movie posters. Pincus' wooden tableaux are like colorful sets onto which she hopes viewers will project their own movies.

Gloria Longval paints images from her childhood, but she grew up far away from Los Angeles and the illusive glamour of the film world. Longval was born in the Ybor City section of Tampa, Florida. Her mother's parents were Cuban. Her father's parents, who were of mixed French and Cuban descent, prevented their marriage because of class differences. Then Longval's father died, by drowning, when her mother was three months pregnant. Longval was

raised by her grandmother, who was a *bruja*, a spiritualist practicing the Santeria cult imported from Africa. Longval remembers the rituals of her childhood, the dolls with pins stuck in them, the sacramental vessels, the flowers, masks, birds and cats. Her paintings portray the netherworld of her childhood, and there are always children in her paintings. "The children are always me," she asserts—and there is always a vieja, a wise old woman. The canvases are crossed with shadows, darkened by the veils of time, blanketed in evocative, ghostly hues. Longval paints the internal shades of memory, rather than any tangible, exterior reality.

Kathryn Jacobi also paints images of her childhood, images caught in the obscure dusk of memory. Her series of self-portraits as a baby she titled *Dwarf in a Tall Man's Closet*. She explains, "I had always been interested in dwarfs, then I read in Leslie Fiedler's book on freaks how people tend to project their dreams, fears and nightmares onto what society calls freaks. Each of us has an image of our secret selves, an image that has almost mythic proportions. I had always been empathetically connected with dwarfs; it was an image I'd always carried of myself. Then I found this photograph of myself in a family album. I was age one or one and a half, and I had the dwarflike face and proportions I'd always envisioned. So I had to paint it." She did a series of ten paintings in 1987, trying again and again to come to terms with that image of herself as a dwarf/baby. In many of the paintings, she places herself in a closet that has shirts hanging in it. They imply the presence of her father, with whom she had her strongest and earliest attachment. The portraits are dark, lit by deep purplish-red light. The dwarf/baby emerges from a shadowy haze to gaze at the view with wise and serious intent. There is a poignancy to these portraits: babies grow so rapidly that they seem to evolve into different people almost every day, every hour even. This dwarf/baby looked like the photograph only once, then changed, then changed again. And yet, Jacobi is recognizable, and she used the portraits to recognize (that is, to re-know) herself in that image and time. Kathryn Jacobi came to her work with photographs from old family albums in a desperate attempt to understand the passing of consciousness, of life, of time. "As far as I can figure, the theme of the 20th century is time and how it becomes compressed and expanded. The function of an artist at this time in history is to create symbols of continuance. Religious messages have been expunged, are relatively useless for must of us, and have left us with a total void in any sort of experience of life continuing. I think that is why images of children, images of people in general, are so compelling."

Jacobi also has painted her parents from family album photographs of the 1910s and 1920s. These portraits help her to understand what of them is in her. As their child, she is in a very real sense their symbol of continuing life, just as their portraits function—for her—as images of time expanding, contracting, doubling over on itself.

The Mother and the Self

For many artists, new visions of themselves are only possible through new visions of their parents. The relationship with the mother is often central; in researching and creating images for their mothers, women artists come to terms with their inherited identity, their place in history and family, the realities and illusions of mothering. They also address the meaning in their shared joys, their separate anguishes, the haunting silences of unexpressed emotions. As Erica Jong has said, when you become a mother, you become Everywoman.[12]

June Wayne's mother Dorothy died on June 25, 1960. A week later, Wayne officially opened the Tamarind Lithographic Workshop, which she headed for ten years. The first print Wayne did for Tamarind was an image of her dying mother entitled *Dorothy, The Last Day*. When Wayne saw the print reproduced in Time magazine, she felt chilled. "Dorothy was very prideful of the way she looked and would have been horrified to have people see her at that moment. I hadn't thought about that at all when I made the print, there was so much more about Dorothy than death. But when I saw that corpselike image reproduced, with the skin of her head and hands the color of earth, well, I felt as though I'd committed a public gaffe. I realized I would have to make it up to her somehow." Fifteen years later, Wayne sat in her studio and, on a whim, took the check Dorothy had given her for a last birthday gift, and a triple string of pearls Dorothy had also given her, and created a print. The print had "a rather special look" that Wayne liked. For the next print, she used Dorothy's social security card and glove. And Wayne realized she had created a whole methodology to restore Dorothy, to let her speak for herself, as she (Dorothy) saw her life. Wayne researched the life of her mother and found out many things she had not known before, many things that had affected her both directly and indirectly. She spent five years (1975-79) on the 20 prints that make up her "Dorothy Series."

"The problem was to reawaken a sense of her and do it in her terms, not mine. It was a very interesting problem aesthetically. Authors can write in many different voices, but artists generally use their own 'voices.' How could my ap-

proach evoke Dorothy? That issue accounts for all my selections, and also for a certain elegance, a certain restraint in the suite. Dorothy was a pacifist and a feminist. She saw herself as sharing problems of other women. So I picked things that had the greatest resonance, that linked her most to other women."

Wayne was actually "mothered" by her grandmother. Dorothy went out to "bring home the bacon" as a travelling saleswoman who sold bras and girdles. In the "Dorothy Series," Wayne portrays her mother's travels, her sales, her marriages and her politics. In 1934, Dorothy was a delegate to a meeting of the Women's International League for Peace and Freedom in Switzerland. Wayne found a photograph of Dorothy and two other delegates waving from the deck of the ship about to take them to Europe, and she used it as the basis for a lithograph. "They could be women today, their clothes are virtually the same," the artist asserts.

The "Dorothy Series" is not only a picture memorial; it is also an assertion that we can endure past the confines of our biographies. Wayne says, "I wanted to give Dorothy a chance to be seen. People arrive and depart, as if nothing happened. I wanted Dorothy to have something better than that."[13]

Nancy Buchanan's early performances were largely autobiographical and they often included reference to her parents. "I'm interested in trying to place myself in the society—and in trying to place my parents. I want to understand who they were, where they fit—which ultimately means where I fit," she says. On Mother's Day in 1979, she did a performance on motherhood at the Woman's Building. She examined the expectations about the perfect mother and her own realities of mothering. Buchanan has also used performance to explore women's roles. "In a lot of the pieces I did about women's roles," she explains, "I used an individual to represent the myth, the role, the cliche. It could be me, or not. Often it was a collection of stories I got from other people. Even when I was doing my most personal pieces, I kept hoping they would be mirrors for shared experiences, that they would be something not just my own."

In 1977, Buchanan planned a *True Confessions* performance to present what she hoped would be the most private, intimate, secret parts of herself. "But I felt a lot of resistance," she admits. "I tried to be as vulnerable as possible, but because I was in creative control—I was in control. I could edit, reshape, delete anything I chose." Of course the artist has control—that is one of the givens of 20th century art, whatever the medium or genre. Further, autobiography is always restructured by the presenter. Such is the nature of representation. When the artist consciously structures that representation to challenge or change the dominant culture's images, that artistic control takes on potent political power.

Much of Buchanan's work from the 1980s is more social and political in content than her earlier work. "You can get so wrapped up in your own life that you don't look outward and change something that's bad," she cautions.

Enduring Images of Self

In focusing on self, art can become eternal witness to the artist's individual existence. Joyce Treiman says she wants to leave a trace of herself. June Wayne says she wants to leave a record of Dorothy (and thus, of herself). Nancy Buchanan says she wants to find where she fits, where her parents fit. These are all attempts to render what Kathryn Jacobi calls "symbols of continuing life."

D.J. Hall uses her photorealist skills to stop time, to freeze moments of happiness, to make lasting images of herself and her friends. Her paintings of the early 1970s often focused on elderly wealthy women caught in moments of indulgent leisure around resort pools. Hall emphasized their tanned wrinkles, their ostentatious layers of jewelry. Looking back, she now realizes that such portraits had to do with her doubts about the values of material abundance.

Now, after coming through therapy to better terms with herself and her childhood experiences, Hall is aware that the best way her art can serve her is to help her create lasting images of those fleeting moments of radiant happiness she most cherishes. She turns her camera on herself and her female friends and paints them smiling from turquoise pools, enjoying drinks in elegant restaurants or celebrating with frosted cupcakes on Hall's beachside porch. Light glistens on the women's blonde hair, reflects off their designer sunglasses, sparkles through the crystal wine goblets. Brilliant tropical flowers contrast with the stylishly subdued fashions. These are gloriously romantic portraits of American idealism. Not only are the moments perfect; Hall's precisionist superrealism is "perfect," too. "I am a compulsive perfectionist," she admits. "Ever since I was a kid, I tried to the *best* in everything—which I was. With art, too, I want to be the very best. And the best to me means it has to look perfect, or even better than perfect. I realize more and more that that's an impossible goal, but it's what I've been after." Hall's perfectionist impulses are directly related to her desire to freeze time. "I used to think that there was magic, that you could freeze time. I *am* freezing time in these paintings. They will live on."

Like all of the Los Angeles women discussed here, D.J. Hall uses autobiographical imagery to construct meaning in her life and, like many of the others, she engages several of the autobiographical "themes" I have indicated. Like Buchanan, Wayne and Jacobi, she represents her mother's life, knowing that she

carries her mother with her always. Like Longval, Pincus and Rosenthal, Hall surveys her childhood to find those memories which have most shaped her adulthood. She also portrays her friends, as do Treiman and Weisberg, among others.

There are other motives for autobiography. Jones, Gaulke, Anderson and Weisberg reexamine their spiritual/religious heritage to find its contemporary significance. Carrasco, Cervantes, Saar and Yashuda plumb their ethnic heritages for images that help them build authentic selves. Neiman, Lanes and Ficara use dreams to understand better their psychological underpinnings, their interior selves.

Many of these artists—Smith, Rosenthal, Saar, Buchanan, Anderson—feel they have worked through their autobiographical reconstruction in art and must move on to less personal, more universal issues. Others feel, with Weisberg, that the more deeply one mines the explicitly personal, the more acutely and accurately one touches the universal. Such autobiographical pursuits are by no means limited to the women of Los Angeles. There is **Carmen Garza** in San Francisco, **Phyllis Bramson** in Chicago, **May Stevens** in New York, **Ellen Berman** in Houston—the list could go on and on and on. More than a decade ago, New York artist **Martha Wilson** told **Lucy Lippard** she had discovered that "artmaking is an identity-making process. . . . I could generate a new self out of the absence that was left when my boyfriends' ideas, my teachers' and my parents' ideas were subtracted."[14] If you eliminate what the voices of authority say to define you, what is left? Women artists continue the daring and difficult task of trying to find their own answers.

I asked Kelyn Roberts to read an earlier draft of this manuscript. His reasoned and articulate commentary seems an appropriate conclusion:

Any act that attempts to define or control power outside the accepted cultural venues is a political act. Women are taking political power from a feminist perspective by controlling their bodies, their lives and—with visual artists—their images as well. Control of one's images separately from the cultural institutions such as religion and Hollywood threatens the existing forms of power including stereotypes of gender, class and assumption of control and conformity. For example, Weisberg's *Scroll* depicts her female Rabbi leading a *bat mitzvah* for her [Weisberg's] daughter. Weisberg is engaged in an active, powerful dialogue with her religion as well as her inner feelings and sense of continuity within time. By identifying themselves singularly either in self-portraiture or in individual action, these women become centers of power, as role models, leaders in questioning dogma, and as choosers of what aspects of a culture are to be questioned, recorded and preserved. In fighting for their own lives, they threaten to save all our lives.

—**Betty Ann Brown**

Notes

1. Whitney Chadwick, "Women Artists and the Politics of Representation," pp.167-186. In, Arlene Raven, Cassandra L. Langer and Joanna Frueh, editors, *Feminist Art Criticism, An Anthology* (Ann Arbor: UMI Research Press, 1988). An earlier discussion was, of course, Linda Nochlin, "Why Have There Been No Great Women Artists?" In, Thomas B Hess and Elizabeth C. Baker, editors, *Art and Sexual Politics* (New York: Collier Books, 1971, 1973).

2. Robert Pelfrey with Mary Hall-Pelfrey, *Art and Mass Media* (New York: Harper & Row, 1985).

3. *Los Angeles Times* Sunday Calendar Section, July 1988.

4. See Lucy Lippard, "Making Up: Role Playing and Transformation in Women's Art," in her *From the Center* (New York: Dutton, 1976), for a discussion of earlier autobiographical imagery in conceptual art by, primarily, New York women artists. See also her "The Pains and Pleasures of Rebirth: European and American Women's Body Art," in the same volume.

5. The proceedings of "The Way We Look, The Way We See" are to be published by The Women's Building in Spring, 1989, with Betty Ann Brown, Shelia Levrant de Bretteville, Sondra Hale and Joan Hugo as editors.

6. Thalia Gouma-Peterson and Patricia Mathews, "The Feminist Critique of Art History," *The Art Bulletin* 69, no. 3 (Fall 1987), pp. 326-357.

7. Judy Chicago's Dinner Party Project is the most notable. Chicago and her large team of artist-workers (which included everyone from conservative Midwestern porcelain painters to radical feminist lesbians from California) discovered—and honored—hundreds of women from history. See Judy Chicago, *The Dinner Party, A Symbol of Our Heritage.* (Garden City, New York: Anchor Books, 1979). In 1983 and 1984, the Southern California Women's Caucus for Art mounted a performance in which each of the thirty-some participants impersonated a historical woman artist. We researched the artists' lives, read whatever writings they had left us, then created a short speech, using, as much as possible, their words. I, the only art historian involved in the project, was Rosa Bonheur.

8. All of the quotations are from interviews I conducted in 1988. Many of the quotations, and some additional sections of text, are adapted from my forthcoming book *Exposures: Women and Their Art* (Newsage Press: 1989), co-authored with Arlene Raven and illustrated with photographs by Kenna Love.

9. Thalia Gouma-Peterson and Marion E. Jackson, *Ruth Weisberg, Paintings, Drawings, Prints 1968-1988* (Exhibition catalogue). (Ann Arbor, University of Michigan, and New York: The Feminist Press, 1988), p. 28.

10. Shifra Goldman, "Portraying Ourselves: Contemporary Chicana Artists" in Raven, Langer, and Frueh, op cit, pp. 187-206.

11. I am reminded of Eleanor Munro, *On Glory Roads, A Pilgrim's Book about Pilgrimage* (New York: Thames and Hudson, 1987), which discusses how we are developing a mythic system in which the continuity of the planet (rather than the individual soul or race) is our sacred purpose as a people.

12. Erica Jong, *Parachutes and Kisses* (New York: New American Library, 1984).

13. For another discussion of images of the artist's mother, see Moira Roth "Visions and Re-Visions: Rosa Luxemburg and the Artist's Mother" in Raven, Langer, and Frueh, op cit., pp. 111-132.

14. Lucy Lippard, op cit., p. 106.

Nancy Ann Jones, *Challenging Myths #3*, multimedia drawing, 1986.

Kathryn Jacobi, *Self Portrait as a Baby*, o/p, 1987.

Carol Neiman, *A Fine Romance My Dear This Is*, color xerox/pencil, 1987.

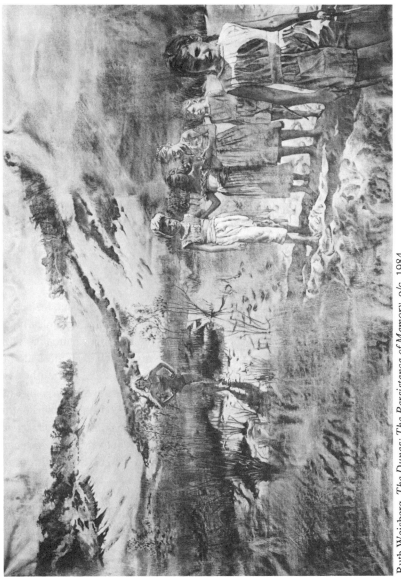

Ruth Weisberg, *The Dunes: The Persistence of Memory*, o/c, 1984.

Art and Spirituality:
Eight Women

When first asked to contribute a chapter to a book about women artists in California,I thought that choosing a subject close to my heart and my involvement as an artist,that is,the spiritual dimension,would be easy to put together. Instead,the project became a process of deep introspection for all concerned.

My friend Melinda Wortz consented to collaborate with me on this project. We invited artists to submit their ideas as to what is spiritual in their art, or their understanding of the meaning of the spiritual in contemporary art. The articulate responses are self explanatory.

—Bruria Finkel

In ancient China or Peru, Mesopotamia or Greece, Egypt or England, the need to identify art as spiritual would simply not exist. Art's purposes were clearly understood to be means for maintaining, praising, facilitating or entreating those forces in the universe that are greater and more mysterious than mere mortals can comprehend. Images of Isis and Osiris, ritual vessels, monolithic and megalithic stones configured in ceremonial formality, temples and cathedrals were all dedicated to higher purposes or powers—forces beyond human control. Cultures throughout the world focused their creative imagination in the service of cosmic events, in the hope of finding a niche for human beings in realms beyond life and death. Art sought to participate in the sustenance of cosmic orders, invoking those which were benevolent and placating those with malevolent powers.

The great religions—Buddhism, Judaism, Christianity and Islam—codified and ritualized paths of behavior and morality. Adherence to these systems promised rewards in the afterlife to the faithful. These religions used art and ritual in various ways, according to their own doctrinal beliefs. In the Middle Ages, the cathedral builders created monumental structures in praise of the glories of God, while the Renaissance popes employed masters such as

Leonardo da Vinci and Michelangelo to adorn sacred edifices with monumental frescoes.

In Western Europe, the questioning of belief systems was followed by the massacres of the Crusades and Inquisition, with the emphasis on fear and punishment. With the Reformation and the Enlightenment came additional schisms and new beliefs. By the end of the 19th century, many theologians found so much difficulty with traditional beliefs that religion itself, at least in the western world, became more and more secularized.

The age of the individual, rather than the communal, dominates the culture of the 20th century. Television evangelists have so altered the purposes of the church to gratify their own needs that religion itself has become suspect in our era. Western religions have also turned more and more away from incorporating art into ritual, so that art itself is now more secularized than spiritual. Hence the need to recognize that a minority of artists working today are calling upon spiritual traditions, imagery and ritual for the expression of their artistic aspirations. Except for work on projects such as the Cathedral Church of St. John the Divine in New York, few opportunities are available for contemporary artists to participate within a religious context.

Recognizing the need for a reaffirmation of the place of spiritual aspirations in art, we focused this chapter on women artists in Southern California whose work incorporates spiritual issues. For the most part, their work is produced outside a traditionally religious context. The majority of these women practice some sort of personal meditation or ritual. In every case, they feel the need to augment their personal practice with larger perspectives. All have travelled extensively, as is evident in their individual statements. While the personal enrichment of understanding the wonderful plurality of world cultures is exhilarating, this knowledge does not stop with personal gratification. Virtually all of these women are highly aware of the cosmic catastrophes that are imminent if we do not start caring about the well-being not only of the planet, but also of the universe. Consequently they participate in various organizations involved with universal social problems such as cleaning up toxic waste, alleviating the plight of the homeless and world hunger. The spirituality of our own time cannot be content with personal enlightenment, but must embrace and work toward the ordering of the cosmos. In this respect, these artists have come full circle with ancient cultures.

—**Melinda Wortz**

Intention establishes the legitimacy of the spiritual in art. Otherwise, its critique in the 20th century must be limiting and harsh, for we live in an era of violence, greed, prejudice and inequalities. Though the spiritual is required for hope, it won't be found on ethereal perches.

The faces of the spiritual manifestation are many. We are collections of all that has gone before us, all that has been considered and made by hands. "Appropriation" presents one problem with intention and legitimacy. Though a stylish, familiarizing method in secular art, in spiritual work this emulation contradicts the search for unique purity. The risk in art is in locating the singular voice within, not the visual vocabulary already deemed sane and sound.

The act of making art, like any human activity when we allow it to captivate, transports the maker into the realm of the spiritual. A lack of self-consciousness in combination with a sensation of wholeness is a magical event which supplants the ordinary with the spiritual. The lightning flash of an idea and inspiration explodes with purity and divine rapture. With honest intentions we become lightning rods attracting inspired assistance for our tasks. All tasks.

If the art is a replication of past rituals, its pertinence is its location in the present. Let it evoke discussions ranging from compassionate criticism to the highly stringent. Powerful art does not ignore the world, but embraces its discrepancies and reacts to its injustices.

—Kim Abeles

If the origin of the word *spirit* means breath, then spiritual means breathing. Therefore, doesn't the spiritual put us in contact with the awareness of life? Art, then, becomes a manifestation of our expression of life. I do not believe it is any more mysterious or unknown to us than that; and yet it does make us aware that life is mysterious or unknown to us because we do not see it in all its manifestations, just as we are not totally aware that the breath is being breathed through us. And who is it actually breathing creation? It is that aspect of the breath behind breath, the life behind life, the greater-than-us force, the force that is so much greater than our perceptions, that we as artists humbly try to touch upon, that causes us to fall on our knees humbly and in awe. To think about making art that is spiritual seems a sacrilege. All we can truly do is to sit in the stillness, and perhaps our breath will be an echo of what is out there.

—Lita Albuquerque

I have never felt passionate about painting "issues." I feel no tradition, few connections with the history of painting. I've only recently begun to realize why that may be. Living and growing up on the Pacific Rim, one is equally as far from Europe as from Asia, so that here we are essentially between the edge of two frontiers and inventing our own future.

Six years ago I made a journey to China. I had wanted to travel there all my life, and I will return there. In the Garden of Tranquility at the Summer Palace in Beijing, I had the most singularly profound experience of my life. The uncommon beauty of ancient Chinese architecture, blended with otherworldly sensitivity to the splendor of Nature, was surely planned on the principles of Feng Shui. The whole garden appeared to float. The colors of walls, pillars, roofs—vermillion red, cobalt blue, viridian green and black—hovered over a magnificent pond. The waterpond was covered with lotus plants, some lotus leaf discs three feet across on four-foot stems, all trembling and glistening with myriad tiny water orbs in the morning light, like so many whirling dervishes. I can't describe it! I was completely overwhelmed, and incredibly, I knew in that instant that my first task as an artist is to make painting which is healing.

Ours is a death culture. I suffer moments of sheer terror sometimes when I am painting this darkness, but I know I must continue. Only in this place do I have a chance to build a myth of images and dreams of new life and hope for the many possibilities in the future of our species. Nothing the human mind conceives is unreal. What we dream becomes real. We need dreams of positive models, and so I am working in the dark right now. I feel very strong urges to "see" them. I will always continue to include the ocean, for it represents the eternally healing oracle.

In Spring of 1987 I was at the Vermont Studio Colony for two months. I made many paintings from nature, and they felt absolutely correct. I will be making altarpieces for empowerment, prayer and meditation over the next few years. I will also continue my work politically, with Greenpeace and other ecology groups.

—Cheryl Bowers

During the last decade I became aware of what I regard as spiritual.

It is not religion, even though religion at its best is a vehicle for the spiritual.

It is not ritual, even though it also is a vehicle and practice for the spirit.

It is not a system of belief, for systems confine the spirit in order to create an explanation for structure.

It is not chaos either—chaos does not allow for the spirit to emerge.

Instead, it is more like Firmament—a state of flux; a state of unformedness, a potential, a promise. I believe that is where the spirit resides in its more expressive state. It emerges in the creation of structure and form, so art is a favorable expression through which the spirit can be gauged.

For an artist, the allowing of the Firmament to divulge the form and space is essential; an idea taking hold and then finding configuration is an interesting and amazing process. The insistent flow of image and thought initiates a realized work of art.

In my work I use abstract ideas that relate to myths and narratives both old and new.

My main concern is to interpret the phenomena of Nature and make it accessible to the general public.

In my concept of the Natural Elements Sculpture Park, a project involving many artists who are concerned with natural phenomena, the Santa Monica beach will have a three-mile-long park, open for all to interact with the environment. This is spirituality at its best: the cathedral is the outdoors, and the participant needs no affiliation to be touch with Nature and the Mystery.

—**Bruria**

As a snake sheds its skin and renews itself, so does the creative process provide a vehicle for the individual to re-see oneself in relation to reality through a new metaphor. Although my painting process has gone through a series of image changes in the last 20 years, there has been a constancy in the essence of the image—much like the notion of spirally circumambulating a mountain, crossing the same territory at each round, always at a different plateau.

My inspiration has continually been drawn from the natural world. From earliest childhood my happiest moments were deep in the forests of the Laurentian Mountains of Eastern Canada. From then on a plethora of environments in many countries and continents have pulled me down into the cyclic complexity of myriad detail delineating systems of nature. I have learned, with comfort, to see myself as one of the details in the universal embrace of the natural world. Through patterns immanent and visible in natural structure, I have been able to observe reflections of psychological human dynamics, the wedding of scientific and mystical ideas of creation, and I have gained insight into the fundamental morphology intrinsic to the development of alphabet.

As conjurer, I work until the image sustains full presence, so that it speaks undeniably in a voice of its own, triggering feeling through its form, providing an emotional and physical context which is alluring, evocative and nurturing. When the space and light of life is evident, I am both freed and impelled to resume the journey.

—**Gilah Yelin Hirsch**

So all-encompassing is the presence of light that it seems to embody the spiritual. My work is about the ephemeral: the way a mere "edge" of light defines an entire image; the way light-defined images float and merge and create spatial dimension; the way spatial dimension suggests the deep, the ominous, the unknowable.

—**Helen Pashgian**

spirit
body-house

perceptual instrument
synaptic translator
interprets, re-interprets.

Imposed "mind-frames"
struggles with the "everyday"
Grocery lists impinge on poetic territory.
Rigidity one day, flexibility, the next;
The woven by-products of our diverse strands
tells the tale of our particular dance.

—**Ann Page**

LIGHT LESSONS

My best friend is my passionate love of and curiosity about the world. I have learned to trust the interior voice that identifies my pleasure and preferences; to pay attention to my own joy as the most vigorous way to be. Joyfulness is the vehicle for the life force in nature; both procreation of new generations and new ideas come from the pursuit of joy. I cultivate that voice as my inalienable essence, the seed which helps me identify who I am. And I respond from this passionate center to myself and the world.

My art is not separate from my life. The two are woven together in an evolving fabric. I think it is crucial to use my artwork to speak about my social and political concerns, to become active in contemporary dialog, to make visible the things that I know and feel about the world.

The image I have included here is a xeroradiograph of Kachina dolls. A Native American became fascinated with the image because the Kachina look like space men. The story of the Kachina is that they came to earth from a distant star.

—Sheila Pinkel

Kim Abeles, *Willing Suspension of Disbelief* from the series "The Image of St. Bernadette," mixed media. Collection of Jeane Meyers, Los Angeles.

Bruria, *The Path of One*, detail from the "Divine Chariot Series," bronze.

Gilah Yelin Hirsch, *Dignity*, o/c, 1986.

Ann Page, *That Which Catches*, sculptural installation/mixed media, 1985-86.

Sheila Pinkel, *Kachina Transform*, xeroradiograph, 1981.

Leading Ladies

Although these five artists—June Wayne, Claire Falkenstein, Helen Lundeberg, Joyce Treiman and Beatrice Wood—have been mentioned elsewhere in this book, their contributions to California art for over six decades warrants a full chapter devoted to their accomplishments. Their reputations are well-established—in painting, sculpture and ceramics. All have been honored with exhibitions and retrospectives at major museums, awards and citations. They have been leaders, innovators, role models and mentors. They have been at the forefront of new movements, developed new techniques and influenced several generations of artists. It seems appropriate to designate them as the Leading Ladies of California art.

JUNE WAYNE

June Wayne, noted artist (in painting, printmaking and tapestry), author, filmmaker, educational TV star, lecturer, administrator, feminist thinker and activist, was born in 1918 in Chicago, Illinois. She quit high school at 15 to become an artist and had her first solo show at the Boulevard Gallery, Chicago in 1935; the following year, living in Mexico at the invitation of the Mexico Department of Education, there was a major exhibition at the Palacio de Bellas Artes. Returning to Chicago she became an easel project artist with the WPA Art Project. In the years that followed, Wayne, already showing signs of the Renaissance woman she was to become, continued to paint, while supporting herself as an industrial designer (buttons and other notions in New York's garment district), production illustrator and staff writer for radio, shuttling between New York, Chicago and Los Angeles. In 1945 she permanently settled in California. Reminiscing in a conversation with Gwen Jones, she recalled, "The 40s and 50s were particularly restrictive. In the 30s when I began my career, no one was doing well, so women artists were accepted. There were no jobs, no money for art schools, and American artists were not being shown. The milieu in which I moved as a young artist centered around the WPA art projects, where the job category was 'artist.' As a young woman, it didn't occur to me that I wasn't equal."[1]

Despite the limitations of the era, Wayne painted, explored and refined her technique in lithography (in Los Angeles and Paris) and exhibited profusely during the 50s in major shows at museums in Southern California (Santa Barbara, La Jolla, Los Angeles County and Long Beach); in San Francisco at the De Young Museum of Art, California Palace of the Legion of Honor, and the San Francisco Museum of Art; at the Art Institute of Chicago and the Philadelphia Art Alliance.

In 1959, Wayne set out to revive the dying art of lithography. She presented her plan for the Tamarind Lithography Workshop to the Ford Foundation, envisioning a place where a pool of master printers would be trained, collaboration between artist and artisans would be encouraged, and markets for lithographs would be developed. The success of this master plan is now history. Under Wayne's direct supervision and administration, more than 300 printers were trained and countless artists were exposed to the medium. Virtually all the major print workshops in America today trace their roots back to Tamarind, which was reorganized in 1970 as Tamarind Institute and transferred to the University of New Mexico. In order to avoid any appearance of conflict of interest, Wayne took her own work off the market and went without a dealer during that period.

With the end of the Tamarind decade, Wayne expanded her work into tapestry, traveling to France to work with master weavers in translating her cartoons into tapestries. "Wayne's interest in tapestry did not develop from a need to revive or perpetuate classical procedures, nor did it derive from an exploratory involvement with textural materials or weaving techniques. She came to tapestry as the most suitable means for her visual metaphors while employing sensual materials to invoke an intellectual sensibility. The weaving of tapestry is intensive, rhythmical, and slow. In these characteristics, Wayne found a direct and appropriate way by which she could transmit to the viewer a sense of *time passing* that is internal to the process. She can lead the viewer beyond *real time* to read certain works at a quickened pace, or to perceive others in extended *cosmic time*."[2]

In the late 70s Wayne created *The Dorothy Series*, a suite of 20 lithographs which traveled to museums across the country. Accompanied by a video presentation, the sequential imagery of the narrative, collaged from letters, documents, newspaper clippings and old photographs, paid homage to her mother. Interviewed by Birmingham artist, Carol Sokol, Wayne said: "I thought of the series as a family album, a one-to-one experience. The series is a hybrid, halfway between the *livre d'artiste* in the European tradition and the portfolioed suite of this country where the prints are often independent and intended to be framed.

The Dorothy Series could fit in either category."[3] "For twenty years now, June Wayne has made paintings, lithographs and tapestries inspired by 'the ineffably beautiful but hostile wilderness of astrophysical space,' a wilderness which fascinated her 'where past, present and future coexist in fugue-like overlays.' Ideally placed for such a quest in California, she has been stimulated by visits to the observatory at Mount Palomar, by regularly reading the scientific literature, by discussing the latest discoveries with physicists or astronauts, and by reviewing the pixels that stream to earth from unmanned space probes. In addressing herself imaginatively to our post-Sputnik universe, she has considered the nature of energy from protoplasm to galaxy, and with it the inevitable philosophic questions concerning origin and destiny. The work that has resulted has not been motivated by a desire to illustrate new physical theories, but to invent metaphors which expand aesthetic sensibilities."[4]

"The Djuna Set," paintings, lithographs, collages and tapestries of work from the 70s to the present, was shown at Fresno Art Museum in 1988 and is scheduled to travel in 1989.

Wayne "has always pursued a vision remarkably unaffected by fashion, or the prevailing styles. For despite the interest in the fourth dimension displayed by some twentieth-century artists, the modernist preoccupation with flatness has in many ways discouraged the visual exploration of space-time, as did postwar American art, with its insistence on two-dimensional materiality. It is hardly surprising, therefore, that June Wayne has looked for inspiration not to her contemporaries, but to artists of other centuries who handled related problems. She greatly admires Leonardo's drawings of the deluge which, blending logic with expressive purpose, made energy visible in pictures of cataclysmic turmoil by drawing atmospheric currents like cascades of water. Turner translated sublime atmospheric effect into images of 'tinted steam.' . . . Perhaps most surprising among her acknowledged influences is Albert Bierstadt, who regarded the overland trail to California, much as we regard outer space today, as the ultimate frontier. . . . 'His coloristic bravura and even his sentimentality,' says June Wayne, 'touch me in spite of myself.' "[5]

June Wayne has been honored with some 40 distinguished achievement awards ranging from the *Los Angeles Times* Woman of the Year in Modern Art in 1952, purchase awards from major California museums, the Library of Congress and other national and international institutions, and from such disparate groups as Los Angeles Advertising Women (Outstanding Communicator Award), twice from the City of Los Angeles, YWCA (Life Achievement Award), Women in Business (Woman of the Decade), the Coalition of Women's

Art Organizations, the Women's Caucus for Art, and an Oscar nomination from the Academy of Motion Picture Arts and Sciences as well as the CINE Golden Eagle for her documentary film on lithography *Four Stones for Kanemitsu*, to a Living Legacy Award from the Women's International Center (1989) and three Doctor of Fine Arts degrees.

Notes

1. Gwen Jones,."My Style: June Wayne in conversation with Gwen Jones," Los Angeles Herald Examiner, January 14, 1985.

2. Bernard Kester, "Tapestries,"*The Djuna Set,* catalog, The Fresno Art Museum, 1988, p.18.

3. Carol Sokol, "Personal History as Political Art," *Art Papers*, January 1983, p.12.

4. Pat Gilmour, "Lithographs," *The Djuna Set,* catalog, p.22.

5. Ibid, pp.22-23.

CLAIRE FALKENSTEIN

Typical of Claire Falkenstein was her insistence that she was too busy to spare the time for an interview for UCLA's Oral History Program. When convinced of its importance she "chatted with the future through 15 hours of tape, tracing not just her childhood in Coos Bay, Oregon, but even her parents' courtship. She discussed teaching art and making art, her years in Paris and in California, her feelings about herself, her craft and her community." Her pungent comment on Los Angeles was it's a "sort of frontier town and there's a sense of liberty here to do things." When asked her reaction to the completed oral history Falkenstein said, "I never like to think of things being finished, but I feel things are becoming tidier now."[1]

After graduating from the University of California, Berkeley, Falkenstein plunged into the artistic life of the Bay Area. She was active in the WPA Project, painting several major murals , teaching at the San Francisco Art Institute and the California School of Fine Arts, where her friends included Clyfford Still, Richard Diebenkorn and Hassel Smith, and was president of the Society of Women Artists during the 40s. She left for Paris in 1950. There she became part of the group formed by art historian Michael Tapie called *Art Autre*—a search for something "other" than Cubism. A commission in Rome (1954) led to her developing a technique for combining glass with metal in a kiln. She returned to the Bay Area in 1958 and resumed teaching at the San Francisco Art Institute, but commissions and exhibition invitations called her back to her Paris studio. In

1963 she was offered an exhibition and two commissions in Los Angeles. Her plans to return to Paris were soon scrapped as more major commissions followed. Falkenstein's life and work have since then been closely identified with Southern California.

In her recent painting, Falkenstein has been exploring the figurative in relation to her *Never-Ending Screen* technique. The best examples of this style/technique are the entrance gates to the former Peggy Guggenheim Museum (Venice, Italy, 1961) and the monumental windows and doors of St. Basil's Church (Los Angeles, 1966-69). The original screen concept, created in Paris in the late 50s, was only 10" x 14", and it, as well as the large-scaled works completed since, continue the idea of a "structure that the viewer could look through in any direction to infinity. The only references are points of conjunction and the spaces between the boundaries."[2]

Although Falkenstein is primarily a sculptor, she has also explored drawing, painting, printmaking, glassblowing and jewelry. Her work has no limits in scale—small paper sculpture, three-dimensional wall-hung constructed etchings, prints, and paintings on up to monumental sculpture, fountains and murals. Her "monumental sculpture is much in evidence in Southern California—from the fountain at the California Federal Savings and Loan Building, to the 80-foot-tall window screens and entrance at St. Basil's Church on Wilshire Boulevard," to *Sun Ribbon* at South Coast Plaza. In *Sun Ribbon*, Falkenstein "has employed the principle of torsion (pulling action) for each of the pairs of screens. This principle is the cornerstone of Falkenstein's formal philosophy; she draws her inspiration from the eternal intertwining of the constellations and from the Möbius strip." She "knows that the cosmos evolves continually, she captures its eternal torsion. . . . Although the screens are not truly kinetic, their torsion creates a visual kineticism. Like the Möbius strip, they twist and shift. Falkenstein designed the steel structure to form spaces for glass 'windows.' . . . The structure acts as a windscreen to protect the Center's public expanses . . . and also acts as a main entrance for the Town Center."[3] The installation is asymmetrical, reflecting the non-parallel placement of the ribbons (or panes of colored glass) set into individual frames of Cor-Ten steel.

Falkenstein attributes major influences on her work to Picasso, Klee, Gaudi, Tapie, Toby, Henry Moore, Louise Nevelson and Germaine Richier, in addition to lasting friendships with Adeline Kent in San Francisco and Carla Accardi in Rome.

Claire Falkenstein has had exhibitions in museums in California at the San Francisco Museum of Art (1942, 1948 and 1963), Long Beach Museum (1968),

Fresno Art Center (1969), Los Angeles County Museum of Art (1973), Palm Springs Museum (1980), University of California, Riverside (1984) and a retrospective of her work 1929-1986 at the University Art Gallery, California State, Stanislas (1987); in New York at the Metropolitan Museum (1948), Museum of Modern Art (1954), Whitney Museum of American Art (1960 and 1964), Brooklyn Museum (1970) and the Guggenheim Museum (1978); in Washington at the National Museum of American Art (1985); in London at the Institute of Contemporary Art (1953), Victoria and Albert Museum (1968) and the Tate Gallery (1978); in Paris at Musée Rodin (1961) and Musée des Arts Décoratifs (1962); and in Berlin, Rome, Venice and Osaka. She has been honored by the International Sculpture Symposium, California State University, 1965; Woman of the Year for Art, *Los Angeles Times*, 1969, Women's Caucus for Art, 1981, Vesta Award, Woman of the Year in Art, City of Los Angeles, 1985.

Notes

1. Barbara Isenberg, "Artists Talking to the Future" *Los Angeles Times*, April 9,1982.

2. Virginia Walker interview in *Connecting Conversations*, Moira Roth, ed. (Oakland: Eucalyptus Press, 1988), p. 59.

3. Susannah Temko, "Ribbons of Sun," *Images & Issues*, Jan./Feb. 1984.

Acknowledgments
Additional material from Midmarch Arts *and* Women Artists News *archive of women artists. We are indebted to Jack Rutberg of Jack Rutberg Fine Arts Gallery, Los Angeles, for the information on exhibitions.*

HELEN LUNDEBERG

To enter the space of Helen Lundeberg's paintings is to begin a journey beyond the familiar geographies of human experience. Through shadowed corridors and sun-raked arches beckon vast landscapes of mountain and plain, sea and desert; beyond those, the planets, and yet beyond into the 'intimate immensities' of the imagination.

—Diane Degasis Moran[1]

Helen Lundeberg was born in Chicago in 1908 and moved with her family to Southern California at the age of four, where she has lived ever since.

In speaking about her life in art, Lundeberg says: "From about the age of 16 I looked on the arts as the most interesting field of endeavor, but I had no definite focus. . . . Although I had taken a few art courses in school, going to a real 'Art School' seemed a remote and rather exotic possibility. Then, in a hiatus between junior college and a further stint in academia, a friend of my family offered to stake me to a few months at a small art school in Pasadena. That was my great good fortune. After about three months of 'life class' and 'composition' geared toward illustration, the teacher of those classes left for a vacation in Mexico and Lorser Feitelson took over. It was then that I learned to distinguish art from illustration—and that was *it!* Whatever an artist can learn from another person, I learned from Lorser Feitelson."[2]

Recognition of Lundeberg's talents came early with inclusion in prestigious annuals at the Fine Arts Gallery of San Diego and the Los Angeles Museum in 1931 and 1932, and one-person shows at the Assistance League and the Stanley Rose Gallery in 1933. In 1934, Lundeberg wrote the manifesto for an art movement she founded with Lorser Feitelson, who would later become her husband. Called the New Classicism, it was better known as Subjective Classicism or Post-Surrealism and soon developed a substantial following. Although her work showed the influence of the Surrealist masters Magritte, Tanguy, Dali and DeChirico, the paintings had a unique poetic style noted for manipulation of planes and exquisitely nuanced and subtle color harmonies. With her husband, Lundeberg spearheaded the California avant-garde scene in the years before World War II. Her contributions to mural painting from 1933 to 1941 are documented in the chapter "Women of the WPA Art Projects," above.

At the time of Lundeberg's first retrospective at the La Jolla Museum of Contemporary Art in 1971, she was quoted in the catalog: "My aim, realized or not, is to calculate and reconsider every element in a painting with regard to its function in the whole organization. That, I believe, is the classic attitude. In

contrast to the surrealist program of intuitive expression or subjective unity which *is* the esthetic order of the painting and makes possible the long discussed ideal integrity of subject matter and form."[3] By 1950, although she continued to explore deep architectural space, she was identifying more closely with "Abstract Classicism" (later called "Hard Edge"), providing flat abstract planes for the placement of objects.

It was difficult in 1971 for a woman artist of Lundeberg's reputation to avoid mention of the ferment of the women's movement in California, and to justify her position she said: "I always felt that I wanted to be taken as a serious artist regardless of my sex. I am not a joiner and therefore dislike the idea of joining women artists' groups. I know that there is still some discrimination against women artists but I have never felt it and have not become indignant about it. I realize we live in a male oriented world but I have never gotten very excited about that."[4]

In 1982, Lundeberg had an exhibition at the Graham Gallery in New York, the first one outside California. Writing in *Art in America*, Prudence Carlson described 50 years of Lundeberg's work: ". . . in Lundeberg's paintings, a stark or superficially ultrasimple geometric order emerges out of a very intricately, if intuitively, structured composition. The dominant geometry may be static, experienced as inexorable, and lead back to a puzzle of tight-locked angular shapes; or it may invoke a slow wavelike motion, set up a hypnotic, almost visceral tug-and-pull across a painting's surface. . . . Usually, though, for Lundeberg, a painting's composition takes as its starting point a clean bisection of the canvas into left- and right-hand halves; the division inaugurates a sophisticated formal counterpoint founded on subtle arrangements of functionally 'modular' shapes and on delicate progressions of the artist's signatory desert-pale colors. Yet, for all this formalist acumen, Lundeberg's motive concerns have never been basically abstractionist. . . . Further, despite her work's cerebral bias, it is enlivened by a light-touch lyricism and a quiet but free-coursing subjectivity. . . . Apparent, too, are the artist's abiding absorptions with arrested or visionary time, with both proximate and immense 'outer' spaces, and with imaginary geometries posited as universal. Poetic spareness, an unearthly tranquility, an incessant oscillation between abstract and representational concerns—these traits have been continually at play in Lundeberg's work . . . up to the present."[5]

Helen Lundeberg has had numerous one-person museum exhibitions: Pasadena Art Institute, 1953, Scripps College Art Galleries, 1958, Santa Barbara Museum of Art, 1959, Long Beach Museum of Art, 1963, Occidental College, 1965; and retrospectives at La Jolla Museum of Contemporary Art, 1971, Los

Angeles Municipal Art Gallery, 1979, Museum of Modern Art and Frederick S. Wight Art Gallery, University of California, Los Angeles, 1980-81, San Francisco Museum of Modern Art, 1980 and Palm Springs Desert Museum, 1983.

Notes

1. Diane Degasis Moran, *Helen Lundeberg* (catalog for retrospective exhibition) (Los Angeles Municipal Art Gallery, 1979).

2. *ARTnews*, January 1982, p. 78.

3. Quoted in Henry J. Seldis, Introduction to *Helen Lundeberg: A Retrospective Exhibition* (catalog) (La Jolla Museum of Contemporary Art, 1971).

4. Ibid.

5. Prudence Carlson, "Deep Space," *Art in America*, February, 1983, pp. 104-107.

JOYCE TREIMAN

Her art does not look like anybody's idea of contemporary California art. It does not give back California its idea of the Bay Area as sensuous and meditative the way Diebenkorn's early work did. It does not reflect the self-satirical glamour of the L.A. Hockney bats out with such urbanity. It has nothing to do with either the detachment of Photo-Realism or the self-consciousness of Neo-Realism. It is art dedicated to preserving classic realist painting without getting stuffy about it.

Treiman's art dodges time and place. Its nearest artistic ancestors come from the 19th century. It does not pay a realist's homage to abstract painting. . . . The most modern artists she doffs her hat to are Eakins, Toulouse-Lautrec and Bonnard. She paints, to the delight of her dedicated admirers, like an Old Master.

—William Wilson[1]

Joyce Treiman was born in Evanston, Illinois in 1922. She had her first one-person exhibition at a leading Chicago gallery at age 20, and had established her professional reputation by the time she was 30 with numerous solo shows in New York and Chicago, including the Art Institute of Chicago and in group exhibitions at New York's Whitney and Metropolitan museums. She moved to Los Angeles in 1964, making an immediate splash with an exhibition at the Felix Landau Gallery and garnering the Woman of the Year (for Art) award from the *Los Angeles Times* (1965.).

Treiman's art is timeless; she's a painter in the Grand Manner tradition, with an expressionist vision with Romantic overtones. The figure is central to her art where images of real people—or historical characters—appear in theatrically staged tableaux.

In 1988, the Fisher Gallery of the University of Southern California organized a 20-year exhibition of paintings and drawings called "Friends and Strangers," which travelled to the Memorial Art Gallery, Rochester, New York and the Portland Art Museum. The earliest paintings from the 60s and early 70s were "large-scale, classical group portraits with a distinctly theatrical look. In each of the paintings, a cast of characters (usually including the artist) stands poised as if awaiting direction. The shallow space, dark interiors, unusual lighting, props, costumes and sometimes even a curtain all amplify the drama and the mystery. . . . In the mid-seventies, Treiman embarked upon the poignant 'artist series,' and her palette lightened considerably. Nowhere is the device of casting herself as a character more moving than in these paintings. . . . The most recent paintings incorporate language into the picture."[2] "The exhibition celebrates an art of human situations . . . from the 'anomie' of empty lives to the joys of the creative life, we witness an artist who delights in the diversity of '*la comédie humaine*'. . . . purely imaginative compositions, seem real incidents observed by the artist because they intimately involve her basic feelings and ideas about art and life. Whether critical observer or active participant, Treiman is the chief protagonist throughout 'Friends and Strangers' ".[3]

"Perhaps *The Nude Out West*, painted in 1987, can be viewed as a recapitulation, a summary, of Treiman's work over the past two decades. It is a painting, for example, that combines the artist's interest in portraiture, landscape and monumental narrative allegory. In addition, many of the characters in the painting are old and 'Dear Friends'. Cowboys and other images of the west, including the artist in western and Indian attire, recall her equestrian portraits of the 1960s and the Americana series of the early 70s. Even the cross-eyed buffalo brings to mind the endearing images of animals that have appeared in her work from the beginning." The painting is "a composition of dramatic contrasts, is equally complex in form and structure. Space is at once illusionistic and flat; paint refined and 'brut'; surfaces transparent and opaque. Multiple perspectives and light sources, in addition to blurred, overlapping and intersecting images, further enhance Treiman's unusual approach to visual reality."[4]

Treiman says a painter is "someone who can't live without doing it. You've got to be born with an eye, but then you have to train yourself to make quality judgements. Painting is a process which should involve the full orchestration of

all elements that go into a complete picture—including figuration. The continuity of great painting has been lost in recent decades. Art schools lack the strong historical perspective. I see so much wallpaper art today, art that seems to exist as background for cocktail parties. Art is not a convivial thing, for with every painting you start all over again from zero. It takes guts."[5]

In 1985, for an honor award from the Women's Caucus for Art, Josine Ianco-Starrels wrote: "Treiman creates unforgettable images embodying vanity and fear, conceit and loneliness, despair and complacency: an entire cast of possessed characters who act out our own drama—the drama of mortals without faith."[6]

Notes

1. William Wilson, "Treiman's Memories of Familiar Faces," *Los Angeles Times/Calendar*, February 14, 1988, p. 81.

2. Nancy Kay Turner, "A Grand Odyssey," *Artweek*, February, 1988.

3. Grant Holcomb, *Joyce Treiman: Friends and Strangers* catalog published by Fisher Gallery, University of Southern California, 1988.

4. Ibid.

5. "Joyce Treiman: The Figure is Central," *Artnews*, February 1978, p.65.

6. Josine Ianco-Starrels, *Joyce Treiman* catalog for the National Women's Caucus for Art Honor Awards, Los Angeles, 1985.

BEATRICE WOOD

People sometimes look wistfully at pieces of ancient ceramics in museums as if such beauty were part of a lost and buried past. But Beatrice Wood is a modern ceramist creating objects today that enhance your life . . .

Water poured from one of her jars will taste like wine.

—Anais Nin[1]

Beatrice Wood, born in San Francisco in 1893, had "no intention of becoming a potter." She was in love, she was engaged, she was in Europe. Inspired to get something for her new home, she dashed into an antique shop and bought six luster plates. She had never looked at crafts before. When she got back to America, Wood looked for a teapot to go with the plates, but couldn't find one. A friend suggested she go to Hollywood High School and learn how to make one herself.

Wood's first efforts resulted in two plates she called "an abomination" and two figures bought by a friend for $2.50. Beguiled by the money, Wood decided to study with Glen Lukens, whose USC class was the only ceramic course of stature in its day. She was, she says, "the worst student in the class," having to "struggle and struggle." Being very talented, it seems she had never acquired discipline. However, as John Baxter, curator at the San Francisco Museum, points out, she "managed to acquire a very good technical command," to avoid the pitfall of "affected crudity or childishness," retain her intuitive methods in clay, and do work that is often a sophisticated comment on life as well as "sometimes downright wicked."

Wood began with Lukens in 1938, at the age of 45. In 1948 she "took a gamble" and acquired a one-acre "rockpile" in Ojai, where she set up home and studio, sleeping in the exhibition room, eating in the workroom. Soon she was selling to all the best places—Neiman-Marcus, Marshall Field, Gumps—and getting pretty fair prices, even in those days (her tea service was $1500), averaging some $800 in sales a month, although after commissions that netted only $175. Various business arrangements, including a partnership that didn't work out, were ultimately replaced by the Zachary Waller Gallery, which took over matters such as pricing and invoicing, which Wood was happy to be rid of.[2]

"We give thousands of dollars to a painter who achieves a few lines of color on canvas," says Wood. "It takes sensitive skill and a lot of time to achieve a pot that 'sings,' and it deserves a high price compared to a painting. A really beautiful pot with its intangible quality (such as some of the pots of Gertrud Natzler) are certainly fine art, as are the old bowls of the American Indian."

Today Beatrice Wood is famous for her lusterware. She's also famous for her love affairs with Marcel Duchamp and Henri-Pierre Roche—and friendships with other Dadaists, including Brancusi and Picabia. When the *Los Angeles Times Magazine* interviewed Wood in 1986,[3] they neglected to ask for her secrets of reduction-fired metallic glaze effects, but did want to know, "Are you the Mama of Dada?"

In the 50s, Wood began her "extraordinary" lusters. Garth Clark[4] explains that a luster glaze is a different effect created by metallic salts on the surface, that luster ceramics date from pre-Islamic Egypt, appeared in Europe with the Moorish conquest of Spain, achieved technical brilliance in Italy, lost fashion after 1500, but revived in 1800 when mass production luster with gold and platinum was perfected in England. This was a commercial product in imitation of Sheffield ware, and was called "poor man's silver." Later, potters of the Arts and Crafts and Art Nouveau movements developed rich iridescent glazes,

comparable to iridescent glass developed by Gallé and Tiffany, but Art Deco luster was mostly commercial.

Most prior traditions of luster were decoration over another glaze. Wood's contribution was a glaze that itself held the luster ("in-glaze luster"), done in a single reduction firing. As Clark put it, she showed an "artistry, theatricality, and an adventurousness that exceeded anything produced before [and achieved] a stunning range of colors and textures, from complex gold/pink/blue combinations to viridian greens, rich yellow golds pocked with flecks of matte black, turquoises and silver." Wood herself says, "I feel where art is concerned, there are no rules."

In 1961, when Wood was 68 years old, another important theme entered her life. Kamaladevi, president of the Handicrafts Board of India, paid her a studio visit, and declared Wood's work the "most beautiful pottery" she had ever seen. This led to a State Department-sponsored tour of India for Wood, a second visit at the invitation of the Indian government, and a third "at the invitation of Beatrice Wood." She adopted the sari for her own dress, completed a book on Indian folk art, and then had a show in Japan. Of her enthusiastic reception in Japan, she said modestly, "I suppose they had enough Shibui and were ready for something different."

Beatrice Wood continues to produce some of her finest works. Her autobiography, *I Shock Myself*, was published privately (although publicly available) by Dillingham Press. It seems MIT Press was preparing to publish the memoir, but was cutting out "a little of the spice here and there" to economize. Richard Dillingham, shown the manuscript by a Duchamp scholar, declared, "By God, I'll publish it and put in the spice." (Wood says it was "really very tame for nowadays.") Asked the secret of her long life and continuing vigor, Wood admits to being a vegetarian and a non-smoker. She adds that she never drank, either. "I wanted to be sober when I was seduced."

Regarding her working methods and her philosophy, Wood says, "I have two points of view about craft. Because my eyes have been exposed to our finest craftsmen, I especially enjoy what they do. I call this the 'snob' approach. I am overwhelmed with what is happening in America, with our museums showing magnificent work, inspiring the rest of us. There is, however, another approach, looking at the thousands of people now doing clay and glass. Even if their work is not especially distinguished, from an evolutionary point of view it's very important. They approach aesthetics, open the door to future appreciation of what is fine and beautiful.

I myself work in two categories. One is bowls thrown on the wheel, generally with luster type glazes. These are formulas I've developed myself, and due to the variations of reduction firing, I never know how they'll turn out. Years ago, the great Spanish potter Artigaz gave me some ancient formulas, but they didn't work because materials, water, kiln and atmosphere, besides the potter, were all different. Then, I make figures based on laughing ideas of relationships between men and women. I call these "sophisticated primitives," because they are unschooled and I approach them without any knowledgeable technique. People are divided in their response. Museums have shown both types of work. I insist on doing what comes from my heart, as, whether good or bad, it has its own reality from me."

In 1985 Beatrice Wood was named a Living Treasure by the state of California.

Notes

1. First quote from Artforum, reprinted by WCA [see note 5]. Second quote from Garth Clark [see note 4].

2. Information to this point, unless otherwise noted, from "Beatrice Wood In Conversation with Tim Crawford." *The Studio Potter Book*, Williams, Sabin and Bodine, editors (Daniel Clark Books, 1978).

3. "She Remembers Dada," by Don Stanley, *Los Angeles Times Magazine*, October 5, 1986.

4. "Luster: The Art of Ceramic Light," by Garth Clark, *Helicon Nine*, August 1983.

5. Adapted from an article in *Women Artists News* (Fall/Winter 1987), pp 9-11, incorporating material from literature prepared by the Women's Caucus for Art for its Honor Award to Wood, February, 1987..

"Beatrice Wood" was excerpted from Women Artists News, *Vol.12:4/5, Fall/Winter 1987, with permission of the author, Judy Seigel.*

June Wayne, *Break Out*, color lithograph, 1986.

June Wayne, portrait. Courtesy of the artist.

Claire Falkenstein, *Sign of the "U,"* bronze sculpture with water wall, 1965. Collection California State University, Long Beach, commissioned for the First International Sculpture Symposium. Courtesy Jack Rutberg Fine Arts, Los Angeles.

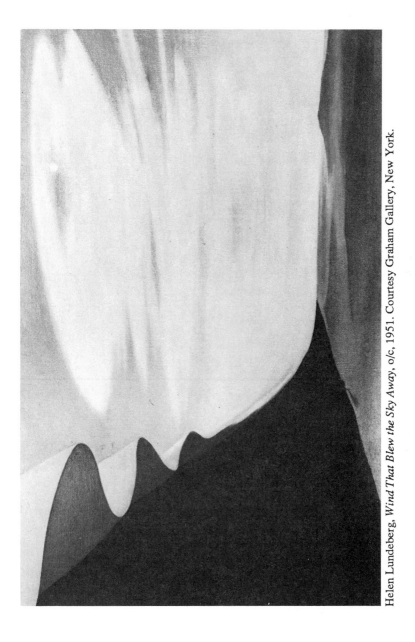

Helen Lundeberg, *Wind That Blew the Sky Away*, o/c, 1951. Courtesy Graham Gallery, New York.

Helen Lundeberg, 1976.

Claire Falkenstein. Courtesy Jack Rutberg Fine Arts, Los Angeles.

Joyce Treiman, *The Nude Out West*, o/c, 1987. Courtesy Schmidt-Bingham Gallery, New York.

[Joyce] *Treiman in Fur* (self-portrait), 1983. Courtesy
Fairweather Hardin Gallery, Chicago.

Beatrice Wood, Loving Cup, earthenware with luster glaze, 1985. Courtesy Garth Clark Gallery, New York.

Beatrice Wood performing in a Duchamp play. Courtesy Garth Clark Gallery, New York.

Silken Threads and Golden Butterflies:
Asian-Americans

Bound to their Eastern culture with silken threads, Asian American women artists in Los Angeles are also highly attuned to Western imagery and have created a rich body of work that symbolizes the symbiotic nature of their lives. Our preconceptions of Asian American art as essentially reductive, spare, calligraphic, subtle, refined and organic are shattered when viewing the exploding, passionate canvases of **Hye Sook**, or the gilded eroticism of **Takako Yamaguchi**'s hermetic Renaissance nudes. The works of art explored in this essay defy categorization, yet always reveal the dichotomy of the East and West. Since Los Angeles is located on the Pan Pacific Rim, the influx of Asian immigrants and their respective traditions has shaped the local cultural landscape and created a fertile artistic climate for the Japanese, Korean and Chinese artists **Mineko Grimmer, Kyoko Asano, Ann Page, Liga Pang**, Takako Yamaguchi, **Jungran Shin, Young June P. Lew**, Hye Sook, **Yuuran Lee, Katherine Chang Liu** and **Julia Nee Chu**.

Three of the most refined visual poets of Los Angeles are the Japanese artists Mineko Grimmer, Kyoko Asano and Ann Page. Mineko Grimmer always loved art, but knew in Japan that she would never make a living as a woman artist. She received a degree in education and worked as a designer for a big commercial firm in Tokyo, then moved to Los Angeles. After the rigid and traditional training in art that Grimmer experienced in Japan, the freedom of her classes at the Otis Art Institute were a revelation. She quickly shed the constraints of academic art and pared down her art to the essentials of nature and spirit.

Grimmer combines spare, elegantly crafted wooden structures with the natural elements of ice and stone to create a series of compelling environments. Pyramids of ice filled with pebbles are suspended over her wooden minimalist structures. As the ice melts, the pebbles strike the wood and create a delicate, random music. Certainly, Grimmer's art is Japanese in its breathtaking simplicity, contemplative resonance and refined craftsmanship, yet the openness of the

California art scene and the natural beauty and variety of the California landscape figure strongly in her aesthetic philosophy.

Recent environmental/kinetic sculptures are eloquent testimonies to Grimmer's holistic approach to nature, where the animate and inanimate resound with spirit and energy. Among her best works to date is her sound sculpture, *Symposium*. Installed at the Whitney Museum at Equitable Center, four open rectangular structures were placed around a square wooden pool. Into each tier of these wooden structures she inserted bamboo rods at various angles. Precariously placed, these rods quivered and sounded when they were struck by the pebbles released from the ice wedge. Grimmer counterbalanced each wooden structure with a suspended, smooth black stone. As in all of Grimmer's work, *Symposium* encapsulates order and chaos. The bamboo rods project freely into space, the pebbles create random music and scattered patterns in the pool, and the irregular black stones hover like magical totems.

The musical component of Grimmer's work is integrated into all her environments. Her most recent installation at the Santa Monica Museum of Art, *Le Cirque de Glace et Caillou* (Circle of Ice and Pebbles), was inspired by a performance of Le Cirque du Soleil which Grimmer saw earlier in the year. Within three different rings composed of rough-hewn pine, Grimmer created her fragile environments of intertwined bamboo rods, strings, quartzite stones and metal. As the pyramids of ice melted, each piece became an instrument producing delicate, sporadic sounds. During a performance with the avant-garde composer Carl Stone, Stone's electro-acoustic recording of random, everyday noises "Jang Toh" mixed with the intermittent sounds being created by Grimmer's process pieces. The first part of the performance was particularly effective, as the low electrical hum of Stone's track combined with the refined music of Grimmer's sculptures to produce a state of Zen contemplation.

Originally, Kyoko Asano wanted to be a poet, and all her paintings reverberate with philosophical speculation. Her earlier mysterious shorelines littered with the forgotten debris of human existence—Pepsi cans, frisbees, letters—have expanded. Each painting is composed of multiple panels and contains elements of abstraction and realism. Her mystical beaches have become an infinite grey ground embedded with disparate objects and symbols; fragments of Einstein's equations for the theory of relativity, a rocket launch, an Angel's baseball cap and Egyptian hieroglyphics. These floating worlds of ancient and contemporary detritus are juxtaposed against panels of pure abstraction. Asano fills these abstractions with dense, interwoven strokes of pure color. Her tiny abstract marks spill over into the realistic panels, creating black holes where the

consciousness slips in and out of history. In several of her new paintings, she injects a panel depicting a solitary bird flying over a limitless ocean. The bird, in Asano's words, ". . . is a symbol of energy, flying through all different times, abstract times, realistic times."

Asano received most of her preliminary education in Japan, including a mastery of calligraphy, but while raising five children in Los Angeles, attended California State University at Fullerton and earned her MFA at the Claremont Graduate School. An exhibition of Claude Monet's paintings at the old Los Angeles County Art Museum originally sparked her interest in visual art, and in the abstract areas of her paintings she still uses an Impressionist palette and technique.

Filled, like the subconscious, with the remnants and thoughts of human history, her paintings draw the viewer into a philosophical debate. "The basic question," says Asano, "is a metaphor. Who am I? What am I? My paintings explore consciousness, relativity of time, space, life and death. In my prior series of paintings, the discarded objects rested in the soft sand. Now, with the new paintings, the sand, objects, and also events are fossilized like a petrified tomb. Thus history, memory and all things and events—fiction and non-fiction alike are suspended in silence."

Ann Page, who was born and raised in Indiana, considers herself a "Hoosier," and creates refined organic sculptures that are potent hybrids of the east and west. Page has immersed herself in the asymmetrical, repetitive patterns of nature. While raising her child, Page began drawing food and plants in her home environment. Popcorn, onions and roses were easily accessible yet infinitely variable. Page's recent mixed-media sculptures such as *Ad Hoc*, and earlier layered paper and wood constructions, are all images born out of her early drawings of the irregular structure of popcorn, or the astonishing, asymmetrical layers of onion. "In looking at nature," says Page, "I found that whenever you cut an onion, you can't help but see that things aren't rectangular and regular, they are asymmetrical. You can see the forces of growth in them."

Page develops her works of art in evolving layers or structures. She is always concerned with preserving the essential spirituality of nature, for her cellular forms encapsulate human emotions. In *Ad Hoc*, the linear connections weave in and out, forming a delicate web that has an infinite capacity for growth.

Page's enigmatic constructions reflect a melding of both cultures. Certainly the use of paper in her constructions and her realization of its inherent flexibility and beauty may be linked to her cultural background, as well as her pantheistic view of nature and her use of organic pattern and repetition. However, Page

grew up with Roy Rogers and Dale Evans, and although her mother did certain things differently, she just wanted to fit in with the rest of the children. Now, she pursues her freedom to experiment, and pushes the limits of her materials, textures and images.

Liga Pang eschews the emotional subtlety and visual refinement of her Japanese heritage for powerful, vividly hued canvases filled with dream imagery. Pang was born in Japan, but was educated at Mount St. Mary's College and the Otis Art Institute in Los Angeles. She now divides her time between studios in Japan and Los Angeles. She also teaches art in Japan, and is the only woman faculty member on staff. She is considered a feminist figure in Japan because she has been able to become a successful woman artist, a rare occurrence in Japan.

Pang works directly on the canvas and recreates her emotions in paint. Her paintings are filled with symbols: the rabbit, a symbol of her childhood, the moon and loosely rendered figures with an Asian look. While her surfaces are filled with painterly activity and intense color, an underlying narrative always links the dream imagery and symbols. In *Letter*, three shadowy, vulnerable figures are part of the drama. One reads a letter: another becomes a winged Mercury. A faceless figure in a suit is perhaps Pang's boyfriend in Japan whom she has to leave for long periods of time while she is in Los Angeles. Whatever the reading of the narrative may be, Pang imbues her drama with much emotive power through her electric color and energized brushwork.

Takako Yamaguchi's strangely attenuated nudes were inspired by the German Renaissance master Lucas Cranach's portrayal of Eve. In her oil on paper compositions, Yamaguchi's nudes pose as mannered sentinels on the edge of her surrealistic landscapes. The anatomical oddities and gestures of Cranach's nudes are further distorted by Yamaguchi. Reclining or standing, Yamaguchi's European-style nudes make a bizarre contrast to the stylized landscape containing curved clouds, flattened volcanos and ornately embellished Renaissance buildings or Oriental shrines. Adding to the mystery are unfinished areas that float through the water and images like fall leaves.

To achieve her rich and sensual colors and surfaces, Yamaguchi initially paints a layer of bronze leaf over her huge pieces of paper. She paints over some areas of the bronze leaf and leaves other areas alone, adding an exotic dimension of shimmering gold light.

Yamaguchi came to the United States on a scholarship to Bates College in Maine, where she majored in communications. She attended the Rhode Island School of Design briefly then moved on to the University of California at Santa

Barbara for her M.F.A. degree. The freedom of her classes at UC Santa Barbara and her introduction to Western art history opened her mind to a myriad of artistic possibilities. When she returned to Japan, she felt nostalgic for the beauty of the landscape and for the rich aesthetic traditions of her homeland. In the late seventies, Yamaguchi began to create densely patterned and ornately decorated screens. Now, influenced by a year in Paris and a long stay in Japan, she combines symbols of the Western Renaissance with the isometric perspective of Japanese art to create compelling and erotic images.

The Korean artists Jungran Shin, Young June P. Lew, Hye Sook and Yuuran Lee have a passionate approach to their art. Jungran Shin grew up and attended college and graduate school in Korea, then received another Masters' degree from the California State University at Long Beach. In her exuberantly colored canvases, Jungran wants to capture the conflicts of her life. Hovering between abstraction and reality, her images reveal the opposites of Yin and Yang, male and female, positive and negative, and light and dark. While living in Korea again during the mid-eighties, Shin conceived a series of brilliantly hued landscape/abstractions called "Mindscapes." While living in Southern California, Shin had sorely missed the intensity and beauty of the four seasons. Her stay in Korea and exposure to the variable seasons inspired her to heighten the intensity of an already luminous palette and to return to the elements of landscape. Shin returned to Los Angeles with a renewed appreciation of her traditions, particularly the glorious colors and patterns of Korean folk art. Yet she feels that her western art training and the sophistication of the contemporary art scene in California has been essential to her growth as an artist. Shin has been most successful in placing her work in Korean galleries and museums.

Shin is frank about the emotional level of her paintings. After major surgery and a lengthy recovery, Shin started a new series, "Crying Eyes." Huge abstracted eyes and tears fill the canvas and interact with her gestural brushstrokes and glowing colors, ranging from deep crimson to royal blue. She pours out her feelings in the "Crying Eyes" series, "I cry a lot these days. When someone cries they can be happy or sad. When people cry they are being honest, they are revealing who they really are inside. Although I paint crying eyes, I still want to create harmonious beauty. I want my paintings to reveal the joys of life, not just the sadness."

Young June P. Lew also draws directly upon her emotions to create her powerful and expressive paintings that contain both abstraction and figuration. Lew grew up in Korea during the war and lost her father when she was two years old. She moved to Southern California in 1973.

Lew's work is a reflection of images and symbols from her childhood. *From White to Black 87-3* is filled with the memories of a childhood marred by a terrible war. Included in the painting is a mask that was her father's. Lew remembers peeking in a closet as a child and being frightened by the mask's frowning countenance. Always in her paintings she includes a white rectangle, a symbol of the linens her mother used to hang out on the line, to her they represent light and freedom. The shadowy figure is herself and other Korean women waiting for fathers, brothers and sons who never returned. Another recurring leitmotif in her paintings is the reaching hand. As a child, she and other children used to visit a famous tomb, and dared each other to reach into a narrow opening in the tomb. She used to imagine that butterflies were born in that dark hole. Filled with luminous blues, purples and deep blacks, her paint surfaces are layered and reworked, yet still retain a gestural fluidity.

Hye Sook, one of the most energetic and politically active of the four Korean artists, immerses herself in the symbols of her ancient culture to produce her potent, expressionistic paintings. A performance artist as well, Hye Sook is always aware of the clash of her immigrant status and the five-thousand-year-old history of Korea. Used to working with bold and dramatic gestures, Sook brings this vibrancy to her large paintings, filled with color and symbols of Korean history. In *1943/Death in Manchuria*, she limits her palette to black, a dazzling royal blue and white. The shattered body of a Korean soldier, far from home and the fight for Korean independence, lies in the snow next to a riderless horse and an abandoned chariot. Two horse heads (the horse as a symbol of youth, beauty and strength is omnipresent in Sook's paintings) lie beside the chariot wheel, itself a black ring encompassing the horrific scene. The drips, splatters and strong, expressionistic brushstrokes mingle with the intense coloration and emotional imagery to reveal Sook's bubbling passions.

Sook continues to steep herself in the poetry and philosophy of her Korean culture and mixes in these symbols to create paintings such as *Islands* . Simple but powerful, the painting depicts broadly outlined horse heads swimming against a strong tide of blue and black paint.

Another recent painting, the *Destruction of Idol: Mao* encapsulates Sook's aesthetic and political beliefs. In sweeping gestures, Sook paints a prehistoric elephant skull emerging from an electric blue ground. "Recently," says Sook, "I have been thinking about the revolution, and reading about Mao. As a human being, I was thinking about all the people who died in 20 or 40 years of revolution. Yet Mao was a huge idol to millions of Asians. The blue ground, which resembles a woman's skirt or the wind, is for me a huge emptiness of space that

breeds death and rebirth. The huge elephant skull is Mao or any dictator. When I first saw the elephant skull in a museum in Bonn, West Germany, I wanted to revolt against its awesome power. I wanted to stand in front of it nude with blood smeared all over my body. Later, I found out that Joseph Beuys had his photo taken in front of this elephant skull. Beuys is dead now, but we both stood in front of the skull and understood the same things."

Yuuran Lee subtly evokes the wonders of nature and the surreal ambience of the major cosmopolitan cities of Los Angeles, Paris, New York and London in two new series of her mixed-media paper pieces *Spring Hail* and *Journey to Nowhere*. Working with black Japanese ink on paper, Lee builds up layer upon layer of ink to create velvety black grounds. She then delicately paints in the details of the landscape and adds tiny bits of torn paper and string to create dimension and harmony.

In her search for identity, Lee feels close to her past. She was born into a scholar's family and lived a cloistered and sheltered existence before moving to Los Angeles. She has degrees in literature, art and design, but sometimes feels overwhelmed with raising a child and the simple tasks of day-to-day existence. Among her ancestors was a woman revered in Korea for her intellect and all encompassing talents. Yuuran was brought up to follow in her ancestor's footsteps as a Renaissance woman.

During the early eighties, Lee's spare, abstract compositions symbolically referred to the freedom of the butterfly. Now, in *Journey to Nowhere: Los Angeles*, Lee combines delicately rendered palm trees with the shrines, mountains and rivers of an ancient Korean landscape scroll. Her compositions are still minimalistic, with areas of ebony black ground highlighted and counterbalanced by the string and torn paper.

The dream-like atmosphere of a hail storm is captured in her "Spring Hail" series. Tiny balls of hail bounce off the grass and then melt back into the ground. Lee's refined touch is present in the tiny blades of grass, the muted colors, the scattered dots and flecks of paint, and the symbolic placement of the sky and horizon lines. Lee remains a visual poet who lyrically evokes the beauty of nature and the traditions of her past. "Often," she says. "I feel that I am unable to describe my feelings and thoughts, even with an ever-growing vocabulary. I began to envy my ancestors who could freely translate their feelings and thoughts into beautiful poems with a few words or paint with just black ink and brushes."

As children, both Katherine Chang Liu and Julia Nee Chu were trained in traditional Chinese brush painting techniques, but their work is completely divergent. When she was a child, Katherine Liu wanted to pursue studies in art and

architecture, but Taiwan was undergoing an industrial revolution. Children with a proficiency in math or science were encouraged to study in those fields. Art was considered a hobby or a luxury. Liu came to the United States on a scholarship to Berkeley, where she received undergraduate and graduate degrees in biochemistry. She met and married her husband, an engineer, and then moved around the country with him, always taking art courses and beginning to build the foundations of her dazzling facility in watercolor.

After a trip to Europe, Liu became fascinated with the ancient walls and facades of the old buildings and incorporated these images into her watercolor series, "Ancient Rumors." In these watercolors, she layers rectangles of gradated color against glowing abstract backgrounds. The fissures and cracks of the walls are transformed by Liu into a luminous map of color and form.

Another recent series also delves back into the past as she places ancient objects and fossilized relics into poetic compartments. More subtle in color, *Chambered Relics #2* is one of the best of her new series of mixed-media paintings. On the bottom layer of the painting, the delicately rendered form of a fossilized fish is encased in a diffused rectangle of color, while above, torn pages of ancient parchment are frozen in time. As she explains, reality and abstraction are held in a tenuous balance, "I like to create reality on the surface of my paintings. I don't look at anything real when I paint. My paintings come from quick sketches of compositions and shapes. All these cracked walls and ancient objects come mainly from my ideas for compositions. I sketch out an idea and then, at one point or in one area of my painting, I eventually make the image look real, a reality that is created by myself." Her Eastern traditions and Western training are combined in her work. The refined blending of her luminous colors, the subtlety of her modeling, her sensitivity to nature and her dainty touch all contribute toward her poetic encapsulations of reality.

Julia Nee Chu's spunk and energy flow directly into her animated and lyrical abstract paintings. Caught unexpectedly in the Communist takeover of mainland China in 1949, members of Nee Chu's family left Shanghai in four different escape attempts. Julia was the last to leave. While she was a teenager, she spent many harrowing years completely alone in Communist China. In 1957, she eventually escaped to Hong Kong in a bottom of a boat, and found her parents. To this day, she still wakes up shaking in the middle of the night and wonders where she is. Since Nee Chu escaped without any papers, she fled to England, then Paris, since the French still officially recognized Taiwan. With her passport, she arrived in Los Angeles, but then left for New York. After a stint at the Art Student's League in New York City, she moved back to California and

went on to receive her B.A. and M.F.A. at the University of California at Los Angeles. She is now represented by galleries in Los Angeles and Tokyo, and the Taipei Fine Arts Museum plans a solo exhibition of her paintings in 1989.

In China, Nee Chu came from an intellectual and artistic family. Her maternal grandmother was a famous local artist. Nee Chu grew up with Chinese brush painting lessons and mastered all the techniques of copying her grandmother's scrolls and writings. As a girl, she studied the classics of Chinese literature.

Nee Chu's abstractions are full of poetry and motion. One of her most poignant canvases, *After the Rain*, grew out of a visit to mainland China. She returned to the village where her ancestors are buried, and instead of graves, she found fields. Luminous blues, greens and gold rectangles jostle against each other in Nee Chu's rhythmic layering of imagery. Black calligraphic circles overlay the rectangles, and her expressive and loose paint handling ties the composition together. The loss of her heritage and the beauty of nature, sadness and joy, are inextricably linked in this lyrical homage. Nee Chu does go back to her roots for her basic philosophy, "My work encompasses nature. It is so deeply ingrained in me as a Chinese that we are part of nature. We believe we are just a tiny speck on the earth."

During a bleak emotional period, Nee Chu painted *The Night Visit*, a shorthand impression of the urban night. Gestural circles, dots and rectangles vie for attention in this electrified composition. Pitch blacks, grays, greens are energized by sulfuric yellows. Nee Chu's zest and exuberance comes through even in this painting of a dark mood.

Nee Chu's paintings truly sum up the dichotomy of the Asian American artist. She yearns for her roots, and continually searches for her personal identity in a culture worlds apart from her homeland. Yet she has assimilated the freshness, vitality and freedom of the West. Even in Nee Chu's imagery the two cultures coalesce. The graceful calligraphy of her lines and her use of pitch black energize the glowing layers of color and the jazzy rhythms of her compositions.

Except for Ann Page, every one of these artists has directly experienced life as an immigrant. Uprooted from Japan, Korea and China, they were eventually transplanted to Los Angeles and have thoroughly assimilated Western cultural modes. Yet all of them still carry their aesthetic and cultural traditions deep within their souls. Passionate and spiritual, their works of art simultaneously reveal two cultures mingling and clashing. Freed from the inhibitions of centuries-old traditions, these artists still incorporate fragments of their cultures into their work, creating a fascinating spectrum of imagery and philosophies.

Because of the proximity of Los Angeles to the Pacific rim, the Asian artistic community continues to grow and gather strength. The artists described here have both enriched and expanded the boundaries of the contemporary mainstream in California. Struggling through the technological urban sprawl of Los Angeles, these women artists have deepened our respect for nature and illumined the infinite layers of our universe.

—Kathy Zimmerer

Katherine Liu, *Chambered Relics #2*, mixed media/c, 1987-88. Courtesy Louis Newman Galleries, Beverly Hills.

Mineko Grimmer, *Symposium*, installation at Whitney Museum at Equitable Center, New York, 1987.

Liga Pang, *The Letter*, o/c, 1988.

Julia Nee Chu, *After the Rain*, acrylic/wood panels, 1987.

Hye Sook, *Islands*, acrylic/c.

Black Women Artists in California

The styles of two artists born and living in Los Angeles, **Varnette Honeywood** (b.1950) and **Betye Saar** (b.1926), could not be more dissimilar. Yet they both explore the rituals of their ancestors, their childhoods and their present lives. Honeywood, working in broad, flat, brightly colored shapes of acrylic and collage, wants to "record . . . endangered scenes—rituals and traditions that will one day be no more." She wants her work to tell stories, and the titles of her works reflect that wish: *Preacher's Pet* (1978), *Snuff Dippers* (1980), *Birthday* (1978), and *Gossip in the Sanctuary* (1974). Richly figured papers and fabrics contrast with the solid, clear colors that form her figures to create scenes of humor and warmth, and to express the love of color she finds in black communities. She continues to live with her parents, crediting them for her inspiration. Her father's hobby of making mosaics and her mother's clothing designs, as well as their stories of life in rural Mississippi and Louisiana, are reflected in her work. "Both my father and mother have a lot of images they want me to paint." Honeywood's images are literally and physically accessible: her paintings are seen on *The Cosby Show* as part of the Huxtables' art collection, and a line of reproductions and notecards is available. Spelman College, Atlanta, her alma mater, honored her with an exhibition in 1987, "Traditions: She who learns teaches."

Betye Saar attempts to portray the spirit of ritual rather than the rituals themselves. Her symbolic range is enormous, although assemblages of boxes and altars are small pieces. Handkerchiefs, photographs, feathers, bottles, shells, beads, small furniture and metal objects are just a few of the many components of her work. They are all objects that were once used so they qualify as "remnants of lost memories"; "they are connected with another sensitivity."

Saar has travelled widely: to Haiti, Mexico and Nigeria. The altar piece *Dambala* (1975) is named for the Haitian serpent spirit, but also includes items found in Mexico. Other works too reflect more than the influence of place and are transformed by Saar's masterful use of form and her own spiritual odysseys. *Spirit Catcher* (1976-77) refers, in its structure, to Simon Rodia's Watts Towers, which Saar saw during their construction. But it has the accumulations of power

and display, and the hierarchical appearance of African figures. The found objects composing it were collected over three years' time. Saar's earlier assemblages include *Black Girl's Window* (1969), *The Liberation of Aunt Jemima* (1972) and boxes containing images of depth and mystery. She began to create the boxes after seeing those of Joseph Cornell and realizing this was an appropriate way to give meaning to her collection of "remnants." A poet as well as an artist, Saar claims to have had clairvoyant and psychic abilities until the age of six, when her father died. Later in life she used her dreams and intuitions as inspiration. Symbols from the occult sciences, which she has studied, appear in her work. As her art all has great ritualistic reverberation, so too does Saar regard her creation a personal ritual of purification. Since 1968 she has had numerous solo and group exhibitions, mainly in California. Two major solo shows were held in New York at the Whitney Museum of Art (1975) and the Studio Museum in Harlem (1980). Saar's daughter, Alison, is also an artist, working in New York.

Suzanne Jackson (b.1944), active in both Los Angeles and San Francisco, has since 1965 been developing a process called acrylic wash. She uses layers of acrylic, some applied to wet canvas, others to dry, to achieve contrasts of translucence, opacity and brightness. The contrasts of texture mirror her concerns with the dualities of reality and fantasy, "aloneness versus loneliness" and choices of all kinds. Jackson frequently uses the symbols of hearts, roots, branches, birds and human figures to achieve works of delicacy and sensitivity which can be read as allegories or surrealist dreams.

An artist who has had an enormous lasting impact in the field of black art is **Samella Lewis**. Born in New Orleans and educated at Hampton Institute, Virginia, and Ohio State University (Ph.D.,1951) she has made Los Angeles her home since 1969. In these 20 years she has set up Contemporary Crafts, a gallery to exhibit the works of black artists.and in 1976 founded the quarterly *Black Art*, now re-titled *International Review of African American Art*, which she still edits. She also founded the Museum of African American Art and has edited or written three books. They are *Black Artists on Art* (with Ruth G. Waddy), two volumes, 1971, 1976; *Art: African American*,1978 and *The Art of Elizabeth Catlett*, 1984. Lewis has been an activist in the worlds of politics and art, and for her they have always intersected. A design Lewis did for a Christmas card for the local NAACP in Florida, where she was teaching, caused the state to investigate her as a communist sympathizer. Her mentor Viktor Lowenfeld helped her find a position at the State University of New York at Plattsburgh, where she and her husband founded a local chapter of the NAACP. In Los

Angeles she was coordinator of education for the Los Angeles County Museum of Art. She has been awarded grants to study Asian art abroad, and her paintings and prints are in the collections of the Baltimore Museum of Fine Arts, the High Museum of Atlanta and the Oakland Museum, among others.

Faith Ringgold (b.1930) is a New York-born artist who spends six months of the year teaching painting, sculpture and performance at the University of California at San Diego. She finds her "fabulous, open" students have "the California spirit in the best possible way." When not teaching or performing, Ringgold writes the stories for her story quilts, which she makes in New York. The quilts, which have alternate blocks of pieced fabrics, embroidered drawings and text, grow out of her political activism and feminist philosophy since the sixties. The most well-known quilt is *Who's Afraid of Aunt Jemima?* (1983). In nine panels of text Ringgold tells the story of Jemima Blakey, a successful restaurateur and her family, communicating "a lot of things I know about black people in America." Ringgold's first exhibited paintings were large and political, using stylized figures: *The Flag Is Bleeding* (1967), *Flag for the Moon, Die Nigger* (1969). She went on to use fabrics and objects to make masks and soft sculptures ("dolls") and story quilts. The women's movement was influential in freeing Ringgold to use women's crafts—sewing—thereby drawing her into close collaboration with her mother, Willi Posey, a dress designer (d. 1981). Posey made the tankas (cloth frames) for some paintings and the clothing for the sculpted figures. An activist for the greater recognition of blacks and women in the mainstream art world, Ringgold has participated in protests at the Whitney (1970), co-founded Where We At, a black women artists group (1971) and won a grant to do a mural at the Women's House of Detention in N.Y. (1972), which used only images of women. She has curated many exhibitions, received numerous awards and has completed an autobiography, excerpts of which have appeared in print.

Deeply involved in the Bay Area's political and artistic life is **Mildred Howard** (b.1945). At present she is the director of art activities at the East Oakland Youth Development Center. Art has always been the primary focus of her life life: both her mother, an antiques dealer, and Betye Saar taught her that "art can be made out of anything." Howard paints, draws and does performance installations, often using collage and assemblage as well. She has recently used doors and window frames to represent personal altars and to express her emotions as a woman, an artist and a person who happens to be black. The cross is a recurrent symbol in her work, representing both a centering and a turning point.

Margo Humphrey (b.1942) is a master lithographer who was born in Oakland and remains associated with California. She has, however, travelled widely: Fiji, Nigeria, Senegal and Uganda. She is teaching at the school of the Art Institute in Chicago until June 1989. Humphrey's lithographs, according to Roberta Loach, are difficult and exacting and employ bright, pure and often harsh colors. The artist has stated that color, lots of it, is critical to her work, a part of the process of communication. She develops ideas for her prints by keeping small notebooks of drawings, photographs and notes about color and composition. Mixing images of daily objects, such as red peppers and yams, with her broader sociological and mystical concerns, Humphrey creates lithographs that are in the realm of surrealism. Indeed, to her, surrealism often describes the circumstances of black life. In the late 60s she moved from abstraction to narrative symbolism, influenced by the civil rights movement and the heavily symbolic art that was then being produced. Other influences on her work include Haitian and Brazilian artists, Masaccio, Rousseau, Gauguin, German Expressionists and TV. Humphrey says it best: "I like the jolt of the unexpected, it's a source of energy in my work." Zebras appear frequently in her prints. After she had read that their spirits can't be tamed she used them as a symbol to say "black people will not be domesticated . . . although along the way it has changed. It has become a signature for my spirit." Humphrey plans to move into the field of sculpture, while continuing to make prints and paintings. She has received numerous awards and grants from, for example, NEA (1983, 1986), Ford Foundation (1981), James D. Phelan (1983) and the Tiffany Foundation (1988). Her works are in collections in California, Washington, DC, Rio de Janeiro and Lagos. In 1988 she exhibited *The Last Bar-B-Que* (1988) and *Portrait of the Artist on the Way to the Store for more Nectarines and Oranges* (1981) at the first National Black Arts Festival in Atlanta.

Marie Johnson-Calloway (b.1920) remembers 1965 as a turning point for the subject matter of her art. As president of the San Jose chapter of the NAACP she was in Selma, Alabama, to participate in the march led by Martin Luther King, Jr. On her first night there she was put in jail, which made her decide that that experience "was as universal as anything." She then used black people in her show of portraits and assemblages for her Master's degree. Johnson-Calloway wants "to produce a portrait of a people - a portrait that is universal in its humanness." The people are black, but she deals with "the things that apply to all: faith, courage, work, birth and death." She creates her portraits by making flat plywood figures, which are then painted, clothed and sometimes carved. They may appear alone, *Silver Circle* (1973), or in an installation group, *Hope*

Street (1985). In the past—Johnson-Calloway's first one-woman exhibition was in 1954 in Alaska—she has worked in watercolors and acrylics. Like other women artists she is frank about her mother's influence: "we grew up with the sewing machine." She, in turn, influenced her 80-year old mother to make art, and Johnson-Calloway considers her daughter and grand-daughter artists as well.

Now an associate professor of art at the University of California at Berkeley, **Mary Lovelace O'Neal** (b.1942), both private and political, admits her art is related to Abstract Expressionism, but is not about ". . . spilling my guts out onto the canvas . . . it's not just splash." In her work she is well aware of the structural, architectonic qualities, the composition and the function of all the colors. During her undergraduate days she was influenced by the art of Franz Kline, which was shown to her by her teacher and mentor David Driskell. Minimal art was a further influence on O'Neal, who now says her art concerns "all that I am at that point . . . what I have learned . . . read . . . seen . . . think . . . feel, what I don't understand and what I want to know."

Two artists now working in New York, but who were born in Los Angeles, are **Camille Billops** (b.1933) and **Maren Hassinger** (b.1947). Billops left California in 1962 for Egypt and has since been to Ghana, India and Japan as well as other countries. Self-described as "a feminist, sculptor, printmaker, photographer and an archivist," she is known for her large ceramic sculptures of abstract figures, such as *Mother* (1971) and *Remember Vienna III* (1986), plaques and vaselike objects. Mexican, Ethiopian and Egyptian ceramics have influenced her work. Billops has had many group and solo exhibitions since 1960, and has received awards and commissions. In the early seventies she founded, with her husband James Hatch, the Hatch-Billops Collection. It consists of over 10,000 slides, over 400 oral interviews and 4,000 books and catalogs, as well as extensive clipping files. The archive is an extraordinary source of primary information about black artists, playwrights, poets, dancers and photographers.

Maren Hassinger has been a sculptor since 1965. Starting with painted wood, she expanded her media to include fibers and rope and now uses wire rope or steel cable. Using the cable as though it were fiber—bunching it, binding it, then fraying the strands—Hassinger makes works that resemble growing things. In fact, she explores our relationship to nature, the "dangers [we pose] to the sweetness of nature." In sculptural terms she explores the relationship between static and moving objects. A site-specific piece, 150 feet long, *12 Trees,#2* (1979) may be seen along the San Diego Freeway, North and Mulholland exit. Hassinger's work is completely abstract, without obvious African-American reference. But she points out the attitudinal, if not stylistic,

influence of David Hammons, a black artist. In her words, she shares with other black artists "a simplicity of construction . . . and less dependence upon a historical set of precedents."

—Betty Kaplan Gubert

Bibliography

"Art as a testament: a conversation with Margo Humphrey." *The Tamarind Papers* 9:1 (Spring 1986), 16-26. Interview by Clinton Adams.

"Artist's work hangs on No. 1 show's set." *Atlanta Constitution* (April 14, 1987), 1B,4B. [Varnette Honeywood]

"My life in art: an autobiographical essay." *Black Art* 1:4 (1977), 31-51. [Camille Billops]

Bontemps, Arna Alexander, ed. *Forever Free: Art by African-American Women 1862-1980.* Alexandria: Stephenson, Inc., 1980.

Campbell, Mary Schmidt. *Rituals - The Art of Betye Saar.* NY: Studio Museum, 1980.

Coker, Gylbert and Lisa Tuttle. "History/Epic/Narrative: The work of five black women artists." in *Selected Essays: Art and Artists from the Harlem Renaissance to the 1980s.* Atlanta,GA: National Black Arts Festival, 1988. [Billops, Jones, Ringgold, Humphrey and Pindell]

"Interview with Betye Saar." *Black Art* 3:1 (1978), 4-15. Interview by Houston Conwill.

"Faith Ringgold now a tenured professor, teaches painting, sculpture and performance." *Women Artists News* 13:2 (Summer 1988), 5-6.

"Maren Hassinger." *International Review of African American Art* 7:2 (1987), 60-63. Interview by Watson Hines.

Roth, Moira, ed. *Connecting Conversations: Interviews with 28 Bay Area Women Artists.* Oakland: Eucalyptus Press,1988.

Wise, Leonard. "Portrait of Samella [Lewis]." *Essence* (February 1973), 46-47, 80.

Acknowledgments

I am indebted to Margo Humphrey for calling my attention to the article by Clinton Adams. I owe special thanks to Professor Moira Roth for her kind assistance and interest.

Margo Humphrey, *The Night Kiss*, color lithograph, 1985.

Mary Lovelace O'Neal, *Whales and Mermaids for Dinner*, mixed media/c, 1984.

Faith Ringgold, *The Funeral: Lover's Quilt #3*, 1986. Courtesy Bernice Steinbaum Gallery, New York.

Mujeres de California:
Latin American Women Artists

Perhaps the most visible presence of Latin American women's art is that whi
covers the walls of many cities in California: the monumental (and not-so-mo
umental) murals produced primarily by Chicana artists from the late 1960s to t
present. Acknowledged as the largest (or longest, over one-third of a mile)
Judith Baca's *The Great Wall of Los Angeles*, painted with teams of profe
sional artists working with community youth during the years 1976 to 1983.
theme is California's multicultural history from prehistoric to contempora
times, including the history of Third World peoples and the women not alwa
encountered in textbooks. While Baca (b.1946) is certainly one of the earlie
(beginning in 1969) and the most enduring of Chicana women muralists in Ca
fornia, she is not the only one. Los Angeles has seen murals painted by **Luci
Villaseñor Grijalva** and **Norma Montoya** in the early 1970s, and also **Judi
Hernández, Barbara Carrasco, Yrena Cervántez, Patssi Valdez** ar
Margaret García.

Latina women have also been active muralists in Northern California. Thr
Chicanas—**Patricia Rodríguez** (b.1944), **Irene Pérez** (b.1950) and **Gracie
Carrillo** (b. 1950)—and a Venezuelan artist, **Consuelo Méndez** (b.1952) we
the original team comprising the *Mujeres Muralistas* (Women Muralist
organized in San Francisco in 1974 and remaining active for about two yea
The four had been students together in 1971 at the San Francisco Art Institu
and they grouped together for support. In 1973, Rodríguez, Carrillo and Pér
did their first experimental mural work in Balmy Alley near Rodríguez's hon
The following year their mural collective coalesced when Méndez w
commissioned to do a "monstrous" wall that required a group and they paint
Panamérica at the Mission Model Neighborhood Corporation parking lot. "T
mural movement was happening," as Rodríguez says, and the women tempor
ily left their painting and graphics to plunge into community art. "We had
prove ourselves," continues Rodriguez. "Women were starting to get hired
PG&E to climb telephone poles. It was an age of women becoming involved
men's work." Other Latina women joined them: **Ester Hernández** (b.194

202

Miriam Olivo and **Ruth Rodríguez**, as well as non-Latina **Susan Cervantes**. However, male muralists were not very supportive. "A lot of women came around," says Hernández "but I think that first of all the men were the ones that had an attack. Most of the large walls up until that point—the very few that had been done in the Bay Area—had been done by men. People were really shocked that a group of women were going to do the whole thing from setting up scaffolds to doing the drawings to doing cartoons. Some people were very arrogant and rude and others were supportive. But we were clear about insisting that the work was going to be done just by women."[1] The last work done by three of the *Mujeres* (without Carrillo) as a team was the *Rhomboidal Parallelogram*, a six-paneled painting-construction 10 feet high and 13 feet long on which were depicted the life of Latin American women and children—the theme that pervaded their murals as well.

Subsequently, each of the women returned to their painting and printmaking. Two years later, Méndez returned to her native Caracas, where she continues to produce her distinctive graphics and has been recognized in Venezuela and in international exhibitions. By 1979, Rodriguez had chosen a new direction for her art: plaster masks of Chicano/a artists surrounded by found objects that detailed their lives. This laid the groundwork for her impressive series of boxes, an ongoing project which she continues to develop and refine today. Carrillo continued to paint murals in and out of California; she also illustrated bilingual children's books and did portraits in oils, watercolors and colored pencil for a living. The influence of **Frida Kahlo** appears most notably in her pencil and watercolor self-portraits. Pérez did silkscreen for many years in compositions of foods, symbols of Indian cultures and other Mexican themes, working with clear flat outlines and colors. In recent years, she has turned to gouache. Hernández has done large abstract paintings, but it is in printmaking that she has produced her most impressive work. Widely disseminated is the serigraph *Sun Mad* (1982) with a skeletal version of the Sun Maid raisin box logo and text about the life-threatening use of pesticides and herbicides. Hernández didn't lack a sense of humor when she reconstructed the Statue of Liberty on a Pre-Columbian model (1975), or made the Virgin of Guadalupe a Black-Belt karate fighter defending Chicano rights (1976). More recently she has addressed the subject of Central America with a print about the civil war in Guatemala.

In the 1980s, other women gravitated to murals. Chief among them is **Juana Alicia** who came to California in 1970 from Detroit and whose 12 murals, created alone or with teams from 1982 to 1987 (one in Nicaragua; one on

Guatemala with the Balmy Alley PLACA Central American Project in San Francisco), establish Alicia as a major muralist. Her themes concern labor and cultural history, women and children. They demonstrate an uplifting and positive point of view that matches that of the *Mujeres*. Like them, the earth and the things that grow on it form a vital part of Alicia's imagery.

Chicana women from Sacramento and from Fresno also collaborated for brief periods on mural projects. Sacramento artists **Rosalinda Palacios, Antonia Mendoza** and **Celia Rodríguez** (some accounts also include **Irma Lerma** and **Barbara Desmangles**) were inspired by the first International Women's Year conference in Mexico City (1975) and painted a pillar mural in San Diego's Chicano Park celebrating women of Latin America. Fifteen Fresno women, taking their lead from San Francisco's *Mujeres Muralistas,* established themselves in the mid-seventies as Las Mujeres Muralistas del Valle. The group included **Helen Gonzáles, Celia Risco, Sylvia Figueroa, Theresa Vásquez** and **Lupe González** who worked on a mural in their city. In addition, San Francisco artist **Yolanda López**, originally from San Diego but not generally known as a muralist, painted a mural at Chicano Park with a team of young women from San Diego. Nevertheless, considered in relation to the enormous number of murals produced in California during the 1970s and 1980s, Latina women have actually played a relatively small role.

Though this essay is not meant to focus on muralism because that topic is covered in another chapter, it is well worth sketching in some of Judith Baca's activities in Los Angeles during the almost two decades of her artistic production. Her experience epitomizes both the difficulties Latina women faced when they entered the field of art, and the successful way women can build supportive structures and organizations without losing an iota of their vision or integrity. In the process, Baca learned the skills she now possesses.

In the early 1970s, with an assumed braggadocio that conquers politicians accustomed to ignoring both Mexicans and women, Baca managed to wrest $100,000 for a citywide mural program from a reluctant Los Angeles City Council (at that time without a single Mexican member to represent the enormous Spanish-speaking community). Her earlier wall paintings were completed with Chicano gang members in the East Los Angeles *barrio* (neighborhood). However, the City Council would neither countenance such a focus, nor supply funding. Consequently, Baca broadened her sights. She proposed an audacious venture that undertook to produce murals all over the city. By so doing, she learned to work in multi-ethnic situations with sensitivity that could counter inter-ethnic racism.

The non-profit organization Baca set up in 1976 to carry out mural projects without government interference was, appropriately enough, named SPARC—acronym for the Social and Public Art Resource Center. Run almost exclusively by women, SPARC managed to procure (inexpensively) an ancient, three-story former jailhouse located in a beachside suburb of Los Angeles. Converted into an arts space, it now has studios, offices, meeting rooms, a slide archive and a gallery that opens its doors to many previously unheard artistic voices. Not only can murals be planned in this location, but lectures, concerts, poetry readings, workshops and resident artists make it an active alternative cultural site based on precepts of multi-ethnicity and feminism.

Very early on, Baca was conscious of the difficulties confronting women who wished to do murals. She recalls, working with Chicano gangs in the early 1960s, that few girls participated. "It was much easier organizing among the young men," she says, "because girls were not allowed the same mobility. It's been a long process drawing the young girls in. You see, Latin women are not supposed to be doing things like climbing on a scaffold, being in the public eye."[2] Baca, as then-director of the city-sponsored Mural Resource Center, produced and illustrated—in addition to her regular mural manual for art directors and neighborhood teams—a special photocopied *Woman's Manual: How to Assemble Scaffolding*. This was intended to help remedy women's socialization which militated against working outdoors on a large scale, being subject to the comments of the passing public, and knowing how to handle tools and successfully construct such large objects as one- or two-story scaffolds.

Chicanas and Latinas in the United States and the Southwest

Any history of Latin Americans in the United States must of necessity root itself in the momentous struggles of the 1960s and the succeeding decades, as well as recent Latin American history. These concurrent histories can give us insight into the work and lives of the women artists surveyed here. Since feminism and feminist artists of Europe and the U.S. have been widely treated in books, articles and exhibition reviews over the last two decades, there is little need to do more than suggest the particularities of the feminist presence in California, where key artists profoundly shaped feminist artistic philosophy on a national level. The history of Latin Americans, on the other hand, is much less well known. In general, the presence of Latin Americans in California, male and female, has been determined by the politics, socio-economic history and cultural opportunities of their countries of origin, as well as of California.

Demographically speaking, it becomes quickly apparent to any observer that the Mexican-descent population of California overwhelmingly exceeds that of all other Spanish-speaking groups. This is so because the Southwest was settled by Spaniards and Mexicans before the Mexican American War made it U.S. territory in the mid-19th century. Moreover, there has been continuous migration—especially during the Mexican Revolution of 1911-20, and during periods of intensive labor recruitment. It follows that any discussion of Latin American women artists in California will be dominated by information about Mexican, Mexican American and Chicana artists. The latter's emergence during the sixties was marked by a young, active, militant and educationally/culturally-oriented movement with outposts throughout the United States. Strongest in the Southwest, some Mexican Americans and Chicanos can claim an ancestry that goes back five and six generations.

Recent statistics indicate that the numbers of Latin American-descent peoples in the U.S. will reach nearly 25 million by 1990. If present trends continue, this will be "the largest ethnic minority in the country" by the year 2000.[3] The 1980 census revealed over four million in California (out of a total population of almost 20 million) of which 80 percent are Mexican. Constant migration, both officially recognized and nonofficial, has been going on steadily. Between 1970 and 1980, the state's Latin American population almost doubled. For example, the Central American refugee population grew to a calculated 350,000 in Los Angeles alone. Most are from El Salvador, with some from Guatemala—the two Central American countries with the most desperate record of death squad killings, kidnappings and disappearances. Beset with severe problems of survival, not many artists surfaced. Those that have—with some notable exceptions—are males working part-time at their art. Mexican professionals began arriving in greater numbers beginning in 1982, when their country's economic crisis became critical. Many Latin Americans have moved to the U.S. (or to the Southwest from Eastern sites) in search of a more propitious social climate or better creative opportunities.

Within little more than a decade (1964 to 1976), five countries spanning the area from the Andes to the Southern Cone of South America entered a period that has been called "the long night of the generals." Repressive military-dominated dictatorships took power in Bolivia, Chile, Argentina, Brazil and Uruguay, often with assistance or training by the United States, which sees Latin America as its bailiwick. Jailings, tortures, massacres and disappearances became a daily occurrence. Exiles from these countries, including a large contingent of intellectuals and artists, sought asylum in Mexico, European

countries and (when permitted entry) the United States. Perhaps the largest exile group is that of Chileans in whose country General Pinochet ruled after the coup d'état of 1973. Chileans continued to leave in voluntary or involuntary exile for a decade after the coup.

Caribbean immigrants, primarily from Puerto Rico and Cuba, mainly reside in New York, Miami or Chicago. While many Puerto Ricans share the working-class status of Mexican immigrants, the Cubans who arrived from 1959-65 (right after the Cuban Revolution) and from 1966-80, have been described as "significantly older, more urban, more educated. . . and much more conservative" than other Latin Americans.[4] Most Cubans do not want to (or cannot) return to their native land, but members of the younger generation have taken a more open attitude to Cuban-U.S. relations.

Movements of the Seventies

Though both the Chicano political movement and the feminist movement were emerging in California at the same time, there was very little political contact. For the community at large, Mexicans and Chicanos were an invisible presence; how much more unlikely was it that even a pioneer artist like Judith Baca should be known to the women's art community seeking its own identity and parameters at the same time.

The Feminist Art Movement:
In the early 1970s, the Los Angeles area was a central site for feminist art. In February/March 1973, the first issue of *Womanspace Journal* appeared, published by the newly opened Womanspace Gallery. It contained articles by such now well-known feminist artists and historians as Judy Chicago, **Wanda Westcoast, Miriam Schapiro, Ruth Iskin** and **Arlene Raven**. Gala opening night for the gallery was January 27th, followed by a series of events that included exhibitions, a celebration of Womanhouse (opened almost a year earlier), a lecture on the 1893 Women's Building at the Chicago World's Fair, a reception for **Anais Nin**, a week devoted to an examination of Lesbian sensibilities in art, a "menstruation weekend" performance imported from the Berkeley Art Museum, plays, workshops, poetry readings, music, films, and a reception for "pioneer woman artist" **June Wayne**. A new experimental program called the "Feminist Studio Workshop" opened in Fall 1973, conducted by Arlene Raven, Judy Chicago and **Sheila de Bretteville**. At the same time, the Woman's Building was launched in the two-story renovated building that for many years had housed the Chouinard Art School.

Though Womanspace has long disappeared, the Woman's Building contin-
ues to maintain a vibrant program of activities. In 1973, Womanspace chose
Olivia Sánchez for inclusion in a juried exhibit and the Woman's Building
invited **Rosalyn Mesquita** to participate in a three-woman show. In 1976,
another contact was made between Chicana artists and the feminist movement
when a group of five artists who called themselves "Las Chicanas" created an
installation and multi-media event in the new three-story Woman's Building. In-
volved were photographer **Isabel Castro**, muralists Judith Baca and Judith
Hernández, **Olga Muñiz** and Mexican painter **Josefina Quesada**. Titled *Venas
de la Mujer* (A Woman's Veins), the installation was a rich compilation of
Mexican/Chicana culture and realities, including a garment factory segment
which illustrated the working conditions of the many undocumented Mexican
women employed at such labor in Los Angeles sweatshops with substandard
wages.

By 1976 the Woman's Building had changed its location when the building
located near MacArthur Park was sold. Those at the old building had probably
never been aware that in the Chouinard structure they had been living with
Mexican art history. In 1932, famed Mexican muralist David Alfaro Siqueiros—
then a young man of 36 in flight from his native land for political reasons—had
painted an important outdoor mural at the School, one of three major murals he
completed in Los Angeles during his six-month stay. Two of the three were
whitewashed within two years. One of them, *Tropical America*, has become a
cause célèbre for the Chicano arts movement, which strongly desires its restora-
tion.[5] When muralists like Baca, Hernández and Quesada presented their work at
the new Woman's Building, events had been brought, in a certain sense, to full
circle. Siqueiros was the Mexican muralist who most influenced Chicano (and
other) street wall painters throughout the 1970s. Though he died in 1974, his
Taller (Workshop) in Cuernavaca, Mexico, continued, and Judith Baca had an
opportunity to learn about his use of deep space and dramatic foreshortening. As
director of the *Great Wall*, Baca translated what she had learned of Siqueiros's
style and methods to California walls in a new configuration.

The contact begun between white feminist artists and Chicana artists con-
tinued sporadically. In 1982, 13 artists and poets brought together by **Linda
Vallejo** and assisted by **Susan E. King**, studio director of the Woman's Graphic
Center at the Woman's Building, worked on a limited edition portfolio with
serigraphy, offset and letter press published under the name of Madre Tierra
Press. The inauguration was held on December 12th, a date sacred to the Aztec
fertility goddess Tonantzin, and to the Virgin of Guadalupe. Included were

artists **Juanita Cynthia Alaníz, Cecelia Casteñeda Quintero, Anita Rodríguez**, photographers **Judy Miranda** and **Rosemary Quesada-Weiner**, as well as Vallejo, Olivia Sánchez and Yrena Cervántez.

The Chicano Movement
Chicana artists in California are relatively easy to locate compared to other Latin American women due to the existence of a network of Chicano cultural organizations and publications that emerged with the political movement to aid, nurture and expose the cultural expression of Chicanos. The movement began in the mid-sixties as an alliance between farmworkers, (organized by César Chávez and Dolores Huerta to establish unions against a powerful California agribusiness), urban working youth and the growing student movement. Economic struggles and the nationwide boycotts of lettuce and grapes led by the farmworkers union gave inspiration to the youth/student movement from whose ranks came visual artists, dance, theatre and film people, and writers. Civil rights, the Vietnam war (in which a disproportionate number of Chicanos were dying), the protest actions of Native Americans and feminism were issues that impacted and were acted upon by the Chicano movement. The years from 1968 to about 1975 saw an emphasis on public art—murals, posters and filmmaking which were militant, nationalistic and Indian-oriented.

Until the mid-seventies, Chicano art was largely dominated by men. Though some were sensitive to women's issues, the images that emerged predominantly depicted women as passive wives, helpmates and mothers, Indian princesses, Pre-Columbian and Catholic goddesses, sex symbols, and occasionally as betrayers like "La Malinche," the 16th century Indian interpreter and mistress of Hernan Cortés. As a more pervasive feminist consciousness developed and greater numbers of Chicanas became visible as artists and writers, new subjects emerged, among them women's achievements within Mexican and Mexican American history. Historical women like Sor Juana Inés de la Cruz—a nun and early exponent of women's rights who became one of Mexico's greatest literary and intellectual figures in the 17th century—were re-examined by writers, while artists undertook to define and redefine the Aztec goddess Coatlicue/Tonantzin, the Virgin of Guadalupe and the Mexican painter Frida Kahlo.

From the second half of the decade there was a turn toward more personal, gallery-oriented work. It was also the period in which many more women emerged into public view. Los Angeles' Mechicano Art Gallery, opened in 1969, the Goez Art Gallery, Self-Help Graphics and Art, and Plaza de la Raza were among the alternative spaces available to Chicano/a artists when most mainstream institutions and commercial galleries were closed to them. At the

same time, Judith Baca's mural and gallery programs, whether for the City or sponsored by SPARC, provided a strong feminist awareness that encouraged women to participate in artmaking and exhibiting publicly. San Diego's Centro Cultural de la Raza, headed until September 1988 by **Veronica Enrique**, whose focus is Mexican dance, also offered space. Its gallery has hosted shows from all over California that have included women, as well as showing artists from its sister city, Tijuana, Mexico.

Alternative spaces were also established in the San Francisco Bay area by the late 1960s, branching into Sacramento and other northern California cities during the 1970s. Unlike Southern California where Chicanos dominated, the term "La Raza" (the "race," or the "people of our race") was employed to signify that artists of all Latin American backgrounds were working together. The Galería de la Raza and La Raza Silkscreen Center—presently called La Raza Graphic Center, Inc. to reflect a shift in direction, and headed by Chicana **Linda Lucero**, one of the few women consistently working with the Silkscreen Center— signaled the unity. Later the Mission Cultural Center catered to an even wider spectrum of Latin American artists. All three functioned in San Francisco's heavily Latino Mission district and were crucial spaces where Latino artists could learn and exhibit.

Latin American women of California have been involved with a great variety of media and techniques. Painting, drawing and printmaking dominate; however, sculpture and installation, video, filmmaking, photography and performance are very much in evidence. Rather than attempting an approach based on national origin alone (the exception being the Chicanas for reasons explained below) it seems more logical to present women artists in clusters determined by geography and chronology. The latter category has been made difficult due to the proscription against women revealing their age. During my research I tried to convince women that giving birth dates was a necessity so their life experiences, art work and influences could be situated historically. Dates that don't appear result from prohibitions to the author, or the consistent omission of this information in published sources. Despite feminism, the old rationalizations—reflecting old and new fears (sexual attractions, employment possibilities, age justifications for career advancement, etc.) —are still operational. As one artist expressed it, "maybe it's time for us to come out of the closet on this issue."

Southern California

Cuban painter **Gloria Longval** (b.1931) is the daughter of a Cuban mother and an absent French father. Raised by her grandmother in the Florida slums, she learned from her about Cuban *brujería* (witchcraft) and about Puerto Rican *santería* (the syncretic African folk-religion widely practiced in the Caribbean) when she lived in New York's Spanish Harlem in the 1940s and 1950s. Imagery of these magical practices remained in her repertoire when she came to California in 1962. Today Longval paints with somber but rich acrylic color on canvas (which sometimes includes collaged papier mâché masks) and with clear glazed low-fire engobe on clay. Her acrylics evoke Goya, Manet, Ensor and Picasso in simple subjects that take on an ominous and mysterious quality through ambiguous space, the use of blue and gray-green light and clothing from another time. Birds like penguins, dodos and roosters (important in *santería* rituals) appear in her small ceramic pieces.

Ceramic sculptor and architectural designer **Dora de Larios** (b.1933) comes from Mexican ancestors who migrated to California because of the Mexican Revolution; she herself was born in Los Angeles where she lives today. As a child, she endured the standard discriminatory treatment of non-English speakers in school and, like many Mexican-American and Chicana women, received great comfort from Mexican myths, folk legends and the healing knowledge of her grandmother. De Larios spent summers in Mexico City with relatives as a child and was enormously impressed by the great Aztec Calendar Stone at the National Museum of Anthropology, which later led her to an interest in Pre-Columbian art. She was also drawn to the Japanese truck gardener families who lived near her grandmother's house; many spoke Spanish and were very kind to her, in contrast to the hostile Anglo world. One day all the Japanese disappeared. Later she (like many others) became aware of the 1943 evacuation to concentration camps of West Coast Japanese during World War II. Her favored clay slab technique owes a debt to both Japanese Haniwa sculpture and to Pre-Columbian Mexican clay figurines. In 1979, de Larios donated a large Portland cement mural, 6 feet high by 26 feet long and 2 inches deep for the relief, to Nagoya, Japanese sister-city of Los Angeles. Constructed with styrofoam modules encased in 24 wooden frames, the cement was poured to form deep textural reliefs. At the University of Southern California (USC),where she and Camille Billops were the only Mexican and Black art students in the 1950s, she met and later married an architectural student. Both were intrigued by the Bauhaus-oriented concept of designing beautiful utilitarian goods for prices affordable to masses of people. When hired by Interpace in 1964 to design

architectural tile and tile murals, de Larios found a direction for her career. Since then, she has focused on architectural commissions in ceramic, concrete, stainless steel and other materials, in addition to smaller works like ceramic masks, bronze sculpture and mixed-media pieces of wood, porcelain, gold leaf and paint.

Esperanza Martínez (b.1933), though she has lived in the Los Angeles area since 1962, considers herself a Mexican. Born in a small village now part of Mexico City, she studied art secretly against the express wishes of her family, and married in the same manner. Forced to earn her living, Martínez sold paintings from her studio and through the Mexican Bureau of Tourism. Martínez travels regularly to Mexican and Central America Indian villages to sketch the people (primarily women and children) whom she paints when she returns home. Of modest size, the figures are idealized, folkloric and meticulously executed in an almost photographic style very popular with her middle-class patrons, who are frequently Mexicans and Chicanos. She uses prismacolor pencils overpainted with glazes and impastos of oil and acrylic.

Josefina Quesada of San Diego is also an older Mexican artist, who first came to Los Angeles about 1970 as a consultant for the possible restoration of the 1932 Siqueiros mural in Olvera Street. (She and Jaime Mejía appear in the PBS film *América Tropical*, produced and directed for KCET television by Jesús Salvador Treviño in 1971.) Later Quesada emigrated to Los Angeles as a restorer and skilled painter and worked in the Goez Gallery of East Los Angeles. She also directed a mural funded by CETA for the Chicana Service Action Center, which trained women for employment. Quesada's painting style follows Mexican realism of the 1940s; she tends toward genre and Pre-Columbian themes.

Mexican American (or Hispanic, according to New Mexican custom) **Rosalyn Mesquita** (b.1935) has lived in California since 1952—first in San Francisco where she turned from classical music to art, then, since 1963, in Los Angeles. Trained at the University of California, Irvine, which boasted a roster of vanguard California and New York artists, Mesquita became fascinated with "process" art. For several years she made huge shallow-relief environmental paintings on paper, richly textured topographies in earth colors that recreated aerial views of landscapes. These pieces were expandable; they could be layered to form rectangles of 20 feet in any direction or, correspondingly, decreased to five feet. A fine conceptual drawing from the 1970s called *Frijoles* creates a field of over 40 outlined pinto beans within which several have been shaded or textured. This was a period in which Mesquita was most in touch with the

California Chicano movement, and her piece was displayed at the 1975 Chicanarte exhibition. A committed feminist, she found the young movement too sexist and its criticism of her experimentalism too limiting.

Mexican American **Mary Lou Ynda** (b.1936) of East Los Angeles is a "graduate" of what she calls "gang consciousness." A 1966 silkscreening class captivated her, and she turned to art from her previous jazz music career. Christian and Native American spirituality is central to her work, which became increasingly abstract and more three-dimensional after 1978. Her *Annie Christian* series of 1982 consists of black-painted abstract collages of wood and wire. The pointed sticks, sometimes crossed, suggest either crucifixion or impalement. The series *Dogs, Wolves and Women in Alphabetical Order*, *Loving the Alien* and *The Family* of 1985-1986 are constructed of painted wood, plaster and found objects with forms reminiscent of fetishes or tribal totems. A syncretism of Christian and "primitive" motifs remains constant in her work.

Not yet a resident of the United States, **Magda Santonastasio** (b.1937) of Costa Rica has spent part of each year since 1971 in San Diego. She received her education at the University of Costa Rica (UCR) in San Jose and is a noted watercolorist in a nation where watercolor has for many years been a preferred medium. Since participating in 1980 in a creative graphics program sponsored at the UCR by the Organization of American States, she has worked on series of color intaglios and relief prints with the Brighton Press of San Diego. Limited edition books containing original prints were published by the Press between 1984 and 1987: *The Window, Letters to an Owl, Via de la Rosa—The Way of the Rose, Retratos* [Portraits], *Rescue of Indian Weavings* and *Meinschatz*. In *Meinschatz* she worked abstractly with gridded, textured and patterned surfaces etched with acid and printed with a viscosity technique. Organic forms in line are engraved over the geometric patterns. In 1984 she embarked on a series of black-and-white relief etchings among which are two outstanding works titled *El Salvador* and *Central America*. The dense background patterns contain human and symbolic animal and bird images related to the present sufferings of Central American peoples.

Mexican American painter and printmaker **Margaret Gallegos** (b.1938) resides in Santa Monica, a suburb of Los Angeles. A figurative artist, she works from life but does her finished work in the studio so as not to get overly involved in detail. Central to Gallegos's work is capturing an initial emotional response. Her broad horizontal landscapes of sea and sky or urban streets show mastery of traditional painting techniques and a sense of drama.

As in Europe, literature has always played an important role in Latin American art, generally imagery inspired by poetry or novels. Literary-based art, however, had a lean time of it in the 50 or 60 years of modernism until Pop art, Conceptual art and Post-Modernism opened the way to the reintroduction of texts with visual forms. In the semi-abstract work of Argentine-born **Susana Lago** (b.1942) we find not only densely piled paint combined with found materials but the inscription of words from poems. Lago lived for brief periods in Brazil, Chile, Italy, Switzerland, New York, Illinois and, finally, California where her family moved in 1957. In her homages to four poets, Brazilian Cecilia Meireles, North American Emily Dickinson, Spaniard Vincent Aleixandre and Italian Eugenio Montale, the words are buried beneath wire mesh, layers of translucent papers, acetate and thick gestural strokes of paint. The writing cannot be read except in fragments, like half-seen words hidden by graffiti. Fragments of polaroid photographic figures sometimes accompany the words, caught in boxes or behind jail-like mesh.

Gloria María Alvarez (b.1945) writes of herself, "I have not been part of the Chicano art movement —actually I only within the last two years have become aware of its history, though I admire the work of Rupert García and Malaquías Montoya. However I tend to disagree with Montoya in viewing the role of art as social commentary. I do identify with being Chicana, but it is an expression of self only."[6] Alvarez came to California in 1969, and now lives in central California. She considers printmaking her medium, enjoying the process and its surprises. An MFA graduate, her work favors non-referential images. Nevertheless, a series of color etchings—as formal, delicate, spatially and texturally refined and poetic as a Japanese private house and employing oval, rectangular and fan shapes in subdued golds, blues, purples and greens—combines these elegant forms with photographically-derived images of female goddesses, from the Venus de Milo to the Virgin of Guadalupe. Having come from hard-edge geometry and gestural abstraction, the most recent work carries a personal symbolism and a new richness of color obtained through the layering of the etching plates.

Olivia Sánchez (b.1946) of Los Angeles is a painter and printmaker who constructs three-dimensional objects. Art served as compensation and escape during a very difficult childhood. Her initial participation with Womanspace Gallery, in 1973, was crucial; she received encouragement from feminist artist Wanda Westcoast, who was her college teacher, and continued this association with the Woman's Building, where she took classes and found an outlet for her poetry. A central motif in her work is long abstract strands of color that represent

brainwaves, electrocardiograms or the forward motion of cars on the freeway. On these forms, made with graphite, pastel, prismacolor and silkscreen, she positions apples, peaches and bananas. For Sánchez, combining abstraction with realism is a way of uniting two worlds: that of her Mexican grandfather, who was an artisan skilled in the production of beautiful candies made as vegetables, animals and fruit and painted with food coloring, and her need for symbols of her present urban life. Meditating on the disastrous freeways that dissect and disrupt many Mexican neighborhoods led to her freeway series of mixed-media boxes enclosed in plexiglass. Images of chile peppers crossed by lines symbolizing freeways are combined with ceramic tortillas and real peppers.

The first college graduate of her family, **Patricia Murillo** (b.1950) has lived all her life in Santa Ana. From this provincial environment she emerged with the personalized and humorous recycled "constructional prints" she makes from handmade paper into which everything from washing machine lint, wood slivers, cut-up older prints, chips of peeling paint, porcupine quills and electrical wire are either embedded (with a blender) or added. Fascinated with found objects and kitsch, with which she likes to play and experiment, Murillo incorporates beads, chevrons, weaving and other Indian symbols into her work, as well as the ubiquitous Southwest *nopal* (prickly pear) cactus. The small wall-mounted abstractions have series titles like *This Bulb is On (aren't you tired of too many parties)*, in one of which a photocopy of huge sexy lips emerges from a spiked cactus-like container; or *Many a Tear Has to Fall*, which evokes eyes with lashes and tears. Never directly associated with the Chicano movement, Murillo nevertheless shares an interest in Native American imagery.

Like Lozano, **Paz Cohen** (b.1951) is a recent arrival in Los Angeles whose first exhibit opened in 1988, though she participated in group shows in Mexico City from 1980 to 1983. Her paintings are of headless, fragmented human figures enclosed in boxes and circles, covered with wire mesh, attached to gears, wires and screws. Cohen's installation of seven dress-store mannequins, whose lower bodies terminate in metal pipes and bars, is arranged as a *March* toward a traffic stop sign. From this, and other pieces, Cohen has created a Dante's inferno of mechanized and depersonalized urban life. Among the most poignant is a complex piece made of metal sections, with rusty metal ribs, representing a female figure stretched on a black metal frame like a Christian martyr. Reaching upward from a gear and an automobile steering column and wheel are two desperate pink plastic hands. Movement, sound and light animate this construction.

The work of **Armandina Lozano** (b.1952) is rooted in the student protests of Mexico City that tragically ended with the 1968 Tlatelolco massacre of unarmed demonstrators in a downtown plaza by the Mexican military. As a first-year student in the San Carlos Academy, members of whose faculty and student body clandestinely produced great numbers of graphic placards and handbills for street use, Lozano helped with the printing. These events not only politicized her, but determined her future artistic course. The 1970s for many emerging artists was a decade of return to political art, drawing on new artistic languages and media. In 1976 Lozano joined with ten other artists to form the group "Suma," which sought to integrate its art with the visual images and symbols of average street people. Employing cardboard stencils, spray cans and paint, Suma members covered walls and sidewalks with serial graphics accompanied by texts. Inexpensive graphic publications used a variety of new techniques such as mimeograph stencils, photocopies, blueprints and rubber stamps which were dubbed "neo-graphics" by their users. When Lozano came to California in 1983, she brought these skills with her, teaching them to Chicano artists and using them for her own work, which remains politically oriented. She is also a skilled security engraver who makes plates for paper currency, stock certificates, commemorative stamps and travellers checks. It is a difficult profession previously closed to women—a fact she is never permitted to forget.

Born in Venezuela, the child of a Mexican mother and a U.S. Cuban-born father, **Linda E. Picos-Clark** (b.1958) lived three years as a child with her mother's family in Mexico City before coming to the United States. Fighting against figural painting, suspicious of love relationships with men after bad experiences, Picos-Clark is profoundly involved with Catholic mystic philosophy based on Platonic thought, which she translated in the early 1980s into luminous black-and-white abstractions in charcoal and lithograph. Two works refer to themes of seduction from the Old Testament: *The Wife of Potiphar* and *The Fight Against Concupiscence*. In another series, titled *Cloud of Unknowing*, the artist explores Dionysian aesthetics—another system of mystical Catholic theology. Geometry and light are the two elements that inform Picos-Clark's most impressive work. In her lithographs, *Luz* (Light) and *Cueva* (Cave), specific reference is made to Plato's Cave: the mythical parable of the uninstructed human as one chained up in a world of shadows which can only be escaped by moving toward the sun, or the highest good. Thus Picos-Clark's framework can be seen as a search for an ethical structure through art. Apparently she believes seduction and sexual desire are evils and mystical faith expressed as light are the Good, the True and the Beautiful.

Chicana Artists—Southern California

Without diminishing the individual characteristics and talents of the artists, it seems logical to deal with Chicanas as a group since there are so many common denominators, not the least of which is the association with a movement that in the early 1970s established an iconography of public art that can be traced nationally. Such themes as Pre-Columbian deities; Catholic deities (especially the Virgin of Guadalupe) and a host of symbols like roses, hearts and thorns; folk rituals like the *Dia de los muertos* (Day of the Dead) which are reflected in Chicano altars and *calaveras* (animated skeletons), and images of curanderas (healers); portraits of early revolutionary and reform leaders from Mexico, and from the U.S. in the 1960s, as well as cultural heroes and heroines; labor and political themes (including labor leaders like Luisa Morena, Emma Tenayuca, Dolores Huerta); and celebration of community women—from grandmothers and mothers to the Pachucas of the 1940s and the *cholas* of today. Enormously important have been the Mexican muralists, but influential above all has been Frida Kahlo, who has been transformed not only into a role model, but into a cult figure.

Judith Hernández (b.1948), like most of the Chicana women, came from a working-class family and possibly would not have gone to college without the movement's insistence on opening higher education to Chicanos. Politicized by the movement, Hernández continued her art education into graduate school. Some of her most effective easel paintings were done with spray cans—the same cans with which neighborhood youth paint their graffiti on walls and which Chicano mural artists initiated as a new paint medium. She was influenced in this direction when she joined an all-male art group called Los Four who, as early as 1973, were painting wall murals in some of the pilot programs of Los Angeles. She became a muralist, working with Judith Baca for a time. Hernández' themes usually focused on women: tough street types, heroic mothers, political women fighting the Mexican revolution, working in sweat shops or organizing farmworkers. In her drawings for Chicano magazines as in her paintings, she evolved an idealized, monumental woman whose type served many of these functions.

Both artist and efficient arts coordinator (curator, coordinator of a publication, etc.) **Linda Vallejo** (b.1951) spent her formative years as an "Air Force Brat" in the United States and Europe. The Chicano movement was in full swing when she settled again in Los Angeles, and she established ties with its Indianist ideas and activities to capture what she felt was a lost identity. As a Catholic-educated printmaker and sculptor, Vallejo is most attracted to Pre-Columbian and

Native American spirituality and ritual. "All my pieces" she says "contain archetypal, mythological or dream world imagery. I use archetypal subject matter found in ancient cultures combined with the modern idea of self-knowledge through the interpretation of dreams."[7] Vallejo works extensively with monotypes and hand-dyed paper (like Murillo, whom she admires, she layers some of her abstract work with remnants of old silkscreen or lithographic prints), and three-dimensional works of cast paper embellished with Welsh wool, electrical wires, honeysuckle vines, papier mâché, feathers, fur, plastic and other materials.

Patssi Valdez met the future members of the experimental conceptual and performance group ASCO (Nausea) while most of them were still in high school; she was the only woman. Creative and iconoclastic personalities, Gronk, Harry Gamboa, Jr., Willie Herron and Valdez formed a team by 1972 that worked individually and collectively. Murals, photography, Super-8 films, costumes, street theatre and tableaux, "No Movies" (real films with no film), magazine illustration, mock interviews, short stories and essays, installations, performances and, in later years, video—all were produced with sharp wit, irony and pointed social commentary on the state of being Chicano in East Los Angeles. Poking fun even at the flourishing mural movement—within which Herron and Gronk were pioneers—ASCO performed "walking murals" (in elaborate costumes) and "instant murals" (Valdez taped to a wall). In the early years,Valdez was often the "target" of the men's actions. She was one of the first to appear in thrift-shop "chic" outfits—extravagant costumes (often black), old jewelry and lavish cosmetics that became part of her persona. She also modeled for imaginative costumes invented by Gronk, like a "tumor hat." Paper fashions often formed part of the action. Valdez did early "photo-booth" conceptual pieces. She then turned to manipulated photography in which she dressed and posed her models, shot with high-contrast film printed on grainy paper, and handpainted the works or covered sections in colored acetate. Her installations have now changed to more complex and refined pieces, always with a stress on extravagantly clothed women who, nevertheless, impart the underlying sadness or despair that reflects Valdez's difficult life. **Diane Gamboa** (b.1957), who participated in some of ASCO's activities from 1971 on, has also become an artist who, like Valdez, dresses from thrift stores. She has produced paper clothing like the *Lizard* series for "cold-blooded people". Until it disintegrated in the mid-eighties, ASCO attracted a shifting group of participants, including several women. When Valdez left, **Marisela Norte** was active in English/Spanish performance pieces.

Yrena Cervántez (b.1952) was raised in an area close to San Diego near an Indian reservation, a proximity crucial to her development as an artist. As a result, Cervántez has maintained a dialog between Catholic religious ideology and what she considers a deeper, more personal Indian-based spirituality. Early in her artistic training she turned to self-portraits, utilizing to good advantage her distinctive moon-shaped face, long dark hair and snub-nosed features. With watercolor as a preferred medium, she creates densely populated small paintings that accumulate a multitude of images around a strong central figure, a mural-like technique that resembles paintings of Diego Rivera or of Frida Kahlo, whom she very much admires. Animals (as Nahual dual spirits), body organs, *calaveras*, plants and various symbols appear in her paintings in brilliant colors. In recent years, Cervántez has begun to experiment with silkscreen prints, a technique learned at Self Help Graphics workshops.

Among the Mexican families who made the trek to California from Texas seeking better opportunities and less racism was that of **Barbara Carrasco** (b.1955). In the mid-seventies, Carrasco fought her way into the prejudiced art school of the University of California, Los Angeles, where she spent two years as a student activist while earning her B.A. The activist role continued for six years with the United Farm Workers (a commitment that remains strong), for whom she made graphics and banners. Carrasco's muralism started in 1978, working with an all-male team on the *Zoot Suit* imagery for the Aquarius Theatre in Hollywood where Luis Valdez's play (later a movie) opened. She has painted other murals: a censored work for the Community Redevelopment Agency that required legal action on her part to retain her rights, in the Soviet Union, and with a Latino team in Nicaragua. However, her most dazzling works are her miniatures: tiny exquisite drawings with prismacolor pencil, ballpoint pens or silverpoint on coated paper. Ranging over the years from portraits of Siqueiros (whom she much admires), portraits about or self-portraits with Frida Kahlo, and the skeletal *calaveras* with which she makes rapier-like comments on friends and foes, personal and political, Carrasco has established a presence in the art world.

Other Southern California Chicanas deserve mention, though space does not permit more extensive treatment: Olga Muñiz, whose early drawings and watercolors showed great promise and who later worked with installation; printmaker **Muriel Olguin; Margaret García** (recently returned to Los Angeles where she was born in 1951), who works with large-scale expressive figure paintings and silkscreens in Faûve-like color that show excellent command; **Anita L. Rodríguez** who, in rejecting realism, turned toward delicate evocative paintings

and collages that draw on personal and symbolic mythology; **Elizabeth "Liz" Rodríguez** of the youngest generation, dedicated to avant-garde experimentation in installations, video and printmaking, and now living in New York.

Chicana Artists—Northern California

Yolanda López (b.1942) from San Diego is a long-time resident of San Francisco. López, who began as a painter, is best known for her critical and iconoclastic "Guadalupe" series, in oil pastel on paper and with collage, in which she replaces the most sacred Catholic icon of the Mexican nation with images of her grandmother, her mother, herself as a runner, an Indian mother and other images, enclosed in the Virgin's typical oval halo. The Virgin's star-studded cloak, the little winged angel, her typical roses, the snake she tramples are incorporated into these portraits of ordinary women whom López feels "also deserve the respect and love lavished on the Guadalupe." Thus she questions the idealized stereotypes women are supposed to emulate. López moved her theme from painting to three-dimensional works when she portrayed herself in shorts and shirt as a runner within a living tableau in which objects from life were incorporated. Her critical mind always engaged, López collected a slide show of advertising images that denigrated Mexicans and eventually translated the slides into a video production called *When You Think of Mexico: Commercial Images of Mexicans.*

In contrast, **Amalia Mesa-Bains** has, since the mid-1970s, focused on altars associated with Day of the Dead ceremonies in Mexico (and now among Chicanos who have institutionalized the ritual) and with home altars accumulated by Mexican Catholic women. With a Ph.D. in clinical psychology earned with a dissertation on Chicana women artists, Mesa-Bains has concentrated (though not exclusively) on drawings and altars dedicated to women: the Virgin of Guadalupe, Catholic nuns, fertility goddesses, Mexican actress Dolores del Río and (most importantly to her) Frida Kahlo. Long-standing interests in textile design and *papel picado* (cut paper) led naturally to the altars as accumulative installations, and to the innovative additions of light-reflecting fabrics and mirrors. Aware of, if not directly inspired by, altars by René Yáñez (who made his first altar in 1967, and instituted Day of the Dead celebrations by 1972 in the Galería de la Raza of which he was co-director), by the traditional altars with offerings, candles and *papel picado* by the older artist **Yolanda Garfías Woo** and similar works by **Carmen Lomas Garza** who also celebrates Kahlo—Mesa-Bains has now changed her "earlier didactic and

functional" altars geared toward the political period of the Chicano movement to culturally based but personal venerating symbols.

Linda Zamora Lucero, born in New Jersey and raised in Detroit, came to California in 1970. Most of her silkscreen work was done between 1973 and 1980 at San Francisco's La Raza Silkscreen Center (later known as La Raza Graphic Center). There she found gratification in being part of a group of artists that "illustrated historical and social movements, questions, etc. of the Latino community, and who as artists constitute an important part of that movement." The posters were used for public announcements in the streets—in store windows and on walls and poles. In 1981, Lucero published an international cookbook, *Compositions from My Kitchen/Composiciones de mi cocina*, which she wrote and illustrated. She also worked on layouts for the bilingual Children's Book Press for which several Chicanas did writing and illustration. In the 1980s, she became Executive Director of the Graphic Center, a non-profit community arts organization (which also runs a gallery) that now limits itself to the design component of offset printing.

Kingsville, Texas—a rural town in the southern part of the state dominated by the King family ranch—may have been a site of poverty and racism, but for printmaker **Carmen Lomas Garza** (b.1948) it is also the site of her most precious childhood memories: the cakewalks, the backyard lotteries, the *curandera* coming to heal the sick, the revered healer of South Texas, Don Pedrito Jaramillo, the fairs, the tamale feasts, the cutting of nopal cactus leaves for breakfast, the syruped-ice cones and all the world of small town pleasures, folk myth and sense of community. Unlike her political and poetic work from Texas, Garza developed a highly-detailed, pseudo-primitive style to recreate these scenes. Since coming to San Francisco in 1976, she has cultivated *papel picado* as a high art, cut copper for small altar-like triptychs, developed her etching and lithography, painted small gouaches, and constructed large beautifully crafted altars, including one to Frida Kahlo.

Other women artists who enrich the area are **Etta Delgado** whose work is concerned with the Chicana, and whose media include pastel, watercolor, acrylics and silkscreen, as well as murals;[8] **Eva C. García** and **Lorraine García** (both from Sacramento), the former of whom is self-taught and has worked photorealistically in charcoal, and the latter of whom works in an assortment of media so as not to be limited in her vocabulary. Lorraine has dedicated a series of mixed-media works that use single and double photographs to her daughter. Lorraine and **Celia Rodríguez** have both worked on murals in Sacramento and San Diego. Celia's small format pieces are constructed with ancient Mexican

glyph writing and symbolic figures in color. **Rosa Barón** works from the human body, particularly soccer players in plaster, and with Indian techniques and textiles. Along with **Kathryn García** and **Patricia Carrillo**, these Sacramento women have exhibited in San Francisco (where Lorraine and Eva now live) in a 1980 show titled "What We Are Now." **Xochitl Nevel**, with **Consuelo Nevel**, of the San Francisco Bay area has painted a large mural for a health center in a colorful realistic style, while **Blanca Florencia Gutiérrez** works in oils and **Bea López** in cast paper and felted wool.

Latin Americans of Northern California include women from Chile, El Salvador, Puerto Rico, Colombia, Argentina and Mexico. The most recent arrival is **Cristina Emmanuel** (b.1935), born in Boston of Greek parents, who moved to Puerto Rico in 1956 and has lived in Somalia (East Africa), Peru and Venezuela. She arrived in San Francisco in 1987 and received invitations to exhibit locally and in New Mexico for 1988 and 1989. Emmanuel's box altars with drawing, collage and assemblage richly encrusting their surfaces with Virgins, Christian saints, religious medals, photocopied devotional prints, family photographs, fragments of lace, tiny silver body parts called *ex-votos* in Puerto Rico and *milagros* in Mexico (to cure bodily illnesses located in the part designated), and, in one case, a banana—the "daily bread" of Puerto Rico—has tremendous resonance with Mexicans and Chicanos of the Southwest many of whom, as we have seen, embody their Catholic faith in their art.

Valeria Pequeño, born in Chile, is a self-taught artist who came to San Francisco in 1962. She found herself "in a society of many artists with access to major museums and art libraries." Although these resources helped her sense of historical and formative trends in the art world, she absorbed influence only from a constructivist woman artist. Since "Pequeño" means "small," it is a felicitous coincidence that many of her superbly crafted paper collages and paper boxes with found objects are tiny; the largest, perhaps, is a book/box about Frida Kahlo. Among the flat collages, modernist European abstraction has exerted an influence, but when Pequeño introduces images of dolls, little figures, plants, skeletons, crosses and other objects, the playfulness and delicacy are completely her own. This is a world of grown-up toys in which boxes grow legs with shoes, or round pedestal cups are stuffed with treasures. The strict geometry prevents any sense of the maudlin.

From Colombia comes puppet sculptor **Linda Haim**, (b.1949) who began as a painter. Always interested in theatre and puppets when visiting the *barrios populares* (working class neighborhoods) in Bogotá where she did social and political work, her frumpy, grotesque puppets of all sizes function as caricatures

of soldiers, presidents (Reagan, Carter and Nixon), cardinals, and even nuns. Her pregnant nun derives from stories of wealthy Colombian young women who hid in convents when they got pregnant. It is not unusual for Latin Americans to satirize presidents, the military and the church—the paintings of Colombia's most famous artist, Fernando Botero, is filled with similar caricatures. What is unusual is the use of puppets.[9]

Educated as an architect in El Salvador, **Martivón Galindo** displays multiple talents in her San Francisco area home where she arrived as an exile in 1981. Coming from a middle-class family "where matriarchy was the rule," Galindo worked in El Salvador as a language teacher, an architect, an interior designer, and a gallery director for three years. She was named Professional Woman of the Year in 1975, and has published poetry, short stories and essays. These activities continue in California where she added visual arts to her accomplishments. Galindo serves as director of the Cultural Documentation and Investigation Center of El Salvador (CODICES), which was established in 1986 to maintain links among artists, writers and the Salvadoran community and to disseminate the expressions of Salvadoran culture. Overt political messages and love of her land suffuse Galindo's drawings, pastels and paintings. Titles like *It Shouldn't Hurt to Be a Child*, *Chaos*, *Endless Suffering* and *The Past Is Always Flourishing* are not rhetorical, but reflect a real and desperate situation. It comes as no surprise to find a recent exhibit poetically called "From Our Earth Kneaded with Sweat and Tears."

Having lived in New Jersey, Miami and Puerto Rico after leaving Havana in 1971, **Maritza Pérez** (b.1955) earned a degree in printmaking at the San Francisco Art Institute in 1984. Her cut-out and embossed etchings, photo-silkscreens, mixed media assemblages and paintings deal with private symbolism as well as more accessible images. In 1983, the etching series *Los mutilados* (Mutilated Persons), showing fragmented bodies, continued the anti-war dialog begun by Goya. A 1986 assemblage containing an image of Spanish dictator Francisco Franco combined with bones, an old radio and other found objects, accuses men of bringing destruction with their technology. Pérez's most recent works recall images and symbols rooted in the Catholic and African Yoruba traditions of Cuban *santería*. Beans with rice are very Cuban, she says, while coconuts, which appear in one piece, are known as a cleansing agent against witchcraft.

In the Bay area, performance is represented by **Guadalupe García** (b.1946). Having participated in performances while living in Mexico, García was prepared, upon her arrival in San Francisco in 1986, to launch a sequence of

what she calls "performance-rituals." This is a term coined in Mexico which García defines as a bridge between myth (which embraces historical memory, cultural symbols and past experiences), and ritual (which provides the dynamic connection between experience and the mythic order). Her performance piece, *Cruz/Cross*, works out in time and space the evolution of the ancient Aztec mother goddess Coatlicue, who is attacked by her daughter Coyolxauhqui (the moon goddess) for being pregnant with the future sun god Huitzilopochtli. Using draperies about her semi-nude body, projected images on the wall, and a series of props, García's most effective scene in this work is the silhouette of the goddess's pregnant body as she parades around the space. Transformed into the dark Madonna, the Virgin of Guadalupe (both the Hispanic reincarnation of Coatlicue and her antithesis, being virgin) and then into women from other phases of Mexican history, García secularizes the mythology while surrounding it with mythical form and movements. A modern myth was utilized in *Viva la vida*, when García transformed herself into Frida Kahlo in a street performance before a painting of the artist.

As a ceramic artist, Puerto Rican **Anna de León**'s work is most publicly visible in the large plywood mural, *Song of Unity*, mounted on the facade of Berkeley's La Peña cultural center in 1978, and now being repaired and refinished. She contributed two large ceramic pieces, a condor (South America) and an eagle (North America), which symbolically unite the music of the continent and balance the large papier mâché head and arm on the other side of the mural of Chilean folk musician Victor Jara, murdered after the 1973 coup. In the present repair of the mural, de León added a large green ceramic quetzal bird (Central America) whose long tail feathers continue in paint across the flat pavement and will later be reinforced with tile. De León, who is also an attorney, is known as an activist and as a sculptor who works both figuratively and abstractly.

Photography, Video and Film

Many talented Latin American women are involved in photographic arts, both still and motion. Some are discussed elsewhere in this book. A partial list follows, stating their country of origin.

Photographers include: **Silvia Ledesma** (U.S./Mexico), **Frieda Broida** (Mexico), **Deborah Netsky** (Puerto Rico) and Chicanas **Isabel Castro, Judy Miranda, Theresa Chávez**, María Vita Pinedo, **Rosemary Quesada-Weiner, Laura Aguilar, Monica Almeida** and **Cyn Honesto**.

Video and filmmakers include: **Lourdes Portillo** (Chicana) and **Susana Muñoz** (Argentina) with a film on the mothers of the Argentine Plaza de Mayo; **Sylvia Morales** and **Susana Racho** (both Chicanas), **Lyn Picallo** (Cuba), **Elia Arce** (Costa Rica) and the Bay area collective Más Media (More Media/mass media) composed of **Ana Berta Campos** (Mexico), **Ana Perla** (El Salvador), **María Elena Palma** and **Juanita Rieloff** (both from Chile), **Mary Ellen Shurshill** and **Toni Lewis Osher** (both from the U.S.).

Increasingly, women of Latin American descent are being invited to show their work in galleries and museums of California and throughout the United States. The ratio of Latina women to Latino men in such exposure is dismally low; even lower than similar ratios for non-Latina women. Correspondingly—since one fact illuminates the other—Latin American male artists receive low exposure *vis-à-vis* the general artistic community. If women and Third World people have mutually recognized linkages between their combined exclusions, the exclusions themselves are compounded for Latina women: later starts, less acceptance, sexism within their own ranks, sexism plus racism in the world at large. One remedy has consisted in taking matters into their own hands by organizing their own shows and making demands for educated curating and consultation by male-run (or even Anglo female-run) institutions.

The whole question of Latin American women artists is tied to larger convulsions in the body politic of the United States: its position as the wealthiest nation of the Americas and also the most imperial and aggressive; its need for cheap labor in its Latin American spheres of influence and at home; and its compulsive subversion of nationalist Latin American governments. The tendency for professionals, intellectuals and artists to gravitate toward the more rewarding economic structures of the U.S. is also causing a "brain drain" from Latin American countries as economic neocolonialism impoverishes their lands.

We in the United States need to realize that such unartistic and unaesthetic terms as "national debts," "falling prices for raw materials," "currency devaluations," "coups d'état," "tortured and disappeared," have their almost immediate impact on the cultural arena, including the world of women artists. While we delight in and welcome the rich contribution to modern and contemporary art of Latin American women, the vacuum they have left in their countries of origin must give us pause to consider our own responsibilities in the artistic world and without.

—Shifra M. Goldman

Notes

1. Patricia Kerr, "Las Mujeres Muralistas," in *Connecting Conversations: Interviews with 28 Bay Area Women Artists*, ed. Moira Roth (Oakland, CA: Eucalyptus Press, Mills College, 1988), pp. 132-133.

2. Judy Baca, "Our People Are the Internal Exiles," in *Cultures in Contention*, eds. Douglas Kahn and Diane Neumaier (Seattle: The Real Comet Press, 1985), p. 67. My information is culled from this interview, from conversations with Baca, and countless visits to SPARC.

3. Geoffrey Fox, "Hispanic Communities in the United States," *Latin American Research Review*, 23:3 (1988), p. 227. Other statistics have been taken from Albert Camarillo, *Chicanos in California: A History of Mexican Americans in California* (San Francisco: Boyd & Fraser, 1984), pp. 105-106.

4. Fox, p. 228.

5. See Shifra M. Goldman, "Siqueiros and Three Early Murals in Los Angeles," *Art Journal*, 33:4 (Summer 1974), pp. 321-27. The author was the original promoter, and remains a consultant, for a restoration. It was her research that brought to light a complete photograph of the original mural which permitted Chicano artists—including Barbara Carrasco, who painted the artist and his mural in a mural of her own—to be aware of its content and appearance.

6. Letter to the author, July 15, 1988.

7. Quoted in Kelly Hollister, "Linda Vallejo," *Caminos* 1:6 (October 1980): n.p.

8. Sybil Venegas, "The Artists and Their Work—The Role of the Chicana Artist," *ChismeArte*, 1:4 (Fall/Winter c. 1978), p. 3.

9. All information about Haim obtained from Sandra Benedet-Borrego's interview with the artist in *Estos Tiempos* (Stanford University), 4:2 (Fall 1988), pp.18-19.

Magda Santonastasio, *Central America*, zinc etching. Collection of the artist.

Carmen Lomas Garza, *Selfportrait*, gouache.

Yrena Cervantez, *Homenaje a Frida Kahlo*, watercolor/oil pastels, 1977.

Folk, Naive, Outsider and Funk

Artists are often the first to appreciate powerful art from unexpected sources. Picasso, for example, arranged a show for the self-taught painter Henri Rousseau and collected African tribal art, while Jean Dubuffet collected drawings made by patients in mental institutions.

California artists, always a maverick bunch, often have been inspired by the work of naive, or self-taught artists. In the 1960s the San Francisco Bay Area was home to the counterculture movement, which began as a protest against racism and the war in Vietnam and mushroomed into a rejection of all authority. Among the most visible authority figures for a Bay Area artist were the New York-dominated art magazines. As the East Coast avant-garde produced increasingly refined art, moving from formalism to minimalism to conceptualism, many Bay Area artists purposely headed in the other direction, looking for art with emotion and personality. They found inspiration in comics, kitsch, advertising, window displays, in the art of other cultures and times and in the work of untrained artists. Folk art and outsider art provided ideas for techniques, styles and attitudes.[1] Women were an important part of this move to art outside the Western academic tradition. This was no accident. During the sixties, women came to the realization that the Western academic tradition was a male tradition. Habit and prejudice seemed to be conspiring to keep it so, despite growing numbers of women artists.

The work of self-taught artists became important to women artists for many reasons. The social position of the outsider artist, who worked without the support of an art world network, was similar to the situation for many women artists. For women frustrated by their exclusion from the art establishment, outsiders offered reassurance that the creative spirit cares nothing for official hierarchies.

The domestic crafts were the socially acceptable creative outlet for women, but were not esteemed as art. Thus the history of women's art became largely hidden. Women have been making art in the form of quilts, needlework and other media for generations. In the sixties, women began to reclaim this history and to demand recognition for these traditions.

There are many striking examples of outsider work in California. With its gentle weather and its tolerance for eccentricity, California is home to more folk art environments than any other state. The most famous is Watts Towers in Los Angeles. The towers, a group of lacy, conical spires, were built by an immigrant laborer, Simon Rodia, who worked on them from 1921 to 1954. He used concrete and reinforcing steel to make the structures, which are decorated with colorful mosaics of broken pottery, old bottles and scavenged materials.

An hour to the north of Watts, in Santa Susana, **Tressa "Grandma" Prisbrey** began building her "Bottle Village" in 1955, when she was 60 years old. Prisbrey had always been a bit of a collector. Before she and her husband settled down on the plot in Simi Valley, they had led a wandering life across the country, with five children in tow. Throughout her married years she collected pencils. Her collection grew to over 2000 pencils—too many to fit into a tiny trailer. She decided to build a small house for the collection, but concrete block was too expensive. Instead, she used bottles layered with mortar. Over the next three decades, she devoted her time to building what became a 40 x 300 foot environment of thirteen structures.

When asked why she began to use bottles, Grandma Prisbrey replied, with a typical flash of humor, that her husband drank himself to death and she had to do something with all the bottles. Availability may have been the initial reason, but she was also conscious of the beauty of her medium. She painted plain bottles on the inside so they, too, would shine like stained glass. Blue milk of magnesia bottles, provided by a local hospital, were mounted on sticks in planters, like flowers.

The Village became Grandma's lure to the world. At an age when many old people slide into loneliness, Grandma had a daily stream of visitors. Local people brought her their discards, and others just came to see the Village, which had become a tourist attraction by the early 1960s.

Walking into the Village a visitor saw sun glinting from bits of metal and glass all around. Bottlenecks bristled from the walls of the little houses, and the meandering walks were inlaid with shining things like toys, coins and marbles. Doll heads dangling on sticks substituted for flowers in a planter decorated with old headlights.

Prisbrey was proud of her mosaic walks. "Webster's dictionary defines a mosaic as being small pieces of stone, glass, wood, etc. of different colors, inlaid to form a picture or design. I guess my mosaic walks come under the heading of the etc., although Webster certainly never saw my mosaic walks or he would have more thoroughly held forth on the subject."[2]

Asked about her materials, Prisbrey said: "We have a dump in Santa Susana where everything under the sun shows up if you wait long enough. It's a graveyard for lost articles, discarded treasures, worn out everything. What some people throw away, I believe I could wear to church. . . . I found so many dolls I couldn't resist the temptation to bring them home and dress them . . . like everything else, I got so many dolls I didn't know what to do with them. The natural thing was to build a house for them."[3]

The Bottle Village is a walk-through assemblage. In fact, the work of Prisbrey and other self-taught artists has made a major contribution to assemblage in California. As art critic Rebecca Solnit has said, "Folk art is the obvious source of many assemblage ideas and practices, and California is full of folk artists who've made marvelous assemblage environments that Jess, [Bruce] Conner and many others have paid tribute to."[4] Among those others was **Lois Anderson**. Originally a librarian, Anderson became part of a group of artists in Mill Valley who were later called the "Gluers." Dickens Bascom, Larry Fuente, and Anderson developed an assemblage technique in which they encrusted large objects with glued-on smaller objects, leaving the basic shape visible. Bascom and Fuente's first work was a Ford Falcon, which they gave a second skin of shoe soles, beads and other "junk." When she saw the car, Anderson said, "That was it! I said, I've got to do that."[5]

Anderson chose more woman-oriented and spiritual starting points than Fuente and Bascom, who often began with objects of male desire—cars, sexy female mannequins, deer. Anderson's wall-hung assemblage Mother Goddess was built over an old multi-bra display from a department store. Four pairs of breast shapes, arranged on the torso like the teats of an animal, were covered with hundreds of tiny plastic babies swarming over the breasts. The whole is surrounded by a radiating aura of colored beads.

The Gluers' spirit was close to that of outsider artists. Anderson said, "Nobody taught me how to glue. I just went home and started messing around. This just came out from the inside 'on the natch'."

She went to the flea market every Sunday for three years, just as Prisbrey made daily trips to the dump. "I started going to the Alameda swap meet in 1970, and started gluing in 1971. You never know what you'll find at the swap meet. I like objects, knick- knacks, beads, icons, statues, shells, mirrors, tiles, glass. It's the color, shape and design that attract me. It has to be pleasing to my eye. Sometimes you'll find a whole box of stuff and it'll be cheap. I just keep on buying things, and maybe I'll use them three years later."

Nationally known ceramic sculptor **Viola Frey** also haunted the Bay Area flea markets. She brought home ceramic kitsch—coy figurines, Disney characters, lawn gnomes. In collecting discarded things, Frey was carrying on a family tradition. Both her father and her grandfather filled the grounds of the family farm in Lodi with potentially useful "junk"—old radios, rusty machinery and tools.

For several years, Frey cast the objects she brought home, making multiple copies which became building blocks for larger forms. A typical "bricolage" from this period might have ten rows of these copies, stacked like bricks, turned in different directions. The whole was then glazed with bright colors, camouflaging the familiar shapes and turning the "kitsch" into an abstract composition.

In recent years, Frey has used the figurine format for monumental sculptures, many of them self-portraits or figures of strong women. *The Powerful Grandmother* is typical of these figures, which stand 10 to 12 feet tall. They have sturdy limbs and strongly modeled features which are the antithesis of the delicate women depicted in the miniatures. Frey has found in these ceramic dolls, which populate women's interiors all over the country, the seed of a powerful race of giants. Her large figures have no need to depend on prettiness—their scale and brash color assert their authority.

Frey and Anderson paralleled Grandma Prisbrey's use of found objects. **Judy North**, a painter whose refined work shows no obvious visual affinity to outsider work, found inspiration in Tressa Prisbrey's spirit and process. After her first visit to the Bottle Village in the early 1970s, she sent Prisbrey a portrait. Later, she became active in a group of artists working to help preserve the Village.

North found her contact with Grandma Prisbrey inspirational: "There's a spirit—you can see it so clearly. The naive have it unencumbered. There's so much spirit flowing out of Grandma Prisbrey, it's a joy to be with her. It's hard for a person to maintain balance and grace in the face of the onslaught of ideas about art. Ordinary people are so intimidated they can't have their own connection (to the creative spirit). Naive artists are working with a real confidence. They have no doubts at all that this and this go together. There's an unshakeable connection with intuition that overrides everything else."

North found an image of hope for the creative spirit in outsider artists, as opposed to artists who are aware of an audience. "Naive artists don't have the issue of ambition in their lives. In sizing up the steps to success, you close the door to the inner spirit." She believes that art schools usually teach students a

linear mode of thinking which is a block to true creativity. Far from considering the training which creates a "fine" artist necessary, North thinks it is a hindrance.

The work of self-taught artists gave painter **Louise Stanley** permission to introduce the personal and everyday into her painting. Searching for her own esthetic, Stanley filled notebooks with copies of folk art paintings and decoration from all countries and periods. She found a guide in Camille Bombois, the European Naive painter, who influenced the stylized distortions of her figures. A former construction worker and circus wrestler, Bombois became known in the 1930s for paintings that combined a love of detail with strong, simplified forms.

In a 1966 painting titled *Rust's Wedding, or the Uninvited Guest*, Stanley paid tribute to Bombois. At 6 x 6 feet, this is one of Stanley's largest paintings. The lower two-thirds of the canvas is packed with wedding guests, not an anonymous crowd but scores of individualized portraits of Stanley's friends and heros. In order to present each guest clearly, she adopted the flattened perspective of naive or non-Western painting. Bombois is characterized like all the guests with a simplified style that approaches cartooning.

In 1968-70, Stanley met weekly with other feminists to paint "breaking all the rules." They saw so-called "bad" or "naive" art as a way to bypass ego and reach a deeper source of inspiration. "I was consciously trying to be a primitive. You were supposed to paint big, abstract oils, and not put things in the middle. We made borders and painted on cheap watercolor paper with tiny brushes. We'd put something in the middle of the paper and say 'Take that, George Post.' " (Post was a tradition-oriented instructor at the California College of Arts and Crafts.) As Stanley's work developed, she became known for a humorous narrative style. She often appears in her own work as a modern woman facing the sublime and ridiculous aspects of life simultaneously.

Eleanor Dickinson,an instructor at the California College of Arts and Crafts, whose primary activity is drawing, was attracted to the spiritual life of folk groups. She spent many years drawing and documenting fundamentalist congregations in the South. Their services encouraged an emotional abandonment which fascinated her. In the early 1970s, she created a traveling show called "Revival," which brought together her drawings, video and sound tapes, photographs and artifacts, and attempted to recreate the revival experience for visitors to the Museum. At this time, folk sources served Dickinson primarily as subject matter. Her drawing style, which features a supple, accurate line, owes more to Matisse than Tennessee.

But in 1973, her evangelical subjects suggested to her an artistic breakthrough in materials. "When the revivalists heard that I was an artist, they as-

sumed that I worked on black velvet, because that was the only kind of original art they ever see . . . eventually, I tried it. I think it's a great medium."

The deep black of the velvet alters the colors painted on its surface, intensifying their impact. Dickinson became fascinated with the medium. "I found black velvet to be the perfect union of form and subject. The darkness duplicated the intense blackness of a Tennessee night and the portions of extreme light were such as would be seen in a revival tent beside the road lit by four 40-watt bulbs overhead. But it was more than mere duplication of the scene, for light coloring on the dense space of extreme black recapitulated the extremes of emotion shown in those intensely charged epic struggles against the Devil and towards the light of God. The claustrophobia of the darkness echoed the closed-in, inbred, convoluted lives of these worshippers. The medium and the message coalesced."

Dickinson's daughter researched the history of velvet painting for her. References were scanty—black velvet was so despised that it was not even mentioned in books on Kitsch—but she was able to determine that it was first used 500 years ago as a less laborious substitute for tapestry. In the 19th century, "theorem" painting, or stenciling onto velvet, was an acceptable pastime for genteel ladies.

In 1988 Dickinson mounted a show at her studio which included her own paintings and a small collection of historic velvet paintings, from Victoriana to Elvis. Although a few other artists, such as Peter Alexander and Julian Schnabel, have used velvet, they have generally used it either for an ironic comment or for its quality as a fabric. In treating velvet as a straight replacement for canvas, Dickinson stands alone among contemporary fine artists.

Mexico, home of black velvet painting factories, also has a rich tradition of folk art, like the papier mâché figurines made for Day of the Dead celebrations. The Mexican figurines show skeletons in everyday situations, selling flowers or telling fortunes as if they were alive. They convey a sense of the constant presence of death in life. The painter **Judith Linhares** adopted this skeletal imagery into her own vocabulary, adding layers of personal and social commentary to the archetypal bones. *Lovers*, a pen and ink drawing from 1972, shows two embracing skeletons nested in a frame of palm leaves. The female skeleton is styling nonexistent hair with curlers; the male smokes a cigarette. The curlers and the relaxed postures give the scene an air of domesticity, as though the lovers are watching TV. *Lovers* presents the skeletal pair from the specific viewpoint of a Norteamericana with a slightly jaundiced view of male/female relationships.

Linhares expressed both her love for folk art and her reservations concerning it: "I really respond to folk art. I love the directness; I love the sincerity. What I miss is a complicated sort of engagement with ideas. I can't use it as much as I can use a Rembrandt or a Watteau. Folk artists' work is often the same from beginning to end. You don't see a kind of development in their minds."

In recent years, the beauty and creativity of quilts has been increasingly acknowledged. The work of "folk" artist **Willie Etta Graham** and "fine" artist **Teresa May** shares an element of surprise for people accustomed to looking at quilts that follow traditional American patterns.

Willie Etta Graham was born in Henderson, Texas, around the turn of the century and learned quilting from her mother at an early age. In 1944 she came to Oakland, where she worked in the housekeeping department at the University of California. After she retired from the University, she took a job caring for an elderly woman, a job that allowed her time to take up quilting again. She says, "I like to work piecemeal because something always calls me to get up and do something else. . . . When I get it together, well I'm surprised at the quilt that I have made. It's so much different to what it's supposed to have been. It's a new pattern."[6]

Graham's quilts follow a folk tradition which has been defined as distinctly Afro-American by Eli Leon in his exhibition catalog, *Who'd a Thought it*. The characteristics of an Afro-American quilt are descended from African textiles, which are often organized along a "strip" pattern. The strip originated from the long, narrow pieces woven on the traditional loom, which were then sewn together to make wider cloth. African textile makers valued individuality and creativity. Rather than repeating a rigid pattern, they made use of accidentals.

Even when Afro-American quilters began with a Western pattern, they used it as a starting point for improvisation. Blocks were cut freehand to approximate a shape and the next block fitted in however it would go. The result was a kind of color and shape jazz. A traditional "basket" pattern is a square split along the diagonal. One half has varicolored blocks forming the "basket," which is completed by a handle appliqued against a solid color in the other half. For her quilt *Basket Variation*, Graham began with a basket block pieced by a friend. She put two of the varicolored basket halves together, which, when pieced into the quilt, formed a ziggurat-seen-in-a-reflecting-pool shape. None of the pieces were measured, and the free-hand cutting made each repeating shape a little different. Like many Afro-American quilts, the tonalities are bright and strident, with

oranges and reds dominating. The quilt vibrates with color and the simultaneous making and breaking of pattern.

Teresa May is a trained artist from San Jose who turned to quilting when her children were small and she didn't have time to draw or paint. Among other sources, she found inspiration in a hooked rug made by her mother-in-law as a housewarming gift. May treasured that rug and valued the creativity that went into it. She found that quilting gradually took over the energies she'd been expending on more traditional forms of art and began to take chances with her quilts in the same way one would push a painting.

May's personal breakthrough came when she dared to begin painting on a quilted piece which represented days of labor. In her present work, she usually begins with a central image, often a fish or a cup, and frames it with a wide band of modified log cabin blocks or her own invented pattern based on the interlocking strands of a braided rug, another treasured gift from her mother-in-law. The image is then amplified with glitter, tacked whirls of thread and dashes of paint.

The division between Graham, a practitioner of a folk-quilting tradition, and May, as a fine artist who uses quilts as a medium, is a very small one. It rests mainly on self-definition, Graham coming from the older world-view which reserved the word "art" for oil paintings and bronze sculpture. But regarding process or aesthetic impact, there is little difference between them.

In the last three years, folk and outsider art have gained increasing acceptance by commercial galleries, collectors, museums and other mainstream institutions. The boundaries between folk and fine artist no longer seem so clear. This is partly because so many contemporary artists have found such a rich source in folk and outsider art. The work of self-taught artists has not had just one influence, but many. According to their needs, artists have found inspiration for material, imagery, style and process. As fine artists began to use the language of the self-taught artist, people were educated to the power of self-taught drawing, personal stories or scavenged materials and thus became more open to the originals. In addition, with the insights of the women's and other liberation movements, definitions of what constitutes art began to change, opening more opportunities for those who do not fit the traditional stereotypes.

Interest in the work of self-taught artists was a trend that was "in the air" for Bay Area artists in the 1960s and 1970s. The artists discussed here are part of a broader movement which affected many of the most prominent artists in California. These artists have assimilated many of the outstanding characteristics of self-taught artists. Examples can be found in contemporary sculpture, painting and fiber arts.

There is now a second and third generation of artists graduating from art schools with a paradoxical wish to imitate the look of an untrained artist. They have often been shown slides of outsider environments, quilts and other work by untaught artists as part of their education. Thus the work of self-taught artists will have an impact on contemporary art, both directly and by influence on other artists, for years to come.

—John Turner and Meredith Tromble

Notes

1. In this chapter, "untrained artists" refers to artists not trained in formal Western art. Folk artists are trained in their own traditions, while "outsider" artists are isolated from any training at all.

2. Tressa Prisbrey with Micki Herman, *Grandma Prisbrey's Bottle Village* (Self-published, 1975), p. 13.

3. Ibid, p. 5.

4. Rebecca Solnit, "Orders and Questions," *Artweek*, Vol.19:28 (August 20, 1988), p. 1.

5. All quotes not otherwise credited are from our personal interviews with the artists in 1988.

6. Eli Leon, *Who'd a Thought It: Improvisation in African-American Quiltmaking* (San Francisco: San Francisco Craft and Folk Art Museum, 1987), p. 34.

Louise Stanley, *Outside Interference*, 1988. Courtesy Iannetti Lanzone Gallery, San Francisco.

Grandma Prisbrey.

Lois Anderson with *Mother Goddess*.

A Remarkable Conjunction:
Feminism and Performance Art

There has been a remarkable conjunction between the forms of feminism and those of performance. In the early 1970s, a social movement and an art genre ignited in California to produce a poignant, innovative body of feminist art. Its inception occurred within the closed circle of consciousness-raising sessions that were part of a class taught by **Judy Chicago** at California State University, Fresno, beginning in the Fall of 1970. Chicago had moved her class from the University of California campus to a separate "safe space." In their consciousness-raising sessions, students in the all-female art class—by sitting in a circle, talking in turn and without interruption about a particular topic—exposed and shared hidden, taboo personal experiences, often for the first time.

The consciousness-raising circle has a precedent in the Chinese Communist "Speaking Bitterness" groups, developed to help peasants understand the nature of their oppression and to formulate political action. Within feminism, consciousness raising retained the notion that insights learned in the closed circle could be transformed to the spiral—to the realization that many personal experiences are common, not simply individual, and that action can be taken to heal psychic bitterness to overcome oppression. Judy Chicago felt intuitively that the spirit of consciousness-raising could "revolutionize teaching."[1] In Fresno, consciousness-raising meetings were, typically, intense. Sex, parents, independence, anxieties about femininity, problems with boyfriends, possible pregnancies, money, body image and other topics reflected the lives of the women speaking. These sessions were sometimes followed by role-playing games, with students taking the parts of other women, employers, lovers or teachers for their classmates. Then there would be role-reversals, in which students put themselves literally in the place of those who scared them, had power over them or manipulated them. The feelings and insights gleaned about their own lives were raw material for a female-oriented art that they shaped into visual forms, writing and performances. Feminist performance eventually became political action and artistic expression simultaneously.

One early performance piece by women in the Fresno class, *Rivalry Play*,

revealed basic facts about self-hatred and competition in women's relationships. The setting, a schematic bus stop, was simple. Two women, one elegantly dressed, the other slovenly, argued literally to the death. The point, crudely and directly made, was that women fight one another as much through their self-hating mutual identification as through their differences in physical attributes, race or class. Women fight with one another because they cannot unite and fight their real torturers.

The circle is the emblem for what Chicago called "central core imagery"— visual art based on woman's body in general and the vagina in particular. The closeness of performance art to the visual arts in Southern California was described by **Linda Frye Burnham** in 1980:

There are no performance artists in Southern California. There are some 30 individuals consistently using live action in artworks, but...none of them wished to be categorized as a "performance artist." Almost unanimously, they wish to be seen as "artists," that is, creators of visual images arising out of the context of art history.

Their use of the human body, sound, light, color, action, time, autobiographical detail and photography and other technology is seen by them as closely related to the choice of materials by painters and sculptors. But they are also unanimous in their opinion that the artist's assignment in the seventies/eighties calls for more than paint, canvas, paper, stone and clay.[2]

Feminist performance is not unique in being aligned with the visual arts, but is part of a tradition of performance as an invention among painters and sculptors, musicians and theater workers, dancers and poets, that originated in New York in the 1950s. The development of feminist performance art in California owes a great deal to **Allen Kaprow**. Kaprow, the originator and producer of "Happenings" in New York in the late 1950s and 60s, was teaching in the School of Art at California Institute of the Arts (Cal Arts) when Chicago and many of the women from the Fresno program initiated the Feminist Art Program with **Miriam Schapiro** in the Fall of 1971. **Suzanne Lacy**, for example, studied with Kaprow and evolved a style of conceptual and performance strategies that were based on her teacher's formal innovations as well as her own and her community's experiences. Lacy, in turn, became a powerful performance instructor and collaborator at the Woman's Building, where students like **Cheri Gaulke**, **Jerri Allyn** and others came to learn during the 1970s, and went on to perform solo and in issues-oriented feminist groups, including the Waitresses, the Feminist Workers, and Mother Art.

Judy Chicago's *Cock and Cunt* play (written in 1970) was performed at *Womanhouse* (the collaborative environment created by women in the Feminist

Art Program in its first year at Cal Arts) in 1972. The play was performed by two women wearing black leotards. The plainness of their costumes highlighted the gigantic pink vagina on the one and the penis on the other. Clearly the difference between the sexes, its personal and cultural uses and its consequences was the subject. SHE is doing the dishes and asks HE for help. HE is shocked: "Help you do the dishes?" "Well," SHE replies, "They're your dishes as much as mine!" His reply emphasizes the connection between biology and culture: "But you don't have a cock! A cock means you don't wash dishes. You have a cunt. A cunt means you wash dishes." SHE questions him: "I don't see where it says that on my cunt." The scene shifts from kitchen to bedroom, where sexual intercourse leads to a wistful statement by SHE—"You know, sometimes I wish I could come too"—and ultimately to the murder of SHE by HE. Sexual intercourse became the foreplay for violent murder.

The *Cock and Cunt* play addressed the traditional relationship between white, middle-class men and women as it had been described in **Betty Friedan**'s *The Feminine Mystique* of 1961. Chicago had followed the format of many of the simple exercises practiced and performed in Fresno. The message was basic—a fundamental fact of predetermined, culturally prescribed relationships can lead to friction and ultimately to death if challenged. The *Cock and Cunt* play expressed the revulsion of uncovering difficult facts of life and the terror of change. This deadly portrayal of the battle between the sexes made the connection between sex roles and women's oppression; the male-female relationship was interpreted as an aspect of the political institution of patriarchy. Chicago dramatized what **Ti-Grace Atkinson, Kate Millett, Shulamith Firestone** and other feminist theorists had illuminated: woman's most intimate relationships, including love and motherhood, are an intrinsic part of a class system which shapes, thwarts and sometimes even kills women.

These early efforts within an educational setting focused on speaking and thus revealing women's bitterness. **Faith Wilding**'s *Waiting* was a litany that rhythmically described women's lives as reactive to the actions of others and as characterized by waiting—"Waiting for my breasts to develop/Waiting to get married/Waiting to hold my baby/Waiting for the first gray hair/Waiting for my body to break down, to get ugly/Waiting for my breasts to shrivel up/Waiting for a visit from my children, for letters/Waiting to get sick/Waiting for sleep...."[3] Wilding herself performed *Waiting*, rocking slowly in her chair and speaking in a low monotone. She was as immobile and expectant as the players of Samuel Beckett's *Waiting for Godot*. She presented a vision of nothingness. In the act of waiting in the empty space which she attempted to fill with the litany of all she

has waited for in her life, Wilding became the American female version of existential modern *man*, but, significantly, without his freedom. She had not even freely and fully committed herself to her own life. She had not even, in her own mind, ever stood alone. She sat.

The traditional woman addressed in *Womanhouse*—in the environments as well as the performances—was not the young woman participating in the Feminist Art Program, but, most likely, her mother. These young artists wanted a different kind of life, yet in their performance work they did not envision what that life might be. Their own experience working with female teachers in an all-female art community, and their new "woman-identification" and "woman-centeredness" was most evident in *Womanhouse's Birth Trilogy*, a ritual of rebirth and new identity symbolizing the community of women who could attend their own and one another's birth.

The ritual of *Birth Trilogy* was almost identical to the ancient wiccan initiation ceremony. The consciousness-raising circle among feminist art performers was historically significant not only as a development from modern Chinese culture but also as derived from the much longer tradition of witches' covens and the dramatic ceremonies they performed at sacred sites. In the initiation ceremony, coven members stand one behind the other with legs spread apart forming a birth canal. The new members line up to pass through the canal, but each is first challenged by a coven member who places a knife at her breast saying, "It is better for you to rush upon my blade than to enter with fear in your heart." The initiate responds: "I enter the circle in perfect love and trust." In *Birth Trilogy*, the circle was recast before an audience and thus brought from the private to the public realm, from secret ceremony to art performance.

Ablutions, performed by Judy Chicago, Suzanne Lacy, **Sandra Orgell** and **Aviva Rahmani** in an artist's studio in Venice, California, in late 1972, was a blood ritual. A woman was "bathed" in raw eggs, earth, and blood, then tied into a chair that was tied to everything else in the vast room. On tape, women told of their rapes. This performance was an expression of blood ties among women as well as a wiccan response to attacks on members of its coven in the largest sense. *Ablutions* also addressed a contemporary social dilemma, rape.

Suzanne Lacy was to devote considerable attention to rape in her performance work. Working with **Leslie Labowitz** beginning in 1977, Lacy organized large group actions throughout Los Angeles and in San Francisco and Las Vegas. Lacy and her colleagues protested rape as well as violent images of women in record advertising, news and pornography. Their collaborations combined performance, conceptual art ideas, feminist theory, community organizing,

media analysis and activist strategies for change. Lacy and Labowitz formed Ariadne: A Social Art Network as a communication information-sharing network of women in the arts, politics, media and women's community. Ariadne produced public events that addressed social issues relevant to women's lives. Their media strategies were carefully planned, concrete, action-oriented, and easily available to all women. Their projects fell into two self-defined categories—the "media performance" and the "public informational campaign."

In May of 1977, Lacy created a three-week time frame for many different kinds of activities, including speakouts, self-defense demonstrations, speeches by politicians and art performances. *Three Weeks in May* was, according to Lacy, an "extended performance" which used the mass media system to publicize its revelations and demands. Two maps of the city of Los Angeles were installed in the city mall. On one, rape reports were stamped daily, showing where women had been raped the previous day. On the other, the locations of services for female victims of violence were listed. Over thirty events were produced during the three weeks; television and print reports covered many of these activities.

In December, 1977, Lacy and Labowitz produced *In Mourning and In Rage* after reading sensationalized media accounts of the discovery of victims of the "Hillside Strangler" in the Los Angeles area. Sixty women formed a motorcade of cars bearing funeral stickers and "Stop violence against women" stickers. They followed a hearse to the City Hall, where news media reporters waited with members of the city council. "Out of the hearse climbed ten tall women robed in black mourning dress. These women each spoke of a different violence perpetrated against women as they received a scarlet red cloak. Women from the motorcade chorused after each statement, 'In memory of our sisters, we fight back!'"[4] These gigantic black figures all in a line, like the alarming red stamps on the Los Angeles map of *Three Weeks in May*, arrested audience and media alike. The compelling visual images Lacy developed in these social protest actions became the hallmark for future work that focused on specific aspects of the feminine.

Lacy's students and other artists at The Woman's Building participated in some of her performance events and also formed their own groups. The Waitresses, for example, was founded in 1977 by Jerri Allyn and **Anne Gauldin**, and included **Chutney Gunderson, Anne Mavor, Denise Yarfitz** and **Leslie Belt**. The group had 14 years' waitressing experience among them at the start, and their material was culled from experience-sharing sessions. They made social and political connections between waitresses and female roles, hunger, and job

discrimination. The waitress, they put forward, is the "wife" of the public sector. One of their characters, performed often by Anne Gauldin and Denise Yarfitz in restaurants for unsuspecting audiences, as well as in performance art spaces and on videotape, was *The Waitress/Goddess Diana*. The Great Goddess Diana, said Yarfitz, "returns in her symbolic form to the modern day place of sustenance—the restaurant. She reveals Herself as the spirit of nurturing within the female as waitress. Diana was a goddess worshipped thousands of years ago. Great many-breasted Mother, ruler and nourisher of the animal kingdom, provider of sustenance both physical and spiritual for all creatures, great and small. How could you stand it? Sweat of reaching hands, open mouths, empty bellies—you must give everything to everyone at once, or be devoured! Friendly and smiling, giving menu, silverware, placemat, napkin, food, drink. White wheat or rye? Eyes ears legs? Thousand, Roquefort, French?" The Waitresses' skits and songs contained a wry humor that was relatively new to feminist performance actions.

Feminist Art Workers, founded in 1976 by Cheri Gaulke, **Nancy Angelo**, **Candace Compton** and **Laurel Klick** (Compton was later replaced by **Vanalyne Green**), sought to combine education, community and art. Cheri Gaulke described the Feminist Art Workers as the group

. . . most directly express[ing] the philosophy of feminist education through performance art. Their work grows out of a deeply collaborative relationship and finds new forms to respond to continually changing political situations. They have performed a float in the streets, conversations with strangers on the telephone, airplane and bus tours—each time functioning as facilitators of a transformation with their audience/participants.[5]

Heaven or Hell was an eating ritual the Feminist Art Workers performed for the National Women's Studies Association's conference in 1981. The story from which this performance sprang was found on the lace doily placemats at each conference participant's place setting:

When Nancy [Angelo] was a child, her grandmother told her the story of the difference between Heaven and Hell. In Hell, a long banquet table is piled high with sumptuous food and all the people are trying to feed themselves with four-foot-long forks. Heaven is exactly the same scene—the long banquet table and the sumptuous meal. The difference is that in Heaven, people are using the four-foot-long forks to feed *each other*.

Individuals and groups continue into the late 1980s to cross the perimeter of the circle, from private to public to private, and to reflect changing personal and social circumstances in their work. The foundation laid in the early 1970s at the center—the conjunction between feminism and performance—that wed consciousness-raising, education, female bodies and women's issues, protest and

theater, has been the springboard for feminist performances from that time to this.

<div style="text-align: right">

—Arlene Raven

</div>

Notes

1. Judy Chicago, *Through the Flower* (New York: Doubleday, 1975).

2. Linda Frye Burnham, "Performance Art in Southern California: An Overview," in *Performance Anthology* (San Francisco: Contemporary Arts Press, 1980), p. 390.

3. Performance texts of *Cock and Cunt* and *Waiting* excerpted from Judy Chicago's *Through the Flower*.

4. Leslie Labowitz and Suzanne Lacy, "Feminist Artists: Developing a Media Strategy for the Movement," in *Fight Back!*, p. 267.

5. Cheri Gaulke, "Performance Art of the Woman's Building," *High Performance* (Fall/Winter 1980).

Parts of this article were adapted from in "The Circle" and "At Home," both in Arlene Raven, Crossing Over: Feminism and Art of Social Concern *(UMI, 1988).*

Anne Gauldin, Chutney Gunderson, Anne Mavor, Denise Yarfitz, Elizabeth Canelake, The Waitresses, *Home on the Range*. Courtesy Jill Baker.

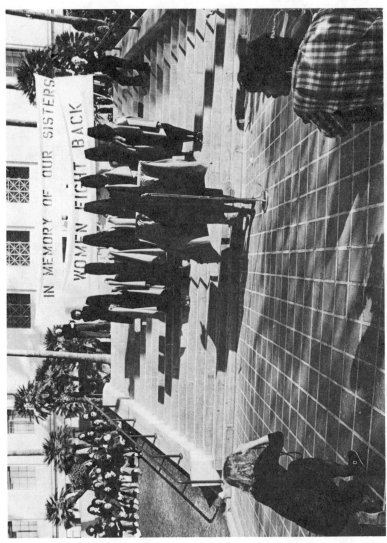

Leslie Labowitz-Starus and Suzanne Lacy, *In Mourning and In Rage*, 1977, Los Angeles City Hall.

Jerri Allyn, Anne Gauldin, Cheri Gaulke, Sue Maberry, Sisters of Survival, *End of the Rainbow*, 1983, Western European tour.

Eleanora Antinova (Eleanor Antin), *Before the Revolution*. Courtesy Ronald Feldman
Fine Arts, New York.

Spectacular Visions: Video Art

During the last fifteen years California women artists have produced an impressive body of video art. As a newly invented medium, video has proved to be particularly attractive to women artists. Video art's directness and its lack of an established tradition have offered unique opportunities for women to visualize and articulate their concerns. Many artists who had been experimenting with innovative forms of film, performance or sculpture began using portable video equipment when it became available in the early 1970s.

Unlike other mediums, video art had no history of excluding women. Since the equipment was easy to operate, and immediate results could be obtained, women artists found it appropriate to utilize video as an extension of feminist consciousness raising procedures. Video could record daily life; more than a mere mirror, video could provide feedback about the user's perceptions and behavior. In addition, videotapes could be used to share the process of individual or collective psychological and social investigation with other groups of women.

The performances that developed out of the Feminist Art Program at California State University in Fresno and the Woman's Building in Los Angeles were frequently documented on videotape. Prominent feminist artists like **Cheri Gaulke, Leslie Labowitz, Suzanne Lacy, Rachel Rosenthal** and **Barbara Smith** have consistently used video to provide a permanent record of their ephemeral work in performance. Videotape also facilitated the inception of a new genre of performance not intended for a live audience. The artist could work alone in a private space and show the products of her intimate self-scrutiny later. The opportunity to make art within a controlled context (often their own domestic environment) afforded women artists the freedom they needed to focus on the political implications of personal subjects.

Nina Sobel, Eleanor Antin and **Linda Montano** are among the artists who have produced highly charged performance tapes that explore issues of autobiography and identity. Sobel was originally trained as a sculptor. In "Selected Works" (1972-74) she adds a psychological inflection to formal investigations of process associated with Minimalism and Body Art. For example, "Breaking Glass" consists of footage of Sobel smashing glass plates

with a hammer. Sobel is not wearing goggles, and the primary tension in the tape is derived from monitoring her facial expressions.

Sobel's later works, "Hey! Baby Chickey" (1978) and "Chicken on Foot, Version II" (1979) further refine her uncompromising attention to the dynamics of cultural inscription. Both tapes use Sobel's play with a cooking chicken as a device for exploring the construction of taboos.[1] Sobel rocks the chicken, rubs it against her own bare chest, massages its pelvic cavity, dresses it in a fur garment and puts it in her purse. On a superficial level, the tapes can be interpreted as the diaries of a mad housewife rebelling against domestic tedium. But on a deeper level they function as a condensation of food/love/ sex/death, transgressing the boundaries separating these emotionally wrought topics. Simultaneously a dead animal, a food source and an infant surrogate, the chicken is emblematic of commodity relations. Women are both consumers (of chicken and other things) and the prime medium of exchange as desired objects. Thus, the images Sobel produces provoke a stream of disturbing associations about women's sexual roles and social position by attesting to linked taboos against.necrophilia, bestiality, pedophilia, infanticide and cannibalism.

Like Sobel, Linda Montano has a background in sculpture. After moving to San Francisco, Montano was influenced by ideas about the shamanistic role of the artist that circulated among members of the counterculture in that city. Along with artists like Paul Cotton or Terry Fox, Montano views art as a spiritual activity that need not be separated from the conduct of daily life. By interjecting social ills during personally crafted rituals, the shamanistic artist can exorcise them.

"Mitchell's Death," Montano's 1978 videotape of an earlier performance, functions as a rite of separation to mourn the sudden demise of Montano's ex-husband. Montano chants a litany of events from the moment she first heard of the death over the telephone through her visitation to the body at the crematorium. The camera goes in and out of focus on Montano's face, as if it, too, is overwhelmed with grief. Her face is pierced by acupuncture needles; appropriated from Chinese medicine, their presence emphasizes the connotations of healing. The recitation of her richly detailed story serves to affirm Montano's own continued existence. "Mitchell's Death" establishes its maker's identity as a speaking subject. Because women do not possess equal social and linguistic status with men, one of the agendas of women's art has often been to symbolically gain access to an enunciative position. When women are silenced, their bodies often "speak" for them by manifesting hysterical symptoms such as anorexia. Montano employs consciousness raising confessional techniques in

"Anorexia Nervosa" (1981), a tape in which she interviews four women who have eating problems. The interviews concentrate on self-image and young women's social powerlessness as contributing factors to the eating disorders of anorexia and bulimia. Montano herself has suffered from anorexia; she had to leave the Maryknoll order of Catholic nuns because of poor health. Like "Mitchell's Death," "Anorexia Nervosa" fuses individual and collective concerns in a ritual of empowerment through linguistic assertion.

Whereas Montano ritualizes daily life, Eleanor Antin theatricalizes it in explorations of the vicissitudes of identity that have also been informed by feminist consciousness raising procedures. Since 1974. Antin has been doing performances in which she adopts one of three personas: a nurse, a ballerina and a king. She has explained that these personas emerged as exaggerated facets of her real personality, expressing the nurturing, glamorous and dictatorial aspects of her behavior patterns. The adventures of her alter egos are chronicled on videotape, as well as in live performances.

One of Antin's earliest tapes, "The Little Match Girl Ballet" (1975). introduces the Russian ballerina, Eleanora Antinova. Attired in white leotards and a tutu, Antinova delivers a spirited monologue that expresses the hopes and ambitions of a young artist yearning for success. She fantasizes about moving to New York, being discovered by Balanchine, and rising through the corps de ballet in his company. Finally, a ballet is written for her, but the story of the ballet brings her frame story back to the harrowing "realities" of the present: a little girl is spurned by the cultural and economic elite, who leave her starving in the cold.

Antin's concern with the interface between public and private destinies is also evident in "The Nurse and the Hijackers" (1977). Playing a game of paper dolls, she animates and gives voice to all the characters in a make-believe account of the nurse's heroism during an airplane hijacking. The obvious artifice of her acting and her adoption of fake accents produces a schizoid, fragmentary ambience, which is further complicated by the fact that the stereotypical characters in her fiction are based on real art world figures of Antin's acquaintance. Consequently, the boundaries separating art from life and the real from the simulated become exceedingly hazy.

In Antin's most recent tape, "From the Archives of Modern Art" (1987), she adeptly substitutes the signs for the real for the real itself. Scavenging several historical dance styles, she reenacts these dated modes as facsimiles that document Antinova's ballet career. She "authenticates" her replication of silent film footage with technical flourishes; the camera goes out of focus at a crucial moment, the film is overexposed, etc. Intertitles placing these rediscovered frag-

ments in a properly stuffy art historical context also serve as oblique reminders of the way information decays or becomes distorted with the passage of time.

Antin's conflation of the simulated and the real is compatible with the southern California landscape: a man-made earthly paradise constructed by irrigating a desert with imported water and planting lush tropical foliage. The presence of the film and television industries in Hollywood likewise contributes to the obsession with authenticity and artifice in much California video art. In Los Angeles, people emulate the dress and behavioral codes of television characters and furnish their homes with quiz show decor. The videotapes of **Susan Mogul** and **Ilene Segalove** parody the kitschy pop cultural glamour that suffuses everyday life both along Sunset Boulevard and in the shopping arcades of Beverly Hills.

Susan Mogul's "Waiting at the Soda Fountain" (1981) is a satirical reenactment of the discovery of Lana Turner in a Hollywood soda fountain. Mogul plays the male chauvinist director as various members of the Los Angeles feminist community audition for their big break. Although their character sketches touch on a gamut of women's roles, the would-be starlets continually fall short of director Mogul's expectations, and are accordingly berated, dismissed or peremptorily forgiven. The phallocentric nature of the camera, its movements directed by the commands of the "male" director, becomes evident.

Mogul's early works were done while she was a member of the Feminist Art Workshop led by **Judy Chicago, Sheila de Bretteville** and **Arlene Raven**. Like Montano and Antin, she works interchangeably in either video or performance. Humor is always a prominent element in her pieces; some of her.monologues follow the stand-up comedy format, although they also reflect a concern with serious issues. Her work has frequently focused on her own Jewish ethnicity and her relationship with her mother.

"The Last Jew in America" (1984) was done as both a performance and a videotape. Using the structure of the seder, a ritual conducted in the home, Mogul deals in this insightful piece with Jewish-American ambivalence about assimilation into the dominant culture. As she layers herself with American flags, Stars of David and shopping bags, she discusses the reason Jews love Chinese food, lists which famous movie stars are Jewish, and explains why it's hard for Jewish women to find Jewish men to date.

Ilene Segalove grew up in Beverly Hills, with television as her electronic babysitter. A member of the first generation for whom television was an endemic aspect of daily life, Segalove uses its formats and icons in both the structure and the content of her work. Segalove's mother is the subject of "The Mom

Tapes" (1974-78). When Segalove learned how to use a video portapack as an art student at the University of California, Santa Barbara, she brought it home to interview her mother. "The Mom Tapes" are characterized by Segalove's straightforward approach to video technology; some of the vignettes were shot in a single take without editing.

Segalove's delight in being able to produce television herself, rather than being relegated to the role of passive viewer, is evident in "The Mom Tapes" Although she rarely appears on camera, her voice-over narration is the hallmark of her style. Like many of the other artists I have mentioned, she speaks to ascertain her own existence and define her position. Her acerbic comments often lampoon the absurdities of middle-class values. She is not interested in what makes her life story unique; rather, she elucidates the generic aspects of her autobiography.

"Why I Got Into TV and Other Stories" (1983) consists of a string of illustrated anecdotes. Segalove describes viewing Kennedy's televised assassination, falling in love with the TV repairman, being glued to the set during a bout of mononucleosis and associating the memory of watching her parents kiss with the music from "Dragnet." "More TV Stories" (1985) continues to mine the same humorous vein with narratives that reflect the mass media's pervasive impact, along with the ironies it fosters.

The progression in Segalove's work from technically crude black and white portapack tapes in the early 1970s to the slickly shot and edited color camera pieces she now produces with a professional crew typifies changes in the utilization of video as an art medium. California women artists were among the pioneering users of new video tools; thus, they have been involved in the invention of an art form at the same time that they were creating individual pieces.

The social activism of the 1960s led to the formation of video collectives to provide community access to communications media. Like the underground press, these groups were established to voice minority viewpoints. The "real time," minimally edited, low-budget video programs these groups produced challenged the myth of objective reportage perpetuated by commercial broadcasters. One of the first video cooperatives, Video Free America, was founded by Skip Sweeney and Arthur Ginsberg in San Francisco in 1970; **Joanne Kelly** joined the group in 1973 and became its co-director. Kelly met Sweeney when the members of the Video Free America group came to Salt Lake City to videotape the Utah Repertory Dance Theater. Kelly was interested in video/dance hybrids; the previous year she had completed a dance videotape

titled "Indigenous." The tape features leotard-clad dancers keyed into slides of biomorphic forms and abstract paintings. Women partner women and lift men in choreography Kelly set to music by Morton Subotnick.

Kelly returned to San Francisco with Video Free America, where she has continued to make dance videotapes and live video/dance performances. Sometimes the inspiration for her video/dance pieces grew out of the technical limitations of the video equipment that was available. For example, "Vertivision" (1974) was conceived as a result of her frustration with the limited dimensions of video monitors. To construct a surrogate "video projector," she stacked three television sets into a pillar and fed three camera images into them, subdividing dancer Susan Banyas' body vertically. When Banyas stood next to the pillar, her body was mirrored in fragments.

As Kelly's work developed, it became more technically sophisticated. "The Goddess," her 1980 performance about giving birth, was made for two video screens with live action occurring behind a back-lit semitransparent paper scrim situated between them. Six video sequences were followed by corresponding interludes of physical movement. Rapid cuts in "Caring," the initial sequence, switched back and forth between Kelly and Sweeney as they each held the baby, emphasizing their shared parental nurturing. Digital pixilation effects in the "Childhood" segment were used to magically animate stuffed animals and other toys. The sequence titled "Identity" showed Kelly donning her clothes on one screen, while simultaneously doffing them on the other. In the concluding section, Kelly punched her way out from behind both screens on prerecorded videotape, subsequently echoing this gesture during the live event by breaking through the paper scrim.

Like Kelly, **Louise Etra Ledeen** and **Jo Anne Gillerman** were innovators in the field of image processed video. Image processed video is made with video synthesizers that electronically alter the signal. Ledeen was studying art education at City College in New York when she met and married Bill Etra. In 1973 the Etras participated in WNET's TV Lab artist-in-residency program and produced "Video Wallpaper," a tape that used oscillators and the Paik/Abe colorizer. Bill Etra subsequently collaborated with Steve Rutt to design a new synthesizer. After they moved to San Francisco, the Etras continued to be involved in the fields of video art and computer graphics.

Gillerman studied video at the School of the Art Institute of Chicago during the early 1970s. She built her own Sandin analogue image processor and moved to California in 1975 to teach at the California College of Arts and Crafts. Her early work combined dance movement with live electronic synthesis in improvi-

sational jam sessions. Recently, she has experimented with new digital technology, using it to fuse human bodies with sumptuously colorized images of orchids in "Orchids" (1987).

The last outpost of the western frontier, California is a state that encourages perpetual transience. Rather than putting down solid roots as people do in regions of the country where culture has a strong traditional base, the denizens of California tend to come and go. Ledeen and Gillerman moved to California after beginning their professional careers elsewhere. Other prominent California artists such as Nina Sobel and Linda Montano left the state to pursue new opportunities. **Martha Rosler, Sherry Milner** and **Judith Barry**.have also relocated on the east coast. However, it would seem inappropriate to exclude them from this article because their presence and their art practice have had a profound impact on California video art.

There was a shift in feminist video art from personal testimony in the tapes of the early 1970s to analyses of representation and the relationship between patriarchy and other forms of repression in the later part of the decade. Rosler, Milner and Barry invented new multilayered multimedia formats that could express their intellectually informed critiques of the mass media's depiction of women, the confining aspects of the domestic cultural domain, the roles of sexual victims and victimizers and other explicitly political issues.

Martha Rosler moved to the San Diego area in 1968. She lived there for the next ten years, receiving her MFA from the University of California, San Diego in 1974. Her pieces are composed of densely compressed information. She collages facts and figures from newspapers with autobiographical.material, mass media images and quotations from academic texts.[2] Because she is concerned with not mystifying her audience, her ideas are always conveyed in accessible, nonspecialized language. She often imparts an intentionally awkward edge to her videotapes by using voice-overs with microphone noise, jump cuts, shots held too long, jerky pans or amateur acting. These Brechtian alienation effects are meant to remind viewers not to suspend their critical acumen by succumbing to the seductive magic of the media.

In "Semiotics of the Kitchen" (1975), Rosler conducts an alphabetical survey of kitchen appliances to demonstrate the ways that the language of the woman at home is circumscribed by her environment. Her mock Julia Child cooking lesson gradually mutates into an aggressive display of weaponry. "Vital Statistics of a Citizen, Simply Obtained" (1977) also focuses on women's internalization of oppressive naming systems. The tape reveals hidden strategies of

measurement and their use as a means of substantiating racial and sexual stereotypes.

The first section of "Vital Statistics" shows the character played by Rosler being slowly stripped by white-coated technicians who measure her body. Three women observe the process, reinforcing the established power structure by enforcing "standards." During the second section, Rosler kneels naked in front of the camera and breaks eggs in a bowl. Her vulnerability symbolizes women's innate ability to create new life, a power that is both revered and reviled by men. The tape concludes with Rosler's recitation of a litany of crimes against women.

For Rosler, the body is the fundamental battleground of patriarchal culture, which objectifies it through the techniques of rationalization and reification. Sherry Milner's first videotape, produced while she was a graduate student at the University of California, San Diego, examines the social construction of pregnancy as an idealized state. Not merely autobiographical in a narrowly psychological sense, "Womb with a View" (1983) uses Milner's own pregnancy to critique the enforced domestication of women accomplished through cultural and biological determinations. Milner preserves the discontinuous structure of the journals she kept during her pregnancy in the fragmented chapter structure of the tape.

Milner's next tape, "Scenes from the Micro-war" (1985), is a fractured fairy tale about the beleaguered American family preparing for war. The "nuclear family" is shown dressed in combat fatigues, eating army rations, drilling for air attacks and driving around in their camouflaged car. The narrative juxtaposes the two prized values of the Reagan era, the family and military strength, and thereby demonstrates the absurdity of the match. Milner also employs humor subversively in "Out of the Mouth of Babes" (1987). In this tape, unequal power relations between the United States and Central America are compared to the power struggles between parents and their children. The tape also explores the connection between language acquisition and domination, analyzing how language functions to obfuscate contradictions.

Judith Barry's work exemplifies the impact of recent post-structuralist discourse by continental theorists like Baudrillard, Derrida, Foucault and Lacan on video art. The installations and single-channel she produced while she lived in San Francisco are primarily concerned with the media-inflected topography of everyday life. Barry's background in architecture and performance art stimulated her interest in situating the body in relation to a three-dimensional sociospatial environment. Her work also attempts to epitomize the new kind of subjectivity embedded in the images that constitute our simulated postmodern landscape.[3]

"Casual Shopper," a videotape Barry made in 1981, portrays a suburban shopping mall inhabited by zombie-like characters who resemble the dummies used in department store displays. The architecture of the mall orchestrates the movements of these people.into a dreamlike ballet of acquisition. Barry's actors remain willfully vacuous ciphers of the goods they exchange. The camera follows a woman as she sleepwalks through the mall, responding to the inquiries of the sales personnel with the pat phrase, "I'm just looking."

An emphasis on visual pleasure is a key element of what the French Situationist Guy Debord has termed "the society of the spectacle"; it is fed by a glut of images from the mass media of magazines, television and film, as the tape illustrates, since all of these media are incorporated into the shopping mall. When the libido has been harnessed into an endless cycle of desire and product consumption, real sex becomes superfluous. This is evidenced when the woman encounters a man;they exchange looks and a kiss. Although the kiss is shot obsessively from a number of angles, their lips never actually touch.

Like Barry, **Patti Podesta** derives her models for making art primarily from continental theory, rather than from broadcast television. The title of Podesta's most recent videotape, "A Glory" (1987), refers to a meteorological illusion in which the image of man appears projected in gigantic scale on a bank of fog. Podesta poses this ancient perception as a metaphor for video; video is employed to create a new genre of landscape painting or lyrical poetry.

"A Glory" features a dynamic interplay of image and text. The text appears as an inscription crawling across the bottom of the video screen. The witty philosophical nuances of the text, with its meditations on nature and phenomenology, annotate a series of slow motion views of a woman walking through a lush canyon. The woman is eventually revealed to be wearing ballet slippers, mincing on point through the underbrush. This startling incongruity effectively conveys our twentieth-century alienation from the splendors of nature.

Podesta.was one of the founders of the video program at LACE, the largest alternative space in.Los Angeles. Because videotapes are not marketable by commercial galleries, their exhibition has been facilitated by alternative spaces. Besides LACE, some of the more prominent alternative spaces that have featured video art in California are LAICA in Los Angeles and 80 Langton Street (now New Langton Arts) and La Mamelle in San Francisco. The development of video art has also been fostered by the active exhibition program at the Long Beach Museum of Art, which David Ross instituted in 1974. The Long Beach Museum of Art offers artists postproduction as well as exhibition

facilities. In northern California, many artists use the postproduction facilities at the Bay Area Video Coalition (BAVC), a cooperatively run media center.

Nancy Buchanan was one of the original members of F-Space with Barbara Smith and Chris Burden. F-Space might be designated as Los Angeles' first alternative space; founded in 1971, it was a cooperative group gallery that was an extension of the Art Department of the University of California, Irvine. Buchanan was also instrumental in organizing the Los Angeles activities of Artists' Call Against U.S. Intervention in Central America, a nationwide movement that sponsored exhibitions and performances by artists to protest U.S. foreign policies in 1984.

Buchanan's "See I A" (1980) conveys in condensed form information that links McCarthy-style witch hunts, the role of propaganda produced by the CIA in the 1973 takeover of Chile, and recent struggles in Central America. The tape also incorporates ironically humorous soft shoe routines performed by actors dressed as CIA agents from an earlier performance Buchanan had done titled "If I Could Only Tell You How Much I Really Love You." The tape sets up a productive tension between the myths about the CIA as an intelligence gathering agency and the realities of the CIA's communication control activities by shifting among a range of discursive modes. Documentary style interviews with experts in political science are juxtaposed with a recitation of the text of what seems to be a children's book about the CIA by a little girl.

Buchanan's tapes deconstruct the mass media's methods for manipulating and falsifying information by appropriating and recontextualizing found material. Corporate-produced systems of representation define who we are in terms of sex, class and race. Several other video artists, including **Barbara Hammer**, **Yolanda Lopez** and **Jeanne Finley**, also analyze the media's ideological apparatuses and hidden agendas by subversively employing strategies of quotation and pastiche. William Olander has cogently described.these techniques: ". . . the feminist voice speaks—jamming, overloading and short-circuiting the male discourse of the media with the heterogeneous female, denying the pleasure of the familiar . . . conventions of television. . . . What is produced instead is a severe case of disequilibrium—a rupture in the visual and aural orders. . . ."[4]

Barbara Hammer's "Snow Job: The Media Hysteria of AIDS" (1987) confronts the distorted mass media coverage of AIDS by collaging a barrage of inflammatory newspaper and magazine headlines against a backdrop of colorized "snow." "Snow" is the visual display of electronic noise in video. Thus, the

blinding mass of falsehood generated by the media is emblematized literally by imagistic static.

By culling examples of the stereotyping of Mexican culture in "When You Think of Mexico: Commercial Images of Mexicans in the Media" (1986) Yolanda Lopez deconstructs repressive representational devices. For example, Lopez takes a clip from a TV appearance of a comedian and repetitively edits his patronizing gestures, using this formal trope to point up the derogatory intention underlying his Hispanic jokes. She then proceeds to catalogue kitsch Mexicana artifacts, showing how these objects encode the projection of intellectual and moral inferiority on Mexicans.

Through her appropriation of the superficial characteristics of journalistic exposes and instructional filmstrips, Jeanne Finley explores the ways personal identity is generically constructed through conventionalized mass media imagery. Finley began her art career as a photographer; her first videotapes were slide shows transferred to videotape. Produced in 1985, "Risks of Individual Actions" was the first of Finley's videotapes to combine live action with slides. In it, an interview with a doctor details the health risk an individual incurs as a result of the trauma occasioned by the death of a loved one. This loss is placed in the context of statistical information about the decrease in life expectancy ensuing from other activities, such as eating a rich dessert or drinking coffee. Personal pain is subsumed by institutionalized rhetoric in the deft parallelism Finley has set up.

"Common Mistakes" (1986) utilizes clips from an educational film on accident prevention to represent the conditions that give rise to more serious traumas. The "common mistakes" Finley inventories include a description of the lobotomies Walter Freeman performed on mental patients with an icepick, a display of mutated biological specimens from the supposedly uncontaminated Three Mile Island area and a summary of Ronald Reagan's 1985 speech in Atlanta, in which he mentioned that apartheid had been eliminated in South Africa. Each of these episodes is preceded by a simulated accident from the educational film and followed by a fictional report by someone who purports to have been involved in the blunder, either as its victim or its perpetrator. The stockpiled bits of evidence form a powerful indictment against the institutionalized practices of education, medicine, politics and the mass media.

Instead of scavenging excerpts from the media, **Max Almy** emulates its style and counterfeits its technical wizardry in her deft video pastiches. Almy worked at One Pass, a commercial video production facility in San Francisco, where she learned to use state-of-the-art equipment. Her razzle-dazzle

videotapes are laden with the futuristic special effects such equipment was designed to produce. In "Deadline" (1981) the image of a running man enclosed in a square is squeeze-zoomed to fit inside a close-up of female lips. These lips exhort the man to try harder in a tone that progresses from seduction to contempt. The digitization process gives the teeth-ringed lips an abstract, dehumanized.quality. The tone of emotional desperation in the tape can be interpreted as a response to the competitive stresses of an increasingly standardized video environment.

The subject of Almy's 1983 videotape, "Perfect Leader," is the construction of a prototypical political candidate through computer-simulated projections and computer-tabulated marketing research. Using Dubner animation and ADO effects, Almy poses her posterized candidate in front of mutating backgrounds. The candidate himself is seen in several different versions: a clean-cut moderate, a black-garbed fascist and a hokey evangelist. These variations are then tested by being keyed into graphics of cars, TV sets, flags, oil rigs, bombers and maps so that the efficacy of the resulting media images can be evaluated. On the soundtrack, a female voice chants repetitively, "We want to have the perfect leader. We need to have the perfect leader." Almy's unique approach to the video medium successfully subverts the use of advanced technology as a means of facilitating social control by turning that technology's glossy seductions against themselves.

Like Almy, **Branda Miller** worked as a commercial videotape editor. Her tapes perspicaciously reflect the circumstances of contemporary life in Los Angeles. Using a surveillance camera, Miller monitored a skid row hangout in downtown Los Angeles, surveying the last moments of activity before the area was demolished by urban developers. This footage was rapidly edited to a complex soundtrack synthesized from the sounds of jackhammers, police sirens, helicopter propellers and the mutterings of prostitutes and drunks in "L.A.Nickel" (1983). "Auto-Olympia" (1984) tells the story of a befuddled ancient Greek runner who arrives on the scene of the 1984 Olympic games in Los Angeles via a time warp. An MTV format structures "That's It Forget It" (1985), a portrait of a group of adolescent girls as they primp and preen in preparation for cruising Melrose Street, Los Angeles' New Wave fashion district.

Rapid advances in video technology have spawned a new breed of artists like Almy and Miller who are comfortable with previously inconceivable modes of communication. **Sharon Grace** uses slow scan transmission to connect geographically distant areas via satellite links. "An Iridescence in the Void," her 1986 performance event at San Francisco State University, featured a three-way

hook-up interfacing Los Angeles, Vancouver and San Francisco. In "The Review Stand" (1988), she constructed a closed-circuit surveillance system to reverse ths polarities of the usual artist/audience relationship. Viewers entered a room furnished with a live video camera and a platform containing a few chairs, while Grace spied on them and videotaped their responses to her installation from an adjacent hidden room.

Lynn Hershman made the first artists' interactive video disc in 1984. Titled "Lorna," the disc was programmed to follow alternative branchings in the narrative it displays. The viewer chooses these options by pressing the appropriate buttons on a remote control unit. Once the laser disc player is activated, still frames shown on a video monitor give step-by-step instructions about how to proceed through the program. Lorna is a woman who suffers from agoraphobia. Afraid to leave her apartment, she has her groceries delivered and does her banking by phone. Viewers get to know Lorna by making choices between the objects in her room. These objects (a mirror, a wallet, a fishbowl, a watch, a television set and a telephone) are inscribed with chapter numbers. When the viewer accesses a chapter, a succession of short vignettes unfolds.

For example, if the viewer selects the wallet, a series of still frames of family photographs from the wallet leads to Lorna's checkbook, which can be looked at page by page. This, in turn, generates the Paradise Motel sequence, featuring Lorna and a shadowy man embracing in the glowing neon light of a heart-shaped hotel sign. Each choice leads to several other.choices, creating a labyrinth of options. Lorna's structure eschews narrative closure. Ultimately, the viewer makes surrogate decisions for Lorna that result in her remaining a prisoner in her apartment, using a gun to shoot herself, or shooting a television set instead of herself and thus becoming free.

"Lorna" serves as a paradigm for opposing the passivity induced by an authoritarian media system. By choosing among Lorna's possessions, viewers take control of the viewing situation. In a significant moment in the piece, Lorna is filmed with her back to the camera as she sprays foam on a window. This is followed by a reverse angle shot of the exterior, showing Lorna writing her name in the foam with her finger. Thus, she names herself, enunciating her presence on the window surface that liminally connects the inner and outer worlds

Lynn Hershman is the director of the Inter-arts Center at San Francisco State University. Many other schools, such as California Institute of the Arts, the San Francisco Art Institute and the University of California, San Diego, also offer video art as part of their curricula. Some of the artists mentioned in this chapter teach at these schools; they are training new groups of women to

produce video art. Although **Erika Suderburg, Joyan Saunders** and **Paula Levine** have graduated recently from MFA programs at the institutions listed above, each of them has already produced a substantial body of video art.

In "The U. S. Traveler's Kit" (1985), Suderburg uses the journey of a fictional character (the U. S. traveler) as a metaphor for the American position in world affairs. The U. S. traveler has acquired a kit of various sculpted objects to help make her journey comfortable and to intercede in troublesome situations. The kit's modular pieces can be assembled in several combinations to form a portable house, a sleeping porch for the avoidance of tropical insects, a sunning patio, a wargame table, portable voting booths, a carry-on bookshelf and a hearth-and-home mantelpiece. However, the objects bear an ironic relation to the person attempting to use them. The porch is too small to sit on, the voting booths have open doors and the roofs provide no shelter.

The U. S. traveler bravely carries on despite these adversities. She obsessively catalogues the kit pieces, compiling lists and totaling figures. However, she discovers that the language books she consults provide erroneous translations. Other malfunctions result in a confusion of cross purposes as the traveler passes through stages of disintegration and attempted assimilation. Meanwhile, the viewer is presented with the flotsam from the journey and notations about the landscapes the traveler disrupts.

Suderburg's use of sculptural tableaux to convey theoretical concepts parallels Joyan Saunders' precise construction of hypothetical situations in front of the camera. Saunders' "Video Tableaux" (1982) consists of seven scenes in which a person is juxtaposed with a series of objects introduced over a period of time. The tape draws attention to the way meaning accumulates and changes with the addition of each element of information. For example, a zoom in "Prefix" focuses on a label that reads "In All Other Respects Normal" while a woman gradually turns her wrist to reveal a scar. The shock of the disclosure of the evidence of attempted suicide is heightened by the tension that has been generated as the viewer waits for the label to become legible. The elements that constitute the vignette titled "A Small Aside" include a shrink-wrapped shirt, a cigarette burning in an ashtray and a placard that states, "And Tell Your Wife It Irons Up in a Jiffy." The drudgery of housework and the coercive pressures of advertising are concisely encapsulated in this meticulously staged tableau.

Paula Levine's work alludes to the basic perceptual codes we use to select and organize information about the world and the effect of photographic media on these codes and on our behavior. Feminist film theory of the 1970s postulated that the cinematic spectator's gaze was inherently male. When fixated by the

male gaze, women were deprived of their subjective interiority and rendered passive objects. Recent theoretical writing has affirmed that the pat formulation of voyeuristic male/objectified female is an inadequate interpretation of a complex dynamic. Levine's 1987 videotape, "Mirror, Mirror," offers a novel revision of the standard feminist position by documenting the operation of a female gaze with a male subject as its object.

In "Mirror, Mirror," Levine's camera captures the narcissistic display of a handsome. barechested young man as he preens for two female admirers on the beach. When the young man notices the camera and realizes he is being photographed, a look of consternation and anger appears on his face. Levine took this ordinary incident and slowed it down during the postproduction process so its underlying implications could be analyzed. In micro-time, the viewer perceives every nuance of the young man's gestures. His visceral, threatening reaction to Levine *embodies* her gaze. Thus, the tape suggests that the male gaze may be disembodied in its abstracted relationship to its object, whereas the female gaze is always somatically incarnated as a consequence of female vulnerability to male response. Synthesizing the documentary impulse to capture the "decisive moment" with aestheticized modes of manipulating images, Levine employs two antithetical traditions of representation to express her revisionist feminist insights.

The pioneering California women video artists whose work is described in this chapter struggled to enunciate their presence as viable subjects. With more assured voices, these artists are still producing vital videotapes as the 1980s draw to a close. New generations of artists have also elaborated on the basic vocabulary of video art established by their forerunners. Employing techniques of quotation, appropriation, didactic collage and pastiche to critique the mass media, these artists deconstruct its coercive ideological strategies. Keeping abreast of both contemporary developments.in feminist thought and rapid technological advances, California women video artists are welding theory and practice into novel aesthetic amalgamations.

—**Christine Tamblyn**

Notes

1. See Chris Straayer, "I Say I Am: Feminist Performance Video in the '70s," *Afterimage*, 13:4 (November 1985), pp. 8-12.

2. See Martha Gever, "An Interview with Martha Rosler," *Afterimage*, 9:3, (October 1981), pp. 10-17.

3. See Margaret Morse, "The Architecture of Representation: Video Works by Judith Barry," *Afterimage*, 15:3 (October 1987), pp. 8-11.

4. William Olander, "Women and the Media: A Decade of New Video" in *Resolution: A Critique of Video Art*, ed. Patti Podesta (Los Angeles: Los Angeles Contemporary Exhibitions, 1986), p. 82.

Lynn Hershman, "Lorna," 1984.

Jeanne C. Finley, "Common Mistakes," 1986.

Joyan Saunders, "Video Tableaux."

Filmmakers

The West Coast state of California, home of Hollywood and commercial industrial filmmaking, is also one of the cradles of independent film art. It was in the early sixties when filmmaker **Chick Strand** strung up a sheet in the backyard of a rustic home in Canyon, right over the hills from the East Bay cities of Berkeley and Oakland, for an out-of-door screening of an experimental film she and Bruce Baillie had planned. Like other arts, film has always relied on a place to show. The complications of projection apparatus and the temporal quality of film art has kept it at bay from the usual gallery system and hence excluded it from commercial compromise, keeping it in obscurity, a mixed blessing. Nonetheless, intrepid Strand and Baillie, with popcorn and long extension cord, introduced to an eager audience works from the burgeoning art form. The cross- genre and sensual use of the close-up lens in Strand's films were to become inspiration for many filmmakers years later.

Strand began mixing classical film genres, documentary and experimental, years before the feminist filmmakers of the seventies appropriated this melange in their work. Dissatisfied with the distant camera, the so-called recording of objective "truth" and the voice of the omniscient narrator, Strand's personal and intimate subjects filmed from a close, profoundly subjective point-of-view, without attempting to be the "voice of authority," daunted anthropologists, who are unwilling to use the close-up because "it is not the normal way of seeing." But Strand says "it is normal for an infant to be close to the face of the mother, normal for a lover to be close to the body of the beloved, normal to face a friend eye-to-eye a foot away and talk intimately and normal for that person to see only the face of the friend and not his or her own face" (from *Wide Angle*, p. 50, Chick Strand, "Notes on Ethnographic Film by a Film Artist").

Persevering and following her own direction, Chick Strand has returned for many years to the village in central Mexico where she has filmed the people with extraordinary sensuality and compassion. *Anselmo* (1967) shows the personal transformation of Anselmo, who receives a tuba as a gift from Strand. The relationship between filmmaker and film subject is heightened by the beginning montage of black and white negative film, followed by color negative superim-

posed on color positive film, dividing Anselmo from his wish-gift. Then, in unadulterated positive color image, Anselmo begins to play his tuba in a passionate desert journey. Strand has not lost the soul and qualities of personhood by bringing her artist self "in relation" to the documented subject.

Strand has studied and explored her own sense of consciousness, history, memory and forgetting in the exceptionally profound *Elasticity* (1976). Fragments from Mexican footage juxtaposed with Strand posed as a questioning muse with a direct camera gaze are interspersed with subtitles that question the spectator's linear ability to construct meaning. Strand weaves the present, past and future with deft, poignant text and images that demand audience receptivity. The film ends with single-frame rephotography of the first frame of each shot, requiring an elasticity of the spectator's memory. Strand writes about her film in the 1988 edition of the *Canyon Cinema Catalog*, No. 6, "There are three mental states which are interesting: amnesia, euphoria and ecstasy. Amnesia is not knowing who you are and wanting desperately to know. I call this the White Night. Euphoria is not knowing who you are and not caring. This is the Dream of Meditation. Ecstasy is knowing exactly who you are and still not caring. I call this the Memory of the Future."

In October of 1988, Strand's *Fake Fruit* (1986) was shown at the New York International Film Festival by newly selected director Richard Pena, who returned avant-garde film to the Festival after a ten-year hiatus. *Fake Fruit* is an intimate documentary about young women who make papier mâché fruit and vegetables in a small factory in Mexico. The focus is on the gossip which goes on constantly, revealing what the young women think about men. The film, sensuously shot in extreme close-up, is avant-garde more in content than form. For the first time on the screen, along with 1200 other audience members, I heard a woman's talk about private matters that shattered a cinematic taboo of silence. Chick Strand, pioneer California filmmaker, teacher and inspiration for many women filmmakers, continues her thirty-year commitment to personal, ethnographic and experimental cinema.

Born in 1911, **Sara Kathryn Arledge** is one of the earliest women filmmakers to produce film as art. Arledge, painter, writer and filmmaker, pioneered the dance film with her early *Introspection* (1941), whose purpose was to demonstrate a new dance medium totally different from the stage. In 1946 Arledge moved temporarily to the San Francisco Bay Area, where she became the first woman to join a local experimental film organization. Members included several now-famous personages—Curtis Harrington, Sidney Peterson, James Broughton, and Kenneth Anger. In 1947 Frank Stuaffacher coordinated

the "Art in Cinema" series at the San Francisco Museum of Art, the first organized screenings of experimental film on the West Coast. *Introspection* premiered there in 1947 and received wide critical acclaim. Arledge used stage-light gelatins for color effects, a hubcap for a convex reflecting surface, slow motion and multiple exposures. Like **Maya Deren** on the East Coast, Arledge tried to make a filmic dance as opposed to recording a stage performance.

In 1958 Arledge produced and directed *What is a Man?*, a film celebrating change, questioning evolution, probing unanswerable questions. Beautiful light-ing, a Magritte-like window scene, a study of physical movement, upside-down superimpositions, stop and slow motion photography herald this film of erotic imagery. Arledge creates films that combine structural and painterly concerns guided by the emotions. She represents for us the filmmaker as whole person, as unified woman and artist. In a 1977 interview with Tony Reveaux, Arledge said, "In creating film, I used my whole self. I used my eyes, my feelings, my intu-ition and my critical intellect. I didn't use just one part of me to make a film."

Interior Garden (1978), *Interior Garden II* (1978), *Tender Images* (1978) and *Iridum Sinus* (1980) are films of slides of 3-1/4 x 4 inch glass plates sandwiching paint, soot, colored gels that are etched, scratched, swirled, fingered and brushed into luminescent film paintings that encourage the viewer to find discernible form or let the reality of the medium itself speak. In 1980, Sara told me "I invented this process of transparencies as art. They were used before in the forties only as visual aids."

Sara Kathryn Arledge's work, as well as her courageous and full life, amaze me. The innovative lyricism and destructural narrative in her work is unique. She is the foremost woman pioneer of West Coast experimental film.

A major figure in the San Francisco Bay Area, **Gunvor Nelson** emigrated to the U.S. in 1953 and moved from painting to filmmaking in the sixties, creating striking visually graphic and intensely personal films that have inspired her students and the viewing populace. Early in 1965, Nelson, along with **Dorothy Wiley**, created the montage of sound (opera, fairy tales, Judy Collins, news an-nouncements and TV interviews of Ms. America contestants) with a visual montage of cut-outs, drawings, real life and off-the-monitor TV film to produce perhaps the first post-modern critique of marriage, pregnancy and childbirth in *Schmeerguntz*. Magazine pictures and the media obscure the reality of what it means to be a woman—a very pregnant woman reads a fairy tale about a princess, other women scrub greasy pans, change diapers and pull the garbage from clogged sinks.

Fog Pumas (1967), Nelson's surreal study of a woman's mind, includes memories of an aged woman, dwarfs and nightmare figures in a montage of black and white negative and positive images that change to color. Nelson creates on a synchronizer, weaving rolls of film side-by-side to be printed in the laboratory later when they reveal to the filmmaker for the first time the results of her work. In the recent masterful *Frame Line* (1983) Nelson works with paint and collage on an animation stand before beginning her risk-taking A/B/C/D rolls. *Frame Line* takes us to the filmmaker's native Sweden with shots of Stockholm, the Swedish flag, people and gestures in cut-outs, drawings and painting as well as photography. Speaking with the audience at The Collective for Living Cinema in New York City in 1984, Gunvor Nelson avowed her love for experimenting, the creative energy that is involved in filmmaking and the risk-taking that she allows in her work. The sound edits in *Frameline* are often one frame long. The Swedish National Anthem is dissected using a different instrumental voice edited to the same note. Nelson works in the tradition of the visual artist who works for her own perceptive abilities and her own interests, not those of an audience.

Gunvor Nelson's recent work of the eighties, *Frameline*, *Light Years* (1987) and *Light Years Expanding* (1988) firmly establish her importance and contribution as a leading figure in Bay Area filmmaking. The lushly painted visual field studies of the latter two films suggest the displacement and personal memories as mattes, cut-outs, black ink and footage shot from trains are juxtaposed and change one another. Nelson reintegrates painterly concerns to the projected light of the film screen.

Janis Crystal Lipzin is an intermedia artist who often works in film. She intentionally avoids placement within any established medium. During her twenty-plus years as an artist, she has been frequently concerned with emphasizing the specific identity of material she uses, revealing the workings of the processes she employs. The materials of her recent work have included compressed fibers from clothes dryers, photographic emulsions, earth and archaeological artifacts. Her means have included video, audio recording, film, three-dimensional constructions and xerography.

In her 1978 film, *Visible Inventory Six: Motel Dissolve,* interiors of motel rooms are filmed with text that notes the date and time as well as the odometer reading on Lipzin's car as she drove cross-country. The disjunctive soundtrack is a reading from Gertrude Stein's *America I Came and Here I Am* and *American Food and American Houses.* The new spatial relationship between spoken word,

printed text and visual image capture her personal impression of a transient view of American life.

Visible Inventory Nine: Pattern of Events (1981) continues the recording of "series" that interests Lipzin in all her work (photographic, installation, performance). A series of ads from the Village Voice provide private thoughts presented in textual images. The soundtrack is an analog progression of tones moving in patterns that suggest the use of mounting tension used in narrative commercial film. Again, the new space and time art that result from a combination of disparate sound and image bring a sensibility encompassing the simultaneity of all experiences, yet at the same time reminding us of the fractured world we live in.

In *Other Reckless Things* (1984), Lipzin uses medical instruments, films of childbirth, hospital procedures and fragments of historical accounts of self-inflicted Caesarean sections. Lipzin writes that the film was prompted by her shock at reading a newspaper account of a kind of human vivisection. In August, 1981, a young woman in Ithaca, N.Y. decided that after seven months of pregnancy it was time for her baby to be born. She performed a Caesarean section on herself with a pocket knife. Performance poet **Ellen Zweig** vocally constructs the soundtrack using several accounts of this medical anomaly.

Janis Crystal Lipzin continues to be interdisciplinarian in art-making, active in arts education and committed to curating, programming and advancing exhibition and support for the arts in the Bay Area.

In 1985 I saw a film that moved me profoundly, a film that challenged accepted ways of viewing and brought another intelligent voice to independent cinema. That film, *Reassemblage* (1982) by **Trin T. Minh-ha**, introduced disjunctive readings of visual images and sound so that the subject (image or viewer) could not be unified without accepting all the ways of seeing and speaking introduced in the film. Minh-ha's first film, shot in Senegal, questions the authority of the omniscient narrator as well as the omniscient audience. Unfinished sections, jump-cuts, multiple framings and fragmented composition do not allow for a single-fixed focus, point-of-view or "reading" by the viewer. This formal method of questioning issues of spectatorship, in particular, refer to the ways of seeing/hearing another culture. There is not a single truth, as there is not a single reading of the film.

Approaching the same questions in a different manner, Minh-ha's *Naked Spaces: Living Is Round* (1985) unfolds leisurely, but with varying methods of showing multiple perspectives. The viewer who watches for two hours begins to have a sense of roundness from both the film form and the architectural struc-

tures and the people who inhabit them. Three different voices make up the soundtrack, reinforcing the various levels of simultaneous reading: a Western viewpoint, a voice representing the African people, and the filmmaker's voice of observation. Trin T. Minh-ha's films are innovative and challenging moving images and sound, compelling us to discover the generosity of understanding we as audience members of filmmakers are capable of reaching.

Working in an antinarrative mode deconstructing narrative devices such as point of view, linear plot and stable characters, **Lynn Kirby** brings us a new cinema in *Sincerely* (1980) and *Sharon and the Birds on the Way to the Wedding* (1987). *Sincerely* is a film about choice. Kirby writes, "I feel it is every woman's choice, regardless of economics, whether or not to have children. This is a film about abortion, specifically state funding of abortion. The government has cut out funding of abortion except when the life of the mother is endangered. The woman writes a response in large pink letters to the senator's refrain: 'try really not to get knocked up in the future.'"

Kirby's films encourage us to question cultural positions on women's issues: to decipher, to accept a multireading of sound and film fragments, and to exit from the film using personal intelligence to structure meaning. *Sharon and the Birds on the Way to the Wedding* shifts point of view on the subject of marriage from a mother's learned dictates to her daughter's questioning voice. Magazine cliches on love and romance, as well as lush, sensual performance-staged events (a woman in a polka-dot silk dress painting a shed), found footage (rephotographed fire fighting scenes) and documentary (a woman and her pet parrots in close-up) prevent the audience from reading a fixed authoritarian voice. The playfulness of the editing and sophistication of the complex sound weaving supports the entry of the spectator into the text. We are not inhibited by distancing or omniscient views. Kirby's work opens the door to the viewer. The cleansing of the eyes of perception is left to us.

Karen Holmes' *Saving the Proof* (1981) is a complex transformation of an ordinary action: a woman walking. Holmes' masterful use of the rephotographic device of the optical printer allows her to repeat sequences again and again giving the sense of endlessly going nowhere and somewhere at the same time. *Returning the Shadow* (1985) uses different interpretations of the same five photographics over a historical period, showing how interpretation changes according to one's life experiences. The tension created in the viewer between the past remembered and the present forgotten, and vice versa, creates a circular rhythm that suggests what Gertrude Stein has called "a simultaneous present," where past, present and future are contained in the same moment. Holmes' con-

tribution as filmmaker, teacher and board member of Canyon Cinema is impor-
tant in the Bay Area filmaking community.

Gail Camhi moved to the Bay Area from New York, where she worked in
filmmaking with Hollis Frampton and Paul Sharits. Camhi has been exhibiting
her films (some of which are Super-8mm) since 1974. The 13-minute *An
Evening at Home* (1979) is a remarkable black and white document of her father,
who conducts an imaginary symphony to the sound of a radio. As he waltzes and
sways as if no one were watching we are led into the intimate sweetness of a fa-
ther-daughter relationship, for we know Camhi, the filmmaker, is present as her
father reveals his playful childlike self. In *Bellevue Film*, an array of portraits of
patients in the physical therapy section of a hospital shows two older men com-
ing to grips with their disabilities. Skirting "documentary," this is a silent film
describing valor summoned against overwhelmingly physical odds.

Dana Plays, born in Baltimore, moved to the Bay Area in 1971 and began
making films in 1976. Her previous work included photography and printmak-
ing. Plays' work, like some already mentioned, brings the viewer into the screen
image to examine the message for her/himself. Using cross-cultural references
and images, Plays values the active audience participation her films engender. In
Across the Border (1982) the complex relationships between El Salvador and the
U.S. government are explored through manipulation of coloration and
fragmentation of the visual elements. Plays deconstructs with subtlety and repe-
tition the "man-made" constructs responsible for the oppression she has
witnessed. Continuing her examination of parts and wholes, *Shards* (1988) looks
at the formal concepts of filmmaking by exploring the film frame, broken se-
quences and excerpts of filmed realities. *Shards* questions ideas of wholeness
and reconstruction in the film form.

Barbara Klutinis, photographer and filmmaker, has completed three per-
sonal films. *Pools* (1961), which she co-made with me, is an exploration of the
two Hearst Castle swimming pools designed by the first woman architect to
graduate from the Ecole des Beaux-Arts in Paris, Julia Morgan. Barbara and I
researched the 20 pools Morgan designed and settled on a personal underwater
exploration of the architectural space, using the visual medium of film as a way
of revealing the design of swimming pools that is not usually seen. As we swam
and filmed, turning circles underwater, using both below- and above-water vi-
sion, we attempted to give the audience an experiential understanding of the
creative use of deep space and chambers in Morgan's design. Further, since no
one is allowed to swim in these pools, we provided the audience with a
forbidden experience.

Klutinis' second film, *Trumpet Garden* (1983), explores in Maya Deren fashion the lush verdant growth and approaching death in a fertile garden filled with aural and visual texture. *Still Life with Barbie* (1986) satirizes the gender training of young girl-children as real life and animation of Barbie dolls are intercut. The use of narrative sequences and pixilation of dolls dressed like the live actors addresses the confusion of the child with the social construction she questions as she manipulates and comments upon the activities of the dolls.

Amidst the hustle-bustle of commercial film industry below the Hollywood Hills, working in film art are a number of young women filmmakers, in addition to seniors Sara Kathryn Arledge and Chick Strand.

M. Serra has produced a remarkable series of very short films (one and two minutes long) within a few years. Her cinema is marked by a lush sensuality, a concern for light, play and artfully woven soundtracks. *Nightfall* (1985) is a black screen probed by a searching light that discovers lilies and orchids, architectural fragments and finally a person, a face. The soundtrack in French is taken from Sartre's autobiography *The Words*. In *Framed* (1985) the blank screen of projection is intercut with a single frame of red. Edge numbers on film and the black, white and red spectrum of the film remind one of the darkroom. Serra comes from a photographic and painterly background, and all her work to date is informed by these mediums. *Turner II* (1987) is the most filmic, accomplished and visually sophisticated work to date. With a lyrical soundtrack by **C. Breeze**, who poetically describes dream and waking states as she tells a sexual story, *Turner II* is rich with superimpositions, single frames and carefully composed yet quickly moving sensual close-ups.

Betsey Bromberg's *Temptations* (1987) is a visual and musical study of performer Tom Waites. Fireworks explode over Waites as he cunningly and wistfully plays an accordion. *Az Is* (1987) portrays a constant tension between life and lifelessness in a raw descent into a desert underworld. *Ciao Bella* (1979), set on the Lower East Side of New York City, features motorcyclists, topless dancers and Coney Island crowds in what the filmmaker describes as a "study of love and mortality."

Intense, rich and political is the collage film *Vital Interests* (1982) by **Beth Block**. Shot in black and white with a sense of performance, sculpture and painting, *Vital Interests* critiques the world of possible nuclear disaster, vast arms expenditures, dirty air and wargames. Using a highly constructed audio track taken from news announcements, Block forebodes an unending world of disaster. Reagan is a mask on a cat and then a dog, stacks of toy soldiers fall over like dominoes, a person riding a carousel turns around and we see a skele-

ton. At the end, pitifully, a parrot weak and without feathers hobbles across a lawn, pulls itself by the beak up a wire cyclone fence, and, finally, sits shivering in a cage. The screen goes black. One last radio announcement, a weather forecast predicts a continuance of the same weather we've been having. Block refuses to shield the viewer from discomfort, and we are left with our own struggles and questions of what to do.

In 1973 I began an experimental cinema that directly confronted taboo subjects: lesbian sexuality, relationships and women's physical bodily functions and pleasures (menstruation, orgasm). Twenty-three films from the seventies are comprised in this body of work. In 1980 a concern for the exterior environment led me to make an experiential cinema of underwater and above water landscape films that directly influence the physiological motor system of the viewer. This attempt to "activate the audience," to challenge "passive spectatorship," began in a rotary projection using eight architectural "found screens" within the space I was projecting in, requiring the audience to move to see the film (*Available Space*, 1978).

Pools (1981), *Pond and Waterfall* (1982) and *Bent Time* (1984) attempt to stimulate interior kinaesthetic sensibilities for the viewer, either through the underwater photography of "frog-eye swim-vision" or the single-frame (one foot equals one frame) walk through high-energy locations in the United States.

In 1985 I began my research with the optical printer in an attempt to restore passion, soul and human feeling to avant-garde film without neglecting formal concerns. This work grew from a concern that the "structural, minimal, formalist" filmmaking of the seventies had fulfilled the goals of attending to the physical properties of the medium itself for content, but now needed replenishment of spirit. *Optic Nerve* (1985) draws attention to the vertical nature of the projection apparatus, as well as the finite beginning and ending of life. Shot in a California nursing home, *Optic Nerve* has a subjective point of view, following my grandmother down the sterile corridors of her last years of memory. Three-dimensionality is reduced with one optic nerve, and the film plane is a two-dimensional graphic surface for light play and the endless repetitions of daily life that lead to death.

Endangered (1988) posits light, life and experimental film to be threatened with extinction in this late 20th century. Every image is marked and cancelled before it disappears. Film emulsion is treated with hydrochloric acid, scratched and etched: foreshortened zooms of frames within frames are abruptly cut and stopped as foreground and background reverse; and the menacing soundtrack by **Helen Thorington** evokes disruption, forebodings and destruction. However,

there is a sense of perseverance with the recurring image of the filmmaker at the optical printer working, working, working.

California women filmmakers continue to make the Bay Area and Southern California important nuclei of film art in the United States. Many women whose films are available for viewing and renting through Canyon Cinema Co-operative and who have contributed substantially to experimental film continue to live and work on the West Coast. **Diana Krumins** (*The Divine Miracle*, 1973, *Babobilicons*, 1982); **Alexis Krasilovsky** (*End of the Art World*, 1971, *Cows*, 1982, *Exile*, 1984); **Nina Fonoroff** (*Some Phases of an Empire*, 1984, *Department of the Interior*, 1986); and **Anne Severson** (*Riverbody*, 1970, *The Big Chakra*, 1972) are names of women filmmakers and films important to the history of experimental West Coast film art.

Film is a visual art form and it is important that it not be neglected in galleries, museums, collections and archives, as well as the cinematheques committed to screening this time-based art. Artists of all disciplines and the viewing public will find by attending experimental film showcases a vibrant, dynamic and challenging art that addresses issues not only relative to film but to perception, spatial practices and viewer viewed relationships pertinent to every sentient being.

—**Barbara Hammer**

Janis Crystal Lipzin, *Other Reckless Things*, 1984.

Lynn Kirby, *Sharon and the Birds on the Way to the Wedding*, 1986.

Barbara Klutinis, *Still Life with Barbie.*

Barbara Hammer and her optical printer used to make *Optic Nerve*, 1985, and *Endangered*, 1988.

19th Century Photographers

The first woman to advertise as a photographer in California was Mrs. Julia Shannon, who, in January 1850, advertised herself as a "daguerrean" in San Francisco. With true entrepreneurial spirit she also touted herself as a midwife with "rooms opposite the hospital."[1] She followed the first known male photographer, Richard Carr, in California by almost exactly one year.

Julia Shannon was both a gallery owner and professional photographer. In January 1850, a San Francisco newspaper reporter may have expressed the prevailing local interest toward Shannon—and women on the El Dorado frontier generally—when he wrote, "[Daguerreotype likenesses] taken in a very superior manner, *and by a real live lady too. . . .* Give her a call, gents."[2] Shannon had to contend with the rough and tumble times of Gold Rush San Francisco. On May 4, 1851, for example, she lost two houses worth $7,000 in one of the city's many destructive fires.[3] Sadly, I am unaware of any surviving daguerreotypes known to have been taken by Mrs. Shannon, nor do I know what eventually happened to her. Yet, even if only a pipedream, I like to think that the following advertisement may have been penned by our illustrious photographer/midwife:

HUSBAND WANTED. Whereas my husband has lately left my bed and board without provocation on my part, I hereby advertise for a suitable person to fill the vacancy thus caused. The gentleman applying must have blue eyes, light colored mustache (my husband had black) an attractive goatee and a genteel figure. He must be not over twenty-five years of age, well educated, of unexceptionable morals, and agreeable address. It is a requisite that his personal encumbrances should be limited, and his prospective fortunes flattering. No gamblers need apply. Address JULIA.[4]

How many women photographers were working in California during the 19th century? At least 600 before 1901.[5] This surprisingly large number requires some explanations. For instance, how do we define the term "photographer"? Twenty years ago, when I began my research on 19th century California photographers, I limited my study to those who had *advertised* themselves as professional photographers. However, as I began an extensive reading of California census records, local newspaper accounts and hundreds of thousands

of surviving photographs, I discovered hundreds of names of photographers who apparently did not advertise.[6]

Next came the various trades *within* photography: operators, negative retouchers, print finishers, colorists, gallery clerks and salespersons, to name only a few of the many jobs in support of photography. Frequently, over time the same person might be observed in multiple roles, working first as a retoucher, then as a camera operator before finally becoming a gallery owner. Finally, there were the amateur photographers—especially those who regularly participated in camera clubs and/or exhibited in the various fine-art salons. I decided to keep track of them all, and created four broad categories as an aid to my study:

1. Gallery owners (exhibited financial control)
2. Photographers (professional or journeymen/women)
3. Workforce
 A. Labor (i.e., clerks, printers, finishers and the like)
 B. Artists (colorists, retouchers, and so forth)
4. Amateur and Fine Art photographers

The more than 600 women whose names I have gathered fit into one or more of these divisions.[7] There are thousands of unanswered questions concerning this group of women. How may we readily distinguish between the work done by a woman married to a photographer from that of her husband? How many were amateurs before they became professional? How many colorists were foreign born? How many were the sole support of their family? I suspect my listing is far from complete. Two factors have contributed to the difficulty of documenting women in the workplace. One of these was a societal bias against working women generally. The other was the great neglect of women in our public records before World War I.[8]

With Julia Shannon gone, the California photographic stage appears to have remained empty of women until June 1857, when a Miss Hudson advertised herself as a traveling photographer in the little village of Oroville.

MISS HUDSON & CO / EXCELSIOR AMBROTYPES, MALAINOTYPES, DAGUER-ROTYPES! MISS HUDSON, having perfected herself in the art, cannot fail to please her friends and patrons. Will remain at Oroville, in the Empire Hotel, room No. 18. CALL AND SEE. Children's Likenesses guaranteed.[9]

The following spring, Miss Eliza Anderson advertised her presence in Santa Rosa (north of San Francisco). She indicated that her gallery was well equipped and that she had received training "from some of the best artists [i.e., daguerrean artists] in the country." After promising to take only pictures of the "most per-

fect kind," she extended an invitation to the ladies "in particular" to call and examine specimens of her work.[10]

Shannon, Hudson and Anderson were followed by a slowly increasing number of women during the 1860s. Geographically they ranged from the northern mid-state region of San Francisco and Sacramento to as far north as Yreka, only a short distance from the Oregon border.

Mrs. Rudolph, who settled in Nevada City, is a good example of a woman trained as a daguerrean before her arrival in California. Born Julia A. Swift, she received training as a school teacher in Litchfield, Connecticut, where she obtained her teaching certificate on May 15th, 1839 (the same year as the announcement of the daguerreotype process).[11]

From 1852 to 1855 she worked for daguerrean Daniel D. T. Davie in Utica, New York. In April 1856 she arrived in Nevada City, California, where she took over the G. O. Kilbourn Gallery on Commercial Street. At that time she called herself "Mrs. Julia A. Raymond."[12] In July her gallery burned to the ground, yet by September she had completely rebuilt it and was back in business as a portrait photographer.[13] By October she had reverted to her maiden name, Julia A. Swift "formerly Mrs. Raymond." She continued her photography business until her marriage in 1860 to a local druggist, James F. Rudolph. By 1865, however, she had opened a gallery in Sacramento, and between the years 1865-88 shifted her gallery alternately between Sacramento and Nevada City.[14] Her 36-year tenure as a California photographer is remarkable and seldom surpassed by a photographer of any era. Surviving examples of her portraiture attest to her competence as a professional photographer.

During the 1870s there was a flood of new portrait galleries in California, of which many were operated by men with families. Clearly, wives and/or daughters of these photographers were expected to assist in these establishments. John D. Godeus, for example, married Mary A. Kemp in 1865, shortly before becoming a photographer (or photographic assistant) in San Francisco's South Park Photograph Gallery. By 1872 he had opened his own People's Art Gallery, where he was assisted by his wife and later his daughter. When Godeus died in the 1890s, his wife took over the business and operated it successfully for several years.[15]

Many women learned photography from their husbands. Some wives did the handcoloring or retouching, often combining her work with the traditional duties of a mother and manager of the family home. One woman—active in the State of Washington—interviewed after having spent nearly 50 years processing and printing her husband's negatives—was clearly surprised by all the fuss when she

observed: "There isn't much to say. I only did my duty. Any good wife would have done as much. Photography was my husband's business, and it was my job to help. I tried never to let him down. . . . I see nothing especially noteworthy about that."[16]

Although women seldom got credit for their role as helpmates in photography, there were some notable exceptions. A "Mr. and Mrs. Morris"[17] shared equal billing in Santa Cruz, and the partnership of "Wm S. Young & Daughter" did traveling photography near Fresno in 1874. The Youngs' advertisement typified the way a traveling portrait operation worked:

PHOTOGRAPHIC. Nothing, unless it be a letter, gives more pleasure in proportion to its cost than a photograph. A likeness of yourself or a picture of your residence would be esteemed beyond price to your friends in the East. . . . WM. S. YOUNG and DAUGHTER, Photographers, of Centerville, will be in different places in Fresno county, as follows: At DRY CREEK ACADEMY, April 1st; MILLERTON, April 10th; BUCHANAN, April 20th. Rain or an unexpected amount of work may delay any one of these appointments a day or so, but they will endeavor to be "on time" . . . they earnestly request their patrons to favor them with calls as soon as they open, that they may be kept busy.[18]

Their advertisement placed an emphasis on the production of portraits (likenesses). This was where the money was made, so much so that it has been estimated that at least 90 percent of all 19th century photographs were portraits. This does not mean that women did not take outdoor or landscape images in California. In fact, Mrs. Withington used her skirts as a portable darktent.

Mrs. E(liza) W. Withington hailed from a tiny dot of a town called Ione in Amador county. Not only did she make a business of taking landscape photographs, but she wrote an article about her techniques called "How a Woman Makes Landscape Photographs."[19] In it she explained that she often traveled great distances "by stage[coach], private conveyance, or fruit wagons" in search of suitable subjects.

During the hot summer months, she explained, she "began to finish up and dismiss local work, clean 5 x 8 [inch glass] plates, select and arrange my chemicals in compact little packages or small bottles . . . [so that] I may hie me to the mountains."[20] In 1876, the year her article was published, traveling photography required a backbreaking amount of cumbersome equipment, especially because glass plate negatives had to be sensitized and processed in the field (the wet-collodion process). Even her camera was a considerable handful by comparison to today's point-and-shoot 35mm photography:

[My] camera, the pet, consists of a pair of Morrison lenses, a Philadelphia box and tripod; on short distances I usually carry these, having the [tripod] legs doubled up and tied, but, if riding far, and I do not want to use it, I take out the [tripod] screw, invert the lenses, i.e., turn them into the [camera] box, turn up the bed-frame, and wrap [it all] up in the skirt-tent and pack away.[21]

The "skirt-tent." Imagine if you will, Mrs. Withington as she traveled around the countryside by stagecoach. Assuming her arrival at a suitable rest-stop, she would get out her camera and assemble it. After focusing on the subject of her choice, she had to sensitize her glass plate. This had to be done in a darkroom or darktent. She did not always have time to set up her portable dark-tent.

I improvised one by taking a dark, thick dress skirt, that was well fringed (i.e., weighted with sticks and rocks), sewing two thicknesses of black calico to the bottom, then, when I knew of a view that we were to pass, I would sensitize a plate and by wrapping a wet towel around the plateholder, and over that the focussing cloth, I have carried [the plates as long as] three hours. When the exposure has been made, I throw the skirt over the camera, and pin [its] band close to the camera box [the camera tripod supported the "dress dark-tent"]. . . . If the sun is bright, and too much light enters, I throw over all a heavy traveling shawl, and with water, [safelight] lamp, and developer, I slip under cover, develop the view [i.e., negative], wash and replace in the plateholder until a more convenient time for fixing and varnishing.[22]

Mrs. Withington was as completely practical as she was innovative. In addition to her photographic kit she also carried a "strong black-linen, cane-handled parasol." She used her parasol "to shade her camera lenses with, or to break the wind from the camera; and for climbing mountains or *sliding* into ravines [as] a true and safe alpenstock."[23]

Mrs. Withington's account is one of our most detailed descriptions of a California field photographer during the 1870s and should be read in its entirety. Since her working area was one of California's most sparsely populated and rugged districts, it speaks highly of her personal courage and fortitude. One cannot help but admire the great energy and initiative that her surviving photographs demonstrate. Her stereoscopic views of gritty mining activities, taken under very difficult conditions, are inspirational.[24]

As I learned of Mrs. Withington's adventurous traveling techniques, I assumed that she was a young woman. In fact, Mrs. Withington was 51 years old when she wrote her article in 1876. She died the following year from unknown causes.[25]

Less glamorous, but equally important, were the women who worked in supporting roles in California photography. Some were gallery clerks, others were print finishers or negative retouchers and a few operated as independent sales agents. Information concerning these occupations has often been obtained through a tiny (often inadvertent) mention in the newspapers. An example occurred in 1873 when San Francisco photographer Carleton Watkins was in the process of mass-producing large quantities of stereographs showing the Modoc Indian War. A newspaper reporter in Yreka (nearest town to the site where the conflict occurred) reported that the photos were being "finished in good style" and that 20 women and a "number of Chinamen [were] being kept constantly at work."[26] The women described here were doubtless piece-work employees, hired specifically to complete a particular task.

Colorists and retouchers were frequently referred to as "artists." Mrs. Emily Eastman, for instance, enjoyed a reputation as an outstanding photograph painter. Active in San Francisco, she regularly exhibited her work in the Mechanics' Exhibitions beginning in the late 1860s.[27] She was visited during the late 1870s by Ukiah photographer A. O. Carpenter, who later wrote the following comment to his wife: "[Mrs. Eastman] is the principal photo-retoucher and colorist here. You have heard me speak of her. She is a Vermonter, a widow, real lively, and plain—about 40 I should say, large and imposing."[28]

Sarah ("Sallie") Dutcher (born in Australia in 1847) began her career as a retoucher in San Francisco during the mid-1870s. By 1880 she had become an independent photographic sales agent. Such sales, done outside the regular galleries, were unusual. It is likely that she served as a go-between for photographers and public outlets such as Woodward's Gardens in San Francisco, a popular tourist attraction of the 1880s. Dutcher was also the first woman to climb Yosemite's Half Dome and was linked romantically with landscape photographer Carleton E. Watkins. By the 1890s the retoucher's trade was an essential element of any major California portrait gallery. No less than ten women are known to have been associated with Frank Schumacher's gallery in Los Angles during the period 1890-95.

Many young women are recorded as holding entry-level jobs in the photography industry at that time. Margaret Curry, born in California to Irish immigrants, worked as a photograph mounter. She lived with her sister's family, was age 21 and single.[29] Claire Haussberg, the 22-year-old daughter of Swiss immigrants, found work as a retoucher. The household consisted of Claire's parents (her father was an artist), grandmother and two sisters, one of whom (age 24) worked as a private tutor while the other (age 17) was unemployed.[30] Likewise,

Cora Heymann, born in California of German immigrants, was listed only as an employee of a "photograph gallery." She was 15 years old.[31]

Beginning in the late 1880s, a substantial number of the women who worked in photography in California were either immigrants or the children of immigrants, especially Irish, German and Italian according to the California census for 1900. Since the 1890 census was burned in the great San Francisco fire of 1906, the 1900 census is our best source of information concerning family configuration during the 1890s.

Sometimes the information is puzzling. Consider the following entry: "Carey, Mrs. Elodia, photographer, born Nebraska [1876], divorced and mother of three children." Reading further, one discovers that *none* of her children were living in 1900 and that she was located at the Hoopa Indian Reservation in the wilderness some 350 miles north of San Francisco.[32]

Think of the adversity of having had three children, all of whom apparently died in infancy. Yet for every sad story there is another in which a woman triumphed in the face of adversity. Abbie Cardozo is an example. The sixth of nine children, she had been forced into marriage at age 14 by her parents. Her husband was nearly as old as her father. Then she opened her first photography business in the small coastal town of Ferndale she was 30, divorced and had three teenage daughters to support. A businesswoman in the frontier West was uncommon, a divorced mother even more so. Nonetheless, she not only competed favorably with the other three galleries in town—operated by men— but she successfully outlasted them all.[33]

An indication of the consistent rejection of women in California photography is revealed by their status in local photographic organizations. Neither the San Francisco Photographic Artists Association (formed August 1866) nor the Photographic Art Association of the Pacific (founded March 1875) had women members. Likewise, the Pacific Coast Amateur Photographers Association (formed March 1883) was essentially a men's social group: "Ladies were never permitted an entrance to those sacred, cold walls on Merchant Street, and many [was] the pleasant evening spent there. . . ."[34]

In 1890 these restrictions came under severe attack, and on March 27th the P.C.A.P.A. passed a resolution admitting women to membership. The vote was the largest ever polled in the history of the society. Twelve women were considered for immediate membership, and within a short time the Society added another eight.[35] All was not well, however, and the Association folded with most of the members joining the California Camera Club (founded March 1890). Not only was the C.C.C. active and long-lived, but it was the sponsor of two influ-

ential journals of photography—*Pacific Coast Photographer* (1892-1894) and *Camera Craft* (1900-1942).[36]

The United States Census reported 17,839 men and 2,201 women as professional photographers in 1890. During the 1890s and early 1900s thousands of women joined the world's ranks as amateur photographers. In California this amateur movement would prove crucial in helping establish a healthy climate for fine-art photography that would rival such fine-art bastions as Boston, Philadelphia and New York.

By 1905 there were more than 50 camera clubs operating in California. Two of these, the California Camera Club in San Francisco and the Los Angeles Camera club, were the most active, These clubs provided a socially acceptable atmosphere for women to learn photography. Some women joined for purely social reasons, but for many others, the clubs provided an all-important forum for the public display and criticism of their art.

In May 1891, for instance, the P.C.A.P.A. held its annual exhibition of lantern slides and prints and noted "the prominent part taken by the lady members." Seven women were specifically singled out for critical comment, of which the following are typical:

[Miss I. W. Palache] showed a large amount of studies, mostly landscapes, which all showed the result of true artistic feeling, combined with a perfect technical knowledge of photography. Her "After the Storm" and "Angora Creek," were the most complete as pictures, but an [reviewing artist] lingered long over "Approaching Storm at Tahoe," and "Early Morning at Tahoe," which fascinated by their true rendering of nature as it really is.

[Mrs. J. P. LeCount] had several genre pictures which showed great feeling and artistic touch in their arrangement. While "Songs Without Words" and "Seaweeds" were both great favorites, her most popular picture was "Anxious Hearts" . . . it represented a mother and child looking anxiously from beneath the stone arches of a castle on to the lengthening shadows for some hoped-for figure which is long delayed.[37]

By 1894 there was a small cadre of women who were considered "serious" workers in the field. Miss J. F. Banks, a member of the C.C.C., exhibited in both the P.C.A.P.A. Salon of 1892 and in the San Francisco Mid-Winter Fair of 1894. The San Francisco *Chronicle* reported that Banks had already established a reputation for herself "as being clever with the camera," and noted that she "has just returned from Alaska with a trunk full of new and interesting negatives . . . [which] will be shown at the California [Camera] Club in the near future."[38] Another was Miss F[loride] Green of San Rafael, who "is one of the most popular and clever members of the amateur ranks. . . . She devotes herself principally

to portrait and figure work and has made some valuable additions to the California Club's collection. She also excels in platinotype work."[39]

These women were among the forerunners of a "west coast school" of art photography and were soon followed by such internationally known luminaries as Annie Brigman and Imogen Cunningham. However, some amateur women photographers used their cameras for different purposes. One of these was Nellie McGraw, born in San Francisco in 1874, the fourth of 13 children. She became a school teacher, and by 1900 was a teacher on the Hoopa Indian Reservation (Presbyterian Mission School). She loved to photograph her students and to record her daily life among the Indians. Following her assignment in Hoopa, she acquired a folding Kodak that took post-card-sized negatives and carried it with her as she traveled all over the United States on behalf of the home mission field. Her goal: "the sad plight of the Indians and how they needed saving from drink, immorality and the Roman Catholics."[40]

By the close of the 19th century, the role of women in California photography was established. On the professional side, many women now owned their own studios and/or occupied positions of respect in the photographic trade. By 1902 the San Francisco School of Photography had opened its doors. It referred to itself as "a kindergarten for the photographer" and offered a course of 12 lessons together with "a practical field demonstration."[41] Much more definitive was the training offered by the California College of Photography, which was established in Palo Alto in 1904. Here an enterprising young woman could learn the basics of the commercial end of the photographic trade:

New fields are opening up for the photographer every day. The Government has placed them in all the agricultural and scientific departments. Advertisers are placing them in their illustrating departments. Half-tones are rapidly taking the place of pen and ink drawings. The large daily, the weekly and the monthly magazines are steadily increasing their staff of photographic artists . . . [also] a few days ago a representative of one of the leading San Francisco stock houses told us that he could place a number of first-class [photographic] printers and operators at once on a salary of $25 to $35 a week.[42]

Photography as a fine art also reached its apex shortly after the turn of the century. During the late 1890s, some women had combined the traditional art training offered by such schools as the Mark Hopkins Art Institute with experiments in photography as part of the California Camera Club or on their own. Laura May (Adams) Armer, for example, had studied painting and drawing under Arthur Mathews before establishing a professional photographic portrait studio in 1899. Her interest in fine-art photography remained high, and she

exhibited ten prints in the first San Francisco Salon (1901). Armer was a successful and prolific contributor to local and national salons for many years.[43]

The foregoing glimpses into the lives of women in California photography before 1901 offer only an outline of their contribution. Yet, each woman's efforts—like the individual pieces of a unique patchwork quilt—help to form a colorful and vital whole.

—**Peter E. Palmquist**

Notes

1. Charles P. Kimball (compiler), *The San Francisco City Directory*, September 1, 1850, pp. 99 and 134.

2. San Francisco *Alta*, January 29,1850.

3. Ibid., May 7, 1851

4. Ibid., October 8, 1850, p. 2, c.5.

5. Photographic partnerships, such as "Ganter & Ganter" (they were sisters) are counted, as is each individual sister (i.e., a total of 3). Some women may be listed twice, once under her maiden name and again under her married name. My previous writings on women in California photography include, "Photographers in Petticoats," *Journal of the West*, Vol. 21:2 (April 1982); and "California Nineteenth Century Woman Photographers," *The Photographic Collector*, Vol.1:3 (Fall 1980). See also "The Indomitable Abbie Cardozo" in *Photography in the West* (Manhattan, Kansas: Sunflower University Press, 1987) and "Stereo Artist Mrs. E. W. Withington: or, 'How I use My Skirt for a Darktent,'" *Stereo World*, Vol. 10:5 (November/December 1983).

6. I list more than 6000 photographers active in California before 1901. However, an educated guess suggests that there may have been upwards of 10,000 men and women involved in some aspect of California photography before 1901.

7. For an interesting classification of women's work in photography in London, England, c.1873, see Jabez Hughes, "Photography as an Industrial Occupation for Women," *Anthony's Photographic Bulletin*, Vol. 4 (1873), pp. 162-66.

8. New names and information have continued to surface, bringing my total to nearly 640 names. Sadly, we may never know the names of many women who worked on a temporary or "piece work" basis, due to lack of primary documentation.

9. *Butte Record*, June 6, 1857.

10. *Sonoma Democrat*, January 6, 1859. She was active as early as April 1858.

11. Certificate held by the California State Library, Sacramento.

12. Nevada City *Journal*, April 4, 1856.

13. Both the gallery and the former gallery owner's house (possibly also occupied by Mrs. Raymond) were burned on July 19, 1856, with a total loss listed at $10,000. On September 12, 1856, she resumed advertising.

14. It is likely that Mrs. Rudolph suffered from a medical problem that was helped by spending part of each year in Sacramento. It is unclear whether she actually owned the Sacramento gallery or merely rented it during part of each year.

15. Both John D. Godeus and Mary A. (Kemp) Godeus were born in Holland. (She was born in April 1849.) Mrs. Godeus was listed as the sole proprietor of the studio by 1896, and by 1900 she was a member of the Photographers Association of California. Her daughter, Mary Clara Levy, also worked as a photographer according to the 1900 census.

16. Dave Bohn and Rudolfo Petschek, *Kinsey, Photographer* (San Francisco: Prism Editions, 1987), p. 308.

17. Ella M. Morris was born in Massachusetts in 1852. She ran a gallery in Santa Cruz, 1883-87. Samuel I. Morris, born in Illinois around 1850, was an upholsterer in Santa Cruz, 1878-80. He joined his wife in the photographic gallery c.1886.

18. Fresno *Weekly Expositor*, April 1, 1874. The daughter may have been Annie C. Young (born in Iowa, 1847), who was listed as a photographer in San Francisco in 1880.

19. *The Philadelphia Photographer*, Vol. 13:156 (December 1876), pp. 357-60. See also Palmquist, "Stereo Artist Mrs. E. W. Withington," p. 20.

20. *Philadelphia Photographer*, p. 357.

21. Ibid., p. 359.

22. Ibid.

23. Ibid.

24. A number of Mrs. Withington's stereoscopic mining views are held by the Huntington Library, San Marino, California. She also did carte de visite and cabinet card portraits and frequently did them in the rural homes of her clients: "A bed-room or clothes closet can so easily be converted into a dark closet, and we are safer from accidents [caused] from wind or dust."

25. The Amador, California, Census for 1870 listed her age as 45, and noted that she was married to George Withington, age 49. Her school teacher daughter, Augusta, was 22. Both Eliza and George were born in New York, while their daughter was born in Michigan. Her death was noted in *The Philadelphia Photographer* (quoted from the *Mosaics* of January 1877) Vol. 14, p. 128

26. Yreka *Journal*, June 25, 1873.

27. As an example, Mrs. Eastman exhibited 30 painted photographs in the 1875 San Francisco Mechanic's Fair, according to the 10th annual catalog of that exhibition. Her name also appeared regularly in the San Francisco business directories through at least 1886.

28. Correspondence, Aurelius Ormondo Carpenter to Helen McCowen Carpenter, c.1875. (Courtesy Grace Hudson Museum.)

29. U.S. Census for San Francisco County for 1900, reel 103, p. 110A, line 48.

30. Ibid., reel 102, p. 159A, line 9.

31. Ibid., reel 107, p. 273A, line 36.

32. U.S. Census for Humboldt County for 1900, reel 87, p. 294.

33. Palmquist, "The Indomitable Abbie Cardozo," pp. 106-109.

34. Citation from an unidentified newspaper—possibly the Monterey *Wave*—dated November 14, 1891.

35. Correspondence from A. J. Treat, published in *Anthony's Photographic Bulletin*, Vol. 21:9 (May 10, 1890), p. 286. "This change will put new life into the Society, as the work of many of the lady amateurs equals the best of the most skillful of the sterner sex."

36. The California Camera Club held regular outings, lectures (usually illustrated with lantern slides) and exhibitions. One lantern-slide lecture titled "Through Japan with a Camera" (June 27, 1890) drew an audience of 1700 people.

37. *Anthony's Photographic Bulletin*, Vol.22:11 (June 13,1891), pp. 346-47.

38. San Francisco *Chronicle*, June 30, 1894.

39. Ibid. She was sometimes referred to as "Chloride" Green and had been a photographer in New York before her arrival in California. A note in an unnamed and undated (c.1897) California newspaper reported a mishap which she suffered by using flash powder: "This ardent lady amateur was severely burned about the hands by the explosive, but is now well on the way to recovery."

40. Information courtesy Joel W. Hedgpeth. Her negatives are on file at the Lowie Museum, University of California, Berkeley.

41. *Camera Craft*, March and April 1902, n.p. The class was scheduled to begin May 5, 1902.

42. Enos Murdoch, "California College of Photography," *Overland Monthly*, Vol.44 (September 1904), pp. 378-79. There are various mentions (and some lengthy descriptions) of the college in *Camera Craft* during 1904.

43. Lavern Mau Dicker, "Laura Adams Armer: California Photographer," *California History*, Vol.56:2 (Summer 1977), pp. 128-39. Armer wrote "The Picture Possibilities of Photography," *Overland Monthly*, Vol. 36:213 (September 1900), pp. 241-45, and a number of books concerning Indian life in the American southwest.

Rose Lasley. Photographer Margaret Rose (Martin) Lasley and friend Bertha
Perigot, Blue Lake, c.1896. "Rosie," as she was called, was born in Blacksburg,
Northern California. In later life she became proficient as a painter. She was a
favorite of the local Hupa Indian tribe, which adopted her. This advertising
portrait is a cabinet card, approximately 4 1/2 x 6 1/2 inches. Courtesy of
Humboldt State University.

Unidentified Woman Photographer, California coastline, c.1900. Image from a stereo card.

Misses White and Hubbell, example of a cabinet card portrait, San Jose, c.1890s. Miss White may be Lily E. White who operated a portrait gallery in Portland, Oregon, c.1902.

Mrs. C. Klostermann (Corrino Caesarina Shaw Klostermann Lambert, 1849-1909), example of a cabinet card portrait of four young women posed with Oriental "props," c.1895.

20th Century Photographers

When **Annie Brigman**'s photographs of nudes in the California landscape were published in *Camera Work* for the first time in 1909, the reviewer affirmed for his fellow New Yorkers that the images were truly made outdoors, "in the open, in the heart of the wilds of California." The editorial note didn't call into question the veracity of photographic representation, it simply marvelled innocently at the grand Sierra Nevada vistas in Brigman's work, reassuring readers of their very feasibility. So alien was the western landscape to the eastern sensibility, even that of the art establishment, that it was still regarded as unfamiliar, uncharted territory.

Such perceptions still linger on in the waning years of the 20th century, forcing contemporary California artists to contend with attitudes of regionalism that place them on a lower tier than their East Coast counterparts. Artists working in photography remain stuck, for the most part, even further down in the hierarchical scheme, and photographers who are women must contend with double standards and domestic and economic pressures to grasp even their lowly rung.

The women photographers in California who have produced outstanding bodies of work during this century have displayed remarkable will and stamina in overcoming these barriers to success. Brigman (1869-1950) photographed her models and herself in communion with rock and tree forms in nature. Her romantic, "pagan" pictorialism earned her one of only three west-coast memberships in the Photo-Secession.

Imogen Cunningham (1883-1976), heavily influenced by the work of Photo-Secessionists as well as the British Pre-Raphaelite artists, produced an unprecedented series of nude views of her husband in the woods of Mount Rainier. An early example of the "superwoman" syndrome, Cunningham raised three sons while maintaining an active, creative life in photography. Since familial responsibilities bound her to her San Francisco home, Cunningham began photographing in her garden, making a remarkable group of close-up views of plants and flowers. The directness and clarity of these images, their subjects isolated and stripped of their natural scale and context, proved resonant with work made concurrently by the Neue Sachlichkeit (New Objectivity) photographers in

Germany, as well as the f.64 group in Carmel, of which she was a founding member, along with Edward Weston, Ansel Adams and others. Cunningham continued to apply her fresh, direct gaze to nudes and portrait subjects until she died at the age of 90, her last project being a series of portraits of others over the age of 90.

The legacy of the f.64 group's reliance on form to reveal essence can be seen in the portraits of **Consuelo Kanaga** (1894-1978), who was not a member but who exhibited with the group, and in the images of **Ruth Bernhard** (b.1905), whose photographs of plants, skulls, shells and the female nude exploit the sculptural, evocative potential of organic form.

Dorothea Lange (1895-1965), like most photographers of the early 20th century, began photographing under the reign of pictorialism, and her elegant and austere portraits of the 1920s show the movement's influence. As the number of unemployed reached unavoidable proportions in the early 1930s, Lange shifted her focus from the contrived dramas of her San Francisco studio to the living sagas of the street. In 1935 she began collaborating with her husband, economist Paul Taylor, on studies of the labor conditions of migrant workers exiled by drought. The same year, she began work for the Farm Security Administration, producing under its auspices a moving document of humanity under strain, including the image *Migrant Mother*, widely regarded as an icon of the depression era. After terminating her affiliation with the FSA in 1939, Lange documented the internment of Japanese-Americans and contributed two essays to *Life* magazine. Kange's concentration on her subjects' facial expressions and gestures, from her early commercial portraiture, through her social reform work of the 30s and 40s, to her last decade of photographs made during worldwide travels, imbued her images with a dance-like grace and power.

The boom in publishing, sales, teaching opportunities and art world recognition that invigorated photography in the 1970s struck on fertile soil in California. Both the f.64 tradition and the legacy of social documentary photography dissipated in favor of more conceptually oriented work and explorations of a range of photographic processes, including multimedia approaches and the conjunction of image and text. In the work of women photographers, especially, a concern emerged for issues of personal identity, gender relations and media manipulation. Portraiture and self-portraiture have prevailed as the dominant channels for such concerns. **Judy Dater**'s (b.1941) work has ranged from straightforward, sensitive portraits to theatrical self-portraits and nude self-portraits made in the wilderness that update Brigman's turn-of-the-century romanticism with an existential starkness.

Judith Golden's (b.1934, now living in New Mexico) self-portraits using collaged, montaged and painted photographs embody personal and cultural fantasies and stereotypes about women. **Eileen Cowin** (b.1947) stages cinematic stills rife with domestic tension, using her own family as subject. **Jo Ann Callis** (b.1940) refers to her staged scenes of figures interacting with simple domestic objects as psychological self-portraits, or ambiguous traces of thoughts.

In other veins, **Linda Connor** (b. 1944) expands on the 19th century tradition of expeditionary photography, in her rich contact prints of landscapes charged with sacred import and imprinted with the markings of cultural or religious ritual. **Barbara Kasten** (b.1936, now living in New York) has become well-known for her fabricated still-lifes, "constructs" using mirrors and other non-representational elements of color, mass, texture and line.

The vigorous diversity of expression exhibited by these and many other women photographers working in California today defies biases of region, medium and gender. It challenges the very voices of suppression that would have it remain unfamiliar, uncharted terrain.

—Leah Ollman

Ruth Bernhard, *Rag*, 1971. Courtesy of the artist.

RUTH BERNHARD
Born in Germany in 1905, Bernhard moved in 1927 to New York, where her
work in advertising introduced her to photography. On a trip to the West Coast
she was excited by the work of Edward Weston and was impelled to leave the
world of fashion photography and resettle in California in the 30s. Thereafter she
devoted herself to images exploring the inherent grandeur of the human body
and common objects, probing the essence of form through light. A dedicated and
impassioned teacher, she has lectured and taught classes and workshops
throughout the country.

Imogen Cunningham, *Magnolia Blossom*, 1925. Courtesy Witkin Gallery, New York.

IMOGEN CUNNINGHAM

Cunningham was one of the few women photographers of her generation known to the general public. In later life, she became the apotheosis of adorable little old lady, in appearance, anyway, although she also had a cunning wit. Cunningham is the l.o.l. in the forest with camera and the nude Twinka in the famous photo by Judy Dater. A tribute to Cunningham after her death observed that she was "living proof that a teenager can live disguised as a 93 year old woman." Invited to do a group photo of American Society of Magazine Photographers [ASMP] members, "for immortality and a good fee each," she responded, "Young man, I do make good money by selling prints of my naked husband from 1906. Why should I take on more problems?"

Cunningham posed her husband, Roy Partridge, naked by a pool on Mt. Rainier sitting on a sheet of ice. But when she exhibited those pictures early in the century they created such a scandal that she didn't show them again for 50 years. Finally, as her fame and demand for her work grew, she had assistance printing and threatened to have a chop made for her prints, bearing a translation into Chinese of, "To Hell with you! This print is just as good as if Imogen Cunningham had made it."

From Women Artist News, *Vol.12:1, February/March 1987.*

Tina Modotti, *Misery*, 1928. Courtesy Whitechapel Art Gallery, London.

TINA MODOTTI

Italian-born (1896) Modotti lived in California from 1913 until 1923, when she left for Mexico with photographer Edward Weston. While in Los Angeles she was featured in several Hollywood films and became interested in photography through Weston. Her work matured in Mexico, where she was deeply involved in the militant revolutionary movement and was a part of the left-wing cultural circle that included Rivera and Siqueiros. Modotti's twin passion for art and politics produced some of the greatest masterpieces of 20th century photography. After some years of exile abroad, she returned to Mexico, where she died in 1942.

Judy Dater, *Imogen and Twinka*. Photograph from *Women and Other Visions: Photographs of Judy Dater and Jack Welpott* (Morgan & Morgan, Dobbs Ferry, New York).

Golden Clay: California Ceramists

Gold, Clay and Art Pottery

From the beginning, California had a history of exploration and settlement and a geography quite different from the East. Both have affected the development of ceramics and the position of women working with clay. Potters were among the first settlers in the 17th century on the East Coast, which was not true as far as we know of settlement in the West. Although the mineral resources for establishing a clay industry were easily accessible in the California soil, it was not until another mineral—gold—was discovered that pottery would become part of the state's future. The Gold Rush of 1849 brought in migrants from other parts of the country, and created a new upper class with the money to buy luxury goods and the leisure to pursue the arts. Other factors such as cultural ties to Mexico and the state's isolation contributed to the growth and direction of the arts. What the state lacked in speed in producing indigenous artists and craftspersons, it made up through leadership, by the mid-20th century, in terms of ceramics. The history of California women ceramists involved in the transformation of a decorative craft to an art form is what this chapter will trace.

Ceramics in California began during the 1890s, long after the art pottery movement and the techniques of china painting and underglaze painting had stirred artistic longings in midwestern women. **Linna Irelan**, a china painter and the wife of the state's mineralogist, joined forces with one of the East Coast's foremost potters, Alex Robertson of Massachusetts. Robertson had come West to San Francisco where he established the Roblin Pottery in 1898 with Irelan, whose husband's knowledge helped them locate geological sources for clay materials. Irelan, in keeping with the late Victorian interest in the exotic, added the sculptured forms of salamanders and lizards to Robertson's vases.

In 1906, when the San Francisco earthquake destroyed almost all of the pottery's unsold work, a discouraged Robertson left for Los Angeles, closing the workshop. There is little information on Irelan's later career, but pottery decoration by women continued within pottery factories. The Stockton Art Pottery (1896-1900) employed women decorators, but like most California potteries it faced stiff competition, especially from imported Oriental ceramics. After the

first decade of the 20th century, women decorators were part of the staff at Arequipa Pottery of Marin County and the Rhead Pottery of Santa Barbara.

Anna Valentien was a particularly talented decorator and sculptor. A former student at the Cincinnati Art Academy, Anna and her husband Albert were decorators at the famous Rookwood Pottery in Cincinnati before they moved to San Diego in 1907. Earlier, Rookwood had sent the Valentiens to Paris where Anna had studied briefly with Rodin. As a result, figurative sculpture became one of the strong motifs on the pottery the couple produced at the Valentien Pottery in San Diego between 1911 and 1914. Lightly clad figures, similar to those found in French ceramics before the turn of the century, lounge around the neck and shoulder of Valentien's jars. Valentien's figurative pottery signaled the finale of the Art Nouveau style, which began to fade during the first decade of the new century. In fact, the Arts and Crafts Movement's philosophy almost disappeared as industrialization, particularly after World War I, became a necessity for small potteries.

The work of women in the small number of art potteries established before and after World War I was rarely noted unless a partnership was involved. Like the Valentiens, **Gertrude** and James **Wall** pooled their artistic skills to establish the Walrich Pottery in Berkeley in 1922. Financial considerations required the Walls to use factory methods such as molds and casting for the production of vases, lamp bases and small sculptures, but Gertrude Wall made some individual pieces that were sold through the pottery. In the following two decades she returned to handcrafted sculpture in a studio pottery setting. By the 1940s her personal work was regularly exhibited locally and she had become an active teacher and member of Bay Area art and ceramic associations.

The handcraft tradition that inspired the Arts and Crafts Movement continued to live in the production of decorative tiles. One of the most significant tile companies in southern California was founded by a woman, **Mable K. Rindge,** in 1926. Malibu Potteries was established in part to keep intact and unspoiled the Pacific Coast property near Los Angeles which Rindge owned. Although she eventually lost that battle to the state highway department, Rindge used the area's red and buff clays to produce a high-grade ceramic tile. At the height of its operation, the company employed 127 people. Tile for almost every architectural purpose—floors, walls, fountains, counters, swimming pools, step treads and fireplaces—was produced. Hand pressed in plaster molds or modeled by hand to architectural specifications, Malibu tile was distinguished by predominantly abstract and geometric designs associated with Moorish art in Spain. During the building boom of the 1920s, the Mediterranean style of archi-

tecture dominated southern California, making these designs and patterns especially in demand. Then, devastated by the Depression, Malibu Potteries closed in 1932, but not before Mable Rindge's company had successfully and colorfully tiled a substantial number of homes and public buildings in the West.

Small clay sculptures as tabletop decorations were characteristic of the late 1920s, often produced as a separate art line by pottery companies to meet popular demand. Though their artistic quality gradually diminished as the economy faltered,these decorative, small sculptures continued to be popular well into the 1930s. However, the practicality of the vessel as a decorative/functional object was better suited to those difficult times. The refined shapes of Oriental ware, a strong influence on California ceramics, directed a large body of work. Reversing this trend was the massive, textured earthenware of Glen Lukens whose students at the University of Southern California in the late 1930s included **Laura Andreson, Vivika Heino** and **Beatrice Wood**. Andreson, who began teaching ceramics at the University of California, Los Angeles, in the mid-1930s emulated Lukens' use of bright glazes as the vessel's only decoration. In the late 1940s, when stoneware clays became available in California and she learned to throw on a potter's wheel, Andreson turned to earth tones and lighter vessels in refined shapes. By the 1950s, when she discovered Scandinavian design, controlled, geometric patterns entered her vocabulary for surface enrichment.

New European and Oriental Influences

The approaching war in Europe sent a small group of potters to America. Immigrants **Gertrud Natzler, Susi Singer** and **Marguerite Wildenhain** would soon give California ceramists direct access to European ceramics. Arriving in Los Angeles in 1938 from Vienna, Natzler and her husband Otto exemplified the disciplined life of studio potters for the southland's ceramists. Gertrud threw remarkably thin vessels, striving for perfection of form. Otto formulated rich glazes (which he referred to as "crater" and "lava") to fit the forms.

Another emigre to southern California was Susi Singer, a Viennese ceramist who had been an active member of the Weiner Werkstatte (Vienna Workshop). Arriving in America on the eve of the war in Europe, Singer settled in Hollywood where she continued the type of sculpture characteristic of her work in Austria. Her expressively modeled small figures were inspired by the characters in ancient myths and the people she met in daily life. She kept alive the handcrafted quality of light-hearted, figurative sculpture enormously popular in the

1920s and 1930s.

The Natzlers' counterpart in northern California was Marguerite Wildenhain, who arrived in 1940. After teaching briefly at the California College of Arts and Crafts, Wildenhain established Pond Farm, a workshop/studio/home in a farming area north of San Francisco. A former student at the Bauhaus of Germany, Wildenhain brought to the West the school's message that work in clay was as much a fine art as painting. The summer students that studied with her were impressed with the high standards she set for herself. Around 1952, Wildenhain began traveling around the country, invited by college ceramic departments to lecture on her life as a potter and demonstrate her well-developed technique on the wheel. As a result, her humanistic philosophy about pottery as a way of life and as an art form influenced a generation of U.S. students.

In her own work Wildenhain, like the Natzlers and Lukens, found inspiration in natural forms and textures. Incised, rough and patterned surfaces replaced the all-over glaze characteristic of her European pottery. But her early direction toward the Bauhaus standard of perfectly thrown forms remained. Figures from mythology, literature and life at Pond Farm added a narrative element to her surface designs. The two books she authored further reinforced what she saw as the interrelationship between the work and the life of an artist. The studio pottery movement of the late 1950s and early 60s, with its emphasis on the vessel, took inspiration from the Natzlers and Marguerite Wildenhain.

Both Gertrud Natzler and Marguerite Wildenhain contributed to raising the technical level of American potters; both were experts on the potter's wheel, a skill not yet mastered by most California ceramists, probably because wheels were scarce or had been built from a treadle sewing machine base and were difficult to control. As a result, handbuilding and press-molding were favored forms of construction until local potters had the opportunity to watch these two women throwing pots. In a short time, new wheels were built like their European models, and potters in northern and southern California were diligently pulling up sturdy bowls, vases and cups. This technical advance arrived in time for the explosive energy that infused the crafts beginning in the 1950s.

During the immediate post-World War II years, the number of northern California ceramic students in schools such as Mills College and the California College of Arts and Crafts steadily increased, due in part to returning veterans using the G.I. Bill. To an even greater degree, the southern part of the state witnessed an increased enrollment in adult education ceramics classes and in public and private university, college and art school ceramics departments. **Susan**

Peterson and Vivika Heino, both graduates of the prestigious Alfred University (New York) ceramics program, brought their considerable technical expertise to Chouinard Art School and the University of Southern California. Beatrice Wood, **Martha Longnecker** and **Dora De Larios**—some of the students they and Laura Andreson taught—would become the teachers and studio potters of the next generation.

Into this thriving, vital community of teachers, students and studio potters came an auspicious group of potters. In 1952 an Englishman, Bernard Leach, and his Japanese friends, potter Shoji Hamada and philosopher Soetsu Yanagi arrived in Los Angeles to conduct workshops and lectures. The trio demonstrated that clay should be respected as an expressive material; this concept directly challenged Natzler and Wildenhain's regard for faultless, classical form. The workshop left in its wake a controversy between the perfection of form and the expressive use of clay that would rage for at least a decade. Reinforcements for the cause of expressionistic clay came when Peter Voulkos, an expert production potter, arrived in Los Angeles from Montana in 1954 to teach at the Los Angeles County Art Institute (now known as Otis/Parsons). Voulkos had met the Leach group earlier, and that experience combined with his exposure in a new environment to the contemporary art scene—especially Abstract Expressionist painting—changed the direction of his work. By 1957, Voulkos was producing massive sculptures assembled from thrown forms, slab-built sections and coiled clay. His spontaneous, intuitive process greatly influenced the male ceramists of the community. Initially, women viewed the size and the structure of Voulkos's sculptures as prohibitive, since they appeared to require the physical strength of an Amazon. Yet a decade or two later, size and bulk would no longer deter their ambitions.

Realism, the Object and the Figure

What Voulkos did in the late 1950s for expressionism, Robert Arneson, teaching at the University of California at Davis, did in the mid-1960s for the inanimate object. His anthropomorphic coke bottles, a toaster and typewriter legitimized the use of objects to express certain human qualities. **Marilyn Levine**, working and teaching in Berkeley, was one of the first women to develop a direction from Arneson's ideas. She saw the possibilities in allowing one object to encompass many levels of meaning and experience. Realistically sagging briefcases, suitcases missing a buckle or strap or scuffed cowboy boots imitated in clay the appearance and texture of leather, the material of the real object. Levine's

sculptures introduced narrative content by appearing to record on the object's surface a personal history of use or abuse. To further confuse the viewer's ability to distinguish between representation and reality, Levine used nonceramic materials such as oil paint, shoe polish and hardening oils. As a result, her meticulously handbuilt objects function in the Super Realist realm of sculpture.

Trompe l'oeil or fooling the eye was an important part of aesthetic expression during the 1970s. Another aspect of this period, labeled the "me" decade by critic Tom Wolfe, was a self-involvement expressed through a return to the human figure. Once again Robert Arneson led the way with a series of self-portrait busts depicting deeply felt emotions—frustration, exasperation, fear. Where Arneson externalized these feelings, Dora De Larios submerged them. Her wall-mounted faces are partially obscured by ribbons of clay, suggesting repressed emotion. These masks of the early 1980s carry the distinctive features of Mayan Indians, whose full lips and long narrow noses are part of De Larios's cultural heritage. On another level, the quiet, subdued faces infer that the past is the present, that little has changed the historical, subservient position of women in many contemporary societies.

Reacting more overtly to the feminist movement, San Francisco ceramist **Karen Breschi** applied animal heads to male busts and torsos in figures that matched the spirit of the movement's early literature castigating men. An arrogant canine/man wears a leather vest and leers at his viewers. Breschi's raucous humor and raw anger extended to shrine-like figures of women. Instead of romantic love goddesses or the nurturing and fertile women described in ancient myths, these Earth Mothers reveal the violent and destructive side of nature.

The connection made in myths and legends between women and nature is one aspect of **Beverly Mayeri**'s series of busts from the 80s. Mounted on small pedestals like 18th-century classical sculpture, Mayeri's women look inward; their heavy-lidded eyes and averted gaze project a dream-like state of altered consciousness. The tiny lizard clothing clasps and the hair braid that becomes a snake inject Surrealism and link these figures to prehistoric symbols of fertility and wisdom.

Except for De Larios, northern California ceramists have dominated the exploration of the figure. Along with Breschi and Mayeri, **Margaret Keelan**'s sensuous female torsos vacillate between a vulnerable and assertive stance. Genre figures were the subject of **Polly Frizzell**'s early 1980s sculpture. Torsos of waitresses and short order cooks surrounded by the kitchen accouterments of their trade call attention to the bland fast-food aspect of American society.

The culture of the 1980s is further defined in the ten-foot- tall sculptures of

angry or fearful men and women that crowd **Viola Frey**'s studio in Oakland. Frey attacked the problems of size and weight that had, in the past, deterred most women ceramists. At first Frey's figures were like figurines grown nightmarishly to life-size. Then they became the farm women she knew growing up in rural central California. Grandmother figures in floral dresses and hats held treasured collections of bric-a-brac, delicate objects contrasting with the ladies' substantial girth and work-worn hands. In the mid-1980s, urban men and women of greater height entered her work, depicted in cartoon style. .Borrowing from Abstract Expressionist paintings, Frey applied gestural slashes of primary colors to the men's suits, a cheerful counterpoint to their angry, hostile facial expressions. The corporate world of power suit-and-tie is under attack here, along with the absurdity of a society that judges people by their appearance.

Viola Frey's confrontational figures testify that working with large clay objects no longer discourages women ceramists. A case in point is Berkeley artist **Marta Wallof**'s six- and eight-foot-high arches. Cantilevered like a kiln or squared off like post-and-lintel construction, these architectural sculptures combine the concepts of entryway and archaic dwelling. Other four- and-five-foot-high combinations of abstract forms suggest factory smoke stacks, gothic arches, and the spires of skyscrapers. Combined with ambiguous structures, the architectural elements metamorphose into bombs and missiles.

The Return of the Vessel

Even though the figure and the object appeared to dominate in the decade of the seventies and early eighties, the vessel—functional and non-functional—remained not only vital but capable of transformation. A number of studio potters who continued in a functional direction produced ware that was nontraditional in design. **Catharine Hiersoux**'s elegant porcelain platters combined oriental brushwork with the spontaneity of an Abstract Expressionist painting. In 1977, her place settings joined those of other ceramists around the country (including Dora De Larios) for a special luncheon at the Carter White House, followed by a national tour that brought recognition to the nation's craftspersons. Bay Area ceramists **Coille Hooven** and **Sandy Simon** incorporate whimsical handles and patterns on cups, bowls and teapots. Hooven's fanciful animals serve as handles and knobs. **Lyn Turner**'s variations on vegetable shapes for cups and teapots recall 18th-century English ceramics. Stylized cacti, palm trees and bright colors lend a California-Mexican flavor to **Cindy Ripley**'s earthenware platters.

Another group of studio potters explored the nonfunctional vessel in part as

homage to diverse historical styles. The classical shapes and warm, monochromatic glazes in **Elsa Rady**'s bowls recall the ceramics of the Sung and Ming dynasties of China. At the same time, her 1980s vessels project an Art Deco spirit. The flaring, curving walls, notched and cut at the rim, accent a sense of circular movement. Presented in groups of twos and threes, the vessels investigate the placement and presentation of objects in space.

In contrast to Rady's unadorned porcelains, **Elena Karina**'s series of *Tidepool Vessels* are lavishly baroque, glistening with opalescent glazes on undulating, pleated porcelain spires. Resembling huge convoluted seashells, these porcelains with their branches, cave-like entrances and mysterious tunnels echo the rocky seashore near Karina's southern California studio. Descendents of the scallop shell prominent in classical sculpture, the handbuilt and slipcast tidepools are sensuous, three-dimensional seascapes.

While Rady and Karina explored art traditions, **Judy Chicago** used the vessel to bring attention to the contributions of women throughout history. "The Dinner Party," a project requiring six years of work and hundreds of volunteers, opened in San Francisco in 1979. Using the china plate as her primary ceramic form, Chicago based her designs on variations of the butterfly or vaginal imagery significant for each of the 39 mythological goddesses, artists, poets, scientists and musicians honored. A baronial-size triangular table held the place settings, accompanied by banners, audio-visual material and publications for a confrontational political-feminist statement. In terms of American ceramics, critical reviews rightfully pointed to the lack of aesthetic quality, but in its tour of the country, the project was greeted by large crowds and intense, generally favorable public response. Without question, Chicago's monumental statement marked a century of social and artistic transformation for women ceramists.

Objects in a Still-Life Context

Familiar objects in a still-life setting, one aspect of Chicago's format, is the primary subject matter for **Karen Koblitz, Nancy Selvin** and **Joanne Hayakawa**. In this context, each of these artists incorporates some of the ideas characteristic of California ceramics. Koblitz's group of familiar objects—pitchers, spoons, plates, pineapples, apples—balance on a tiled shelf or hang on a wall. The juxtaposition of bright colors and dizzyingly complex patterns turns the objects into abstractions that recall the vigor of 1920s Malibu tiles. At the same time, an energy and vitality emanate from these settings which mimic the overload of media stimulation in contemporary life. Ambiguous objects, perhaps

referring to women's cosmetic jars and bottles, balance on Joanne Hayakawa's tilted shelves. Grouped in front of a mirror-like painting, the arrangement focuses on a distorted perception of the familiar. Framed by a double-sashed window, Nancy Selvin's abstractions of faceted bottles and vases are a minimalistic arrangement. The architectural qualities of these familiar forms emphasize volume, line and plane. The strong influence of Japanese art is apparent in Hayakawa's objects, while Selvin captures the distillation of form and muted color associated with the Bauhaus. The Spanish/Mexican heritage of California flows through Karen Koblitz's vibrant groupings.

Each of the still-life arrangements incorporates some non-clay materials such as wood, acrylic paints and nails. Non-clay materials have been part of California ceramics as early as the 1960s when Marilyn Levine introduced nylon fibers to strengthen the slabs that form her objects. As boundary lines continually shifted over the last 25 years, the question of just what materials remained appropriate to clay sculpture encouraged wide experimentation. Drawing inspiration from nature and a concern for the environment, artists used adobe in combination with other organic materials for site-specific work. **Joyce Kohl**'s compressed semi-circular mixed earth forms of the 1970s are architectural, archaic and mysterious, like the massive boulders of England's Stonehenge. Earth, sod and whatever seeds are present in this mixture temporarily transform **Elaine Scheer**'s sculptures into sprouting greenery. A political statement is part of *Peace Theater*, her site-specific sculpture of 1986, located on a cliff above a beach north of San Francisco. An eight-foot adobe globe rests at one end of a shallow indentation that could be interpreted as a grave. Surrounding the space are white school desks, transforming the site into a classroom for a discussion on the future of the planet.

In tracing the progress of women working with clay in California, a few conclusions can be drawn. Given the opportunity to pursue education in ceramics from talented teachers, California women have made substantial contributions to this art form in both the vessel and sculpture. Indeed, many have pioneered in a particular direction or concern. Some ceramists such as Breschi, De Larios and Mayeri have dealt with ideas that specifically relate to women. Generally, however, these artists have confronted the widest range of ideas. As California artists, many have reacted to the geography characteristic of the state—the unique mixture of seashore, desert and mountains and the concern for environment this has entailed. On the whole, these artists have contributed significantly both to ceramic tradition and to contemporary art.

—**Elaine Levin**

Sources

Bray, Hazel. *The Potter's Art in California 1885-1955*. Oakland: The Oakland Museum, 1978.
Smith, Kathryn. *Malibu Potteries*. Los Angeles: Craft and Folk Art Museum, 1980.
Personal interviews and correspondence with the contemporary women mentioned.

Laura Andreson with her work of 1975.

Dora De Larios, *Inner Eye*, 1982. Collection of the artist.

Elsa Rady, *Porcelain Bowl*, black matte glaze, 1981.

Marilyn Levine, *John's Jacket*, 1981. Collection of M. Arnaud Rossi.

Quiltmakers

There is something special about a quilt. Whether it be hundreds or thousands of colored and printed geometric-shaped pieces of fabrics carefully pieced by hand or machine, or an entire surface appliqued with thousands of tiny stitches to make up the top, or an explosion of color or mixture of fabrics, bound by quilting stitches to maintain its shape, a quilt is simply two layers of cloth with a filler between, a canvas of sorts for the artist.

Sometimes quilts are carefully placed in drawers and cupboards, lovingly folded to be preserved for future generations. Some are tucked over family members to keep them warm at night as they sleep. Still others are not meant to be used in a functional sense at all; these hang on walls at both private and public establishments to be enjoyed as "art."

Each quilt, no matter what its purpose, is a piece of art. Be it constructed in the traditional manner or in a contemporary form, presented to the viewer gloriously in a gallery or modestly on a bed, each quilt is an expression of the creator.

Quilts give us insights into days gone by. They share the hardships and the good times through small patches of fabric sewn together. Maybe a message, a biblical verse or a personal teaching from mother or grandmother to future generations was thoughtfully inscribed in a corner—a mark of wisdom to say softly, "listen, I speak to you and have something important that you must understand about me."

Quilts gave warmth to our grandmothers and great-grandmothers, a bright spot not only physically but emotionally in the dingy darkness of the pioneer cabins. Quilting gave women a chance to express themselves creatively, a social stimulus, as well as adding a smile and a sense of well-being to the family and the creator.

Many times quilts were used to express political views by women who for many years did not have the right to vote. Candidates were supported and proclaimed through stitches. Even Susan B. Anthony found quilting bees to be a wonderful place to share views on early feminist theories.

The arguments will continue for years to come about form versus function. Can a quilt with it's roots so deeply wrapped in the tradition of this country as a functional item be considered "art"?

Many women and organizations expended great amounts of energy, both in California and the United States as a whole, during the 1970s and 80s to bring about awareness of this unique art form. "California has been in the forefront of the fiber art movement during the past 20 years or so. The Bay Area in particular has had whole schools and college departments devoted to fiber art. So, information has been more easily accessed" (**Linda MacDonald**).[1]

Gallery exhibits in major museums such as The Fine Arts Museum, San Francisco, the San Francisco Craft and Folk Art Museum and Los Angeles County Museum of Art have welcomed exhibits of quilts. An entire museum, The American Museum of Quilts in San Jose, is dedicated to the appreciation of quilts and quiltmakers. In 1977 four Santa Clara Valley Quilt Association members opened the first quilt museum in the United States. In 1986 it was incorporated as a nonprofit public benefit museum. The museum has nine to ten exhibits per year.

The American Quilt Research Center at the Los Angeles County Museum of Art was founded by **Sandi Fox**, Senior Research Associate, to provide a national repository for those objects, images and written words that mark the history of quilts and the men and women who made them.[2]

There is something special about a quiltmaker. This in most instances is a woman, one who is willing to work for many hours each day on a quilt for an average span of approximately one year to bring it to life. This is a woman who has perseverance, a love for color, a need to express herself through a medium that is touchable, almost vulnerable. In **Pat Ferrero**'s film *Quilts in Women's Lives*, **Radka Donnell** beautifully said, "Quilts carry a lot of emotion. Touch is important to women because there is a lot of physical caring that they have to do. It makes them touchy-sensitive. That's why objects that involve the sense of touch have emotional meaning for women."

The pioneer women, the first generation of California quilters, those that braved the bitter cold of the mountains and heat of the deserts, traveling by covered wagon and horseback, carried with them both the skills of their mothers and grandmothers and many quilts. Early quilts made in California are rare because of the migration from other states and countries. **Linda Otto Lipsett**, author of *Remember Me, Women and Their Friendship Quilts* (San Francisco: The Quilt Digest Press) writes, "I have been collecting quilts since about 1972 and have a sizeable collection. All of those years of collecting have been while I have been

a resident of California; yet not one of them was made in California that I know of . . . so few California quilts can be identified or found."

But, luckily, several have recently been found through a project known as The California Heritage Quilt Project, established in 1983 by the Northern California Quilt Council. It was formed to find the historically and aesthetically significant quilts of the state of California prior to 1945. Thirty-three different quilt days were held throughout the state, with an estimated 3,400 quilts registered. Consultants and experts of antique quilts dated and analyzed each quilt, an exhausting yet exhilarating process by **Charlotte Eckback, Sally Garoutte, Lucy Hilty**, Rod Kiracoff, **Judy Mathieson, Virginia McElroy** and **Linda Ruethger**. Thirty-three quilts were selected for the museum exhibit at the Fresno Arts Center and Museum in the fall of 1989, six years after the conception of this project.

A quilt day is something that is hard to describe, in that there is an energy in the room that is felt by both the antique quilt owner and enthusiast alike. Stations were set up around the room, with volunteers taking historical data, numbering quilts, applying sleeves for hanging, and the experts documenting crucial information such as size, sewing techniques, approximate date made, fabrics, colors, patterns and condition.

At a quilt day held at the Fresno Arts Center and Museum in 1986, over 200 peopled attended, some driving two hours to share and learn more about their quilts. Most had their treasured bundles of family heirlooms clutched tightly as they waited for documentation. The quilter who had created each quilt would have been pleased to see their grandchildren or great-grandchildren displaying their loving efforts so proudly. One could almost feel the presence of the quilters-past filtered through the threads of each quilt unfolded. Some quilts gloriously displayed the meticulous stitches that the quilter had labored over. For others, it was the pride of piecing that showed through, displaying the quilter's care to ensure that every point and seam as precise as possible. Other quilts gave insight into family background by the types of materials used, such as fine velvets and silks common among the well-to-do, others with the country charm of clothing scraps.

Some came to share the folklore of their quilts; others came with first-hand recollections of quilts made by mothers or sisters. Hazel Wood was one such woman. She clutched one of the few quilts her mother made. With a spark in her eye she said, "My mother was much too busy to make many quilts, she was more like Calamity Jane. She spent much of her time fighting prairie fires, canning, butchering pigs, baking and running a farm; there was little time to stitch."

Ms. Wood remembered the quilting bees that as many as 500 women would attend on Saturday afternoons. "They were common about 1910, but became passe´ about 1918." Did she ever go to one? "No, like my mother, I'd rather have ridden horseback."

The stories that have traveled through time from one generation to the next were in many ways as wonderful as the quilt itself. For instance, **Helen Buller** of Fresno held a quilt that she made as a girl in 1923. She was 14 years of age at the time. The squares were pieces of discarded wool suit swatches given to her father by a tailor friend. During the long days, as she tended the family herd, she would while away the hours embroidering different scenes on each square, ultimately pieces of a quilt.

"The most wonderful effect that a state quilt search has is not what it has completed but what is has started," says Jean Ray Laury, author of *Ho to California* (New York: E. P. Dutton, 1989), the book describing the California Heritage Quilt Project. "People have begun to see quilts in a new way. Sharing the quilts with others and watching their reactions has created a new interest in both their own quilts and those of others. Many times wives will send husbands home for other quilts that may be in closets. Families begin searching their own histories."

"A quilt search has also made it clear how little is actually written about women but how much is written about men. Many times quilts were brought in without any information about the quiltmaker. The owner had no idea who made it, or they just don't remember—it was in the house when they moved in." "This tells us how little products of a woman's creativity were valued. The symbol was kept but what many times was lost was the meaning behind the symbol."

"In a sense, the quilts are secondary, a means in which women were known. If it wasn't for these quilts, these women would not have anything in which their existence was known. Quilts are living history, told by women. The whole history of this country, the major wars, the movement is documented through the quilts of this country."

The oldest California-made quilt in the project's exhibit was made by a woman named **Juana Machado**, a most amazing woman who was the first woman living in that area of Spanish descent to converse in English, Spanish and Indian. She lived at the Presidio with her father, who was a soldier, and witnessed the transitions in California from the Spanish to Mexican and ultimately to statehood. The quilt was made during the mid-1820s during her married life. It is red appliqued on a white background, with a center medallion. Lines radiate from the center. Her life was documented by her grandson, Thomas Savage, who

worked for Hubert Bancroft. He transcribed her life story in 1878, including facts about this quilt. This tape is currently part of the Bancroft Library in San Diego.

These women and their quilts influenced the future generations of quiltmakers in California. Many quilts remain in California families, and probably only a small percentage were documented by the California Heritage Project.

There is evidence that there are influences other than the past accomplishments of recent generations that affect the current surge of magnificent quilts constructed in this state. California is rich in innovative talent. To single out one or two of the best, or most accomplished, quilt artists is next to impossible.

I do not believe that one person alone can tell the story of contemporary quiltmaking in California. To give an accurate account with fair representation, I queried 34 of California's leading women quilt artists. I asked them why they felt California quiltmakers were different from those in any other state. I asked them if there are any geographical, historical, sociological or psychological differences that affect quiltmakers of California, and about their personal histories, how they view their own work and if living in California has influenced them in any way.

They are a very special group of women, working independently of each other, yet all bound by the love of quilts and regional proximity. In all cases, these women are celebrated artists who have achieved success by furthering their own technical expertise, as well as sharing the continued inspiration of their quilts for the public to enjoy.

It is an extraordinarily giving group of women who have dedicated their lives to teaching others the techniques that they have found successful in their own work through books, lectures, seminars and exhibits, both in the United State and throughout the world. These women are **Ann Albertson, Hiroka Agawa, Sonya Lee Barrington, Cheryl Greider Bradkin, Elinore Burns, Moneca Calvert, Christal Carter, Sharyn Craig, Grace Earl, Charlotte Eckback, Sandi Fox, Helen Young Frost, Willia Ette Graham, Lucy Hilty, Mary Ellen Hopkins, Roberta Horton, Gay Imbach, Vicki Johnson, Holley Junker, Jean Ray Laury, Diana Leone, Linda MacDonald, Mary Mashuta, Judy Mathieson, Kimberly Long Masopust, Hortense Miller, Margaret Miller, Ellen Mossbarger, Velda Newman, Esther Parkhurst, Katie Pasquini, Yvonne Porcella, Marjorie Puckett** and **Blanche Young.**

Of the 28 women who so kindly chose to share their opinions, several similarities kept reappearing on each questionnaire returned. The majority of the

leading California quiltmakers are self-taught, learning the techniques while making a full-size quilt, wall-hanging or doll quilt for a family member or special occasion—quilt for daughter (Roberta Horton), quilt for oldest son's twelfth birthday (**Joan Schulz**), a wedding gift (Yvonne Porcella) or for a friend's baby (Jean Ray Laury).

Others have special memories of times spent learning to quilt with grandmothers' and great-grandmothers' assistance. Sandi Fox softly recalls, "I grew up in the midwest (Nebraska) and I can still remember sitting there with my grandmother and great-grandmother. How like my grandmother to be intuitive enough to give me wonderful fanciful fabrics to work with such as pieces of crepe, rayon and silks. My first quilt was a doll quilt, and measured approximately 9 x 13 inches. It was a blue and white one-patch, simply cross-hatched quilted with no binding (a method easy for a child to handle). I must have been about five years old, because I still have a picture of myself with this quilt."

Another doll quilt was made at age 12 by Cheryl Greider Bradkin. Her next quilt was not completed until several years after, with the birth of her daughter. Not until 1977 did Bradkin begin her work in seminole patchwork, 23 years after that first attempt. Still others took classes to learn basic techniques, some given by local teachers (Christal Carter) and from programs given by adult education (Sharyn Craig). Now these two women teach others.

Most of these women migrated here at different points of their life from other states. The rest are natives, some first generation, and one, Yvonne Porcella, a fourth generation Californian. Collectively, these women have lived in California an average of 32 years.

Why are California quiltmakers different than those in other states? California quiltmakers are known to be "more adventurous—not bound to past. Many are new quilters and didn't learn from their mother or grandmother. Many come to California rather than being a native resident" (Mary Mashuta).

"Californians, in general, seem to be more open to everything. Far West location leaves us less traditional, possibly more willing to take risks. Just being a resident leaves one open to comments of 'wild westerner' or 'crazy Californian' " (Monica Calvert).

"California is the state furthest west physically and is the end of the American westward expansion. People come and go, new ideas are tried, it is the land of opportunity in a way that other parts of the U.S. aren't. Its landscape is dynamic and varied and encompasses every climatic extreme. All this promotes diversity, risk-taking, and adventurous living" (Linda MacDonald).

"History has had an impact, but probably not as high as the geography which is so diverse and vast, creating an atmosphere where artists often work in isolated and beautiful environments. This in turn creates socio-psycho situations which lead to innovation and invention. Many California quilt artists lecture and teach outside the state, and their influence has had a strong impact throughout the U.S., and indeed, as quilting becomes more popular, throughout Europe, Australia and Japan" (Holley Junker).

"Sociologically we have a greater mix than many states—cultures from Mexico, Asia and diverse areas are reflected in our quilts. We are open to new ideas, techniques because of this. Californians are known to be more progressive, 'artsy' and innovative than many areas, predominantly because of our location. It is a fast-paced area—and our quilts are too!" (Christal Carter).

"California quilt artists seem to have broken with tradition in striking new ways. For example, their use of color and design is fresher and freer" (Holley Junker).

"I think there are differences in California quilts. The biggest factor seems to me to be a freedom here. We have fewer traditional quilts, and fewer traditional elements in general. Therefore, while in many ways that is too bad, it also has advantages. When we loose close ties to the traditions, we loose some strong and good influences, but we also loose some structures and limitations. People who moved to California originally were those already restless, seeking change—so that had an effect. They were forced, once they got here, to make a new life. To be open to new possibilities. For decades people came here seeking something new—therefore they were not receptive to the new."

"The same lack of convention we see in quiltmaking can be seen in other areas of the arts. Therefore, people with a background in painting are more likely to feel free to move into fabric. They, too, are less structured so will move into what is usually regarded as a 'craft' area. Now with books, TV and communications disseminating all ideas, everywhere, I think the differences will shortly disappear. Perhaps quiltmakers in general are less likely to be innovative or original than some other fields—it is a traditional medium. But, it depends a lot on who approached it. Now that lines are being cut, we'll see more and more people from different backgrounds comings into quilting and that should liven it up" (Jean Ray Laury).

Roberta Horton writes "What makes California quiltmakers and their quilts different? 1. The use of lots of color. 2. Good workmanship. 3. A broad spectrum of traditional to contemporary designs. The lack of strong tradition here in

California makes it so much easier to break the rules. In general, the acceptance of many ways to do one thing fosters creativity."

"California quiltmakers are less concerned with making traditional quilts. In general, Californians are known to the rest of the U.S. for our espousal of the new and unusual, and is true of our quilters, too." (Cheryl Greider Bradkin).

California quilters have had many honors bestowed upon them for their espousal of the new and unusual. When one thinks of a California quilt artist, one of the first that will come to mind is Jean Ray Laury, of Clovis. Laury began making quilts in 1956 while doing graduate work at Stanford University. Her quilts have been exhibited at The Museum of Contemporary Crafts in New York, The De Young Museum in San Francisco and the Museum of Folk Art in Los Angeles. Her quilts are merely a vehicle, one which gives her the opportunity to work with and to be supportive of other women's efforts. She was one of six women given an award by the Women's Foundation in San Francisco in 1987, honoring their work with other women.

Laury's quilts reflect her theory "of not taking the world too seriously, keeping perspective on life and having fun." *Barefoot and Pregnant*—the *Senator Van Dalsem* Quilt is one such example of this approach. This quilt, sashed in vibrant red, fuchsia and purple, is nine blocks quoting a speech given to the Little Rock Optimist Club by Legislator Paul Van Dalsem. Jean Ray Laury pictorially gives her interpretation of the speech block by block. This quilt was purchased by Planned Parenthood of Northern California and currently hangs in their office. Another of the series hangs in the Museum of American Political Life.

Holley Junker of Sacramento shows her work at least three times a year in such exhibits as Quilt National '85 and '87, Dairy Barn Cultural Arts Center, Athens, OH; Earth View, Flight and the Arts Gallery, National Air and Space Museum, Smithsonian Institution, Washington, DC; Beyond Tradition, 1986; and a solo exhibit at American Museum of Quilts, San Jose. "I create quilts of places (both real and imagined) where I would like to be. Most quilters piece or applique—my work is almost Pointillist in technique. I cut 1/2 inch to 1 inch pieces of fabric with pinking shears and overlap them to blend colors and make images. Most of the pieces incorporate as many as 50 different colors of fabric. I use embroidery, paint, silk screen and copier transfer images when I feel the quilt warrants embellishment other than color and quilting to enhance it."

Sandi Fox of Los Angeles is a curator, teacher, author and quiltmaker. She is known as a "purist," using only 100 percent cotton materials, including thread, batting and fabrics. Her piecing is traditionalist, with impeccable craftsmanship

her trademark. She was commissioned by the Performing Arts Council of the Los Angeles Music Center to do an autograph quilt and was awarded a $10,000 grant, "the Master Craftsman," by the California Arts Council in 1982.

Her interest in quilts began in the late 1940s when she was 15 years of age. She bought her first quilt, a brown and blue 19th-century geometric, off the back of a truck. Fox says that "this quilt will remain hidden from view and will cover her or her casket after death, a parting gift from Sandi Fox to her friends and family."

So began her interest in quilts as object and artifact. "We had a summer cabin by the South River in Southern California. I'd see quilts in strange places, wrapped around refrigerators, as was my first quilt found. I found some that were tattered in old junk shops, and in cabins there would be old, old quilts placed between the mattresses and springs on summer sleeping porches. Also, I saw many beautiful quilts, but generally these quilts were valued, put away in cabins as family treasures. Although I didn't realize it at the time, I began taking oral histories of elderly women, who happened to be quilters, to hear many stories about quilts and how they were made."

From these early teenage experiences, her love for quilts grew. Today she is an internationally respected quilt historian and artist. Sandi Fox has curated many exhibits, including the 1977 and 1984 "American in Patchwork" and "19th-Century American Patchwork Quilts" at the Seibu Museum in Tokyo, Japan.

Monica Calvert of Rocklin won first in California and the grand prize award of $20,000 in the Great American Quilt contest in 1986 with her quilt entitled "Lady Liberty." This quilt is a masterpiece of softly blended colors, enhancing a strong Statue of Liberty figure, mountains and plains. The American flag is woven through each, reflecting the symbolism of our country. Calvert writes "I strive for my work to have the technical appearance of wonderful traditional quilts of the past combined with the design and pattern I hope will become traditional for this era."

Quilts are the tangible evidence that the maker lived. Sometimes the justification for life, sometimes a symbol, a frozen piece of time to be enjoyed and treasured and sometimes, like life itself, left to be carried on by future generations.

I received this letter with a returned questionnaire attached but not filled out.

October 27, 1988

Dear Linda K. O'Dell,

I am writing on behalf of Hortense Miller in response to your letter on October 22, 1988.

Hortense is now nearly 95 years old and has had a series of strokes. She is unable to respond to your letter or fill out the questionnaire.

As you know, Hortense and her sister (now deceased) were featured in *Quilts in Women's Lives*, by Pat Ferrero. They always continued to quilt in the old fashioned way as their mother taught them—and coming to California did not change that in any way.

I am at present quilting the last quilt that she pieced at the age of 92. It is an hourglass quilt.

I am Hortense's niece and live with her and care for her.

I am not a quiltmaker, but I love to quilt and can do very fine stitches.

<div align="right">Sincerely, Louise Aldrich</div>

Quilting lives. Quilts live. Time is marked.

<div align="right">**—Linda K. O'Dell**</div>

Notes

1. All quotes come from responses to questionnaires that were designed specifically for this chapter.

2. The Research Center is open by appointment (213) 857-6083.

Jean Ray Laury, *The Senator Van Dalsen Quilt.*

Linda MacDonald, *Clear Palisades*, 1987.

Moneca Calvert, *Glorious Lady Freedom*, 1986. Grand prize winner, American Quilt Contest, 1986.

Art and Politics: A History

Although artistic achievements are the chief focus in this book, women have had an equal if not prime role in the arena of organizing and running arts institutions and passing arts legislation for the benefit of all artists. California has led the nation in developing major, innovative art legislation, and women have played an important part.

Artists not only create but frequently participate in community affairs, manage studios, hire assistants and models and develop patrons. They maintain long-range business relations with dealers, agents and a wide variety of associates from models to foundrymen, photographers to attorneys, Master Printers to tax advisors. They usually travel around the country and the world, take part in intellectual organizations, teach at the high-school or college level, manage all the usual business relations of any other small-business person, and on occasion may even run for public office (for example, Bruce Conner ran for Mayor of San Francisco and **Susan Dakin** ran for President of the United States). A talent for administration and organization is a great asset, perhaps even a requirement, for success in the world of art where a sculpture or mural commission pays $25,000 to $200,000 and may involve one or two year's work with myriad assistants, loans, technical/industrial planning, sales skills, writing skills and personal relations with corporate or political employees.

There is nothing more normal, therefore, than for an artist with a passion for righteousness and fairness in the world to put these organizational talents to use in reconstructing the art world itself and rethinking and redoing the terms of the operation.

California is a large, prosperous state with a complete economy; indeed, it is the fifth richest "country" in the world. The economy is balanced; there has been stability when other states with single "cash-crops" fluctuated economically. This stability has given workers the opportunity to demand and make changes. Although the so-called Eastern Establishment has historically taken the lead in political and legislative policy and held the purse strings, California represents the vanguard with respect to artists' rights and art legislation.

332

Historically there has been a different atmosphere and background in California, especially with regard to women. Under Spanish rule the Napoleonic Code governed in California instead of English Common Law. Much of California law today, particularly family law, reflects this influence. Beginning in 1850 when California became a state, women were protected by Community Property law, which assured them an equal share of the marital property. Since there were also many fewer women than men, women were much more valued in pioneer times. During the Gold Rush era, for example, women made up only 10 percent of the total population. Whether the motivation was Gold Fever, land hunger, restlessness or escape from oppression, psychologically the pioneers had reached their goals when they arrived in California. Man or woman, they could go no further on the continent and so planned a new life here; in other states there was always the perceived option of moving on.

In this century, migration to California was frequently a rejection of adverse conditions elsewhere. Whether economic deprivation prompted moves from the Dust Bowl or urban soup kitchens, or whether migration was determined by antipathy to repressive local institutions such as churches or community social structures, most people came to California determined to build a new and more fair community. The artists were part of that. California is quite a young state. There was no entrenched status quo, few "robber barons," no overpowering social structure to be conquered before changes could be made. Heavy continuing immigration from China, Southeast Asia, and Central and South America has brought in many cultures with a history of suffering and oppression. These individuals brought a determination and the skills to effect changes in their lives and for their descendents. The big shift of population to California occurred during and immediately after World War II, when many women were working outside the home in defense industries for the first time. The women enjoyed earning money and having legal control over it and were not anxious to relinquish this control when the war ended.

Art groups were active in early California. The collections of the Oakland Museum, which specializes in California art, document this activity. The San Francisco Art Association was founded in 1871 beginning with a very large membership, both men and women. In 1874 the Association organized the California School of Design (now the San Francisco Art Institute and the California College of Arts and Crafts), one of the earliest schools in the United States. In 1916 the Association organized the San Francisco Museum with **Grace McCann Morley** as its first Director. It also set up lively exhibitions at the Palace of Fine Art from 1915 on; one early show exhibited 1143 artists. In the

1880s the women students of the Pine Street Art School formed a Sketch Club which held semi-annual exhibitions and lectures. In 1915 this merged with the San Francisco Art Association until 1925, then re-formed as the San Francisco Women's Art Association and began holding exhibitions at the California Palace of the Legion of Honor Museum. Sculptor **Claire Falkenstein** served as President of SFWA during World War II. The organization is still active, with a gallery on Hayes Street. From the 1930s to the 1960s **Nina Valvo**, curator at the DeYoung Museum, exhibited many women artists. In the 1940s **Hazel Salmi** founded the Richmond Art Center and School and was Director into the 1960s. An early cooperative in the 1950s was Gallery 6, which showed the works of now well-known women artists.

From the beginning there was more freedom for the woman artist in California than in the East. For example in 1885 Thomas Eakins was fired for trying to teach women artists anatomy from the nude model at the Pennsylvania Academy (he finally brought a cow to class). **Linda Nochlin** states in "Why Have There Been No Great Women Artists?" (*Art and Sexual Politics*, Collier, 1971): "well into the 20th century there exist, to my knowledge, no representations of artists drawing from the nude which include women in any role but that of the model. . . ." By contrast, women were an active part of the California art scene and were taught with somewhat more freedom. This freedom was more possible due to the many fine professional art schools, especially private schools such as the San Francisco Art Institute, California College of Arts and Crafts and Otis Art Institute and Art Center, Los Angeles. In addition to greater access to art education and art groups, many artists had migrated to California. **Emily Carr**, for instance, defied her parents to come to San Francisco from British Columbia to study art. In the more relaxed ambiance of California, local artists mingled easily with more famous ones.

Women have been active in developing and running major art movements in California in addition to those specifically for women. The Arts and Crafts Movement was headed by **Lucia** and Arthur **Matthews**. Long before the Bauhaus with its fears of an alienating and mechanistic technology, Dr. Frederick and Mrs. **Laetitia Meyer** revived the California College of Design/Hopkins Art Institute (the San Francisco Art Association school), which had been demolished by the 1906 Earthquake and fire, and reconstituted it in Berkeley as the California School of Arts and Crafts (now C.C.A.C.). The Meyers worked with many faculty members, male and female, who passionately felt the importance of the union of art with craft, "to develop a simple craftsman's approach to life."

Murals are an important art form in California with its Spanish heritage (there are an average of 1,000 large murals at any one time in San Francisco alone), thus the WPA projects in the 1930s were natural and logical and included women artists as active participants. (See chapter "Women of the WPA Art Projects.") **Edith Hamlin** and her husband Maynard Dixon (both worked on the WPA) formed the Mural Artists Society in 1937. Designer **Marcelle Labaudt** turned a small art school she had founded with her husband into a gallery and exhibited the work of "emerging artists" until 1980. Women founded galleries, were curators in museums and supported the exhibition of the work of women artists to a greater degree than was prevalent in other parts of the country.

One of the first chapters of the national Artists Equity Association (founded in 1947) was formed in Northern California by **Ruth Cravath, Lucienne Bloch** and others. Today, California has more local chapters than any other state, with women playing a major role in their formation and administration: **Joan Carl** In Los Angeles, **Jean Braley** in San Diego. **Prudence Leach** in Santa Barbara, **Carolyn Berry** in Monterey and Ruth Cravath in Northern California.

During the 60s women founded several institutions that enhanced the cultural prestige of the state: **June Wayne** (Tamarind Institute of Printmaking), **Pauline Oliveros** (Center for Contemporary Music), a printmaking collective in East Los Angeles founded by a nun, and **Lillian Paley** (Center for the Visual Arts) among others.

The Women's Art Movement and the revolutionary concept of feminist art education had its start in California (see chapters "The Feminist Art Movement: Southern California Style" and "Recalling Womanhouse"). The proliferation of art publications that spilled out of California from the 70s on were almost all founded or edited by women; among them were: **Cecile M. McCann**, *Artweek*; **Roberta Loach**, *Visual Dialog;* **Linda Frye Burnham**, *High Performance*; **Judith Hoffberg**, *Umbrella*; **Betty Ann Brown**, *Visions*; **Kirsten Grimstad**, *Chrysalis*; **Ann Walker**, *Shift*; **Leslie Wenger**, *Courant*; **Judy Slotnick**, *Newsletter*; and **Jean Couzens**, *West Art*. In addition, in 1971 *ARTnews* published a special issue on women artists, singling out a group of the new superstars. This set off an orgy of counting and quantification of the degree of discrimination in art. From California came June Wayne's "Sex Differentials in Art Exhibition Reviews," Eleanor Dickinson's "Sex Differentials in Art Employment and Exhibition Opportunities," and Roberta Loach and Dickinson's "Does Sex Discrimination Exist in the Visual Arts?" The National Women's Caucus for Art (founded in 1972 in San Francisco) started to compile statistics

and maintain records documenting the discrimination experienced by women in academic employment and exhibition opportunities.

The skills that artists—male and female—had acquired in the setting up of co-ops, collectives, organizations and demonstrations set the stage in California for one of the most important events to occur in the art world. The artists rejected the romantic myths of the incompetent "artist/victim," which served a repressive function, to take charge of their own lives and change the terms of their work. By the 1970s the California art world was in ferment. People mobilized that had never worked together before, and with almost no money, political knowledge or advantages moved to change their world.

As example: The California Arts Commission was a long-time state agency with very little funding, energy or interest. Appointees to the Commission were always wealthy persons who had helped elect the governor. Funds were awarded to the establishment institutions. By 1974 the Commission had run out of direction and was being hounded in print to clean up its image. Its last director, **Susan Hooper Bilstein,** tried in vain to rejuvenate it without success. Finally newly elected Governor Jerry Brown cancelled it completely.

After several preliminary Visual Arts Conferences to clean-up the bad feelings between the Northern and Southern art communities, the Governor established the California Arts Council to select recipients for art grants and to disburse and monitor funds for the arts. **Daniella Quinn**, a printmaker initially hired to do a survey of art owned by the state, played a major role in setting up the Council. Only one member was a patron of the arts; the rest were working artists, including **Ruth Asawa, Suzanne Jackson** and **Ellouise Smith** as the first director. **Arlene Goldbard** edited its newsletter.

Support of a practical kind for the work of the Council came from a newly formed lobbying organization, the California Confederation of the Arts. Its mission was to increase funding for the arts, provide advice to the Council, promulgate public policy for the arts and act as a voice for artists and organizations. Another organization formed in the early 70s was Bay Area Lawyers for the Arts, now known as California Lawyers for the Arts. It provides state-wide law referral, arbitration, mediation and legal educational advice for groups and has had an important role in the development of arts legislation in California. In the following years California led the nation in implementing arts legislation frequently with the help of Senator Alan Sieroty. *The Fine Print Statute* made legal distinction between fine prints and reproductions and required full disclosure to buyers; the *Artist/Dealer Relations Act* required the dealer to insure and protect art work held on consignment, provided for payment to the artist first on in-

stallment sales and prohibited the sale of art work to pay a bankrupt gallery's debts. *The Copyright Statute* stated that copyright of an art work does not pass to the buyer upon its sale but remains with the artist. The *Art in Public Buildings Law*, which depends upon an annual appropriation by the legislature for its funding, was passed in 1976. The most controversial *The California Resale Royalties Act* of 1977, provided for a fixed percentage of the resale price to revert to the artist, and was fought all the way up to the Supreme Court. Federal Judge, Robert Takasugi, ruled in favor of the artists as follows:

Not only does the California law not significantly impair any Federal interest, but it is the very type of innovative law-making that our Federal system is designed to encourage. The California Legislature evidently felt that a need existed to offer further encouragement to, and economic protection of, artists. That is a decision which the Court shall not lightly reverse. An important index of the moral and cultural strength of a people is their official attitude toward, and nurturing of, a free and vital community of artists. The California Resale Royalty Act may be a small positive step in such a direction.

The Housing Bill SB812 and Amendment (Live-Work Space) of 1979 authorizes cities and counties to designate areas for a newly denominated occupancy called "Artist Live-Work Space"; *The California Art Preservation Act* of 1980, the "Moral Rights Act," protects art works against intentional alteration or destruction by affirming the artist's continuing interest in the work. Since these laws were passed in the late 1970s there have been auxiliary laws and acts to enhance or redefine the original legislation. For example, State Income Taxes could be reduced by deducting the value of gifts of art to non-profit institutions; the *Health Hazards Law* required labeling of art materials with appropriate warnings of (toxic) ingredients; the control of *Toxic Art Supplies in Schools* was passed in 1987; *The Older Californians Act* mandates the promotion of the arts as part of the quality-of-life services to the aged.

In the continuing battles for artists' rights additional women have emerged in leadership roles. **Jo Hanson**, artist and Art Commissioner of San Francisco, has fought for equal representation for all artists in the commissioning of public art works, and for the establishment of professional guidelines (as set forth by Artists Equity) for the selection of public art. She has been assisted by **Claire Isaacs**, Director of the San Francisco Art Commission, **Jill Manton** and **Regina Almaguerre**. **Toby Judith Klayman** wrote *The Artists' Survival Manual* based on her seminars training artists in professional practices for survival; attorney **Susan Grode** edited *The Visual Artist's Manual* for the Beverly Hills Bar Association Barristers; **Alma Robinson**, Director of California Lawyers for the Arts, has continually expanded the range of services provided; **Susanna**

Montana, of San Francisco City Planning, has developed an innovative concept in arts housing; and **Merry Norris** has worked with local and national legislators for the establishment of the Los Angeles Endowment for the Arts.

Artist **Jill Baker** of Los Angeles and **Shirley Levy,** both officers of National Artists Equity, have been active in promoting the enactment of national arts legislation similar to that of California.

Women artists have been consistently in the egalitarian arts movements in the state. Although often disenfranchised from the elite art world, women nevertheless threw their energies into alternative methods of exhibiting, organizing and administering arts organizations and fighting for arts laws. Confirming the importance of California's leadership in arts legislation is the escalating imitation by other states and the federal government. California and the nation will never be the same again since the artists of California rearranged the terms of doing business in the art market, took control of their profession and changed the rules forever.

—**Eleanor Dickinson**

Supplementing and reinforcing some of the material that has been covered in "Art and Politics: A History" is the following:

The Quest for Visibility

In the Bay area, women have long displayed a key role in both museums and galleries. As early as 1918, **Florence Lehre**, a writer for the *Oakland Tribune*, was one of those who helped establish the Oakland Art Gallery, which continued well into the 1930s. On the other side of the Bay, **Beatrice Judd Ryan** with Maynard Dixon opened a small downtown space, "Galerie Beaux Arts," to show work by the "progressives" of the time, including artists such as **Helen Forbes**.

In January 1935, the San Francisco Museum of Art (now the San Francisco Museum of Modern Art. opened its doors. **Grace McCann Morley**, its first director, remained in that post until 1960. The De Young Museum selected **Nina Valvo** as curator of painting and sculpture in 1939. Two years later, **Jermayne MacAgy** was appointed head of the educational department at the Legion of Honor; she later became Acting Director. Many painters who were influential in the Abstract Expressionist movement were exhibited under MacAgy's tenure.

However, women artists were rarely given one-woman shows at the major Bay Area museums, and this trend continues. Women artists are more frequently shown as part of special (thematic) shows, usually representing less than 10% to

20% of the works being exhibited. The women artists' movement in California opened the way for important exhibitions in the late 1960s and 70s such as: "Twenty-five California Women of Art" 1968, Los Angeles, curated by **Josine Ianco Starrels**; "Visible/Invisible—21 Artists" 1972, Los Angeles, curated by **Dextra Frankel**; "Festival of Women Artists" 1972, San Francisco, curated by **Brenda Richardson**; "Women of Photography: An Historical Survey" 1975, San Francisco; "The Woman Artist in the American West, 1860-1960" 1976, Fullerton; "Contemporary Issues: Works on Paper by Women" 1977, Los Angeles; "The Dinner Party" 1979, San Francisco; "California Women Artists, 1945 to Present" 1987, curated by **Kathryn Funk**. In 1988 there was "Bay Area Masters" an exhibition of 12 women artists selected for their involvement and influence in the community; and "Diversity and Presence" focusing on 22 women artists who occupy permanent faculty positions on the campuses of the University of California.

There have been a handful of one-woman exhibitions at the major museums of artists such as: **Claire Falkenstein, Anna Elizabeth Klumpke, Constance Coleman Richards, Marjorie Acker Phillips, Ynes Johnston, Ruth Asawa, Joan Brown, Helen Lundeberg, Joyce Treiman, June Wayne, Ruth Weisberg**, and **Beatrice Wood**. However, in many ways, galleries have become the showcase for those women artists who have managed.to survive in the increasingly commercialized world of art and art dealers. As art has become a commodity and an "investment," the competition for exhibition space has increased and the decision to select an artist to be exhibited is dependent on the sales potential of the work in a particular market.

There are many woman-owned galleries in the Bay Area, as there are in Los Angeles, however only a few focus solely on the works of women artists. These include: **San Francisco Women Artists Gallery** (See chapter "Art and Politics"); **Matrix Gallery**, Sacramento; **Gallery 25**, a co-op started by students in **Joyce Aiken**'s feminist art class at Cal State, Fresno, in 1974; and **Artistas Indigenas**, Berkeley, founded in 1982 to support the work of women from the American Pacific Islands.

Other woman-owned galleries that do not show women artists exclusively include: **Rena Bransten Gallery**, established in 1975, specializes in figurative or "object related work" from Northern California and Europe; **Braunstein/Quay Gallery**, known in the 1960s as the ceramics center of the West, now shows California artists and all forms of art; **Ivory/Klimpton Gallery**, owned by Jane Ivory and Kay Kimpton, who unequivocally state they do not "believe in the concept of women artists as a category to be separated from the

mainstream ... it's belittling to women"; **Mincher/Wilcox Gallery** is another gallery which believes that ". . . singling out artists by gender is just another form of sexism." **Paule Anglim Gallery, Louise Allrich, Susan Cummins, Fuller Gross Gallery, Jeremy Stone Gallery, Marie Boss Fine Arts, Elaine Potter Gallery, Erika Meyerovich Gallery, Judith Litvich Contemporary** and **Roberta English Gallery** round out the list in the Bay Area. In Southern California the following woman-owned galleries show a high proportion of women artists: **[Joan] Ankrum Gallery, Art Source L.A. (Francine Ellman), Tamara Bane Gallery, Jan Baum Gallery, Jessica Daraby, Krygier-Landau Contemporary Art, Kurland/Summers (Ruth Summers), Tobey C. Moss Gallery, April Sgro-Riddle Gallery, Schifflett Gallery, Wade Gallery, Wenger Gallery, The Front Porch (Zeneta Kertisz), Dorothy Goldeen Gallery, S.I.T.E. (Ann Schneider), Newspace Gallery (Joni Gordon), Ashley Gallery (Suzanne Stone), Hippodrome Gallery (Cynthia MacMullin), Diane Nelson Gallery.**

—**Rita Cummings Belle**

Notes

All quotations are from conversations between the writer and gallery owners.

Katherine Diage, Director, University Art Gallery, Riverside, in her *Introduction* to the catalog for "Diversity and Presence" says: "In 1963-64 an exhibition entitled 'Artists of the University of California' was organized by the UCLA Art Galleries. Forty-four artists participated in that exhibition; of those only three (about 7%) were women. But the past 23 years have seen significant changes. There are now more than 90 faculty artists within the University of California, and of those roughly one quarter are women, a far more representative ratio than in the UCLA exhibition." ("Diversity and Presence," 1988, included 22 women faculty artists.)

The Feminist Art Movement
Southern California Style, 1970-1980

Between 1970 and 1980, hundreds, perhaps thousands of women were involved in some aspect of the women's art movement in California. Their efforts to change the prospects of women artists, public attitudes toward them, even the definition of what is considered art and the conditions of its production and exhibition, are a pivotal factor in the history of contemporary art. In embarking on the project of making feminist art, women first had to acknowledge that art as practiced by the dominant sex was not able to account for women's experience. Feminist artists formed alliances with political feminists and other progressive social and political forces. They found that the new art called for new conditions of art production, teaching and exhibition and that their local interests needed to embrace national and international concerns. They discovered that race and class issues are closely aligned with those of gender and that new ways had to be found to include these issues in their analysis of culture.

To accomplish their goals, women artists in California pioneered innovative educational programs in colleges and art schools; founded alternative galleries and institutions in which they could make, show and discuss their work; collected slides and began to research women artists past and present. Feminist artists testified at state Congressional hearings; they mounted effective, colorful protests of museum shows which excluded or misrepresented women. And they fanned out into the community, teaching, lecturing, organizing and making art about a wide range of public and private concerns. In this process older women artists reached out to younger ones and to their students, becoming mentors, collaborators and friends. Feminist critics and scholars began to develop a rich feminist scholarship and criticism. Black, Chicana and Asian women artists voiced their concerns, initiated intense discussions and made coalitions with feminist groups.

It was a heady, dramatic, painful and exhilarating decade of feminist art activism. In this chapter I have tried to trace the outline of events in Southern California more or less chronologically—though of course many things happened concurrently. As an active member and founder of many of the groups and

341

programs described in this article, I have relied largely on personal recollection, journals, archives and notes, as well as extensive interviews with many of the women mentioned

In the late eighties there are many feminist groups and individuals all over the country who are working culturally to effect social and political change. There is no question but that the feminist art movement in California and elsewhere during the seventies pioneered the foundation on which their work is based.

In 1970 the Los Angeles County Museum of Art mounted a monumental "Art and Technology" show that did not include a single woman artist among the exhibitors. Enraged women mobilized to organize protest meetings and actions focused on the Museum's blatant discrimination against women artists, including a thorough analysis of its overall educational, hiring and showing practices. The results of this research were devastating: they showed among other things that all senior-level curators and directors were male, that 95% of volunteer docents and support staff were women; and that women artists were virtually absent from the historical collections and practically unrepresented in the contemporary wing. The women organized themselves as the Los Angeles Council of Women Artists, and thus the California women artists' movement, which flourished in the heady atmosphere of social change and upheaval of the 70s, was born.

In contrast to New York and the East Coast, the California art scene of the 1960s tended to be isolated in small pockets, which often centered around the university art departments and art schools. Thus, for example, Chouinard in Los Angeles and the San Francisco Art Institute trained and fostered groups of artists who became identified with the schools and with certain styles practiced by the artist/teachers. In the late 60s student demands for more "relevant" education made room for radical revisions of college curricula. At the same time California became the site for experiments in social interaction, investigations of new life styles, sexual explorations , and psychological innovations such as "encounter" and "tea groups." The emphasis was on building alternatives to traditional institutions, life choices and careers. This peculiarly Californian conjunction of educational and social/psychological experimentation and reform determined in large part the particular projects and the emphasis on education and group work which characterized the California women artists' movement and differentiated it to a certain extent from other branches of the movement.

As well as being influenced by particular geographic or historical conditions, movements are characterized by their participants and leaders. It would be

falsifying history not to acknowledge that the tone and style of the women artists' movement in California were largely set by a few eloquent and charismatic women artists, chief among them **Judy Chicago, June Wayne, Miriam Schapiro, Sheila de Bretteville, Bruria, Rachel Rosenthal, Betye Saar** and **Max Cole**. That said, it is also important to note that from the beginning the movement was eclectic and multifaceted and had an active membership of students, art professionals and educators who worked in loosely defined and shifting groups on the basis of consensus and the equal participation of every woman. Of particular interest is the spontaneous system of student and mentor that evolved in the alternative educational projects which became so important.

By 1970 the "second wave" of the feminist movement, energized by the civil rights and antiwar movements, had grown enough to begin dividing into interest groups and to build constituencies in various professional organizations such as the Modern Language Association and the College Art Association, both of which had women's caucuses concerned with the invisibility of women's achievements in college curricula. Education, or rather, the miseducation of women, became a vital concern for many women academics. Spurred by this concern and by her own struggles as a female art student, Judy Chicago moved to Fresno in early 1970 to start the first Feminist Art Program at California State University, Fresno, a former teacher's college in the heart of the San Joaquin Valley.

The Fresno Feminist Art Program was founded for the purpose of experimenting with a specifically feminist education for young women art students. Chicago was committed to challenging the roles forced on women in patriarchal culture and to expanding her students' capabilities, vision and aspiration as women and as artists. The 15 women who enrolled in the program had diverse backgrounds and experience. Most were entirely ignorant of feminism and had little formal art training. **Suzanne Lacy** (a psychology major) and **Faith Wilding** (with a BA in English Literature) were deeply involved in the feminist movement, having started Fresno's first women's consciousness-raising group and women's studies course. **Nancy Youdelman** and **Janice Lester** brought a lively interest in costume, fantasy and film imagery, which had found little encouragement in the art department. Other women were interested in photography, dance and theater. The combination of the multidisciplinary strengths and interests of the students would give a particular shape to work produced in the program. Meanwhile, however, the students lacked an understanding of the commitment necessary to be serious artists and of the strictures of female role conditioning.

Together, Chicago and her women students developed experimental group processes on the basis of which they evolved principles of a feminist art education. There was something uniquely Californian in the environment and atmosphere of the program. The group met in a room which was furnished only with bright carpet scraps and big pillows. Often there was a yoga lesson or group stretches to begin. The women were encouraged to hug, touch and hold each other, to scream, role-play and emote freely. Once a week a revolving committee cooked a communal dinner, which was the occasion for a real "family get-together," complete with praise or blame for the cooks, story-telling, fights and raucous jokes.

Four basic principles of feminist education emerged from the program:

1. *Consciousness-raising:* A basic process adopted from the feminist movement by way of the Chinese Cultural Revolution. Each participant speaks about her own experience on a common topic (mothers, money, sex) and the group then analyzes the commonality of their experiences and discusses its implications in the struggle for personal, social and political change.

2. *Building a female context and environment:* In those days of radical practices this literally meant going outside of the university. An old barracks building was found which the women rented and refurbished to their needs. The space was entirely controlled by the students, and it gave them the opportunity to experience a working community of women without male judgment or interference.

3. *Female role models:* These were largely lacking in the education system and were supplied in the program by Judy Chicago, guest artists (such as Miriam Schapiro) and research and reading in history, literature, myth, sociology and psychology.

4. *Permission:* To be themselves, to make art out of their own experiences as women. This opened up a new world of possibilities and paved the way for investigating the possibilities of a feminist art.

I have outlined the principles of the Fresno Feminist Art Program in such detail because they became the basis for all the feminist educational programs which came later, and because they are still adaptable to art classes (even mixed ones) in most educational institutions.

The Fresno Feminist Art Program has been described in detail by Chicago and Wilding, so I will only add a note here about the work produced by the students. The particular constellation of the students' interests and knowledge combined to produce work in a wide range of media, styles and techniques and with a varied content. They produced photographs, collages, films, performances,

videos, narratives, paintings, drawings, writings, environments and installations. While many of these forms were being practiced by individual artists in the 60s, it was probably the first time that such a plurality of forms,styles and content were brought together and focused on themes of women's experience. If the work was often technically crude and rough, it was also intensely evocative, painful, forthright and humorous about subjects which had not been seen as fit territory for women artists—or indeed for art—before. Additionally, the manner of production and exhibition of this work marked it as uniquely female and feminist.

Chicago's radical experiments in applying feminist ideas and methods to the education of women artists proved so provocative that she was invited by Miriam Schapiro and Paul Brach to bring the program to the California Institute of the Arts in Valencia, near Los Angeles, the following year.

Meanwhile, in Los Angeles, under the leadership of **Joyce Kozloff** (who had recently moved from New York) Bruria, June Wayne and others, the Los Angeles Council of Women Artists was working vigorously for changes in the structures of LACMA and the LA art community. In a short time the Council had attracted over 250 active members in whose name it presented a proposal for sweeping changes in the structure and policies of the Museum (which at that time was the only major art museum in the area). The Council organized meetings, press conferences and consciousness-raising groups. Here women learned the new language and procedures of the political feminist movement. They began to collect evidence of discrimination against women artists by sending out questionnaires and counting works by women on view at various galleries and the Museum. It should be noted that the research collected by the Council was read into the State Congressional Record. The landmark show, "400 Years of Painting by Women," curated by **Linda Nochlin** and **Ann Sutherland Harris**, which opened at LACMA on December 20, 1976, was a direct result of the Council's work. By 1972 the Council's interests shifted from focusing on institutional reform, and its members began to concentrate their efforts on creating an art space of their own.

In the Fall of 1972, the Feminist Art Program at CalArts, under the direction of Judy Chicago and Miriam Schapiro and graduate assistant Faith Wilding, created *Womanhouse*, a landmark collaborative environment and first showcase of the new "feminist art." *Womanhouse* has been well documented in a film by **Johanna Demetrakos**, in a catalog and in numerous books and articles. Since it was widely seen, reviewed by *Time* and all the major national networks and discussed as the first large-scale example of feminist art, it is important to de-

scribe some of the characteristics of this art, reproduced in much women's art of the 1970s. First, the art was based on and revealed the experiences of women. Second, it challenged the separation between the public (male) and the private (female) spheres (*Womanhouse* was an actual house on a residential street in a Los Angeles neighborhood which was opened to the public) and, by implication, the structures by which society creates and reinforces female difference. Third, the work offered a social/political critique of the way society views and constructs women's identity and roles and proscribes the viability of their productions except in the domestic sphere. Fourth, the art was multimedia and multistyle, combining materials and processes from low and high art: making new integrations of crafts, women's traditional lapwork and needlework, autobiography and narrative, modernist collage and montage strategies, and Dada theatre, ritual, performance and happenings. *Womanhouse* also used other strategies which would become the norm for much later feminist art. These included collaborative work based on group consciousness-raising and discussion; art production and exhibition in a completely female-controlled alternative space; and a definition of art as a socially critical and participatory activity designed to invite and promote dialogue, thought and discussion.

While *Womanhouse* was being made, Judy Chicago and Miriam Schapiro made their first tour of the country giving slide lectures about "central core imagery" or "cunt" art. The identification and popularization of a specifically female imagery soon became very controversial, especially among more politically active women who resisted what they felt was a definition of woman by her sexual characteristics, which tended to reinforce the idea of women's difference. This was only the beginning of a still actively raging national and even international debate that is often couched in the question: "Is there a specifically female art with identifiable characteristics, and how can it be described?" Space limitations do not permit a description of the complex and fascinating history of this debate, but it is important to note that movements go through many stages of development and consciousness, and in the heady turbulent days of the early 70s "cunt was beautiful" just as "black was beautiful," and feminists were not yet thinking so clearly about the implications of extolling female characteristics and reinforcing elements of difference. It was a necessary time of exploration and rebellion which bred its share of dogmatism and ideology, some of which now seems almost embarrassingly naive and confining.

As a result of their lecture trips in 1971, Chicago and Schapiro with **Lucy Lippard, Marcia Tucker, Ellen Lanyon** and others formed West-East Bag, or

WEB, an international network of women artists. WEB functioned as an information service for women's groups all over the country, with its newsletter being written by a different chapter each month. In 1972 the Los Angeles and San Francisco chapters of WEB called the first West Coast Conference of Women Artists at CalArts in Valencia. One hundred fifty California women artists participated in a three-day marathon of discussions, performances, slide shows and films. The high point of the conference was the unveiling of a great body of unusual and powerful art by women, much of which had never been shown before. The need to have places to show women's art became more urgently apparent now, and the conference became an organizing base. Curators and artists met and began to plan shows, and groups were formed to plan a women's gallery. The conference helped to overcome the overwhelming isolation of many women artists and gave them the courage to organize on their own behalf.

The years 1972 to 1975 saw tremendous activity by women artists in Los Angeles. Womanspace gallery opened in 1973 and soon had more than 1200 members, attracting capacity crowds to ground-breaking shows like "Female Sexuality/Female Identity," "Black Mirror," "Taboo" and "Opulence." Womanspace also provided many extraordinary programs to the community, including discussions with major artists and professional women, performances, films and the special "Pioneer Women" evenings with guests like **Anais Nin**, June Wayne and **Bella Lewitzky** which reached hundreds of women with empowering force. At the same time, artist and activist June Wayne began her series of "Joan of Art" seminars to teach women artists about professional and business practices. A landmark show in 1972, "Invisible/Visible: 21 Artists," curated by **Dextra Frankel** and held at the Long Beach Museum of Art attempted to identify work by women artists that demonstrated certain "female sensibilities," such as layering, central core imagery, biomorphic abstraction, fabric and pattern use and fantasy narratives. While *Womanspace* gave many emerging and professional women artists a unique exhibition opportunity, its emphasis was always on educating women and the public—it never functioned to promote individual careers, even though some artists who received their first public exhibitions there went on to become rising stars in the Los Angeles art world.

In order to explore the more radical implications and possibilities of feminist education, Judy Chicago, Sheila de Bretteville and **Arlene Raven** resigned their teaching jobs at CalArts in 1973 and banded together with *Womanspace* and other feminist organizations to found the Los Angeles Woman's Building.

Ironically it was in the now vacated old Chouinard Art School building that they found the space for a new women's art school, the Feminist Studio Workshop (FSW), the anchor group of the Woman's Building (WB). In the following seven years, the FSW graduated more than 300 artists and graphic designers. It was described by its founders as "an experimental program in female education in the arts. Our purpose is to develop a new concept of art, a new kind of artist, and a new art community built from the lives, feelings, and needs of women." (From the first FSW poster).

Many of the educational processes used in the FSW had been pioneered and tested at Fresno and at CalArts by Chicago and Schapiro. Sheila de Bretteville also had created a unique and successful women's design program at CalArts. An early member of the LA Council of Women Artists, de Bretteville was interested in investigating the interfaces of feminism and design. She was convinced that women, through centuries of social conditioning, have acquired psychic, emotional and physical qualities and needs different from those of the dominant (male) culture. de Bretteville based her program on teaching women to value and express these humane qualities, which include creating relationships, working collaboratively and providing nurturing and comforting environments. Suzanne Lacy became De Bretteville's graduate assistant and contributed her wide knowledge of feminism and group process. The program they designed included research and reading of feminist literature, consciousness-raising and group discussion, applying feminist values to design problems, working on collaborative projects (such as the *Menstruation Tapes*), and practical hands-on training in printing, design and graphics. When de Bretteville made the wrenching decision to leave CalArts and devote herself exclusively to FSW she did so because, "I came to realize the ability of the dominant culture to annihilate a positive act, and to change and misuse the original meanings and intents of forms" (Quoted in *By Our Own Hands.*).

After Chicago and Arlene Raven (who had begun to develop courses on feminist art history and criticism at CalArts) left to found the Feminist Studio Workshop, Miriam Schapiro continued the Feminist Art Program at CalArts with the help of a graduate assistant, artist **Sherry Brody.** Schapiro brought a new emphasis to the visual work in the program, for she had been part of the New York art world and had years of teaching experience. Now she opened up investigations into the nature of women's art production and with her students began to explore women's traditional arts such as fabric collage, pattern, decoration, quilting and the use of opulent materials. With Brody, who had worked with fabric for years, she created a fantasy adult "Dollhouse" for

Womanhouse and began to use fabric collage in her own painting. Between 1973 and 1975, under Schapiro's direction, the program issued two valuable publications. The first, *Anonymous Was a Woman,* documented a festival of women in the arts sponsored by the program in 1974 and included a fascinating section called "Letters to a Young Artist," in which over 70 nationally known women artists, designers, writers and performers shared their experiences and concerns with the students. This book was one of the first collective works to come out of the feminist art movement, and the method has since been emulated over and over again. The other publication was *Art: A Woman's Sensibility*, a compilation of works and writings by women artists. In 1975 both Schapiro and Brody left CalArts, and with them vanished the last organized feminist art activity there. The experience at CalArts seemed to prove the near impossibility of women making significant changes in a heavily male-dominated institution, unless they are willing to do permanent battle with it. In the 1980s CalArts has all but forgotten its feminist history. In a review of the 1988 CalArts Alumni show at the Newport Harbor Art Museum, Colin Gardner writes, "Conveniently ignored in the exhibition were the graduates of CalArts' (in)famous Feminist Art Program, guided by Judy Chicago and Miriam Schapiro in the early 70s . . . here was a chance for the curators to inject a substantial dose of ideological and sexual *difference* into what has become a smugly elitist temple of closure . . ." (*Art Forum*, April 1988).

From 1973 onward the Los Angeles Woman's Building became the center for feminist art education, art exhibition, discussion, performance and study. It took its name from the Woman's Building of the World's Columbian Exposition in Chicago in 1893, and its mission became the nurturance and communication of women's experience and culture. From its initial location in the former Chouinard Art School on Grandview Street, the WB moved to its present location on Spring Street near Chinatown. At this writing the WB has had more than 10 years of operation during which its organization and management has often changed—but never its philosophy and its deep commitment to the needs and visions of women of all classes and races. In November 1988 the WB celebrated its 15th anniversary of service to the community. It is to be congratulated particularly for its work against racism and its emphasis on multicultural, multiracial programs and projects.

The Woman's Building has established itself as a unique institution at the forefront of women's cultural, educational and socio-political work. The list of lectures given there over the years by internationally, nationally and locally known speakers reveals the breadth and depth of issues which have concerned

feminists; it included feminist art history and criticism, art and politics, the global food crisis, ecology, nuclear disarmament, design in the age of technology, Chicana muralists, Black women writers, AIDS, lesbian culture, women in architecture and many, many others. From the beginning the vision of art fostered at the WB has been that which "raises consciousness, invites dialog and transforms culture." The Woman's Building is a prototype of feminist institutions in which structure and methods of management emerge from the internal process rather than imitating existing models. As those who have worked in collectively managed enterprises know, this kind of organization takes an enormous toll. On the other hand, the excitement and satisfaction of the process of creating an alternative institution has sustained many dedicated staffers at the WB.

I will describe some of the organizations and groups which were housed there in the first five years of operation. The Feminist Studio Workshop became the anchor group of the WB—indeed, for the first few years the WB can be seen as the public extension of the Workshop's energies and philosophy. The founders, Judy Chicago, Sheila de Bretteville and Arlene Raven, brought their extensive experience of female art education to this venture. The FSW was committed to breaking down the rigid distinctions between the professions and to teaching its students to approach their practical productions and problem solving through an analysis of the social, cultural, economic and psychological (emotional/consciousness) factors implied. This was done through mandatory reading and discussion classes and through specific projects in which students had to grapple with the public implications and extensions of their work. The emphasis was on building a women's community that would be a paradigm for other communities. Students were extensively trained in interpersonal skills, in management and group facilitation and in teaching. FSW also had a strong program of teaching technical skills, with much of the emphasis on the communicative skills of graphic design, printing, layout, photography, video production and writing. FSW work in all media shares a clear aesthetic—an aesthetic of relationship. This was demonstrated in the 1975 and 1976 group shows, "Woman to Woman," which included several photo-documentary pieces, many performances and two major collaborative pieces made with two local professional women artists. FSW art production was mainly an art about the process of building community and experiencing women's acculturation and conditioning. Often it ventured into new territory of subject matter such as spirituality, lesbian life and incest, and some striking and haunting work resulted. However, there was always a feeling that the graphic, design and printing work was much more sophisticated and aesthetically realized than the visual art. Raven summed up

this problem, "We haven't really found the medium yet with which we can make effective revolutionary artistic statements in public. We have finally come to a healthy realization that our feminist institutions and our feminist art are in a large sense still essentially powerless in the culture, though we ourselves have become powerful through personal change and human relationships. The challenge is to be able to thrust this power into the public arena in a way that matters and make our personal changes manifest." (*By Our Hands*, pp. 85-86).

Looking back, it is clear that this slow development of a strong visual production was to be expected. The feminist upheaval of the 1970s has taught us that the disruption of the dominant cultural assumptions and representations is no easy matter, and it was to be expected that the traditionally entrenched "high art" fields of painting and sculpture would be the most difficult to open up to new subject matter. But many feminist artists have been able to do so. **Nancy Fried**, for example, who was making exquisitely patterned tiny bread-dough sculptures at the FSW has now found ways of using more traditional sculptural media for her nontraditional content. In general, there was a great opening up of possibility in the art world in the 70s, and a closing down in the 80s. Many women who thrived as performance and installation artists and worked in alternative spaces in the 70s are now trying to adapt their work to the more object-oriented 80s—or have given up altogether. The strongest art work to come out of the FSW was probably the performance work led by Suzanne Lacy, Leslie Labowitz, **Vanalyne Greene** and others, and this is the subject of another chapter in this book.

By 1977 the FSW could no longer attract enough students, and the educational program at the WB changed to an extension program, which is still flourishing today. The printing and graphics operation has become the financial mainstay of the WB as a commercially viable shop, as well as continuing to be highly thought of as an innovative program in fine printing, one-of-a-kind book making and the production of many different kinds of artists' multiples. The original founders of the FSW (de Bretteville, Chicago, and Raven) are still involved actively in an advisory capacity at the WB. Operations are in the capable hands of former FSW students (**Terry Wolverton, Cheri Gaulke**, and others), who are passing on their feminist training to new generations of women. There is a rich archive of slides, documents and photographs, which is open to scholars and others for research. The Woman's Building has proved to be a long-lasting, viable, feminist institution which has won great respect and honors (including several Mayor's Awards) in the Los Angeles community and looks forward to years of expansion and service.

After moving into the Woman's Building in 1973 Womanspace did not last very long. It closed in 1974—just one and a half years after its exuberant, hopeful opening. During its short life Womanspace nurtured a growing community of women artists in Los Angeles and helped to create new opportunities for them. Bruria, one of the directors of Womanspace, enumerated the following factors which she thought led to the closing of Womanspace: the move away from the West Side of Los Angeles where many of the women artists lived and worked, making it more difficult to just drop by and feel part of the space; the change of leadership in the organization from older women to younger ones who did not have family obligations and were less tolerant to the schedules and needs of others. Once Womanspace moved into the WB the energy was directed more toward the FSW and co-op galleries, and there was no replenishment of leadership or membership. In addition, the financial difficulties, and, more seriously, the conflict between professionalism and politics which plagued the gallery almost from the beginning were not solvable. It became evident that one gallery could not be all things to all people. However, this experience taught women to organize on their own behalf and that it was possible to build and manage their own institutions.

In November 1973, 35 women who had been associated with Womanspace formed the first women's cooperative gallery on the West Coast, naming it Grandview I &II. The group encompassed a wide spectrum of political and aesthetic persuasions and was broadly diverse in age and background. Members of Grandview had one-woman shows which frequently afforded the first comprehensive view of a body of their work. Grandview also attempted a series of artist talks, slide lectures, open houses and openings. The group held continuing dialogues on their philosophies of art and feminism and soon encountered difficulties because of the pressure from some members to develop a cohesive position. When the first WB was sold in 1974, Grandview members were forced to confront relocation or dissolution. After much discussion, a small group of members who had a strong feminist commitment and close personal rapport re-formed as a coalition of women artists dedicated to making women more visible and their art accessible to a wide audience. This group, renaming itself Double X, decided not to rent a fixed space but to organize a series of women's shows and events in public spaces wherever they were offered. In the following four years there were shows in factories, warehouses, colleges and alternative art spaces, and lectures in a variety of colleges. Double X also compiled a documentary show of the history of the women's art movement in

Southern California and published a book on the subject: *By Our Own Hands: A History of the Women Artists' Movement of Southern California, 1970-76.*

Almost from the beginning, historical research about women's art and the development of a feminist art criticism and critical theory were a vital part of the feminist art movement. In spite of its short existence Womanspace immediately began publishing a journal of criticism and reviews, *Womanspace Journal*, which published 3 issues. In 1973, shortly after the WB was organized, Arlene Raven and **Ruth Iskin** (both with art history degrees from Johns Hopkins University) established the Center for Art Historical Studies, which was affiliated with the FSW. They were interested in art historical research and criticism of women's art, the development of a feminist perspective with which to re-view the history of art, and in advancing women's capacities to verbalize and write about their own art. The Center collected and maintained extensive archives and slide collections of women's art and published book lists and course outlines for use in colleges across the country. It also carried out fascinating visual and exhibition projects, such as a show documenting the 1893 Chicago Woman's Building. An exhibition opened during the 1977 College Art Association Conference called "What Is Feminist Art?" to which women from all over the country responded. Much of the massive data accumulated during the existence of the Woman's Building archives and slide registry has never been compiled and published. Some of it saw publication in the short-lived West coast-based publication for women's culture, *Chrysalis*, and many students and scholars have used the material in their research and writing. But there is a vast treasure trove of materials still being accumulated, the systematic study of which could give a more definitive and comprehensive view of contemporary feminist art than anything yet published.

Over the past 15 years the women's art movement in California has changed in many ways. Groups, galleries and publications have come and gone. Many of the original founders have moved away; other activists have taken their place. The Women's Caucus for Art chapter has taken over some of the educational and institution-critical functions that used to originate from the Woman's Building. But there is still a strong sense of coalition among feminist artists in Los Angeles. In 1980, for example, the WCA organized a protest of LACMA's big "Los Angeles Art of the Sixties" show, which included no women artists. For this occasion a group of performance artists, mostly from the WB, joined WCA and many unaffiliated artists to stage a "Cowgirl Commandos" raid and a picket line of women wearing Maurice Tuchman (curator of the show) masks. These actions temporarily closed down the show's opening. The WB has also

hosted and cosponsored national meetings of the WCA chapters during conferences in Los Angeles.

It is clear that in spite of the years of activism women artists are only slightly more visible in gallery shows throughout the city (which now has a far more active art scene than in the 60s and 70s), and are still largely unrepresented in the museums. This will not change so long as society defines woman as "the other." Feminist artists all over the country are continuing to effect change by producing work that challenges established notions of what art is and how culture functions. Although most alternative feminist spaces have closed, feminist art is stronger than ever as it builds a more solid theoretical base, continues its historical research and publicizes the work of contemporary women artists. In Los Angeles, the Woman's Building still stands as a strong testimony to the collective power of women.

—**Faith Wilding**

Sources

Anonymous Was a Woman: A Collection of Letters to Young Women Artists, published by the Feminist Art Program, California Institute of the Arts, 1974.

Art: A Woman's Sensibility, published by the Feminist Art Program, California Institute of the Arts, 1975.

Chicago,.Judy *Through the Flower: My Struggle as a Woman Artist,* New York: Doubleday, 1975.

Everywoman (Special issue by the Fresno Feminist Art Program), Vol. 11:7, issue 18 (May 1971).

Twenty-One Artists: Invisible/Visible, catalog, Association of Western Museums, Long Beach Museum of Art, (March 1972).

Womanspace Journal, Vol. I:1, 2 & 3, (1973). Womanspace, Los Angeles.

Womanhouse, catalog, published by California Institute of the Arts, Valencia, CA, (1972).

Wilding, Faith. *By Our Own Hands: The Women Artists' Movement, Southern California, 1970-1976,* Los Angeles: Double X (1977).

Appendix: Projects and Publications

Few events in the history of the women artists' movement of the 1970s have had the impact and lasting significance of the innovative projects and publications that follow in this Appendix. Some have been touched on in earlier chapters, and others are presented here for the first time. The selfless dedication each woman gave to these projects is apparent. It is our hope that this documentation will be a revelation and an inspiration to the next wave of innovators.

Recalling Womanhouse

Womanhouse was started early in the fall of 1971. **Paula Harper**, an art historian who worked in the Feminist Art Program at the California Institute of the Arts, suggested the idea to **Judy Chicago** and me, and we presented it to the women in our group.

On November 8, 1971, 23 women arrived at 533 Mariposa Street in downtown Hollywood armed with mops, brooms, paint buckets, rollers, sanding equipment and wallpaper. For two months we scraped walls, replaced windows, built partitions, sanded floors, made furniture, installed lights, and renovated the 75 year-old dilapidated structure. Our purpose was to remake the old house into a place of dreams and fantasies. Each room would be transformed into a nonfunctioning art environment. The kitchen would become a metaphor for nurturance. **Ann Mills**'s "Leaf Room" would tell the story of cycles and seasons. The "Oversize Nursery" would be a room where the artist **Shawnee Wollenman** would make giant furniture to recapture memories of being so small that the dolls, the rocking horse, the bed, etc., loomed above her.

The first feelings Judy and I had about collaboration were hopeful, not just for the dreams we shared as ambitious artists but also for the exciting educational experiment ahead. Judy's pioneering efforts at Fresno State College with a group of feminist women artists were about to be expanded. Her struggle with the implementation of feminist ideas frightened her at times. Was the teaching of women so difficult? Were women, by the nature of history, such outcasts from creativity that the damage done to their inquiring spirit was irreparable? Her lack of role models as examples made the "teaching" seem

355

primitive. The conditions of consciousness-raising were arduous. For every step forward, for every flash of the creative goal, there were two steps backward.

When I was invited to talk to Judy's students and look at their art, I experienced elation at the audacity of the experiment. The women were much more advanced than any of them realized. **Faith Wilding** and **Suzanne Lacy**, older than the others, were already destined for individual success. Wearing their hiking boots, long skirts, headbands and jewelry, these students looked different from other women at college who dressed, it seemed, only to please the men. In fact, the look of Judy's students made me realize how experimental their attitudes were in reevaluating their social positions. They needed to seem different in order make art as "others." No more "old doormat" act for them. I asked myself, "Where are they going?" They didn't know, nor did any of us. It was 1971, the quiet revolution had already begun and some of us were part of it.

Consciousness raising was the technique used at Fresno in order for women to identify their condition and status as women. Women would sit in a circle and address themselves to a single topic, such as "What was our real relationship to our fathers?", speaking in turn around the room, each telling her story to provide a common denominator of patriarchal experience. This also demonstrated the kinship of each with her sisters, establishing the basis for all female networks.

This experience also provided an underpinning for content in the art-making process. I found that the "idea to image" process authenticated the work the women made. They did not, however, have much skill or technique in implementing their ideas, nor did they know anything about the culture of art. My feeling was that without such information radical statements were not viable. That would be my job at *Womanhouse*. In sharing my expertise, I would be able to show them how to emphasize their womanly focus within the setting of a universal culture; at least I would try to show the artfulness of art. They had brilliant ideas but no way to contextualize them, which is why the structure of an archetypal house form worked so well.

My first job was to get the Fresno students enrolled at Cal Arts (a more sophisticated environment than Fresno and where the faculty needed some encouragement to admit a group with feminist art portfolios). I introduced Judy Chicago to members of the art department and to their dean, my husband, Paul Brach. Finally after much explaining, even cajoling, plus a few dinners at my house, I argued for a class for women artists only (unheard of at that time) to be team-taught by Judy and myself. Since Cal Arts was a hotbed of avant-gardism anyway, why not us? We were approved; Judy Chicago was hired.

Judy and I, high on our hopes for the future, immediately named our new baby the Feminist Art Program and placed an ad in *Art Forum* announcing our birth. It ran concurrently with an ad in which New York women artists lambasted the Whitney Museum for avoiding parity in choosing group shows.

Our students, who now included not only the Fresno group but a number of original Cal Arts women as well, became enthusiastic about beginning the new class with a group project. They approved the idea of *Womanhouse* and proceeded to find a suitable environment in which to work.

One of my clearest memories is my own shock at the speed with which our students actualized the ideas for *Womanhouse*, given that at the same time they were trying to locate affordable housing, find jobs, and enroll in their other classes. In our meetings we discussed the project ahead and evaluated ways in which going forward with the plans might be psychologically difficult. The students lacked positive self-assertion, feared the unknown, were anxious about survival and were afraid to face competition with the sophisticated men in the art school. All these impediments were voiced and discharged in an initiation of the support system that was to carry us all through the difficulties of the project.

The first consciousness-raising session, after the students went out to find a house, was a narrative of complexity and confusion. In downtown Hollywood, an abandoned house was sighted. The Hall of Records provided details. The owner, an older woman who wanted to meet with the students on a street corner, was persuaded to donate the building to Cal Arts for the three months of the project's duration. (Later, the building would be demolished.)

In no time the students organized the details of the project. I was again shocked, this time at the nature of their inventiveness, their sudden assertion, their description of their desire, and the will to make things happen. They were ultimately different from any group of artists I have ever taught. In the consciousness-raising sessions, I didn't feel like their teacher. I felt part of the circle of women, giving and taking information. The democratization process was immediate and extraordinary. In the old days of teaching at Parsons or at the University of California at San Diego, I remembered standing in front of my class— sometimes a group of bored receptors attending because they needed the credits—and feeling ill at ease with my role. Here, where the teaching and the learning were shared, my load was lightened and I was able to grow and develop myself.

When women are given permission to be full human beings, they are not prepared for it. Is anyone? Working with the pressure of having to finish the house within a certain time made them crazy. We had to push them and that

meant long hours, hard work, driving the damned freeways late at night, disappointing friends, giving up a social life—all of this was enraging. Judy would describe situations sociologically: "Women are unused to getting their hands dirty, working beyond their capacities, they are spoiled, they have no proper models of working women . . ." Once, when we were just getting started and the toilets were clogged, the electricity was off, it was winter, the windows lacked glass, and there was no water. Judy pointed out that the men who came to fix the toilets were used to putting their hands in shit. "Would a woman do that?" she asked.

As a teacher, my most exciting times in *Womanhouse* were when I could intuit a student's vision or a partial vision and help her articulate the wholeness of it. Encourage her to begin, give her some of my own experience, remind her that for a creative person, making art was part of being alive. Students forget that they, too, have experience. They sometimes think that each day dawns without antecedents, so they feel empty. Because they don't take their own rehearsals for creativity seriously, they end up feeling blank each time they enter the studio. The need for encouragement was powerful, and all of us shared in the exhaustive nurturing that had to be done to make up for centuries of neglect and damage.

I remember one of our students coming back from her first adventure in the lumberyard. She cried. What was wrong? Between sobs, she managed to tell us that they sent her home to bring back her brother, father, or uncle to help her. One easily forgets how things were in 1971. No models existed for assertive females. No models for women who knew their own minds and could speak authoritatively. If a man in power spotted such a person as our student, who became anxious in a man's territory, who faltered, the browbeating began. Or if the token woman of power made her appearance, she was charged with being uppity or called a monster, ballbreaker, or dyke.

There was a general angst in all of us. What were our male colleagues going to say when they saw a true woman's environment? Would they identify with the house? Couldn't everyone empathize with the archetypal framework? But how would they react to little clay models of food on the dining room table or to the decorative stenciling on the floor? What would they say to Judy's "Menstruation Bathroom" with its wastepaper basket containing a few facsimiles of used tampons? How would the men deal with the "Nurturant Kitchen" where we painted everything in the room a pinky pink and glued painted, latex molds of fried egg forms, youthful breast forms, and pendulous breast forms all over the ceiling and on the walls? How would they take to my "Dollhouse," which I made in collaboration with **Sherry Brody** (a Los Angeles artist who later be-

came my assistant in the program)? After all, I was the eldest on the project and had a creditable career in the New York art world. I had exhibited my mural-sized, abstract, illusionistic hard-edge paintings at the Andre Emmerich Gallery for many years. Why would I make a dollhouse? Such a trivialized image, such a slap in the face of high art.

What we had no way of knowing then was that the reactions of the men would not play a large role in the critical aftermath. There was no knowing for us as we worked on the house that it would unleash women's pride, ideas and creativity. Women responded to the house in ways that still echo. They were inspired to make art in their own image. Even if they only saw the project in slides or on film or just read about it or heard tales of it, they understood that they were finally given a model. Women began to reevaluate their own traditional arts.

Although one of our guiding psychological rules was to ignore the phantom criticism that hung over us every step of the way (to pretend there were no male nay-sayers around), we had no idea that the essential theme would mean that we were speaking to women for the first time. What does this say about the art world? That it is dominated by men, surely. Would there ever be room in this arena for a woman's sensibility?

I arranged to have a film made of *Womanhouse*. The filmmakers came in during the last few days of the exhibition and made a movie under the auspices of the American Film Society. Some of the information on how we were perceived is preserved on this film. For example, when you see people's faces as they move through the environment, there is a wonder and an awe on the faces of the women and frequent disdain on the part of older men. One group of males regards the "Menstruation Bathroom," asking themselves, how could this ever have happened?

Maurice Tuchman, the chief curator of contemporary painting and sculpture at the Los Angeles County Museum of Art, visited us. As a modernist he is noted for bringing all the successful male artists' shows from the East coast to the West. In the "Dollhouse Room," he picked up one of Sherry Brody's lingerie pillows from the table where they were displayed. Each of these is covered with an item of women's lingerie. Small, soft to the touch, satiny, they convey a remarkable sense of intimacy, even eroticism. No sooner had he picked one up (at our urging) than he immediately dropped it, saying, "Ugh." We all laughed at the time. Wrong. It wasn't funny. It was a gesture of disdain, of separation from us.

Introducing content into mainstream modern art was the surprise of *Womanhouse*. Content, based on the lives of women. Art as we women know it is

sewn, embroidered, quilted, tatted, woven. These are the domestic arts. Not that we love **Artemisia Gentileschi** or **Angelica Kauffmann** or **Sonia Delaunay** or **Natalie Goncharova** less, but that we all, all of us women, know our lap arts more.

Looking back at the work Judy and I did together, I remember the feeling we both had, that we were two tired people working to make a reality of something we believed in. It was our own letter to the world.

We were on the edge. We did not imitate anymore. We felt the support of the women's movement for our creativity. Cal Arts was an extraordinary setting for our aesthetic adventure. It was a pocket of culture in Valencia, California. The school was divided on our cause, but no one stopped our effort. The women in the entire school were enlightened by *Womanhouse* and later, when Judy left the school and I remained working with the women in the Feminist Art Program, we produced two wonderful books: *Art: A Woman's Sensibility*, a compendium of words and pictures of leading women artists and *Anonymous Was a Woman*, in which prominent women in th field of the arts wrote letters to the women in the Feminist Art Program, telling them of their experiences in becoming successful in their fields. It is a matter of pride that we set out to do something in 1971 and did it so well that we are still writing about it.

—**Miriam Schapiro**

Womanhouse Artists:
Beth Bachenheimer, Sherry Brody, Judy Chicago, Susan Frazier, Camille Grey, Vicki Hodgetts, Kathy Huberland, Judy Huddleston, Karen LeCoq, Janice Lester, Paula Longendyke, Ann Mills, Robin Mitchell, Sandy Orgel, Jan Oxenberg, Christine Rush, Miriam Schapiro, Robin Schiff, Mira Schor, Robin Weltsch, Faith Wilding, Shawnee Wollenman, Nancy Youdelman.

The above essay is excerpted from Women's Studies Quarterly*XV:1&2 with permission of the writer.*

The "Womanhouse" crew, 1972: *top row, from left:* Ann Mills, Mira Schor, Kathy Huberland, Christine Rush, Judy Chicago, Robbin Schiff, Miriam Schapiro, Sherry Brody. *bottom row:* Faith Wilding, Robin Mitchell, Sandra Orgell, Judy Huddleston. Courtesy Miriam Schapiro.

Judy Chicago: The Dinner Party and The Birth Project

Judy Chicago (b.1939) is probably one of the best known woman artists in California because of her unique and controversial exhibit, *The Dinner Party*, which continues to evoke both criticism and admiration. *The Dinner Party*, a sensual feminist tribute to women broke all attendance records at its inaugural opening at the San Francisco Museum of Modern Art.and has travelled across the country and to Europe, developing an almost cult-like following. In each city where it has been shown women were willing to raise the money and solicit the support to ensure its success. Each place setting was a symbolic expression of a woman's individual achievements from Cleopatra to Georgia O'Keeffe.

But although Chicago's work was new to the more traditional art world, it was the culmination of many years of work in Fresno and Los Angeles with other women artists, especially Miriam Schapiro, with whom she shared feminist concerns about art (see chapters on "The Feminist Art Movement" and "Womanhouse"). They met at California State University in Fresno, where Chicago established the first course and department of its kind on Feminist Art.

The extraordinary beauty of *The Dinner Party* transcends the controversies about its feminist attitudes. Developed collectively by women artists in a variety of media, the piece stands out as a landmark, showcasing not only the ability of Chicago as an artistic leader, but also the woman artists whose talents in ceramics, weaving and painting were so dramatically expressed.

Chicago's later works included *The Birth Project*, another large-scale project drawing on the collective talents of women across the country to produce textile forms that explored each woman's personal vision of the birth experience. Both projects have been fully documented with books and film. Chicago recently moved to Santa Fe, New Mexico, and is working on a project focusing on the Holocaust.

—**Rita Cummings Belle**

ARTWEEK: A Backward Look

ARTWEEK began as a response to a need. Out of graduate school, teaching part time at various colleges in the Bay Area, I felt desperately out of touch with the sort of information that had been a stimulus and strength for me during the grad-school years. It was hard to know who was planning exhibits, where the job openings might be and what exhibits might really be worth seeing— particularly those of less-known artists. Talking with colleagues, I found I wasn't alone in this need. As a result, the original intent of *ARTWEEK* was to supply a line of communication among professionals in the visual arts— professionals in the broadest sense, including students, academics, curators, established artists and serious collectors. This was visualized as a community of interests, as interlinked as any geographic community. Since so many magazines already existed to serve the East Coast and I was living in California where the need was great, I took as my geographic area the West Coast, from Vancouver to San Diego and including the contiguous states of the Northwest and Southwest. The first issue came off the press dated January 2, 1970.

Over the 19 years of publication, this has proven to be a viable program. From the 400 subscribers who accepted our prepublication offer, our circulation has grown to approximately 15 thousand copies of each issue. I have been told that *ARTWEEK* is the world's only weekly art magazine, and copies now take information about West Coast art activity to libraries, university art departments, galleries, museums and individuals worldwide.

Reviews in *ARTWEEK* have been important as documentation. We regularly covered exhibits of photography as an art form at a time when no other publication was doing this, though there were occasional articles in *The New York Times*. As interest in conceptual art grew among artists and in a few adventurous galleries, we had frequent articles about these strange new activities which otherwise went unreported. Performance, video art and experimental film received attention from *ARTWEEK* from the beginning, long before these began to attract mainstream coverage. Requests for copies of old issues confirms for us the importance of this function. In addition, there is no question that *ARTWEEK* reviews have helped to advance the careers of many deserving artists.

For those who may not be familiar with *ARTWEEK*, I should explain that it is a tabloid printed in black and white on book paper, with occasional four-color covers. Each issue contains reviews of exhibits, a screened listing of current exhibits throughout the West Coast states, a list of events throughout the region that readers might like to attend and information on competitions that are open for artist participation. It also has a heavily used classified advertising section. The timeliness of publication permits reviews to appear while the art is still available to be seen, a service readers find very useful.

In addition, *ARTWEEK* has provided an outlet for art writing that has allowed critics in our area to develop and grow. Art criticism was a sadly neglected skill when we started publication. Perhaps our openness to emerging critics has been a factor in its subsequent development, something from which the entire discipline has benefited.

If there has been a guiding watchword over the years, it has been "respect"—respect for the imagination, intelligence and commitment of the artists, respect for the works they produce and respect for the writing that discusses it. For me, editing and publishing *ARTWEEK* has been a learning and growing experience so rewarding that I have no adequate words with which to describe it. I feel enormously fortunate to have had the opportunity to do it.

—**Cecile N. McCann**

Visual Dialog:
A Historical Perspective, 1975-1980

Intense dislike and distrust of elitism in art gave me the passionate commitment to spend the time, energy and money required to launch *Visual Dialog*, a fine arts quarterly, in 1975. Though California-based and chiefly concerned with California art, we gave coverage to other areas of the nation and also had foreign subscribers.

Visual Dialog was a genuinely alternative art publication, guided by a pluralistic point of view that chose to emphasize what we considered good art, not just the fads, fashions, fly-by-night gimmicks and readily recognizable "names." Since California had few art publications, our major goal was to give deserving California artists of widely diverse persuasions the press coverage they desperately needed for career survival. Our goals were simple and direct; we never tried to climb aboard the bandwagon of the much vaunted "new" in art, unlike the established art magazines.

Each quarterly issue of *Visual Dialog* was built around a specific art world topic, i.e., painting, printmaking, collectors, clay art, sculpture and similar subjects. Each of these topical issues carried three or four interviews, both with well-known and less prominent artists. We also, although not consciously, gave wide coverage to emerging, mid-career and established women artists. At the time this did not seem unusual to me, since we chose the art on the basis of quality, not gender. We also sought to demystify the role of the artists, allowing

them to speak for themselves through interviews. In so doing, some important philosophical and spiritual guideposts were revealed, along with pertinent technical information.

Another departure from standard art publications is what I chose to call the "Studio Review." This gave us the option of reviewing a body of work in the artist's studio without having to wait for a gallery or museum exhibition. I'm especially proud of this because it gave many artists their first, much-needed press exposure. We also carried reviews of regularly scheduled gallery and museum exhibitions. In addition we featured columns dealing with legal issues, technical information and other topics. Especially important was a section called "Gallery Close-Ups," consisting of three or four pages of photos devoted to work by California artists. We packed all we could into our precious, scant 48 pages.

Visual Dialog ceased publication in 1980, having had the longest run (up to that time) of any fine arts magazine in California history. We closed primarily because we got caught in the inflationary spiral of the mid-70s. Although our printing, typesetting and paper costs more than doubled in a four-year period, we could not reasonably double our subscription rate or cover price. Also, my career as an artist was beckoning my return. Publishing *Visual Dialog* was a horrendously tiring job, leaving me little time to do my art work. It is gratifying now to be putting that kind of energy into my own work and reaping some much needed rewards.

As I look backward at the *Visual Dialog* years, I'm satisfied that I did what I set out to do. I felt it extremely important to help cultivate a pluralistic climate which would allow for art that did not fit into any prescribed mode.

—Roberta Loach

High Performance

In 1978 I founded *High Performance*, the first magazine devoted exclusively to performance art, and my decision had a lot to do with women artists. At that time performance art was virtually brand new, a stepchild of the Happenings and Environments produced by visual artists in New York during the 60s. Some of the most interesting artists, many of them women, were dislocating art from painting and sculpture and putting their energy into live works, incorporating time and live bodies.

Trendspotters tried to declare painting dead and performance art the next hot consumer item, to curb it with definitions and speculate about its success or failure. What was really going on was not the triumph of performance art over painting, but a restructuring of the role of the artist, a redefinition of the artist's tools and a reconsideration of the boundaries of the artwork itself.

We now recognize that *any* element can be art material and that the strict limitation of an artwork to two dimensions, canvas, paint and frame is only an illusion, a fantasy, a lie. Context, frame of reference, gender, cultural differences and political realities were revealed to be part of every artwork as well as every commercial image, every educational strategy, every human decision.

The enormous energy of the 70s "alternative" art world arose from this Pandora's box of discoveries. Artists raced out of the galleries and museums to relocate themselves in the streets, churches, homes, prisons, workplaces, community centers, laboratories, open fields, mountaintops and electronic space, demanding participation of artist and audience in every aspect of existence, going through the motions that literally change perception.

We, the audience, see things differently now because of what artists did in the last 20 years. We are somewhat sadder but wiser, more skeptical and less gullible, adept at and addicted to deconstructing the illusions constantly imposed upon us by our culture. This uncomfortable posture in which we now live, this "postmodern condition" was exposed for us by creative artists. A trip backward through the pages of *High Performance* will reveal the progress of the exposition—in physical action, in text, in the crossing of disciplines, in the clashing of cultures, in the exploitation of technology, in the exploration of the limits of the human body and mind, in the confrontation with life and death.

In this new cultural universe, women hold up far more than half the sky. From my point of view, this revolutionary turn of events was driven by women artists who were deeply involved in the feminist movement and fiercely committed to turning the whole world upside down.

Women artists flooded into performance art because it was an open door, an exhibition space requiring no curator and no permission from the male power structure. They were also drawn to performance art because its flexible boundaries made it a ready platform for political ideas. By the early 70s the art world I reside in, Southern California, was already under assault by women performance artists.

My first experience of performance art was a project by women, and I experienced it, oddly enough, on television—**Johanna Demetrakis'** tape of *Womanhouse*, a feminist art project in Los Angeles in 1972. *Womanhouse* came somewhere between Judy Chicago's first feminist performance workshop in Fresno and the establishment of the L.A. Woman's Building in 1973. Women in the feminist art program at CalArts had obtained an old deserted mansion in Hollywood, reconstructed it and set up their art work there. On view for one month were installations and performances that spoke, often in alarming and graphic ways, about housework and women's role conditioning, nurturing and body experiences. Individuals or groups had each taken over portions of the house. Demetrakis' film showed the kitchen painted a sickly flesh color, with fried eggs on the walls, transmuting into breasts hanging from the ceiling. The "Menstruation Bathroom" by **Judy Chicago** was filled with used Kleenex and Tampax. One female figure was trapped in (built into) a linen closet, while another was plastered into the bathtub. A mechanical bride descended the staircase on a rail, only to crash into the wall at the bottom.

Womanhouse performances paid ridiculous and endless homage to costume, makeup and domesticity. Meanwhile, **Faith Wilding**'s *Waiting* offered a simple but devastating definition of woman's life as constant anticipation.

I became fascinated with this new form that brought the artist's vision so close to what I knew was real life. Over the next few years I sought out more women artists who were producing intimate live experiences, as well as citywide pageants about issues now recognized as vital to the lives of people anywhere: sexism, rape, incest, child abuse, battering, aging, nuclear war, racism, unemployment, homelessness.

Performance was not only the vehicle for this work, it was embedded in education and the raising of consciousness itself. The Feminist Studio Workshop at the Woman's Building in Los Angeles, an accredited college degree program, used performance as a tool for autobiographical and historical research, for student group interaction and for outreach to women of color and the community at large.

A combination of group process work, theater skills and visual design principles produced intense and important works like *The Oral Herstory of Lesbianism*, a group piece performed for audiences of women only, which described the journey of self-discovery taken by the gay women artists working in the building.

Much of this work appeared in *High Performance*. Issue #9 featured two women from *The Oral Herstory* kissing on the cover and reproduced some of the monologs from the piece. It was so revolutionary that my printer refused to process one graphic treatment of two women making love.

The magazine provided the early (and sometimes the only) documentation of this work, spreading it to a network of eager readers from coast to coast and around the world. The current (since 1986) editor of the magazine, Steven Durland, is an artist who was among my first subscribers because he was searching for information about women's performance art activities. From all the way across the country in Massachusetts he responded to the first cover, which pictured artist **Suzanne Lacy** astride a dragster.

As the 80s ensued, *High Performance* joined with a small publishing company called Astro Artz, owned by **Susanna Dakin**. Together we published several books by or about women performance artists, including *Art in Everyday Life* by **Linda Montano**, *Being Antinova* by **Eleanor Antin**, *Dressing Our Wounds in Warm Clothes* by **Donna Henes** and **Sarah Jenkins**, and *Initiation Dream* by **Pauline Oliveros** and **Becky Cohen**, culminating in *The Amazing Decade: Women and Performance Art 1970-1980* edited by **Moira Roth**. The magazine's 10th anniversary issue came out in 1988, and its continuing respect for and commitment to women's performance was underscored by the cover—a reproduction of the Suzanne Lacy cover of issue #1. As the publication moves into the second decade, it obviously owes a great debt to women performance artists for its progressive vision of personal, aesthetic, social and political realities. While it is no longer limited to performance art and not defined exclusively as a woman's art magazine, it is certainly a source for that information and infused with that spirit.

As the pioneer generation of contemporary feminists ages, the galaxy of master artists is increasingly graced with older women who are role models for generations to come. It has been a great honor to know, write about and publish many of these women.

—**Linda Frye Burnham**

Chrysalis: A Magazine of Women's Culture

We called our magazine *Chrysalis*, a high-spirited venture that took wing in 1977, soared idealistically through ten quarterly issues before burning to a finish in 1980. The name was meant to suggest the metamorphosis of the caterpillar as a metaphor for women's transformation from earthbound creature into weightless and winged symbol of freedom and untamed grace. Of course, to follow the metaphor, the butterfly always sheds its chrysalis at the moment of its emergence, a fact of nature that might have hinted at the short-lived existence of our magazine but for the lovely sibilant sounds of the word "chrysalis" that gently prevailed over other considerations.

The magazine grew out of a fusion of East Coast political feminism and the West Coast feminist art movement. From our New York base in the early 1970s, **Susan Rennie** and I had collaborated on cataloging—Whole Earth style—what I now see in retrospect as a unique development of the time. We called it women's alternative culture, and we imagined that it was here to stay. In response to the discrimination against women in the mainstream, feminists were abandoning the establishment and creating instead their own institutions—health centers, record and publishing companies, credit unions, book stores, and so on. Among the most impressive examples of these feminist alternatives were the Los Angeles Woman's Building and the Feminist Studio Workshop, both institutions fueled in large measure by the vision and hard work of **Sheila de Bretteville**, designer, **Arlene Raven**, and **Ruth Iskin**, both art historians. In 1976 Susan and I moved west to join forces with these triune visionary activists. Later **Deborah Marrow**, art historian, and **Peggy Kimball**, copy editor extraordinaire, joined the editorial board, bringing our number to a perfect seven.

California has always occupied a special place in the American psychic landscape. As the western frontier, it appeals to the soul of the rugged individualist bent on shaking off the shackles of convention that define and confine life in other parts of the country. Anything goes, and all things seem possible. Where else could one find a more fertile ground for the free play of the imagination, for a fresh point of view unhampered by tradition?

The moment in time turned out to be far less propitious for our new venture than our chosen place. In 1976 we were riding the crest of high idealism, not realizing that a vicious anti-feminist backlash and the return of Good Housekeeping woman were waiting in the wings along with the runaway inflation and interest rates of the Carter years. It was, we found out, a terrible time to embark on a new business. Without any Cassandra vision of the shifting tides that lay ahead and endowed only with our own rosy ideals and a small grant from **Adrienne**

Rich—proceeds from her book *Of Woman Born* (a fitting subsidy for a parthenogenically conceived magazine)—we stepped off the precipice.

The diversity of focus and values among the cofounders found expression in the content, which reached across a spectrum from hard-hitting and provocative analyses of current events to original visual works created for *Chrysalis* by women artists. *Chrysalis* was not a magazine of the arts or literature or scholarship or criticism, but rather all of these and more in one publication.

This all-embracing concept was, I believe, one of the magazine's special contributions. It reflected an ideal of balance and connectedness among the insights of the mind, the feelings of the heart, works of the imagination, and the physical worlds of sensation. It attempted in its content to integrate the outer world of social arrangements with the inner world of feeling and intuition, the designs of the conscious mind with the symbols of the unconscious—and to enrich our critique of the world as it is with an ideal of the world as it might be if woman's experience shared equally in its making. This was the creative vision of *Chrysalis*.

Our particular delight was in publishing pieces that turned conventional assumptions upside down and inside out. Our premier issue, for example, featured an original collage by **Mary Beth Edelson** in which she adapted the faces on the naked, idle harem women of Ingres' painting, *The Turkish Bath*, to form a group portrait of feminist artists celebrating the senses as the well-spring of their creativity. Arlene Raven's accompanying commentary called this work of art "an ad hoc guerilla action," in which a sexist image is reclaimed and made to serve a feminist vision.

The synthesis between art and politics turned out to be precarious, especially when the absolute freedom claimed by the artist ran up against fervently held political views. When performance artist **Eleanor Antin** was pictured in *Chrysalis* in a few of her many personae—King Charles I (with beard), Little Nurse Eleanor, and a black movie star—one reader charged her with racism reminiscent of the degrading use of "blackface" for the amusement of white audiences. For Antin, coloring herself black was an artistic means of exploring the existential connection among women, blacks, and artists as "the other" in the monolithic world as defined by white males. The creed created around the issue of racism—concerned with political freedom—clashed head on in our pages with the spiritual freedom of the artist and the intellectual, exposing an age-old conflict that could not be resolved under the banner of feminism.

A related debate took place over the publication of two fantasy pieces by **Chellis Glendinning** in which she lightheartedly traced coded archetypal im-

agery of the Great Goddess in the Hollywood movie musicals of the 1930s and in *Star Wars*. The author set about her task in the spirit of a feminist archaeologist reclaiming treasured artifacts from the patriarchal wasteland of Hollywood. Some readers felt, however, that these films deserved to be held in complete contempt by all correct-thinking feminists, exposing again the chasm that separated political values from creative values. The dialog on these issues unfolded in our "Letters" column, sometimes expressed in terms that sounded more like a thundering case for the prosecution than a respectful exchange of views.

Some of our other features aroused far less controversy—our resource catalogs on natural healing, women's spirituality, women artists' books. grantswomanship, feminist theater, self-publishing. Also selections from the first wave of the women's movement, our regular sports column, fiction, poetry, our feminist doublecrostic, book and film reviews, interviews with **Joan Snyder, Kate Millett, Helen Caldicott, Judy Chicago**. And original art by **Susan Mogul, Ellen Lanyon, Betye Saar, Lili Lakich, Barbara Nugent** and **Leslie Labowitz**.

Several of our current events and historical analysis pieces anticipated significant social developments, demonstrating that we were not exaggerating too wildly when we claimed that *Chrysalis* was on the cutting edge of change. I am thinking in particular of **Florence Rush**'s ground-breaking article, "The Freudian Cover-Up," published in our first issue (1977). The author exposed Freud's abandonment of his seduction theory—namely, that the emotional symptoms of his female patients were caused by sexual abuse during childhood—in favor of the more acceptable theory that powerful and suppressed erotic desires gave rise to these events in the imagination, not in reality. As Rush was the first to point out, Freud's revision of his original theory helped to conceal the pervasive sexual victimization of children. That is, until very recently when her work, along with that of **Alice Miller** and others, blew the lid off the layers of denial hiding this ugly secret.

The task of giving visual order to our editorial mélange fell to Sheila de Bretteville, whose contributions to the appeal of our magazine cannot be underestimated. Each individual selection received its own space, a "room of its own" in the magazine, separated by a full page of white from the preceding selection. Ads were grouped at the end of the issue so as not to compete with editorial content for the attention of the reader. The look was quiet, understated, and non-commercial; the words and images were allowed to speak for themselves without the aid of visual tricks designed to seduce or entice the reader.

The gracious visual aesthetics of *Chrysalis* completely belied the economic realities of our operation. The magazine looked so handsome with each issue that many readers assumed that our costs were somehow subsidized. Instead, we were subsisting largely on unpaid labor while struggling to pay off bank loans at interest rates of 20 percent. And as these fell due, we began to grapple with the question of how to increase sales. Couldn't our quiet, understated *Chrysalis* perhaps be a teeny bit flashier? And thus, entering through the back door of economic need (instead of the front door of greed and profit motive), we landed square on the issue of enhancing our anti-commercial magazine's commercial appeal. From this discussion design changes were introduced over which Sheila still to this day (nine years later) gives an occasional little shudder at. Our small attempts to meddle with our concept for the sake of survival were in any case no match for the economic tides. By the time Ronald Reagan entered the White House in 1980, we knew it was time to call an end to our venture.

Chrysalis existed briefly but meaningfully as a document of a time that was itself in transition out of the social awareness of the 1970s and into the harsh self-serving climate of the Reagan years. The ending was sad because it meant the loss of the special family of *Chrysalis* readers and supporters—at one point they numbered 13,000—and the community of values we had shared. What remained for me was the awareness that the dynamic of transformation that can magically make a butterfly out of a caterpillar does not depend on the fate of any individual institution or even social movement. It exists within the creative core of each individual person, where the process that began as a political movement, aimed at the imbalances and inequities of the outer world, continues to address these same issues as in the inner world of the individual. This shift to the inner landscape offers—for me—the hope that the influences we bring to bear in the future toward changing our very flawed yet precious world will flow from love of its beauty rather than contempt for its defects.

—**Kirsten Grimstad**

Contributors

Nancy Acord completed her Master's degree in art history at California State University, Northridge, in 1989. She has been the assistant director at the Mekler Gallery in Los Angeles since 1983.

Heather Anderson is a former art educator, currently lecturing in the Women's Studies Program at the California State University, Fresno. She has a Ph.D. in art education from the University of Oregon. She is a lover of landscape and mountains and has climbed in the California Sierra, the Northwest Cascades, Mexico, Africa and Nepal.

Rita Cummings Belle has published several articles on women artists in *Exhibit*, *Westways Magazine* and *Women Artists News*. She owns a public relations firm in San Francisco.

Betty Ann Brown, art historian and critic, is on the faculty at California State University, Northridge. She has written extensively on art, women and history for periodicals such as *Arts, Artweek, Art Scene* and the Los Angeles *Herald Examiner*, and was the founding editor of *Visions.*. She has served on the Board, and as president, 1987-88, of the Los Angeles Woman's Building. She co-authored, with Jim Burns, *Women Chefs, A Collection of Portraits and Recipes from California's Culinary Pioneers* (Aris Books, Berkeley, 1987), and with Arlene Raven, *Exposures: Women and Their Art* (NewSage Press, Pasadena, 1989).

Linda Frye Burnham was founder of *High Peformance* magazine and its editor, 1978-1985. She is now a *High Performance* columnist, a contributing editor to *The Drama Review*, a staff writer for *Artforum* and a frequent contributor to *L.A. Weekly*. She is administrator for the Los Angeles Poverty Department, a performance art group of homeless/formerly homeless people directed by John Malpede. She is manager of the 18th St. Arts Complex in Santa Monica and co-founding director (with Tim Miller) of the Performance Project, a performance space at the complex.

Eleanor Dickinson is an artist who has lived in Los Angeles and San Francisco since 1953 and has been active in many arts organizations. A figurative realist, she exhibits widely and has works in many museum collections. She is a professor at the California College of Arts and Crafts, where she pioneered in the field of Gallery and Museum Management classes. She serves as national Vice-President of Artists Equity Association and Vice-President of California Lawyers for the Arts and was formerly on the Board of California Confederation of the Arts.

Timothy W. Drescher has documented and lectured on community murals and aesthetics worldwide since 1972. He edited *Community Murals Magazine* from 1978 to 1987, and has worked on murals in the Bay Area and elsewhere. He currently teaches in the Humanities Department at San Francisco State University.

Bruria Finkel, an Israeli-born artist and sculptor, has lived in Southern California for the last 30 years, is married and the mother of four. Her work has been exhibited around the world in galleries and museums. She was a founding member of Womanspace and the Santa Monica Arts Commission.

Shifra M. Goldman is a Los Angeles-based art historian with a Ph.D. from UCLA who specializes in modern Latin American art. She has published *Contemporary Mexican Painting in a Time of Change* (1981); *Arte Chicano: A Comprehensive Annotated Bibliography of Chicano Art, 1965-1981* with Tomas Ybarra-Frausto (1985) and numerous articles in Latin America, Europe and the United States. She has lectured in many parts of the world, and is a Research Associate with UCLA's Latin American Center.

Kirsten Grimstad was cofounder, executive editor and publisher of *Chrysalis*. She is an educator on the faculty of the Vermont College Graduate Program, Los Angeles office, and a publishing consultant.

Betty Kaplan Gubert is Assistant Chief Librarian for General Research and Reference at the Schomburg Center for Research in Black Culture, New York Public Library. She has contributed to *African Arts* and is the editor of *Early Black Bibliographies, 1863-1918* (1982).

Barbara Hammer began making experimental films that confronted taboo subjects in 1973. She then developed a concept involving rotary projection with multi-screens; experimented with underwater landscapes; and researched working with the optical printer.

Elaine Levin, art historian, writer and curator, is a lecturer in American ceramic history at the University of California, Los Angeles. Her book, *The History of American Ceramics,* was published in 1988 by Harry N. Abrams, New York.

Roberta Loach is a third generation California artist. She received her B.A. and M.A. from San Jose State University. Loach taught at the college level, became an art writer and published and edited *Visual Dialog Magazine,* 1975-80. She currently spends most of her time painting, etching and drawing.

Cecile N. McCann grew up in New Orleans and in 1960 moved to California, where she completed a B.A. and M.A. in art at San Jose State University. McCann taught at San Jose State, Hayward State and Chabot and Laney Colleges before starting *Artweek.* Her ceramics and glass works are in collections of the State of California, the City of San Francisco, Mills College and numerous private collections, and she has had several solo

exhibitions. Since 1970 her primary activity has been as editor and publisher of *Artweek*. McCann is a frequent participant on art-criticism panels and exhibition juries.

Sylvia Moore is a Managing Editor in college textbook production at Simon & Schuster's Prentice Hall division. She writes frequently on women in art, coedited *Women Artists of the World* and *Pilgrims and Pioneers: New England Women in the Arts* and edited *No Bluebonnets, No Yellow Roses: Essays on Texas Women in the Arts*.

Linda K. O'Dell is a fiber artist who does commercial and residential commission work. She writes a weekly fiber art column for the Bakersfield, California, daily newspaper.

Leah Ollman writes about art for the *Los Angeles Times*/San Diego County edition, *ARTnews Artweek*. She lives in San Diego.

Peter E. Palmquist is a photographic historian specializing in 19th century California photographers. He is the author of 14 books, of which the best known is *Carleton E. Watkins, Photographer of the American West* (University of New Mexico Press, 1983). His numerous articles on Western photographers have appeared in *American West, Portfolio, The Californians, Journal of the West, History of Photography* (London) and *California History*.

Arlene Raven is an art historian writing criticism in New York for the *Village Voice*, art magazines and academic journals. Her selected essays were published in *Crossing Over: Feminism and Art of Social Concern* (UMI Press, 1988). She was an editor and contributor to *Feminist Art Criticism: An Anthology* (UMI Press, 1988) and co-authored *Exposures: Women and Their Art* (NewSage Press, 1989). Raven was a founder of the Women's Caucus for Art, the Los Angeles Woman's Building and *Chrysalis* magazine. Recipient of two NEA art critics' fellowships and an honorary Doctor of Humanities degree from Hood College, she has curated exhibitions for institutions such as the Baltimore Museum of Art and the Long Beach Museum. Raven studied at Hood College, George Washington and Johns Hopkins Universities and holds an M.F.A. in painting and M.A.and Ph.D. degrees in art history.

Miriam Schapiro, an internationally known artist, was cofounder of the Feminist Art Program at CalArts and a leading figure in the development of the feminist art of the 70s.

Merle Schipper received her Ph.D. in art history from UCLA and has taught at UCLA, USC and California State University, Northridge. She has written criticism for *Arts, Art in America, ARTnews* and *Artweek* and is a columnist for (Los Angeles)*ArtScene*. She has curated many exhibitions including "1931: The Artist's View" (Sierra Madre Museum of Art, 1982) and co-curated "Visions of Inner Space" (Wight Gallery, UCLA and the National Museum of Modern Art, New Delhi, 1987-88) and "MARMO: The New Italian Stone Age" (Los Angeles Museum of Science and Industry and the Fischer Gallery, USC, 1988). She is currently project director for the Santa Monica Arts Commission and is preparing an exhibition on "The 50s and 60s in Santa Monica and Venice."

Christine Tamblyn teaches video and performance art and theory at San Francisco State University. She is a regular contributor to *Afterimage*, *ArtNews*, *Artweek* and *High Performance*.

Meredith Tromble is a painter, who also writes and does a weekly radio commentary on art, "West Coast Weekend," for KQED, San Francisco.

John Turner has been collecting and documenting folk art for 15 years. His most recent book is a biography of Reverend Howard Finster (Random House, New York, 1989), published concurrently with a Reverend Finster retrospective at the Museum of American Folk Art, New York, 1989. Turner is also a news editor at ABC/KGO, San Francisco.

Faith Wilding is a feminist artist who was a founding member of the Southern California Women Artist's Movement. Currently living in New York City, she teaches part-time at Cooper Union and produces work in radio, drawing and artist books. A member of the Heresies Collective, Wilding has recently received an NEA Media grant for her radio piece "Hildegard and I," and a NY Foundation for the Arts Grant for bookworks.

Melinda Wortz received her B.A. in Art History from Radcliffe College, M.A. from the University of California, Los Angeles and a Ph.D. from the Graduate Theological Union, University of California, Berkeley, in Theology and the Arts. She writes art criticism for various magazines such as *Artforum* and *Arts*, and lectures throughout the country. She is Director of the Fine Arts Gallery, University of California, Irvine, and Associate Dean of Fine Arts.

Kathy Zimmerer is currently the Director of the University Art Gallery, California State University, Dominguez Hills. She received her M.A. from the Williams College Graduate Program in the History of Art, and in 1977 received a Rockefeller/NEA Museum Training Fellowship. She is on the staff of *Visions* magazine and has contributed articles to *Artweek*, *ArtScene*, *Images and Issues* and *Arts*.

Photo Credits
(references are to pages)

cover design: Two Lip Art
interior design: Barbara Bergeron